DESIGNDIRECTORY **Italy**

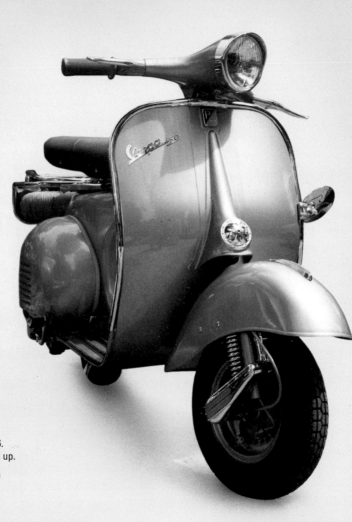

Quick Start in 1946.
Italian design revs up.

Vespa for PIAGGIO

Claudia Neumann

DESIGNDIRECTORY

Italy

Universe

Successful Series.
SAPPER and **ZANUSO** design boxes
with global appeal.

Algol for **BRIONVEGA**, 1964

About this book

There are perhaps more designers per square mile in Italy than anywhere else on earth. And nowhere else have so many companies so consistently defined themselves through design. Design Directory: Italy tries to make the enormously diverse Italian design landscape accessible to the reader, through a simple alphabetical structure and numerous illustrations. The directory's main focus is individual profiles, with an emphasis on furniture and product designers. A number of major fashion and graphic designers are included, as well as discussions of important styles and currents in Italian design. And this book is the first of its kind to include portraits of companies both big and small involved in the business of design. The Interni Guide, a directory of the Italian furniture industry, lists about 1,000 design-oriented furniture makers and no less than 200 lighting manufacturers. Out of this immense number a selection was made that reflects the companies' historical significance as well as their relevance to contemporary design. An annotated index contains many additional entries; throughout the book, names and terms in bold in the main text refer to the index.

The Authors

Paola Antonelli is a curator at the Department of Architecture and Design at the Museum of Modern Art in New York. A graduate of Milan's Polytechnic, she is a frequent contributor to such publications as *Abitare, Domus*, and *Nest*. Exhibitions she has curated at MoMA include Mutant Materials in Contemporary Design. She lives in New York.

Fulvio Ferrari is a writer and world-renowned dealer and collector of Italian design as well as one of the leading experts in the field. The owner of an important private design archive, he has a particular interest in Radical Design. He lives in Turin.

Claudia Neumann is a freelance writer and editor and owner of the Design Archive agency. A copublisher of the Design Calendar, she has published numerous articles on design. She lives in Cologne.

Translated into English by Jürgen Riehle.

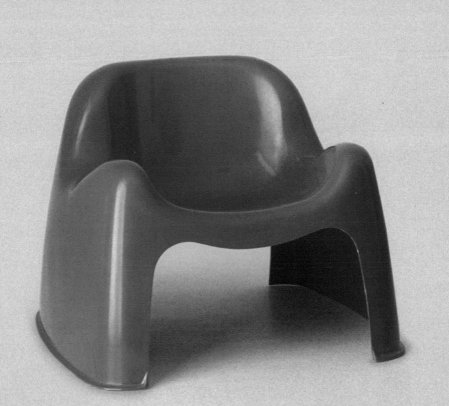

Classics for the Masses.
ARTEMIDE molds plastic into serial
seating.

Toga by **Sergio MAZZA,** 1969

High Beam.
Achille and **Pier Giacomo**
CASTIGLIONI put lighting on a
pedestal.

Taccia lamp for **FLOS**, 1962

Design Nation

Above and beyond any romantic declaration about Italians and their secret recipe for success stands the exceptional effectiveness of Italy as a twentieth-century design case study. Nowhere else in the world can one find so many varied examples, both in terms of conception and of formal outcome; so many applications of diverse technologies; such a complete representation of all applied design forms, from fashion and graphics to product and set design; such an extensive and multifaceted documentation recorded in literature; and such an international resonance. By engaging the best industrial and cultural forces of the country in a single-minded and spontaneous operation of national image-building, Italian design has become an icon in itself, almost independent from its products.

Moreover, different national design cultures have reached their zenith at different times during the century, thus becoming temporary international symbols in the history of design. While it was France's turn in the teens and twenties, Germany's in the thirties and forties, and the United States and Scandinavia shared the fifties, Italy seems to own most of the sixties and early seventies, a period particularly dear and positively meaningful to the world.

Legend has it that during the 1950s in Italy, several talented but unemployed architects fortuitously met some enlightened industrial manufacturers in search of products; in the background, the mechanical and chemical industries were bubbling with innovations waiting to be grabbed and applied.

Together, they established the collaborative formula, based on sharing technical knowledge, dreams, and goals, that bore them great fruits in the sixties. The best examples of Italian design reflect this tight collaboration, a relationship that to this day provides designers from all over the world with exceptional support for experimentation.

Before World War II, only a few companies, concentrated in the food and

mechanical industries—**Campari, Pirelli,** and **Olivetti** among them—shared this attitude. In the fifties, the model became contagious. **Achille** and **Pier Giacomo Castiglioni, Vico Magistretti,** and **Marco Zanuso,** to name just a few, might never have achieved their success without this receptiveness on the part of manufacturers. Likewise, many existing companies that relied on big contract commissions, yet also on trite imitation of eclectic styles, like **Cassina,** would have never become pioneers of design. The family-based companies, located primarily in northern Italy, in the region north of Milan and in Veneto, and in pockets of central Italy, reacted positively both to these architects' sophisticated culture and to the technology transfers provided by the idle war industries.

The postwar economic boom provided fuel for numerous new companies. Some of them were created from scratch to take advantage of new technologies, like **Kartell,** founded in 1948 by engineer Giulio Castelli to exploit the invention of polypropylene. Others, like **Arteluce,** were begun by designers who wanted to manufacture their own ideas, and who therefore approached technology in a more thought-out fashion. Meanwhile, the architecture and design community sparked a lively dialogue with the rest of the world and fostered the spectacular edge of Italian design through publications like *Domus, Abitare,* and *Casabella,* and international events, like the Milan furniture fair, established in 1961, and the *Triennali.* Italy felt like the epicenter of the design world.

This golden moment of Italian design culminated in the 1972 *Italy: The New Domestic Landscape* exhibition at the Museum of Modern Art in New York, also considered by some its swan song. The oil crisis and the "lead years" of terrorism took a toll on designers' optimistic attitude, yet could not defeat the

profession's visionary soul. The **Memphis** phenomenon and the postmodern activity of companies like **Alessi** exemplified a new Italian way to design, more attuned to the fashion industry—companies started using the word "collection" in their catalogues—and focused on the designers' signature styles, supported by the companies' well-studied images.

To this day, Italian design companies have been able to maintain their status and their experimental verve and, in a time short of great indigenous designers, are attracting the best talents from all over the world. They keep the flag of Italian Design flying high.

Paola Antonelli
Museum of Modern Art, New York

Model for a Decade.
While the furniture objects remained prototypes the **MEMPHIS** mosaics by **SOTTSASS** & Co. were ubiquitous in the 80s.

Carlton shelf unit, 1981

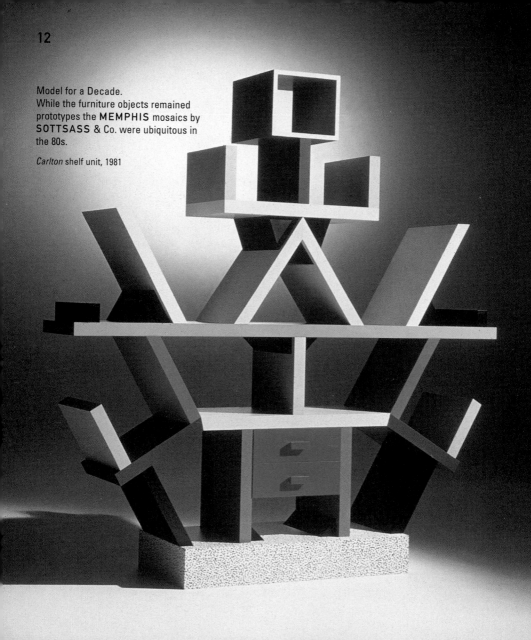

Red Wedding.
VALENTINO finds his signature color.

Couture, 1965

Dissolving Quotes.
In 1978 Alessandro MENDINI
proclaims the end of design history and
dismantles it with a saw and a
paintbrush.

Poltrona di Proust
for **ALCHIMIA**

Bicycle Thieves.
In 1957 **Achille & Pier Giacomo
CASTIGLIONI** steal the show with a
wobbly seat.

Sella, produced by **ZANOTTA** since 1983

olivetti DIVISUMMA 18

Soft Calculator.
Mario BELLINI's soft-keypad
adds a sensual touch to arithmetic in
1972.

Divisumma 18 for **OLIVETTI**

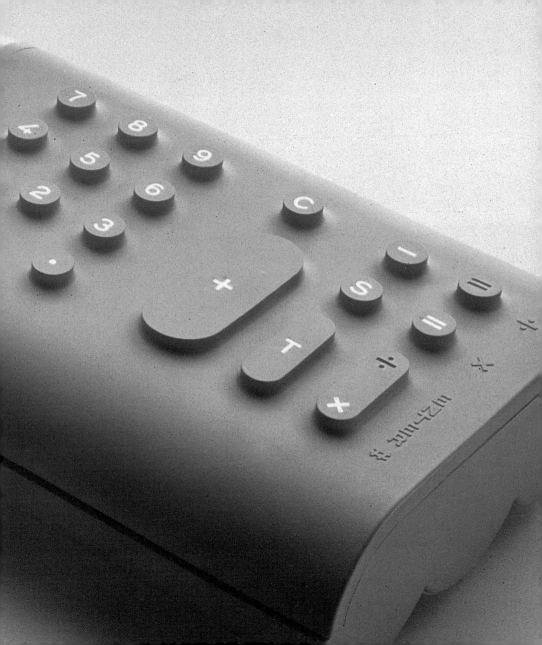

Interactive Mattress.

Years before Ikea, **Joe COLOMBO** invites furniture buyers to assemble their own beds.

Additional System for **SORMANI**, 1967

Cool Presence. In 1954
Bruno MUNARI brings
a smooth new style to
cocktail culture.

TMT ice bucket, produced by
ZANI & ZANI

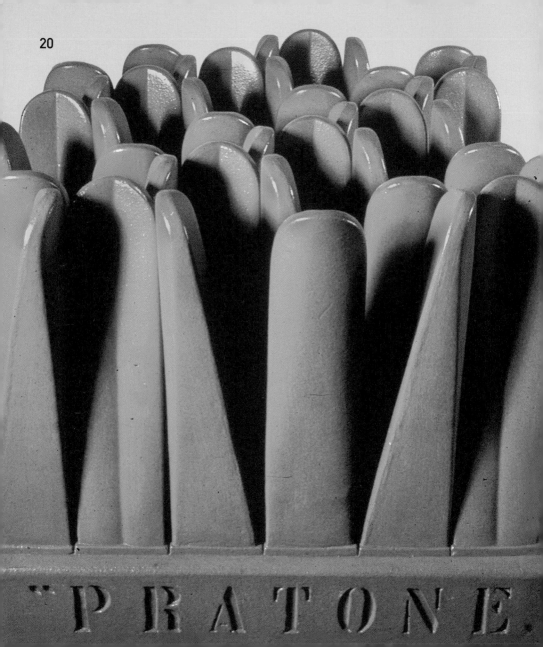

"PRATONE

Plastic-Provocation.
GUFRAM'S designs create
pop icons out of foamed plastic.

Pratone artificial turf by **CERETTI,
DEROSSI, ROSSI**, 1971

High Contrast.
SAWAYA & MORONI give
seating a racy edge.

Bine by **Marcello
MORANDINI**, 1991

Piccolo Teatro di Milano

Ente Autonomo

Direzione Paolo Grassi - Giorgio Strehler

Milano - Palazzo del Broletto - Via Rovello, 2
Telefoni: 896915 - 603464 - 867206 - 867208 - 873585

Ufficio Abbonamenti e Propaganda
Via Rovello, 6

Biglietteria 872352 - 877663

stagione 1964/65 al Piccolo Teatro

diciannovesima dalla fondazione

da sabato 28 novembre

lunedì, mercoledì, giovedì, venerdì, alle ore 21,10 precise
sabato alle ore 15,30 e 21,10 precise
domeniche e festivi alle ore 15,30 precise
termine spettacoli: pomeriggio: ore 18,10, sera: ore 23,50
martedì (esclusi festivi e prefestivi) riposo

Sul caso J. Robert Oppenheimer

2 tempi di Heinar Kipphardt
prima rappresentazione in Italia

allestimento di Giorgio Strehler e Cioni Carpi
Luciano Damiani, Gigi Lunari, Virginio Puecher,
Fulvio Tolusso

Distribuzione:

J. Robert Oppenheimer, fisico	Renato De Carmine
La commissione d'inchiesta:	
Gordon Gray	Raffaele Giangrande
Ward V. Evans	Ferdinando Tamberlani
Thomas A. Morgan	Gastone Bartolucci
Gli avvocati della commissione per l'energia atomica:	
Roger Robb	Franco Graziosi
C.A. Rolander	Ugo Bologna
L'avvocato della difesa:	
Herbert S. Marks	Mario Mariani
I testimoni:	
Boris T. Pash, ufficiale del servizio segreto	Corrado Nardi
John Lansdale, ex ufficiale del servizio segreto	Ottavio Fanfani
Hans Bethe, fisico	Antonio Meschini
Edward Teller, fisico	Luciano Alberici
David Tressel Griggs, geofisico della Air Force	Attilio Duse
Isadore Isaac Rabi, fisico	Giulio Girola

Assistente alla regia: Paolo Radaelli

Le scene sono realizzate dal Laboratorio
di Scenografia del Piccolo Teatro
pittore scenografo Leonardo Ricchelli,
costruttore Bruno Colombo

Direttore di palcoscenico: Bruno Martini
Capo elettricista: Mino Campolmi
Rammentatore: Giuseppe Lelio
Vice direttore di palcoscenico: Luciano Ferroni
Primo macchinista: Fortunato Michieli
Attrezzista: Aldo Dal Santo
Sarta di palcoscenico: Lea Gavinelli

Prezzi:

1600 Poltrona di platea / 1100 Poltroncina di platea / 800 Balconata

Le prenotazioni si ricevono alla biglietteria
del Piccolo Teatro (tel. 872352-877663)
ogni giorno dalle ore 10 alle ore 19.
La vendita e la prenotazione dei posti
vengono aperte con quattro giorni di anticipo.

I posti prenotati telefonicamente si ritengono rinunciati

I prezzi su esposti includono ingresso e tasse.
Posteggio autorizzato per automobili.

Vale il tagliando n. 2 degli abbonamenti

Biglietteria 872352 - 877663

stagione 1964/65 al Piccolo Teatro

diciannovesima dalla fondazione

da sabato 26 dicembre

lunedì, mercoledì, giovedì, venerdì, alle ore 21
sabato alle ore 15,30 e 21,10 precise
domeniche e festivi alle ore 15,30 precise
termine spettacoli: pomeriggio: ore 18,10, sera
martedì (esclusi festivi e prefestivi) riposo

Il Signor di Pourceaugnac

commedia in tre atti di Molière
nuova traduzione di Ruggero Jacobbi

regia di Eduardo De Filippo

Distribuzione:

Il Signor di Pourceaugnac	Tino Buazzelli
Oronte	Armando Alzelmo
Giulia, figlia di Oronte	Manuela Andrei
Nerina, ruffiana, finta moglie di Pourceaugnac e finto ufficiale	Gabriella Giacobbe
Lucetta, altra finta moglie di Pourceaugnac	Narcisa Bonati
Eraste, innamorato di Giulia	Umberto Ceriani
Sbrigani, napoletano raillemestieri	Franco Sportelli
Primo medico	Sandro Merli
Secondo medico	Ivan Cecchini
Un farmacista	Sandro Dori
Un contadino	Giancarlo Cajo
Una contadina	Narcisa Bonati
Primo avvocato	Ivan Cecchini
Secondo avvocato	Pietro Buttarelli
Primo svizzero	Giancarlo Cajo
Secondo svizzero	Parida Calonghi

Infermieri, Bambini, Magistrati, Secondini, Arcieri

Giorgio Biavati Pietro Buttarelli Giancarlo C
Paride Calonghi Piergiorgio Menegazzo

Musicisti

Antonio Baldini Giuseppe Bova Augusto Ca
Antonio Esposito Mario Sarria

L'azione si svolge a Parigi

Scene e costumi di Mino Maccari
Musiche di Fiorenzo Carpi
Pantomime di Rosita Lupi
Regista assistente Virginio Puecher

Le scene sono realizzate dal Laboratorio
di Scenografia del Piccolo Teatro
pittore scenografo Leonardo Ricchelli,
costruttore Bruno Colombo

I costumi sono realizzati dalla Sartoria
del Piccolo Teatro
Capitecnici: Angelo Bocenti, Tina Nicoletti,
Ines Rezzonico
e dalla Sartoria Maria Consiglio di Napoli

Direttore di palcoscenico: Luciano Ferroni
Capo elettricista: Mino Campolmi
Primo macchinista: Fortunato Michieli
Rammentatore: Ildebrando Biribò
Attrezzista: Aldo Dal Santo

Prezzi:

1600 Poltrona di platea / 1100 Poltroncina di platea / 800 Balco

Le prenotazioni si ricevono alla biglietteria
del Piccolo Teatro (tel. 872352-877663)
ogni giorno dalle ore 10 alle ore 19.
La vendita e la prenotazione dei posti
vengono aperte con quattro giorni di anticipo.

I posti prenotati telefonicamente si ritengono
rinunciati se non vengono ritirati entro le ore 18
del giorno successivo alla prenotazione.

I prezzi su esposti includono ingresso e tasse.
Posteggio autorizzato per automobili.

Vale il tagliando n. 2 degli abbonamenti
Servizio di recapito a domicilio
dei biglietti o dei posti in abbonamento
prenotati telefonicamente.

Di tutti i poeti comici che subirono, in Europa,
le influenze della Commedia italiana
dell'arte, il più grande e insieme quello che più
direttamente ne proviene è Molière.
Molière è un francese e come tale è italiano.
È un misto di latino e di smaliziato. Si fondano in

precisamente il contrario, ... in certo senso,
d'ogni morale eroica. La morale eroica...
è in qualche modo «contro natura»: contro natu
il coraggio, contro natura il sacrificio, contro na
la rinuncia, contro natura la castità, contro natu

Beautifully Banal. **KARTELL**
brings plastic elegance to the humble
chore of straining pasta.

Gino **COLOMBINI**, 1959

Dramatic Red and Black.

For thirty years, a two-tone alphabet
has been **VIGNELLI**'s unmistakable
hallmark.

Playbill for the
Piccolo Teatro in Milan, 1964

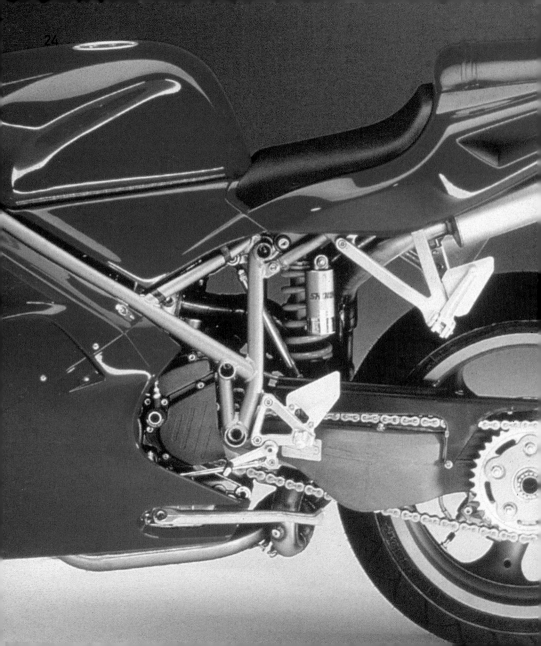

Ample Charms.
Gaetano PESCE's
duvet-lined chair gives
comfort in the hectic 80s.

I Feltri for CASSINA, 1987

Nude Machines.
DUCATI radically
strips down its
bikes in the 90s.

Ducati *916 Biposto*,
1998

Street Style.
In the 70s **FIORUCCI** launches
fashions for the urban catwalk.

Collection 1997/1998

Gentle Waves. **Carlo SCARPA**
meditates on glass in 1940.

Battuto Bicolore vase for **VENINI**

Translucent Objects.
Marco FERRERI's stacking bowls make a soft landing in the kitchens of the 90s.

Antipodi for **DANESE**

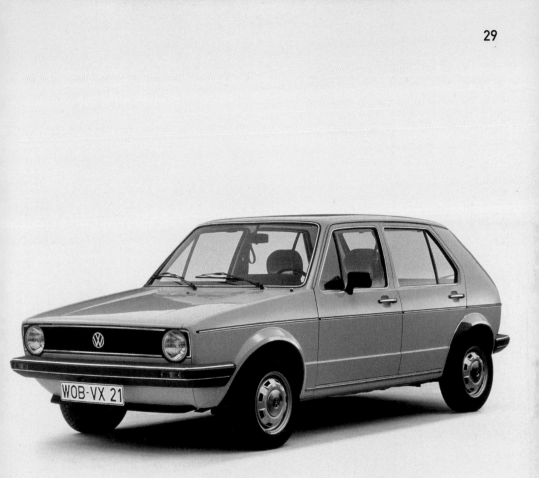

Friendly Invasion.
Giorgetto GIUGIARO'S Golf
puts Italian Design on German roads.

VW *Golf* by ITALDESIGN, 1974

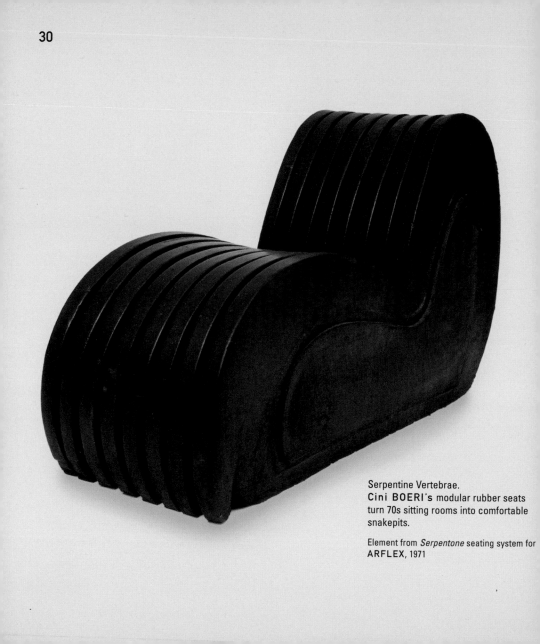

Serpentine Vertebrae.
Cini BOERI's modular rubber seats
turn 70s sitting rooms into comfortable
snakepits.

Element from *Serpentone* seating system for
ARFLEX, 1971

Furniture Aerobatics.
Stunt pilot **Carlo MOLLINO**
puts bold curves into hard wood.

Table of the series *Arabesque*, 1949

Streamlined Calculator.
Marcello NIZZOLI borrows a look
from car design for **OLIVETTI.**

Elettrosumma 14, 1946

Marketing Discovers Art.
The **FUTURISTS** turn into poster
designers and boost the sales of
beverage companies.

Poster for **CAMPARI** by
Fortunato DEPERO, 1920s

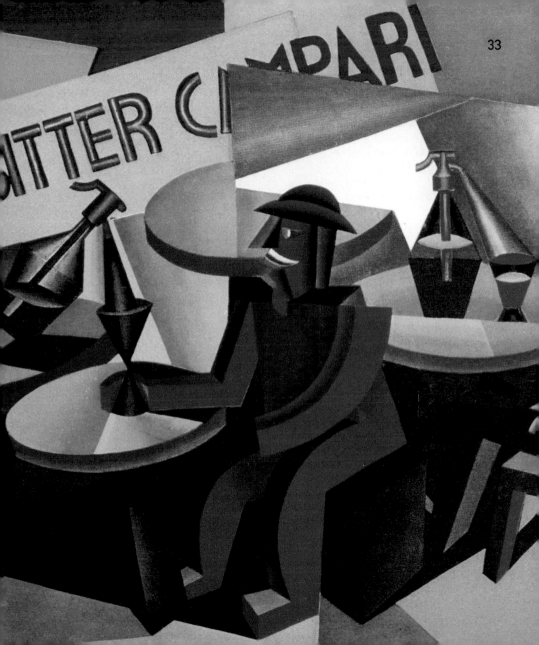

Illuminating Geometry.
Vico MAGISTRETTI'S
brings a sense of proportion to 70s
tables.

Atollo for O LUCE, 1977

Triangulated Sitting.
In 1969 **ARCHIZOOM** takes formal
reduction to parodic extremes.

Mies for **POLTRONOVA**

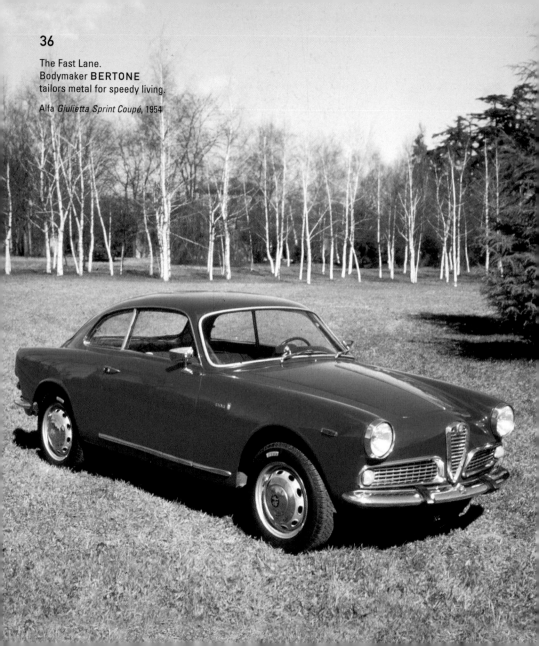

36

The Fast Lane.
Bodymaker **BERTONE**
tailors metal for speedy living.

Alfa *Giulietta Sprint Coupé*, 1954

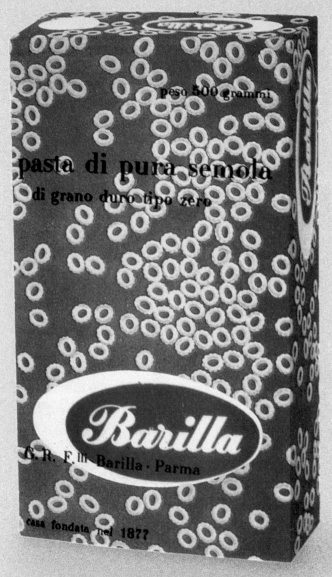

peso 500 grammi

pasta di pura semola
di grano duro tipo zero

Barilla

G.R. F.lli Barilla · Parma

casa fondata nel 1877

Packaging Art.
Erberto CARBONI
makes a convincing
case for pasta.

Packaging for
BARILLA, 1956

Suspense.
In 1989 LUCEPLAN'S luminous UFO
enters into the office atmosphere.

Titania by Paolo RIZZATTO
and Alberto MEDA

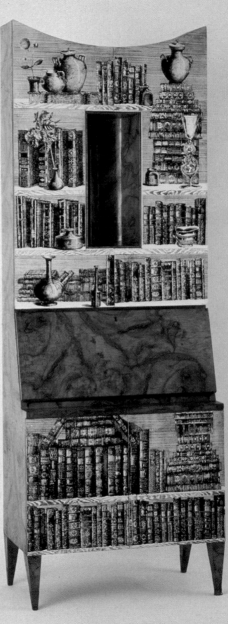

Liquor or Learning?
Piero FORNASETTI
pastes books on **Gio PONTI**'s
cabinet.

Prototype, 1950

Slouch Zone
In 1968 the Flower-Power
generation gets mellow on
ZANOTTA's beanbag.

Sacco by
GATTI/PAOLINI/TEODORO

Bright White. In the 1960s VALLE and
ZANELLO establish order in Italy's
motley kitchens.

P.5 compact washing machine
for ZANUSSI, 1966

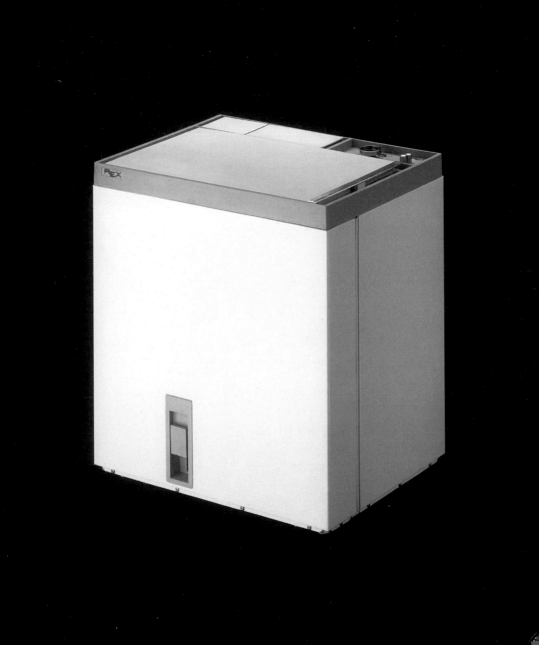

Auto-Erotic.
Enzo FERRARI and **Battista PININFARINA** lend sensuous form to combustive power.

Ferrari *250 GT Berlinetta SWB,* 1960

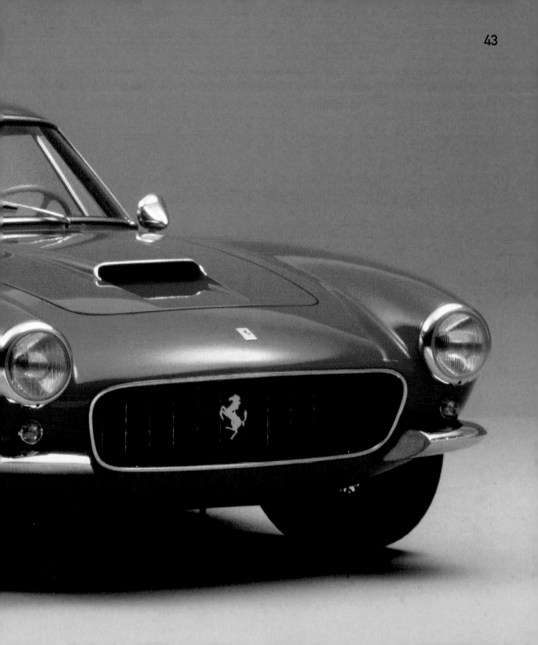

Iron Maiden.
MENDINI'S corkscrew ushers in
ALESSI'S colored period.

Anna G., 1994

Poster à la mode **Albe
STEINER** dresses up a
department store.

L'estetica nel Prodotto, poster for
LA RINASCENTE, 1953

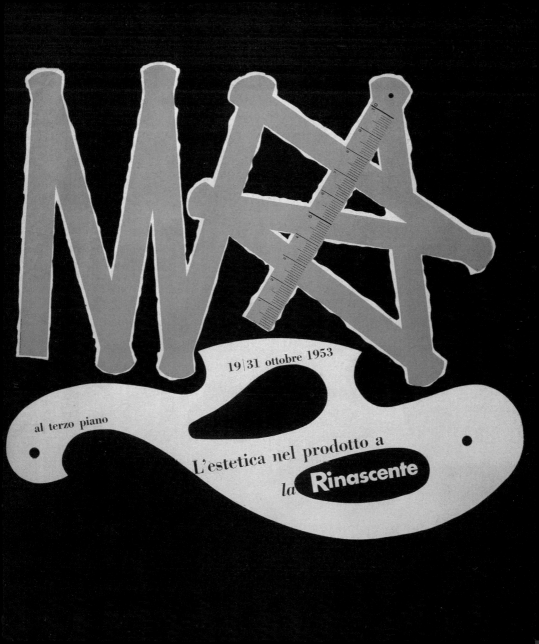

Eye-Catcher.
With their gargantuan mitt
DE PAS / D'URBINO / LOMAZZI
pay homage to Joe DiMaggio.

Joe for **POLTRONOVA**, 1970

Plastic Elegance. **Enzo MARI**
gives high style to a lowly material.

Pago Pago vase for **DANESE**, 1969

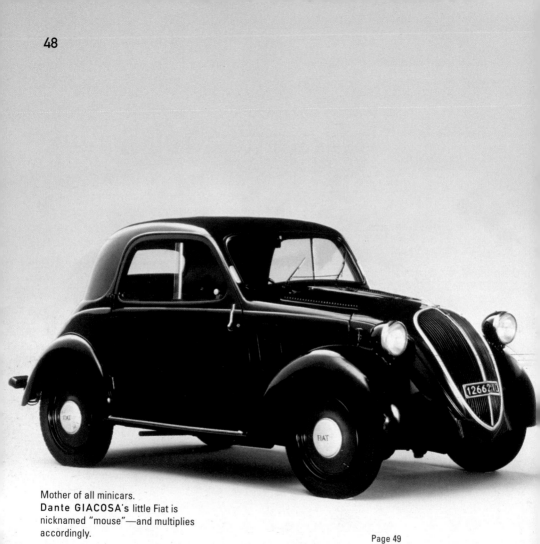

Mother of all minicars.
Dante GIACOSA's little Fiat is
nicknamed "mouse"—and multiplies
accordingly.

Fiat *500*, 1936

Page 49

Timor calendar by Enzo Mari
for Danese, 1966

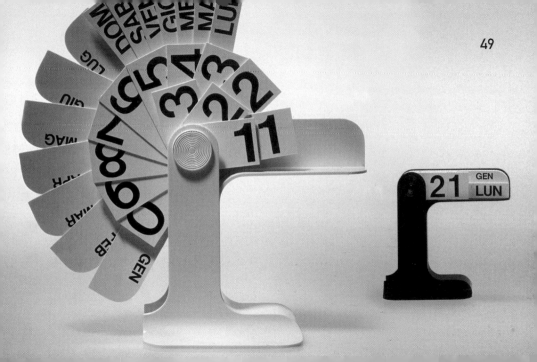

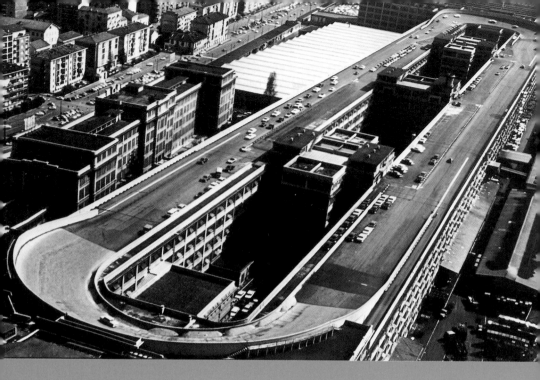

1860-1945

From Single to Series:
Pioneers and Prototypes

Pioneers and prototypes

Italian design did not grow out of specialization. From the *Vespa* scooter to the *Sacco* beanbag, from the inflatable *Blow* chair and **Olivetti's** red *Valentine* typewriter to **Alessi's** *Conica* espresso maker, most of Italy's design classics were created by self-taught designers. None of the people responsible for Italian design's mythic aura had ever studied "design,"a field that didn't even exist in Italy's schools until the 1980s. Instead, they are architects, artists, engineers, chemists, aircraft builders, and race car drivers.

Less surprisingly, all of those icons of Italian design were made after 1945. After the end of Fascism, every part of Italian culture was swept with the desire to build a new, democratic country. The architect **Ernesto N. Rogers** set the tone for the era when he demanded that everything in the human environment—"from spoons to cities," from the monumental to the utilitarian—be treated as objects worthy of design. This democratic spirit released an enormous amount of design creativity. Even a simple bucket could now transcend its basic use and win its creator Italy's highest design prize, the *Compasso d'oro,* awarded to **Gino Colombini** in 1955 for his plastic pail.

The history of industrial development and the history of industrial design are tightly intertwined—a fact often overlooked when the focus is fixed on aesthetic judgments. But it was only with the comprehensive industrialization of Italy

"And though there are philistines here, they're at least Italian orange philistines and not clumsy German potato philistines."

Heinrich Heine

Page 50
Fiat factory in Lingotto, Turin, with spiral ramp to rooftop test track, 1921

from left:
Pirelli, tire assembly, c. 1920
Cobra chair by Carlo Bugatti, 1902
First Olivetti factory in Ivrea, c.1910

and the economic boom of the 1950s that the conditions were created in which Italian design could rise to global preeminence and, in the 1960s, break the dominance of Scandinavian design.

The Industrial Revolution did not reach agrarian Italy until the 1870s, decades after it had transformed the economies and cultures of England and France. Even then, there were only a few adventuresome entrepreneurs willing to take a cue from abroad and build factories for the mass-production of consumer goods. One of these early pioneers was Camillo **Olivetti,** who in 1908 founded a typewriter company. Typewriters, he believed, shouldn't be "parlor items with ornaments of questionable taste," but objects distinguished by their utilitarian value. His vision took shape in his design for the *M1* typewriter of 1911, whose simple, clean lines were entirely derived from the industrial manufacturing process.

The Italian automobile industry developed more rapidly, though its output of luxury limousines and race cars was reserved for a small, wealthy clientele. **Fiat** was founded in 1899, followed by **Lancia** in 1905 and **Alfa Romeo** in 1909. These companies combined progress and tradition in a peculiar mix: while technological achievements and division of labor in the manufacturing process pointed forward into the new century, their cars' interiors displayed the pompous opulence the old

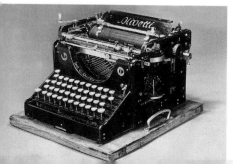

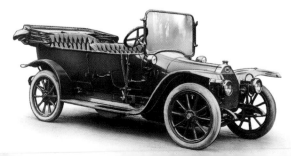

century had felt at home in. The Fiat *Zero,* introduced in 1912, marked a turning point. The Italian answer to Ford's *Model T,* it followed the American principle of lower cost through mass production.

The manufacturing industry's lingering reluctance to embrace formal experiments affected even its most ardent cheerleaders, the Futurists. Enthusiasm for the thundering Machine Age may have run high, but not high enough to integrate the furniture concepts or boldly patterned textile designs of Futurist artists such as **Giacomo Balla** into industrial production, or into everyday life.

The end of the First World War meant the end of the huge government contracts that had been fueling the country's industry. In Italy, as in the rest of Europe, the consequences were social unrest and a massive economic crisis. The situation became so desperate that Mussolini's promises of leading the nation back to its old grandeur found a receptive audience. When the Fascists rose to power in 1934, they immediately began subsidizing domestic industry, introducing the average consumer to mass-manufactured and, occasionally, well-designed products. Olivetti, now headed by the founder's son, Adriano, was again among the pioneers of functional design. The elegant typewriter models *MP 1* (1932) and *Studio 42* (1935) and an innovative, eye-catching advertising program all came out of the company's creative

"Look for your competitors' best parts and then combine them better than they do."

Fiat motto

from left:

M 1 typewriter by Camillo Olivetti, 1911

Fiat Zero, 1912

Table and chair for Gualino office by Giuseppe Pagano and Gino Levi-Montalcini, 1928

Alfa Romeo RL Super Sport, 1925

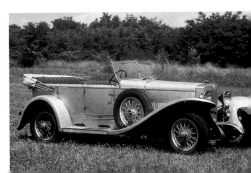

department, whose staff included the Bauhaus alumnus **Xanti Schawinsky,** architects **Luigi Figini** and **Gino Pollini,** and graphic artist **Marcello Nizzoli.**

Efficient industrial production after the American model became increasingly common, particularly among the large automobile manufacturers. Adopting the streamlined look, car-body designers such as **Pinin Farina** and **Bertone** applied it to such luxury models as Lancia's *Aprilia Coupe,* the Fiat *1500,* and the Alfa *6 C 2300 "Pescara"* Coupe. In 1936, Fiat took a more important step, introducing a car that had been designed for social reasons, not spectacular looks. The Fiat *500,* priced at a widely affordable 8,900 lire, was the world's smallest car and quickly became ubiquitous on Italy's roads. By 1948, 150,000 of the *"Topolini"* had been sold.

While cars conquered the roads, another technological achievement, the radio, invaded Italy's homes. At first they came encased in stately wooden cabinetry. That changed in 1940, when **Luigi Caccia Dominioni** and **Livio** and **Pier Giacomo Castiglioni** caused a sensation with the introduction at the Milan *Triennale* of their Bakelite radio for Phonola, designed with the functional aesthetics of the telephone, another symbol of progress.

These innovative designs bore the marks of European Modernism, which in Italy was known as **Razionalismo.** Originally a movement within architecture, the principle of form following function soon permeated product design. The

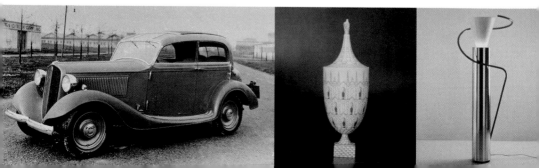

Fascists supported this movement through the mid-1930s; in 1934–36, **Giuseppe Terragni** built their party headquarters, the Casa del Fascio in Como, in the rationalist style. Mussolini eventually favored as the "true" Fascist style the architectural movement of the **Novecento,** which tried to integrate and modernize, rather than overcome, neoclassical traditions. In furniture production, the modernist influence was strongest in Bauhaus-inspired tubular steel and chrome pieces such as **Piero Bottoni's** *Lira* chair, whose frame had thin stainless-steel inserts, which stabilized the chair and formed the backrest. (The chair is now produced by **Zanotta.**) Many other rationalist designs never went beyond the prototype stage because Italian factories lacked the technology to manufacture them.

The effects of global politics were more acutely felt in 1936, after the League of Nations imposed sanctions on Italy for its invasion of Ethiopia. With its businesses cut off from international markets and suffering from shortages of raw materials, the country was now largely dependent on its domestic production. For all the hardship this caused in daily life, it also spawned a spirit of improvisation. **Salvatore Ferragamo,** a shoemaker, made a virtue of necessity and, instead of leather, used materials such as metal, raffia, and cork for his shoes, inventing a signature style that would later make him famous.

"Art has fallen in love with industry (...), and industry has become an intellectual phenomenon."

Gio Ponti

from left:

Fiat *Ardita* by Bertone, 1927

Serliana urn by Gio Ponti for Richard-Ginori, 1927

Luminator floor lamp by Luciano Baldessari, 1929

Desk for design studio by Annibale Pecorelli, c. 1930

Poster by Xanti Schawinsky for Olivetti's *MP 1* typewriter, 1935

Tea set by Nikolai Diulgheroff for Mazzotti, 1930

Ferragamo was a gifted artisan, a representative of the "other" side of Italian manufacturing. Cars, radios, and typewriters made up only a fraction of the products designed in Italy. Outside of the growing industrial sector, the country had countless small enterprises and workshops, each with a history that went back decades or even centuries. By the end of the nineteenth century, for example, cabinetmakers such as **Carlo Bugatti,** Eugenio Quarti, and Carlo Zen had established enormously successful businesses, while Venetian glass manufacturers such as Salviati and ceramics workshops like **Richard-Ginori** were on their rise to fame. Bugatti was renowned at home and abroad for his highly original interpretation of Stile **Liberty,** as Art Nouveau was called in Italy. By the early twentieth century, furniture manufacturers in the Brianza, northeast of Milan, had begun adopting industrial production techniques. (It is still the center of Italian furniture design.)

Well into the twenties and thirties, however, most utilitarian household objects were still manufactured by traditional methods, and the bulk of Italy's furniture production continued to be stylistically conservative and manufactured in small quantities. This was true even of a company like **Cassina,** whose products would epitomize modern Italian design only a

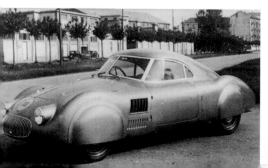

few decades later. In the meantime, adherents of the Novecento movement gently but decisively revolutionized the arts-and-crafts industry. Celebrated Milan architect **Gio Ponti,** for one, redesigned the venerable ceramics manufacturer Richard-Ginori's entire product line and prepared it for mass production.

Yet the word "design" was not yet part of the Italian vocabulary; "industrial design" was a mission, not a job description. At the 1936 Milan *Triennale*, for example, the architect **Franco Albini** designed *"A Room for a Man"* as a comprehensive environment that included not only furniture but also an extremely functional, habitable structure built around basic human needs. Design as a profession emerged casually, without a name and largely unnoticed. And for most Italians, the achievements of design's early pioneers were of rather marginal interest.

Of course, the central aspect of the period between the two World Wars consists in the fact that it was almost entirely defined by Fascism and its introduction of aesthetics into politics (a tendency as pronounced in Italy as in Germany; though Italian Fascists were remarkably open to Modernism). It is an aspect that still awaits comprehensive critical reflection by Italian art and design historians.

"An object is much harder to design than a building."

Luigi Caccia Dominioni

from left:

Lancia *Aprilia Aerodinamica* by PininFarina, 1936

Chair from Carlo Scarpa's *1934* series, reproduced by Bernini

Moka Express espresso maker by Alfonso Bialetti, 1933

Interior by Ottorino Aloisio, Exhibition, Turin, 1934

Giuseppe Terragni

Novocomum apartment building aka "Transatlantic," by Giuseppe Terragni, compl. 1929

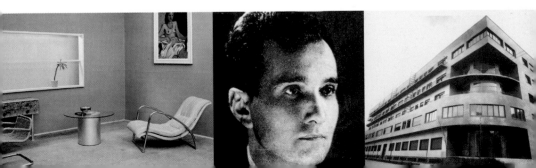

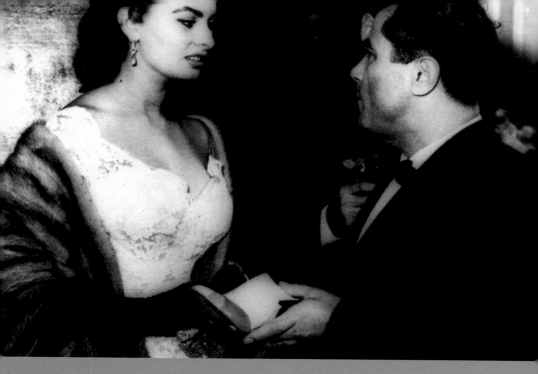

1946 - 1965

Bel Design
From Basics to Beauty

In 1946 the first *Vespas* rolled off the assembly lines of the **Piaggio** factory. An aircraft engineer named **Corradino d'Ascanio** had designed the little scooter, with its voluptuous curves and innovative integral body. Cars weren't within the means of many Italians, but most could afford this relatively inexpensive vehicle, which after two decades of totalitarianism symbolized a new sense of free living. Like Gregory Peck and Audrey Hepburn in the 1953 movie *Roman Holiday,* more and more Italians buzzed through the streets on their "wasps," celebrating a modern style of *La Dolce Vita.*

In 1948, Olivetti introduced the *Lexikon 80* typewriter, designed by **Marcello Nizzoli.** Critics and buyers alike responded enthusiastically to its sleek form and smooth lines. The Museum of Modern Art in New York soon acquired it for its permanent design collection, noting, "The *Lexicon 80* office typewriter is **Olivetti's** most beautiful. The hands of a sensitive designer have turned its bright metal shell into a sculpture."

Both products—and many more after them—became emissaries of a totally new, modern Italian style distinguished by organic or "sculptural" forms, high functionality, and a complete absence of ornamental detail. In the 1950s, this so-called **Linea Italiana** established itself as an internationally

"Italy is a democratic republic based on labor. Sovereignity is exercised by the people within the forms and limits of the Constitution."

Article 1 of the Italian Constitution, 1947

Page 58

Salvatore Ferragamo presents Sophia Loren with a shoe, 1954

From left:

Vespa by Corradino d'Ascanio for Piaggio, 1946

Liù slipper by Salvatore Ferragamo, 1945

Vase from the *Battuti* series by Carlo Scarpa for Venini, 1940

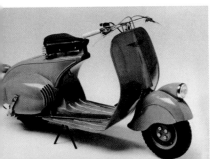

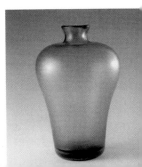

admired paradigm of good design. The scooter and typewriter, too, were designed for mass production, their aesthetics reflecting the "democratic" cause of making desirable products affordable for all people.

After the deprivations of the war, Italians longed for such products. Everything was in short supply: food and housing, transportation, furniture, and clothes. Many architects, committed to the social causes of the Left, increasingly devoted themselves to the design of everyday objects. **Rationalists** such as **Franco Albini** and the members of the architectural firm **BBPR** employed the ideas of European Modernism in the service of building a more humane society that addressed everyone's needs. The time of vainglorious architecture was finally over—architects became designers, their motto, "new forms to shape a new society." Initially that meant a return to basics. In 1946, a furniture exposition organized by the Riunione Italiana Mostre per l'Arredamento (RIMA) showed works by such architects as Franco Albini, **Ignazio Gardella,** and **Vittoriano Viganó.** Their furniture designs were simple, inexpensive pieces for small apartments, most of them made of wood, since other materials were still scarce. In 1947 the first Triennale since the war opened. Its theme was L'abiatazione—the home. Its curator, the communist architect

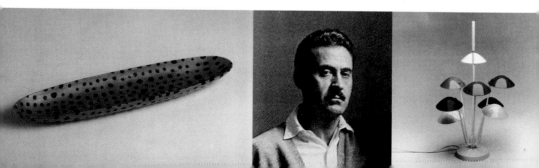

Piero Bottoni, emphasized the need to tackle and solve "the problems of the least privileged classes."

Despite the sharp disappointment caused by the exclusion of the Left from Italy's government, which was led by conservatives, designers stuck to their agenda of reform. But their rigid adherence to the utilitarian value of designed objects softened considerably. At the end of the 1940s, new trends in contemporary art and American product aesthetics began to influence Italian design. With the economy slowly improving, a younger generation of designers emerged, among them the brothers **Achille** and **Pier Giacomo Castiglioni, Marco Zanuso, Ettore Sottsass,** and **Vico Magistretti.** These seminal figures, who have remained defining forces in Italian design, established a new design formula: "usefulness plus beauty."

While all of them agreed on this principle, they implemented it in vastly different ways, with each designer developing a highly personal formal language. For that reason, the history of Italian design is best reflected in the careers of individual personalities, rather than trying to arrange their achievements under specific "schools" or "movements." The creative freedom Italian designers insisted on, even when dealing with industrial clients, fostered a rich variety of forms not found in

"The real and the ideal home must both be considered part of the same problem."

Ernesto N. Rogers

From left:

Murrine opache glass bowl by Carlo Scarpa for Venini, 1940

Franco Albini

Table lamp by Gino Sarfatti for Arteluce, 1951

Casino in San Remo by Gio Ponti and Piero Fornasetti, 1950

Laminati plastici tables by Lucio Fontana, 1954

Palladiana porcelain jar by Piero Fornasetti, 1950s

1949 Agrarian crisis in southern Italy; partial dispossession of big land owners; economy recovers; Italy joins NATO; **Kartell** founded

1950 *Arabesque* furniture series by **Carlo Mollino;** Establishment of *Cassa per il Mezzogiorno* for the economic improvement of the south; Reopening of **La Rinascente**

1951 **Arflex** founded; *Lady* chair by **Marco Zanuso;** Italy joins European Coal and Steel Community

1952 Olivetti's *Lexikon 80* typewriter included in permanent collection of MoMA, New York; **Moroso** founded; *370* fruit bowl by Ufficio Tecnico **Alessi**; **Brionvega** begins prod. of TV sets

other countries. There were individualists and eccentrics like the Turin architect **Carlo Molino,** whose *Arabesque* furniture of 1950 featured oddly distorted plywood shapes, or the Milan artist and designer **Piero Fornasetti,** who covered the surfaces of countless utilitarian objects with strange architectural, sun, and fish patterns.

Other designers established close working relationships with industrial companies. At the suggestion of the tire manufacturer **Pirelli,** the young architect Marco Zanuso developed a piece of furniture to be produced in a new kind of foam rubber called gommapiuma. The result was the *Lady* chair, equipped with kidney-shaped armrests, which became famous as an icon of fifties design. Zanuso's experimental design turned out to be so successful that he founded a new furniture company, **Arflex,** in 1951. He went on to design other classic pieces, such as the *Sleep-o-matic* convertible sofa of 1954, a pragmatic response to the tight living quarters in the public housing developments that began to go up all over Italy.

Another successful partnership evolved between **Gio Ponti** and the furniture manufacturer Cesare **Cassina.** The company had been around since 1927, but it was Ponti who supplied its first clear design strategy. His designs — including

the elegant *Distex* easy chair of 1953 and the famous *Superleggera* chair of 1957, which harmoniously synthesized traditional form and modern style—secured Cassina's place in design history.

There were many other examples of crossover between design and industry. The lamp manufacturer **Gino Sarfatti**, who had founded his own company in 1939, also designed all its products and pioneered modern lighting design. Dino **Gavina** was committed to a fusion of modern furniture design and fine art, and invited architects such as **Carlo Scarpa**, the Castiglioni brothers, and Marco Zanuso to work with his firm. All these entrepreneurs were willing to take stylistic and financial risks, to employ modern production technologies, and to experiment with new materials. Ever since, the principle of collaborating with both a pool of small workshops and large industrial suppliers has enabled Italian manufacturers to be flexible in their production and use specialized knowledge to realize seemingly impossible designs.

By the early 1950s, the public had become interested in design. In the competition for buyers, a product's aesthetic appeal became increasingly important. The Milan *Triennale* of 1951, 1954, and 1957 focused on the new field of industrial design. In 1954, a department store, **La Rinascente**, instituted its own design award, the

"I needed to make our mission and purpose transparent to our workers. This wasn't simply a matter of being an ›enlightened employer‹; it was my responsibility to society."

Adriano Olivetti

From left:
Wood-and-crystal table by Gio Ponti, 1954

Gio Ponti

24 ore overnight bag by Giovanni Fontana for Valextra, 1953

Supernova Bu sewing machine by Marcello Nizzoli for Necchi, 1953

Sleep-o-matic sofa by Marco Zanuso for Arflex, 1954

Cicognino side table by Franco Albini for Poggi, 1952

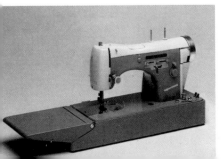

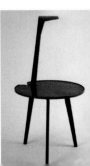

Compasso d'oro, which is still the ultimate measure of achievement in the profession. Since 1959, the awards program has been run by the Italian association of industrial designers, **ADI,** which was founded in 1956. The standards are famously high: in 1957, the judges, who included Franco Albini, Pier Giacomo Castiglioni, and **Ignazio Gardella,** gave the award to just five products, out of 1,200 entries. Only **Gino Colombini's** plastic bowl for **Kartell;** Marcello Nizzoli's *Mirella* sewing machine for Necchi; Benso Cesarino Priarollo's *Dolomite* ski boots; Ruth Christensen's *Alta Marea* fabric design; and a few colored glass vases by Vinicio Vianello met their strict criteria, which demanded that the objects display "a singular expressive power in their technical, functional, and aesthetic characteristics."

Across the industrial spectrum, the relationship between designers and manufacturers gradually became closer. In 1953 Marcello Nizzoli took charge of the design of *Necchi* sewing machines; he also put his stamp on Olivetti's products of the 1940s and 1950s. **Gino Valle** oversaw the design department at Zanussi, where he gave the firm's elettrodomestici—small household appliances—their elegant, purist look.

Unlike their peers in other countries, designers in Italy usually worked as independent consultants. Unhampered by

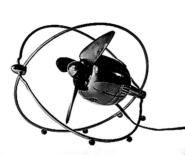
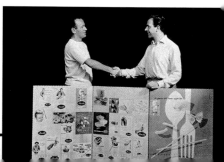

corporate structures, a designer like Ettore Sottsass could, in 1959, create the design for Italy's first domestically developed computer, the *Elea 9003,* and at the same time show his ceramic objects in small art galleries.

The automobile industry was another major client for the country's designers. With their genius for elegant and occasionally spectacular details, the car body designers **Pinin Farina** and **Bertone** were celebrated as the automobile's haute couturiers. Cars like Pinin Farina's 1947 *Cisitalia,* with its voluptuous curves, and the sleek 1956 **Alfa Romeo** *Giulietta Spider* became the embodiment of motorized luxury. While the former racecar driver Enzo **Ferrari** focused on producing speedy sports cars, **Fiat** concentrated on building mid-sized and compact models. Fiat's 1957 introduction of the *Nuovo 500,* an updated version of the old *Topolino,* turned countless Italians into motorists. "Italians wanted cars, and would have accepted the smallest space, as long as it was on four wheels," **Dante Giacosa,** the little vehicle's creator, wrote in his memoirs.

When Italy joined the European Economic Community in 1957, many export restrictions fell away. The effects fueled an economic boom that finally turned the country into a full-

"If people are afraid of the new, let's give them something even newer."

Giulio Castelli, Kartell

From left:

Marco Zanuso
Zerowatt V.E. 505 fan by Ezio Pirali for Fabbriche Elettrotechniche Riunite, 1953

Erberto Carboni and Pietro Barilla, 1960

K.S. 1146 plastic bucket by Gino Colombini for Kartell, 1954

Torre Velasca by Studio BBPR, Milan, compl. 1958

Kosmos chair by Augusto Bozzi for Saporiti, 1954

Poster for *Cinturato Pirelli* by Bob Noorda, 1956

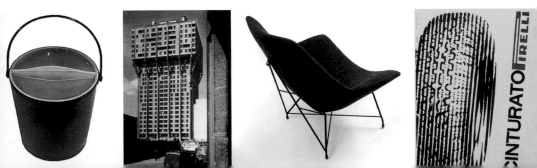

fledged modern consumer society, and Italian design finally came into its own. By the early 1960s, Italian products were so successful internationally that their **"Bel Design"** broke the dominance of the Scandinavian aesthetic. In 1961, Milan hosted the first *Salone del Mobile,* still the most important international furniture fair. Design turned even common, aesthetically indifferent devices such as washers and sewing machines into desirable objects. Italians were proud of their design and celebrated it as a cultural achievement.

Close cooperation between design and industry had become the norm by the 1960s, when a second generation of creative consultants came to prominence—among them **Gae Aulenti, Rodolfo Bonetto, Cini Boeri, Mario Bellini, Afra** and **Tobia Scarpa, Anna Castelli Ferrieri,** and **Joe Colombo.** As different as these designers' personal styles were, they all realized a common motto, "Success through design," in bold, memorable forms. The products of radio and TV manufacturer **Brionvega** provide striking examples. Working with such designers as Marco Zanuso, **Richard Sapper,** and the Castiglioni brothers, Brionvega encouraged spectacular formal experiments and created products that stressed the playful aspect of design. For example, the purpose of Zanuso and

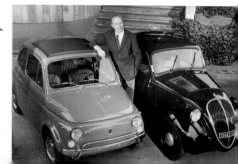

Sapper's cubic *TS 502* radio, designed in 1964, remained hidden as long as it was closed; only when opened did it reveal itself as a radio.

If the designer's basic mission consisted of giving function a clear form, it could now be expressed in imaginative ways. This was true even in the plastics industry, where Italian designers were instrumental in presenting new technology in an appealing package. Working with firms like **Kartell** and **Artemide,** they developed their own material aesthetics, liberating plastic from its negative connotations as a cheap, inferior material, and highlighting its advantages—its low cost, durability, lightness, and flexibility in terms of shape and color.

By the late 1950s, however, there were also some critical voices within Italian design, led by a group of Milan and Turin designers that included Gae Aulenti, **Roberto Gabetti, Aimaro Isola,** and **Aldo Rossi.** Calling themselves the **Neo-Liberty** movement in an ironic homage to the Italian version of Art Nouveau, they criticized what they saw as a conformist and increasingly dogmatic fixation on the Modernist tradition. The *Cavour* chair by **Vittorio Gregotti, Lodovico Meneghetti,** and **Giotto Stoppino,** with its "old-fashioned" curved lines, was

"People 'wear' their cars like jackets or coats."

Gillo Dorfles

From left:
Carlo Mollino
Card table by Carlo Graffi, single piece, 1950
Engineer Dante Giacosa with Fiat *500*, 1936, and *Nuova 500*, 1957
Plastic tub by Gino Colombini for Kartell, 1956
Mirror by Ettore Sottsass for Poltronova, c. 1960
Divisumma 24 calculator by Marcello Nizzoli for Olivetti, 1956

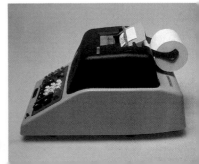

a statement of their dissent. Though the group did not find many followers, it did inject a dose of doubt in any single style's claim to ultimate truth.

There was soon controversy not only about stylistic issues but also about content. At the Eleventh *Triennale,* held in 1964 and centered around the theme of "leisure," a younger generation questioned whether the functional design of objects could or should be their profession's only goal. What, they asked, was the social context in which products existed. In numerous debates, participants queried the absorption of design into the cycle of production and consumption. One thing was clear: design had lost the social commitment that had driven it after the war. The renewed focus on social context led some designers to broaden their scope to include office environments and to develop flexible, modular furniture solutions. Other designers began to pursue holistic approaches.

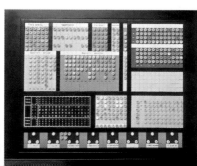

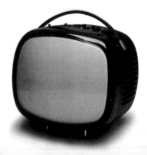

Methodical organization and planning were stressed, and there were calls for a systematic approach to design education.

The principle of exploring the social implications of product design, first developed at the Hochschule for Gestaltung in Ulm, Germany, strongly influenced Italian designers throughout the 1960s. **Tomás Maldonado,** the Ulm design school's president from 1964 to 1966, became a leading figure in the field. In Italy, he developed a unified concept for the La Rinscente department store, which included the design of the salesrooms, merchandise display, and the store's graphics.

By the mid-1960s, Italy's economy had sunk into a deep recession. Struggling with high inflation and pressured by the country's unions, it had to abandon its low-wage policies. Workers and students took to the streets. Design, too, was part of the general upheaval and experienced fundamental changes in how it defined its role and function.

"Each object is a message that requires responses. The fact that tens of thousands of it are produced is very stimulating because it puts you in contact with the world at large."

Anna Castelli Ferrieri

From left:

Static table clock by Richard Sapper for Lorenz, 1959

Elea 9003 computer by Ettore Sottsass for Olivetti, 1959

Doney TV set for Brionvega by M. Zanuso and R. Sapper, 1962

BMW *3200 CS* by Bertone, 1961

Spinnamatic beer tap for Splügenbräu by Achille und Pier Giacomo Castiglioni, 1963

Cavour chair by G. Stoppino with V. Gregotti and L. Meneghetti, 1959

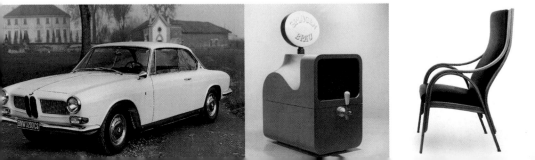

1966-1979

Design on the Barricades
Between Revolt and Marketing

In 1972 an exhibition that has since become legendary opened at New York's Museum of Modern Art. *Italy: The New Domestic Landscape* reflected the contradictory impulses of contemporary Italian design. On the one hand, the show's presentation of furniture and living environments showcased the aesthetics Italian design was known for. Visitors flocked to pieces like **Giancarlo Piretti's** *Plia* Plexiglas chair, **Anna Castelli Ferrieri** and **Ignazio Gardella's** *4997* plastic table for **Kartell,** and **Marco Zanuso's** *Grillo* telephone for Siemens, which combined dial and handset in one compact unit.

Other exhibits, however, did not fit in with the accustomed image of **Bel Design.** There was **Mario Bellini's** *Kar-a-sutra,* for example, an experimental vehicle that seemed to have sprung out of a science fiction movie. Encapsulated in glass and fitted with thick, soft cushions, it was a kind of mobile abode for modern nomads. Another "micro environment," **Joe Colombo's** *Total Furnishing Unit,* consisted of a modular container system with living area, kitchen, and bathroom tightly compressed but flexible in their arrangement—a futuristic vision of a home. Other exhibits explored public space in drawings, collages, and texts, and investigated alternative forms of living and dwelling.

These contributions showed that parallel to Italy's commercial production a new, subversive design culture had emerged. Clearly, there was no longer one unified Italian design

"There is no urban form that hasn't failed or else isn't about to fail."
Andrea Branzi

Page 70
Lassú, performance by Alessandro Mendini, 1974

From left:
Ricerche individuali di design (design research) by Enzo Mari, 1967
Dondolo seat by Cesare Leonardi and Franca Stagi, 1967
Frine table lamp by Studio Tetrarch for Artemide, 1969

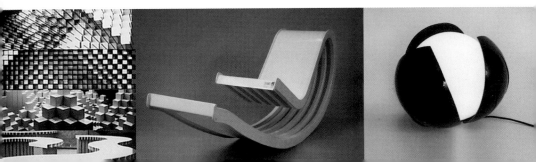

philosophy. In the years since 1965, Italian design had experienced a deepening identity crisis as social unrest and workers' protests shook the country. If the pioneers of Italian design had been preoccupied with function and beauty, the young rebels pointed out the dead end this approach had led to. In their view, design had become enslaved to industrial interests.

As in the rest of Europe, Italian universities—including the architecture departments—were in turmoil. Florence especially became a spawning ground for activist architectural groups like **Archizoom, Superstudio, UFO,** and **9999,** who, with the support of established figures such as **Ettore Sottsass,** the critic and filmmaker **Ugo La Pietra,** and the artist **Gaetano Pesce,** produced an endless stream of utopian designs, manifestoes, and exhibitions. The rebels' main targets were the cult of the product, the unchanging cycle of production and consumption in capitalist society, and the naive faith in functionalism. Their movement became known by two names: **Architettura Radicale** and **Radical Design.**

The young radicals drew inspiration not only from similar movements abroad, such as the Archigram group in England, but also from Pop Art, Arte Povera, Conceptual Art, and other contemporary countercurrents to traditional aesthetics. Their goal was to change society through design and architecture. If

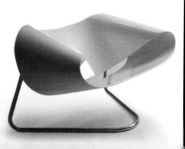
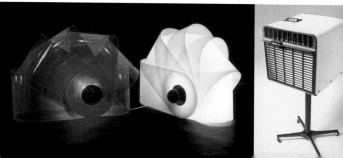

the movement became influential, though, it was not because of the few projects that were actually realized. Their most important designs, like Archizoom's *No-Stop-City,* a dystopian vision of a highly artificial future city, were never meant to be built. In a more ironic vein, the *Mies* chair by Archizoom members **Andrea Branzi** and **Massimo Morozzi,** had a seat so steeply angled that its purported function—rest—turned into an apparent threat. A sarcastic comment on the constructivist elements of modern furniture design, it served as a kind of shock therapy.

Manufacturers, for their part, continued to rely on Bel Design's innovative impulses in order to survive the recession. Among the memorable designs that came out of the economically strained mid-1960s were Kartell's elegant plastic furniture, Ettore Sottsass and **Perry A. King's** *Valentine* typewriter for **Olivetti,** and luxury limousines from **Alfa Romeo, Lancia,** and **Ferrari.**

It is a purely Italian phenomenon that the two divergent movements in design—classic industrial design and its utopian counterproject—occasionally ran together in the work of individual figures. Sottsass, for one, reflected on alternative design processes in various experimental projects while at the same time continuing his work as a consultant to Olivetti. At the 1972 MoMA show, Mario Bellini exhibited not only the cocoon-like *Kar-a-sutra,* but also an elegant leather chair designed for **Cassina.**

"When I started designing machines it occurred to me that they can influence not only physical states but also emotions."

Ettore Sottsass

From left:
Ribbon chair by Cesare Leonardi and Franca Stagi, 1961
Gherpe lamp by Superstudio for Poltronova,1967
Air conditioner by Joe Colombo for Candy, late 1960s
CUB 8 seat by Angelo Mangiarotti for Poltronova, 1968
Orio light by Sergio Mazza for Quattrifolio, 1973
Plia folding chair by Giancarlo Piretti for Castelli, 1969
Enzo Mari

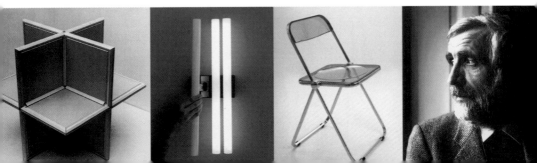

A number of open-minded, adventurous entrepreneurs took on the challenge of integrating the new trends into designs for production. Around 1970, illustrious visitors from Milan began to turn up at the Archizoom studio in Florence. One of them was the furniture magnate Cesare Cassina, who came to discuss the possibility of putting the group's antiestablishment designs into commercial production. When he left, he had agreed to give them a monthly check in order to secure their creative output for his company.

Radical designers transformed the look, feel, and very definition of furniture: **De Pas/D'Urbino/Lomazzi's** 1967 *Blow* chair for Zanotta was inflatable like a balloon; **Paolini, Gatto** and **Teodoro's** 1969 *Sacco,* also produced by Zanotta, was just that: a sack to sit in; while Gufram's cartoonish *Cactus* of 1971 served as a clothesrack. But the furniture industry's embrace of the new design culture also took some of its edge off. And in any case, there were limits to what design's radicals could achieve; their built-in antagonism and obsession with theory

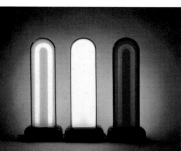

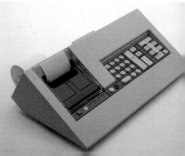

helped the movement run out of steam by the mid-1970s. Surprisingly, radical design returned only a few years later, and this time took hold. Its first center was the **Alchimia** design studio in Milan, which held its first show of small objects in 1978. **Alessandro Mendini** emerged as the leading theorist of the reborn movement, which before long included **Michele De Lucchi,** Ettore Sottsass, the UFO group, and several other young designers. Through the unconventional use of different design "languages," cultural pluralism, and ironic redesign (Mendini covered period furniture and classic Bauhaus pieces with colorful laminates and ornaments), the movement rigorously questioned the doctrines of good taste, correct form, and functionalism. Although Alchimia did not reach a wider audience, its work marked a progressive turn, a fresh approach that was taken up in the early 1980s by the **Memphis** group and would lead to a comprehensive transformation of Italian and international design.

"Alchimia believes in the importance of memory and tradition."
Alessandro Mendini

From left:
Asteroide lamp by Ettore Sottsass for Poltronova, 1968
Massolo table by Piero Gilardi for Gufram, 1974
Logos 50/60 calculator by Mario Bellini for Olivetti, 1972
Chiocciola chair by Studio 65 for Gufram, 1971
Paramount lamp for Alchimia by UFO, 1979
Mario Bellini

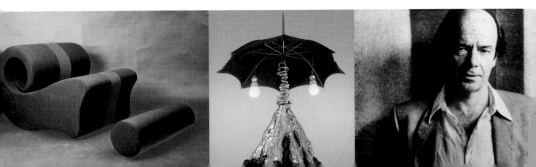

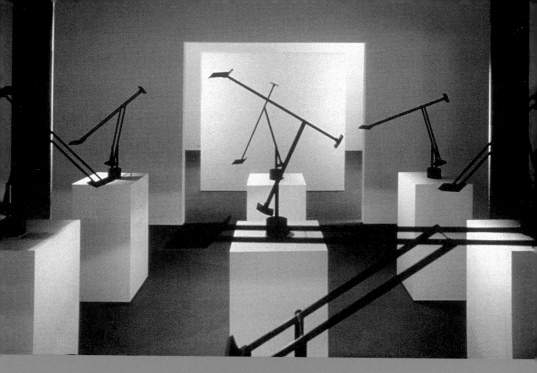

1980-1999

Memphis, Mode, and the Market
From Avant-garde to International Standard

There was a traffic jam in front of a Milan showroom at the edges of the 1981 Salone del Mobile in Milan. Here, the recently established **Memphis** group presented its first collection. More than 2,000 people came to examine pieces like **Ettore Sottsass's** *Beverly.* The object was made of a rather unconventional mix of wood, laminate, and metal and kept viewers guessing at its function—the doors indicated a wardrobe, an angled console on top of it suggested a shelf, and a red lightbulb screwed to a metal bow turned the whole thing into a lamp. Other designers, including **Michele De Lucchi, Andrea Branzi,** and **Mattheo Thun,** showed similarly undefinable objects and, presumably, furniture. Martine Bedin had designed a small cart spangled with little lights, **Marco Zanini,** a throne-like sofa called *Dublin.*

What got lost in the fuss—the press finally had something to write about—was the fact that the objects were not intended for industrial production, even though the ideas behind them would, in time, revolutionize the design culture of Italy as well as many other countries'. Memphis had unceremoniously and irredeemably slaughtered a holy cow—the doctrine of correct form. The focus of design now shifted toward colorful, sometimes exotic surfaces and patterns; multifunctionality; and the communicative aspect of products.

"The industrial sector doesn't realize that consumption can also mean pleasure and that pleasure can never be entirely controlled, not without consequences."

Barbara Radice

Page 76
Showroom for Artemide
by Vignelli Assoc., New York 1987

From left:
Piece from an experimental series of household appliances by Michele De Lucchi for Girmi, 1979
Beverly by Ettore Sottsass for Memphis, 1981
Ettore Sottsass

The group showed a new collection every year. Soon a Memphis cult arose. When the fashion designer Karl Lagerfeld furnished his entire apartment in Memphis, the media made sure everyone knew about it. Inevitably, the movement devolved into fashion, and it was already past its peak when a second Memphis generation, which included **Massimo Iosa-Ghini,** appeared on the scene in the mid-eighties. Countless copies "in the Memphis style" began to flood the market. By that time, most of the movement's original founders had lost interest in what they had started.

Still, it is hard to overestimate the group's influence. Memphis unleashed a fresh wave of bold experimentation in form and color. The lighting manufacturer **Artemide,** the furniture companies **Driade, Zanotta, Cassina, Bieffeplast,** and many other firms worked with Memphis designers. And a slew of new firms emerged, including the furniture manufacturer **Alias,** which commissioned Mario Botta's architectural chair sculptures and **Carlo Forcolini's** archaic-looking *Apocalypse Now* table and lamp. Early in the 1980s Alessi hired **Alessandro Mendini** (who rarely worked for Memphis but remained committed to **Alchimia)** to develop the *Tea and Coffee Piazza* project, for which contemporary architects designed small utilitarian objects, such as **Aldo Rossi's** *Conica,* an espresso

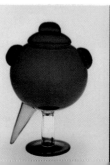
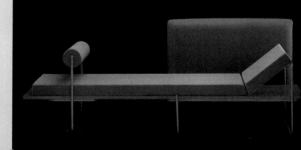

maker with distinct architectural elements. At the end of the decade, Alessi introduced a collection of playful products such as **Stefano Giovannoni's** *Merdolino* toilet brush, which is planted in a flower pot, and Alessandro Mendini's *Anna G.* corkscrew, shaped like a stolid woman who raises her arms each time a bottle is about to be uncorked. The emphasis in all these objects was on their communicative abilities, their humorous connotations, and their tendency to ironically reflect on recent design history. Without the liberating example of Memphis, this would not have been possible. Italy now was a hotbed of a diverse, open, playful design, which also had a strong impact in Germany, France, Spain, and England. **Nuovo Design,** as it came to be called, decisively shaped today's notion of "designer" objects. Formal eccentricities, once thought unacceptable, were increasingly identified with the very idea of design. And unlike the practitioners of the 1960s and 1970s—or even the early Memphis members—the new designers and firms, such as **Edra** or **Baleri,** worked with one eye firmly on the market.

Design's cult of personality, which made celebrities of people like Philippe Starck, developed during the 1980s. The distinction between less expensive "regular" products and pricier "designer items" was made more visible. And design became synonymous

"The eighties were an ecstatic era, obsessing about form and language. Today we are trying to overcome this fever by returning to things that make more sense."

Alberto Meda

From left:

Michele De Lucchi

Rigel glass object by Marco Zanini for Memphis, 1982

Century daybed by Andrea Branzi for Memphis, 1982

Riviera chair by Michele De Lucchi for Memphis, 1981

Asoka lamp by Ettore Sottsass for Memphis, 1983

D 7 lamp by P. Rizzatto and S. Colbertaldo for Luceplan, 1981

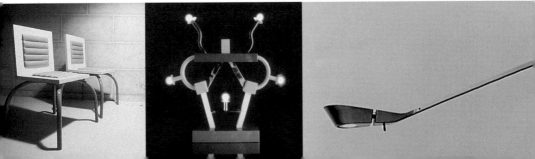

with "lifestyle," taking on a crucial role in any marketing strategy. It is not surprising that the same decade also gave birth to "signature" ad campaigns designed by high-profile agencies, and to an unprecedented emphasis on corporate image and identity. "Memphis is unusual," commented Michele De Lucchi, "because it gathered, concentrated and defined the essence of the eighties."

The boom in advertising also benefited Italian fashion. While designers like **Giorgio Armani** and **Gianni Versace** had gained a certain degree of fame in the 1970s (Armani through his "invention" of casual business attire), the media frenzy around fashion's stars and supermodels didn't fully set in until the 1980s. And as the decade drew to a close, a number of young designers had emerged to assert Italian influence on international fashion. **Romeo Gigli** counteracted the image of the power-suited business woman with visions of ethereal creatures in flowing robes made of velvet and lustrous golden fabrics. **Dolce & Gabbana** updated historic Italian peasant costumes into icons of early-nineties chic. The 1990s also saw the comeback of traditional fashion houses such as **Prada** and **Gucci** (which introduced new, luxurious designs by the American Tom Ford).

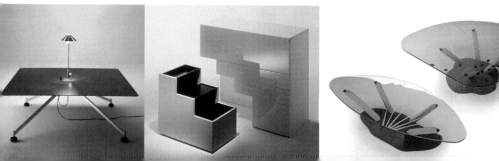

In product design, Memphis and Nuovo Design were largely confined to furniture and housewares. In the automotive industry, where high production costs demand a certain predictability of success, design followed other criteria. **Giorgetto Giugiaro** was representative of a new generation of car designers. Progressive and service-oriented, his focus was not on luxury models but, after the oil crises of the 1970s, on lower-priced compact and mid-sized cars. The stripped-down 1980 Fiat *Panda* and the 1983 Fiat *Uno* still displayed a distinctively Italian flair and were hugely popular with young, upwardly mobile Europeans, a testament to Giugiaro's subtle instinct for stylistic details and trends.

At the beginning of the 1990s, the cult of the spectacular designer object had exhausted itself, and gave way to a countermovement. With their raw, black chairs, the **Zeus** group, founded in 1984, explicitly dissociated itself from Memphis. "If the Memphis object is an affirmation of the transitory, the luxurious, the superficial, a costly and amoral object . . . the Zeus object is a modest, moral object with transcendental tendencies. As such, it reaffirms an absolute quality," **Paolo Deganello** wrote. Zeus thus anticipated the gradual shift of values that characterized the economically troubled 1990s.

"Designers must have taste but also be able to break the rules we, as their industrial clients, confront them with."

Alberto Alessi

From left:
Apocalypse Now table by Carlo Forcolini for Alias, 1984

Steps container system by Cini Boeri for Estel, 1982, with Laura Griziotti

Artifici tables by Paolo Deganello for Cassina, 1985

Studio set for TV show, *Obladì Obladà*, by Massimo Iosa Ghini, 1985

Tatlin sofa by Roberto Semprini and Mario Cananzi for Edra, 1989

Alberto Meda

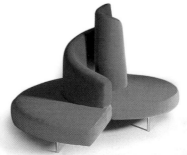

Design lost some of its bluster in the nineties. After pieces like Philippe Starck's *Juicy Salif* lemon squeezer for Alessi and **Capellini's** flamboyant "auteur" furniture had successfully flaunted their "anything goes" attitude, many manufacturers, including **B&B Italia** and Cassina, returned to a more classically elegant approach. In 1995, the renowned avant-garde company Driade tried to reach out to a young generation of sophisticated "nomads" with its *Atlantide* collection, a line of blond wood furniture created by younger designers such as **Marco Romanelli,** Konstantin Grcic, and **Rodolfo Dordoni.** The lighting manufacturer **Luceplan,** founded in the late 1970s, experienced its greatest sales since the late eighties when it focused on transparent, minimal designs.

But while its aesthetics seemed out of favor, another trend associated with Memphis has prevailed: Italian firms have increasingly cooperated with international designers. Capellini, always a trendsetter, produces furniture by the British designers Jasper Morrison and James Irvine; Driade's catalogue features designs by Konstantin Grcic, a German, and Philippe Starck, a Frenchman; **Moroso** markets designs by the Spaniard Javier

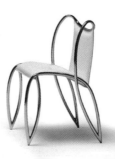
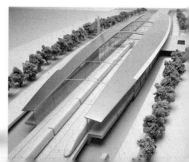

Mariscal; **Sawaya & Moroni** relies on the ideas and expertise of international architects; Ron Arad and Danny Lane have designed glass furniture for **Fiam**—and so on.

The work of today's young designers can no longer be characterized as specifically Italian. The famed **Linea Italiana** of the 1950s has made way for a Linea Internazionale, whose contours are much more difficult to make out. Innovation in design has moved to new arenas: the media, consumer services, and environmentally sensitive design. On the verge of the new millennium it is becoming harder to identify a country by its design; and Italy, in recent years, has not particularly distinguished itself compared to England or Scandinavia. So it is not too surprising that at the close of the 1990s, nostalgic reeditions are all the rage: Piaggio has revamped its old Vespa; Fiat has introduced yet another retread of the *Cinquecento;* and the Dutch Philips Corporation, under the direction of Italian designer **Stefano Marzano,** has produced a fifties-style collection of kitchen appliances. All these objects borrow their aura from design's great icons, so abundant in Italy's past.

"The first rule for every designer is to find the right client."

Massimo Morozzi

From left:
Merdolino toilet brush by Stefano Giovannoni for Alessi, 1994

Denis Santachiara

Angel Chair by Terri Pecora for Bieffe, 1990

Architectural model for ICE train station, Limburg, by Studio de Lucchi, 1997

Bellini Chair by Mario Bellini for Heller, 1998

Ducati *916 Biposto*, 1998

A bocca aperta mirror by Ugo La Pietra for Toppan Barbara, 1997

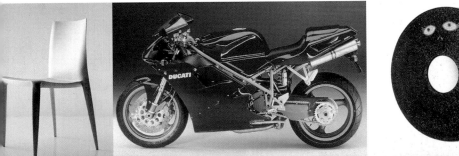

The Rediscovery of Beauty

Italian Design: La bella bionda

The long, wonderful period of Italy's economic boom, which lasted from the postwar years into the early 1970s, was pervaded by a pagan cult of beauty. A sense of freedom and optimism, economic success, and rising standards of living characterized this time whose aesthetic spirit can be aptly expressed by the image of a beautiful young woman.

Italian design was the era's golden-haired girl everyone was happy to see and be seen with—a radiant symbol of privilege and taste and, above all, beauty. For beauty was considered the ultimate goal of formal expression as well as a sure means of success.

The period before the Second World War was monotonous and creatively barren. After the conflict ended, Italians wanted to break with that, and to get away from the misery of the war—ideal conditions for the beginning of a time that favored everything new and applauded those who could design it. People literally and figuratively wanted to rebuild their home, to furnish it in a completely modern spirit tied to no tradition. And they eagerly followed the aesthetic criteria given by the blonde, blue-eyed girl.

There was color, lots of color: red, yellow, blue, green, purple, in a patchwork expression of existential bliss. And there were rich new forms inspired by the smooth lines of the human body. The form of the automobile was plastically reshaped; and plastic shaped a whole new world of forms. A tremendous number of new developments in transportation, aeronautics, graphic design, and material technology were promptly absorbed and transformed into objects, which were often minor masterpieces.

Design, the blonde, blue-eyed girl that had taken us by the hand, was growing up, and in the 1960s became interested in new technologies and the opportunities offered by a rapidly expanding market. The results were more sophisticated, a bit bourgeois, perhaps a bit boring. But our lively blonde rediscovered art, and pop culture began its joyful and massive invasion of Italian design. It was a restless, intense time. The blonde got caught up in its struggles and at the end of the decade discovered the first wrinkles in her face. But she

did escape the ever-present danger of becoming trapped in a past no one is interested in anymore.

At the Milan *Triennale* of 1968, she asserted herself by shifting her focus from design to the politics of design and its "sociocultural implications," in the parlance of the time. Then, in the 1970s, an economic crisis temporarily cut off the financing for the development of her ideas. Toward the end of that decade, Mendini, Sottsass, and friends began to revitalize Italian design with their projects for Alchimia. And by creating Memphis in 1981, Sottsass and friends made sure that the blonde, now a mature lady, remained as alluring as ever.

The eighties also introduced the idea of "Italian Design" as a style and historical period. An archaeological hunt for design products of the previous decades turned up a wealth of objects that had been gathering dust in factories, workshops, showrooms, basements, and warehouses. In the process, numerous prototypes were discovered, single pieces that had been designed for presentations at the Salone di Mobile in Milan or the Eurodomus fairs in Milan, Turin, and Genoa. Discontinued products that had failed on the market were unearthed and in many cases turned out to be authentic avant-garde objects. Names of forgotten designers reappeared along with abandoned materials (such as burnt enamel) and objects that couldn't easily be classified as either art or utilitarian artifact. There were lamps with mysterious halogen bulbs or equally mysterious remote controls, and there were large sculptures made of foamed polyurethane and dyed a fluorescent green or red: a cactus, a mouth, a brick, a piece of turf.

This eclectic collection was finally presented to the public by the Wolfgang Ketterer Gallery in Munich. A catalogue itemized each piece and its asking price. At the auction that followed the lots were sold in a manner previously reserved for collections of fine art. Products made of foam rubber, plastic, or chrome were suddenly treated as valuable collector's pieces. Five thousand copies of the catalogue, *Italienisches Design* 1951–1984, were printed and immediately sold out. The auction was organized by Steven Cristea, the former director of Sotheby's Munich branch, and the bidders included numerous international museums, galleries, and collectors.

The auction took place on March 24, 1984, and attracted extensive media coverage in Germany and around the world; Italian design again appeared like a sleeping beauty kissed awake by a prince. The event marked the rediscovery of a limpid beauty achieved through a combination of experimentation, creative power, color, material, and ambition. Of course, it was also an opportunity for manufacturers to take a second look at their old products and, if possible, reintroduce them. This has created some confusion on the market. It often appears unclear whether products are new or reproductions, historic pieces or contemporary contributions—which, on second thought, may simply be an argument for the agelessness of Italian design.

Fulvio Ferrari

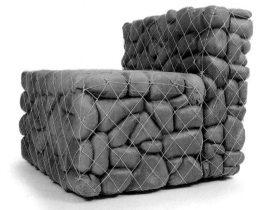

Argine chair by
Studio Libidarch for
Gruppo Ind. Busnelli, 1974

Page 87
Capitello chair
by Studio 65
for Gufram, 1972

Directory

From Abet Laminati to Zeus

ABET LAMINATI

Laminate manufacturer

Abet Laminati spa,
Bra (Cuneo)

1957 founded Abet in Bra

1979 new company name,
Abet Laminati

1987 *Compasso d'oro* for
Diafos (first transparent
laminates)

Products

1961 *Laminat Print*
(later *Folden*, *HPL Print*)

1978 *Bacterio* pattern by
Ettore Sottsass

1979 *Spugnato* pattern by
Ettore Sottsass

1981 *Fantastic* and *Micidial*
patterns by
Michele De Lucchi

1983 *Marmo Print HPL* by
George J. Sowden

1988 *Diafos* exhibition,
Material Lights

In the 1960s and 1970s, Abet Laminati had worked with **Gio Ponti, Joe Colombo,** and **De Pas/D'Urbino/Lomazzi** in the development of innovative laminates like *Print, HPL Print,* and *Folden.* But the laminate manufacturer's real breakthrough didn't come until the early 1980s. The design groups **Alchimia** and **Memphis** had sparked a renewed interest in surfaces, and designers like **Ettore Sottsass** and **Michele De Lucchi** were creating such eye-straining patterns as *Bacterio, Spugnato, Fantastic,* and *Micidial* for the company. By using these laminates in spectacular furniture designs such as the *Carlton* shelf (fig. p. 12), they lent cachet to a material often dismissed as cheap and ugly. Abet caused a sensation a few years later, when it introduced the first translucent laminate, *Diafos.* The 1988 exhibition *Material Light* showcased Diafos's properties with applications designed by Sottsass, De Lucchi, James Irvine, **Antonio Citterio, Massimo Iosa Ghini,** and others. Today, Abet's laminates are used in furniture and trade show construction and in the design of building facades.

Regal *Union* by Marco Zanini, 1983
Laminat *Spugnato*
by Ettore Sottsass, 1979

Franco ALBINI

Architect and furniture designer

Franco Albini was already a well-known architect when a young **Anna Castelli Ferrieri** joined his Milan studio in 1942. Her first assignment was to draw his famous hanging shelves. The next day, she found a note on her desk, in which Albini instructed her to put the rulers in a tidy row and precisely align the triangles each night before leaving work. He demanded perfection.

Albini's minimalist, spare designs were far ahead of their time, which preferred a heavy, more stately look. His shelves of the 1940s—metal or wood-framed glass shelves suspended from metal chains—had reinvented a familiar product, giving it the dual functions of storage unit and room divider. Even before the war, he had presented a prototype for a transparent radio, whose components were housed between two rectangular panes of glass. (The radio never went into production.)

Alessandro Mendini once described Albini as "the greatest master of modern Italian architecture." And though architecture was his primary field, he was also one of the early heroes of

1905 born in Robbiate, Como

1929 graduates from architecture school in Milan

1930 opens architectural office

1945 publisher of *Casabella* (until 1946)

1949 professor of architecture, Venice and Turin (until 1963)

1950 renovation of *Palazzo Bianco* and Museum in Genoa (with Franca Helg)

1952 works with **Franca Helg**; *Museo del Tesoro di San Lorenzo*, Genoa

1955 *Compasso d'oro* (again in 1964)

1957 **La Rinascente** department store, Rome (compl. 1961)

1958 *Premio Olivetti* architecture prize

1962 works with **Antonio Piva**

1964 professor of architectural-composition, Milan Polytechnic (until 1977)

1965 works with **Marco Albini**

1977 dies in Milan

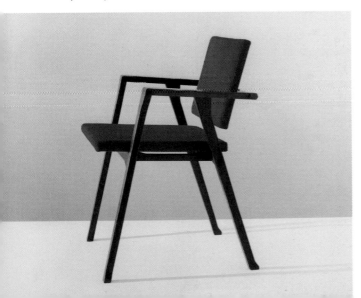

Luisa chair for Poggi, 1954

Franco ALBINI

modern Italian design. His *Room for a Man,* shown at the 1936 **Triennale,** was a remarkably progressive object. It consisted of a tiny room in which each element had clear but multiple functions—a shelving unit featured a built-in desk; a ladder leading up to the bed also served as a coat rack; the bed provided the room's ceiling.

After the end of World War II, Albini's deep involvement in discussions about the social tasks of architecture and design was reflected in his various commitments as publisher of the journal *Casabella,* member of the Congresso Internazionale di Architettura Moderna (CIAM), and professor of architecture. But he also continued to work on architectural projects and furniture designs, applying the ideas he had formulated before the war under the influence of Modernism. The Luisa chair for **Poggi** (a company specializing in wood furniture, whose postwar production was largely designed by Albini), the *Margherita* wicker chair for **Bonacina,** and the *Fiorenza* chair for **Arflex** confirmed Albini's reputation as a master of restrained, but never bloodless, forms, who found ingenious solutions in the most diverse materials. One of his most complex projects still provides guidance to visitors of Milan— in the early sixties, together with his partner **Franca Helg** and the graphic artist **Bob Noorda,** he designed the subway stations and developed the signage system for Milan's Number 1 line.

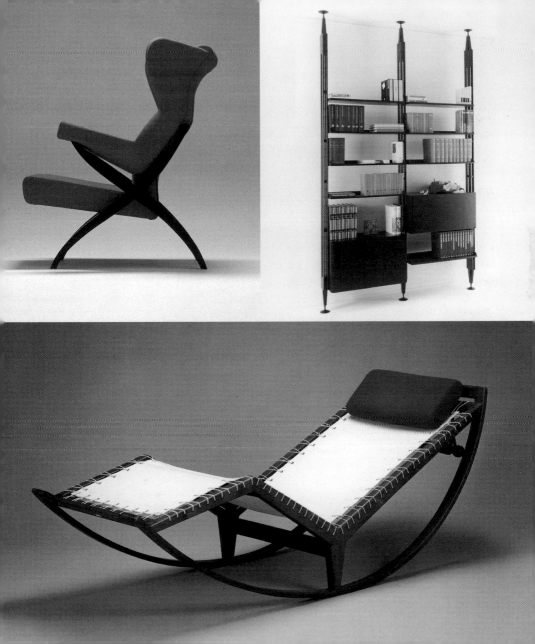

ALCHIMIA

Gallery and design group

In 1976, **Alessandro Guerriero** invited a group of designers, including **Alessandro Mendini, Andrea Branzi, Ettore Sottsass, Michele Lucchi, Franco Raggi, and Paola Navone,** to create experimental designs for an exhibition in his Milan gallery. Freed from the constraints of industrial production processes, the designers used vernacular materials such as laminates, combining supposedly incompatible styles in various appropriations of design classics and in their own, wildly unconventional creations (fig. p. 14). "There is no more originality, declared Alchimia's chief theorist, Alessandro Mendini. Invention of forms has been supplanted by variations on decors, patterns, and surfaces— design as re-design. Designing is decorating." His manifesto challenged the doctrine of functionalism and, along with it, the dominance of Italian **Bel Design.**

In the exhibitions *Bau.Haus I* and *Bau.Haus II,* held in Milan in 1979 and 1980, respectively, Alchimia designers ironically commented on classic Bauhaus and period furniture by covering them with colorful laminates and quotes culled from the fine arts. For their *mobile infinito* (infinite furniture), presented during the 1981 Milan furniture fair, they asked prominent designers, architects, and artists, including Sandro Chia and Francesco Clemente, to design decorations, handles, lamps, and banners that could be applied to blank wooden objects. An almost infinite pool of patterns was provided for the object's surfaces; everyone could put together his or her own mobile. While such events did not gain Alchimia much of a clientele, the group was an important catalyst of **Nuovo Design** and a precursor of the much more commercially successful **Memphis** movement.

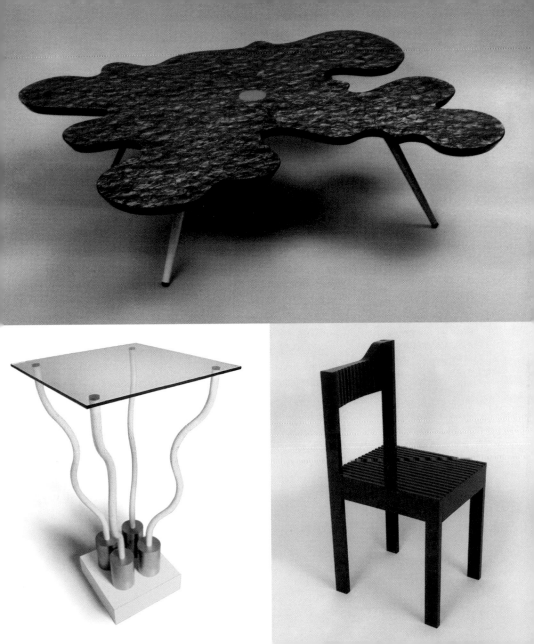

ALESSI

Housewares manufacturer

Page 95

Bird Kettle 9093 by
Michael Graves, 1985

Nuovo Milano silverware set
by Ettore Sottsass, 1989

Juicy Salif lemon juicer by Philippe
Starck, 1990

To the countless owners of the firm's housewares, the name Alessi is permanently wedded to the idea of design. In the 1980s, its association with illustrious designers, its sleek shiny products, and their playful takes on form, function, and color made Alessi the design company. The firm's design approach is neatly epitomized in Philippe Starck's famous *Juicy Salif* lemon juicer of 1990: everyone knows it, many own it, but no one uses it. A striking but barely functional "designer object," it is more commonly displayed as a status symbol.

In Alessi products, form follows not only function but also the designer's fancy, which has found expression in pieces like **Guido Venturini's** bulbous *Firebird* gas stove lighter, **Philippe Starck's** oblique *Hot Bertaa* tea kettle, the warbling little bird on **Richard Sapper's** kettle, and **Alessandro Mendini's** *Anna G.* corkscrew (fig. p. 44), modeled after the designer's companion. The path to this "anything goes" approach was paved in the early 1980s by groups like **Alchimia** and **Memphis,** whose products defied design's subservience to function. Alessi systematically applied this new design philosophy to mass-produced housewares.

But design is not just an effective marketing tool for Alessi; the firm been integrating innovative design into its products from its beginnings in the 1920s, when the firm's founder, Giovanni Alessi Anghini, designed coffee pots and trays in his metalshop. Since then, designers have always found ideal conditions to freely explore new ideas and forms at Alessi. In 1945, Carlo Alessi introduced his famous *Bombé* coffee set, and in the 1950s the firm produced its classic stainless-steel fruit bowls and breadbaskets. In the seventies, Alberto Alessi established relationships with Richard Sapper, **Ettore Sottsass,**

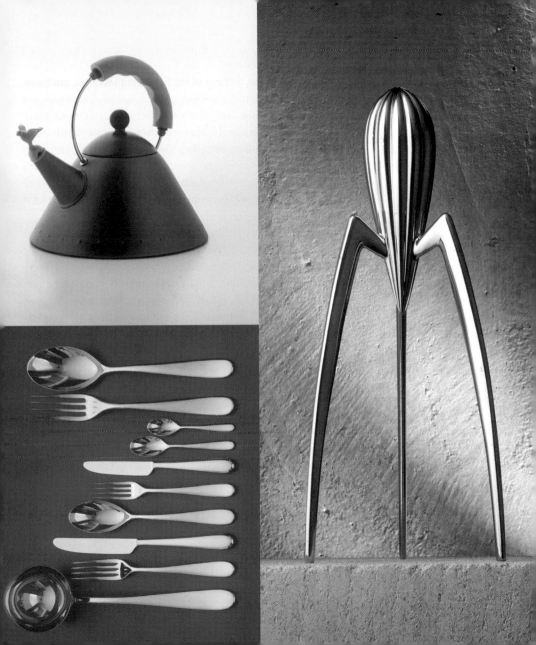

Achille Castiglioni, and Alessandro Mendini, who became the principal authors of today's Alessi design. At the beginning of the next decade, Mendini invited a group of international architects, including **Aldo Rossi,** Michael Graves, and **Paolo Portoghesi,** to design tea and coffee sets. With its collection of "miniature architectures," the project, known as *Tea and Coffee Piazza,* was an instant success, and led Alessi to split its production into separate divisions. While the mass production of stainless-steel housewares continues under the **Alessi** label (with espresso makers by Rossi and Sapper, pots by Massimo Morozzi, and silverware by Sottsass and Castiglioni), the new division, *Officina Alessi,* focuses on limited-edition products in various metals. Housewares made of turned wood have been marketed under t he *Twergi* label since 1989, and the *Family Follows Fiction* collection, introduced in 1991, comprises Alessi's colorful home accessories.

Products

1945 *Bombé* coffee set *by* Carlo Alessi Anghini

1951 *826* wire basket

1952 *370* fruit basket
both by Ufficio Tecnico Alessi

1970 *7690 Spirale* ashtray by **Achille Castiglioni**

1978 *5070-5079* oil and vinegar set by **Ettore Sottsass**

1984 *La conica* espresso maker

1988 *La Cupola* espresso maker
both by **Aldo Rossi**

1990 *Juicy Salif* lemon juicer by **Philippe Starck**

1994 *Anna G.* corkscrew by Alessandro Mendini

1997 *Cobán* espresso maker by **Richard Sapper**

Firebird gas lighter by Guido Venturini, 1993

Page 97

top: *9091* teakettle by Richard Sapper, 1983

left: *Pasta Set* by Massimo Morozzi, 1986

right: *Il conico* series by Aldo Rossi, 1989

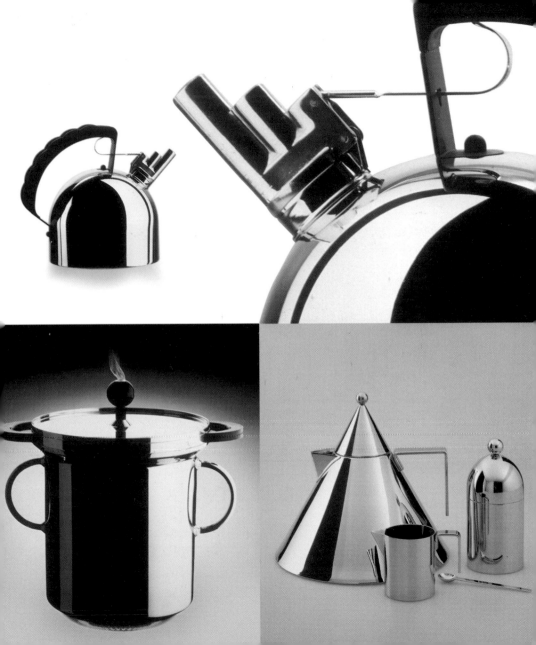

ALFA ROMEO

Automobile manufacturer

Alfa Romeo
(now Fiat Auto spa), Turin

1910 founded as *Società Anonima Lombarda Fabbrica Automobili* (ALFA) in Portello near Milan

1915 Nicola Romeo joins the firm

1932 new organizational structure

1938 factory in Pomigliano d'Arco (Naples)

1963 Factory in Arese

1967 Construction of *Alfasud* factory

1987 acquired by **Fiat**

Page 99

top: *Giulietta Sprint* by Bertone, 1954

bottom: *1750 GT Veloce*, 1967

below left: *Montreal Coupé* by Bertone, 1967

below right: *Giulia 1600 T.I.*, 1962

According to company legend, Henry Ford once said that every time he saw an Alfa Romeo, he tipped his hat.

Alfa Romeo was founded in 1910, Italy's only major automobile manufacturer based in Milan rather than Turin. Initially, the Anonima Lombarda Fabbrica Automobili manufactured primarily utility vehicles and aircraft engines and compressors for the defense industry, which became an important client during the First and Second World Wars. But even in its earliest years, Alfa Romeo triumphed in the racing arena. Its *24 HP* racing model won the 1911 *Targa Florio,* establishing a precedent for the Alfa *RL 's* great successes of the 1920s and the countless victories that followed.

For many years, the construction of racing engines drove Alfa's entire automobile output. Starting in the 1930s, though, the company hired renowned car-body makers to translate speed and power into more satisfying outer forms. For the 1937 *8 C 2900* B sports roadster, **Touring** created a body that seemed to have been poured into place; **PininFarina's** aerodynamic design for the *6 C 2300 Pescare Coupé* of 1936 displayed the car's power in aggressively swelling fenders and low-mounted headlights. With the end of the Second World War and Italy's rise to prosperity, Alfa Romeo gradually shifted into large-scale production. The elegant *Giulietta* series of the mid-1950s, for which both Bertone and Pinin Farina designed body variants, marked Alfa Romeo's successful breakthrough to a broader

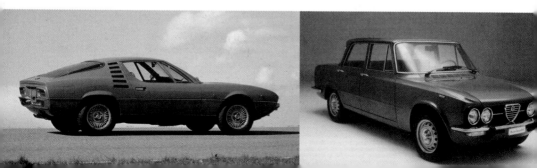

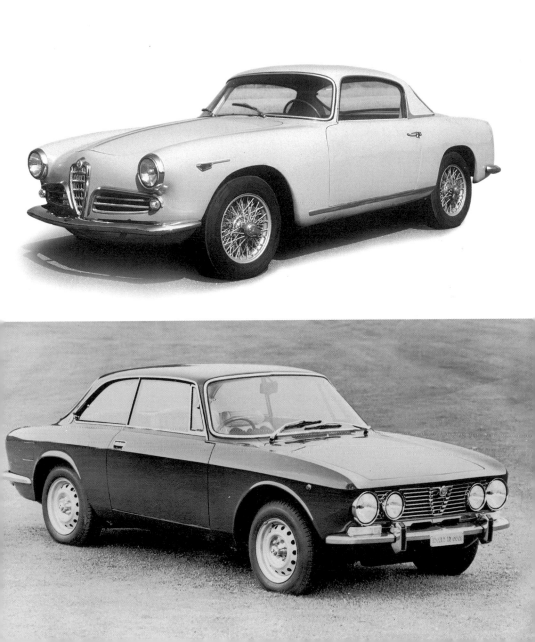

Products

1910 *24HP* touring car

1927 *Typ RL* racing car

1937 *8 C 2900 B* roadster
by Touring

1939 *6 C 2300 B* convertible
by Pininfarina

1954 *Giulietta Sprint* sportscar
by Bertone

1960 *Giulietta Sprint Speciale*
sportscar

1962 *2600* sedan

1963 *Giulia Sprint GT Coupé*

1966 *1600 Spider
Duetto* convertible;
Giulia 1300 t.i. sedan

1972 *Alfasud* sedan

1998 *Alfa 156* sedan

market. In the fifties and sixties, the company succeeded internationally with models such as the Spider *1600 Duetto* of 1966 and Pinin Farina's Spider 1750 of 1969, both of which have since attained cult status. One of the most Alfas was the 1972 *Alfasud,* for whose production a new plant was built.

In the early 1970s the company slipped into a lingering financial crisis that led to Alfa Romeo's acquisition by Fiat in the mid-1980s. Under its new owner, Alfa Romeo has continued to produce cars noted for their sporty performance and design, such as the sleek *164 Berlina* of 1987, with its narrow taillight section, and the wedge-shaped *ES 30* of 1989. More recently, the Alfa *156* was voted Germany's Car of the Year, not least because of its beautiful design.

Alfa *156*, 1998

Furniture company

Alias's very first product, **Giandomenica Belotti's** 1979 *Spaghetti* chair, which featured a rubber-string seat, became an instant bestseller. The young company went on to translate the new creative freedom of **Nuovo Design** into an eclectic product line that reflected its designers' different approaches. Belotti remained a purist, while Mario Botta went for sculptural effects in his *Prima, Seconda, Quarta,* and *Quinta* chairs*,* and **Alberto Meda** focused on technological innovation with his ultra-lightweight seating designs such as *Armframe* and *Highframe.* Other designers associated with Alias include **Carlo Forcolini, Paolo Rizzatto,** Jasper Morrison, Häberli & Marchand, and Riccardo Blumer. The simple, transparent pieces are fabricated by selected manufacturers; Alias concentrates on development, marketing, and distribution. In 1991, the company became part of the **Artemide** group; since 1994 it has been distributing the **Danese** collection of housewares.

Alias srl,
Grumello del Monte

1979 founded by
**Giandomenico Belotti,
Carlo Forcolini** and
Enrico Baleri;

1991 Alias becomes part of
the **Artemide** group

1994 Alias takes over
Danese

Products

1979 *Bloomstick* series
by **Vico Magistretti**

1984 *Apocalypse Now* table
by **Carlo Forcolini**

1986 *Quinta* chair, *Tesi* table
by Mario Botta

1987 *Light Light* chair
by **Alberto Meda**

1994 *Longframe* chaise
and *Highframe* chair
by Alberto Meda;
Alpha bookcase by
Jasper Morrison

1997 *Sec* furniture system
by Häberli / Marchand;
Laleggera chair by
Riccardo Blumer

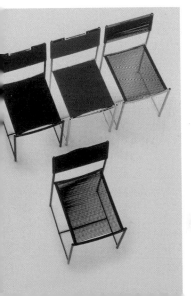

left: *Spaghetti* chair
by Giandomenico Belotti, 1979
right: *Seconda* chair by Mario
Botta, 1982

ARCHIZOOM

Design and architecture group

A sterile, air-conditioned, artificially lit, shopping-mall city determined only by the cycle of selling and buying—from today's perspective, the pessimistic science-fiction tableau Archizoom developed in the *No-Stop-City* project of 1970 seems rather prescient.

Founded in Florence in 1966 by the architects **Andrea Branzi, Paolo Deganello, Massimo Morozzi,** and Gilberto Coretti, Archizoom formulated its ideas in the context of the political protest and upheaval of the time. The young rebels, who had visited London, Branzi said," to see Carnaby Street and the grave of Karl Marx" took the work of the English architecture group Archigram as guiding inspiration. In manifestoes and contributions to exhibitions, they criticized design's blind faith in functionalism, its subservience to industrial interests, and its role as a status symbol. Most of their work consisted of drawings and texts, which were far better suited to their utopian concepts than concrete objects—a tendency characteristic of the entire **Radical Design** movement. Nonetheless, they realized a number of ideas, such as the *Mies* chair (fig. p. 35), which exaggerated the constructive elements of one of Mies van der Rohe's famous chairs to a degree that it looked unusable (though it really was not—one could comfortably sink into its steeply angled seat). And in their pompous *Dream Beds,* Archizoom used kitschy elements from Art Deco and Pop Art to undercut **Bel Design's** purist aesthetics: bad taste became part of their strategy. Archizoom dissolved in 1974, but the group's ideas, stripped of their explicitly political agenda, continued to be influential in the **Anti-Design** movement led by **Alchimia** and **Memphis.**

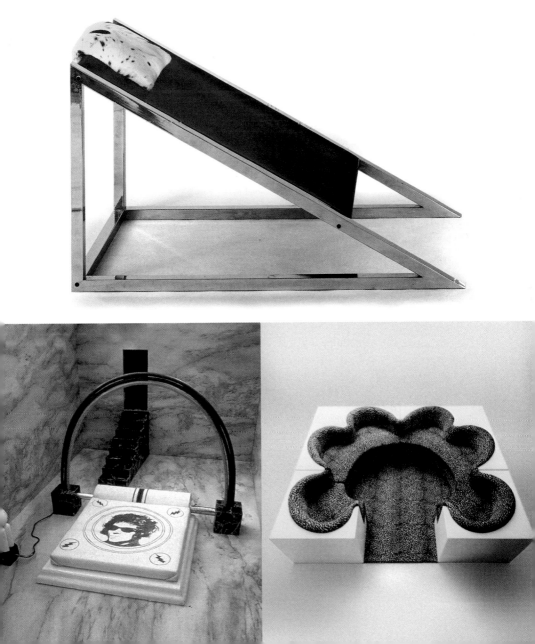

ARFLEX

Furniture manufacturer

Arflex International spa
(now Gruppo Seven
Italia), Giussano (MI)

1950 founded by **Pirelli**
managers Aldo Bai,
Pio Reggiani, Aldo Barassi

1994 Arflex becomes part of
Gruppo Seven

Products

1951 *Lady* chair by
Marco Zanuso

1952 *Fiorenza* chair by
Franco Albini

1954 *Elettra* bench and chair by
BBPR; *Martingala* chair
and *Sleep-o-matic* sofa
by Marco Zanuso

1959 *Airone* chair by
Alberto Rosselli

1964 *Fourline* chair by
Marco Zanuso

1971 *Serpentone* seating
system by **Cini Boeri**

1985 *Felix* chair and sofas by
Burkhard Vogtherr

1996 *Calea* chair by
Prospero Rasulo

Page 105

top left: *Bobo* by Cini Boeri, 1967

top right: *Lady* by Marco Zanuso,
1951

bottom: *Delfino* by Erberto Carboni,
1954

At the 1996 Cologne furniture fair, Arflex reintroduced its classic seating from the 1950s and 1960s, including **Marco Zanuso's** *Lady,* **Cini Boeri's** *Bobo,* **Erberto Carboni's** *Delfino,* and **Franco Albini's** *Fiorenza.* But the event was not completely steeped in nostalgia; it's title was "*Modern Times.*" Arflex, after all, had been Italy's most modern furniture company since its founding in 1951.

Unlike most of its competitors, which were rooted in Italy's long crafts tradition, Arflex was a child of big industry. It was started after the tire manufacturer Pirelli had developed a new kind of foam rubber, named "gommapiuma", and was looking for ways to use it in furniture. The company approached the young architect Marco Zanuso for advice, and he gave "gommapiuma" shape in his *Lady* chair. Not only the material was new in this piece; Zanuso had also replaced the traditional metal inner frame with a system of elastic bands. At the 1951 *Triennale,* the chair was cut open to reveal its innovative innards. *Lady* won the show's gold medal and went on to become a ubiquitous presence in the world's living rooms and a symbol of the organic style of the fifties.

Founded on the strength of the chair's success, Arflex continued to experiment with new materials and develop products noted for their modern design. Over the years, it has worked with an expanding circle of designers, which has included, among others, Burkhard Vogtherr, Paola Nava, and Prospero Rasulo. Marco Zanuso created a number of other pieces for the company, including the Martingala, Antropus, and Woodline chairs, and the convertible Sleep-o-matic sofa. The polyurethane Bobo chaise, designed by Cini Boeri in the late 1960s, was the first piece of furniture to dispense entirely with an inner frame, and Boeri's Serpentone (fig. p. 30) became an icon of progressive chic in the seventies.

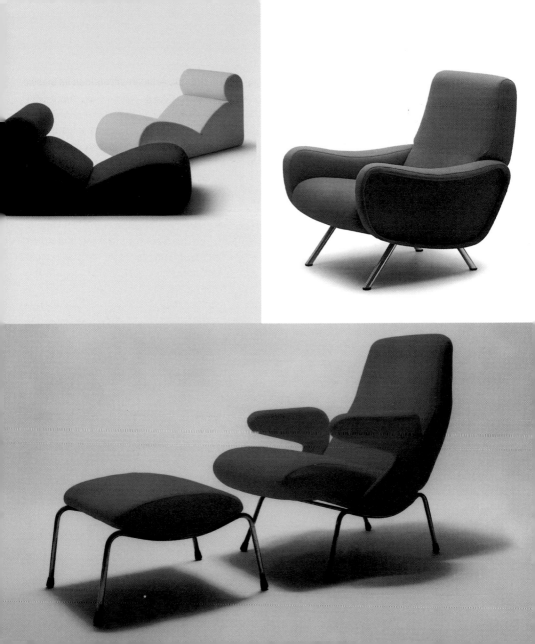

Giorgio ARMANI

Fashion designer

There is a scene in the 1980 movie *American Gigolo* where Richard Gere spreads out his jackets, shirts, and ties on a bed. Some critics commented that the clothes could claim acting credits, and in a sense they did: the cinematic gigolo's workwear had been created by Giorgio Armani, Milan's master of casual understatement.

A medical school dropout and former buyer for the **La Rinascente** department store, Armani, born in 1934 in Piacenza, did not always seem destined to be a star. Starting out as a designer for Cerruti before striking out on his own, he first came to attention with his 1974 line of menswear and, a year later, a collection for women. With his men's jackets, Armani rebelled against the dominant style, which he called "Maoist" He discarded the then-popular shoulder pads and used luxurious fabrics for a loose, easy, and elegant fit. Soon women, too, began wearing these innovative jackets, Armani's sister being one of the first. This inspired Armani to liberate women from their stiff business suits. He "invented" the loose-fitting ladies' blazer, which could be coordinated with a wide range of clothes to fit almost any occasion. Today, the Armani-style blazer is a fixture in many women's wardrobes.

If Armani has revolutionized fashion, he has done it in a gentle manner. He shuns all lurid effects. His haute couture designs suggest, rather than reveal, the body's forms. His fashions are comfortable, their colors muted, their lines subtle, and their fabrics of exquisite quality. Armani's name stands for cool, sophisticated elegance aloof from shock and scandal.

ARTELUCE

Lighting manufacturer

Arteluce by Flos
Flos spa, Bovezzo

1939 founded by
Gino Sarfatti in Como

1954 *Compasso d'oro* for
Gino Sarfatti's *559* table l
lamp

1974 merger with **Flos**

When the high society of the 1950s took their after-dinner promenades on the luxury liners *Michelangelo* and *Raffaelo,* the decks were illuminated by Arteluce lights. The ballrooms of the Castello Sforzesco and the Palazzo Bianco in Genoa, the airports of Rome and Milan, the **Olivetti** building in Barcelona, even ordinary offices and schools used the firm's lighting. For private homes, the firm produced imaginative sconces, sculptural mobiles such as the models *2072* and *2097,* small table lamps in the typical fifties look, and also functional floor lamps.

The company was founded in 1939 by **Gino Sarfatti,** who designed almost all the early Arteluce products. An inexhaustible pioneer of lighting design, he developed the proper illumination for much of Italy's Modernist postwar architecture. Obsessed with light and its possibilities, the former aeronautics engineer

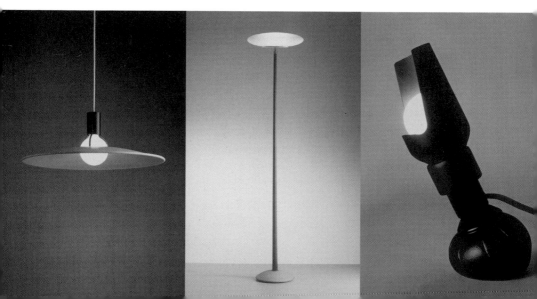

focused all his energy on his company, taking charge of everything from design to marketing and distribution. He kept his distance from Milan's cultural establishment and used the company's store on the city's Corso Matteotti as a place to meet young designers such as **Marco Zanuso, Franco Albini, Vittoriano Vigano´** or **Gianfranco Frattini,** who shared his enthusiasm for modern industrial design. The many awards his products won mattered little to him.

When Sarfatti realized in the early 1970s that his company needed to be restructured to remain economically viable, he sold it to his competitor *Flos*. Since 1974 *Arteluce* has been an independent product line within Flos, presenting the work of a younger generation of international designers, including **Matteo Thun, King-Miranda, Rodolfo Dordoni,** and Stephan Copeland. Many of Sarfatti's designs are also still being produced.

Products

1952 *187* wall lamps

1954 *1063* and *1064* floor lamps

1957 model *2097*

all by Gino Sarfatti

1977 *Jill* lamp by **Perry A. King** and **Santiago Miranda**

1979 *Ring* desk lamp by **Bruno Gecchelin**

1989 *Tango* table lamp by Stephan Copeland

1991 *Corolle* floor lamp by Ezio Dodone; *Pao* floor lamp by **Matteo Thun**

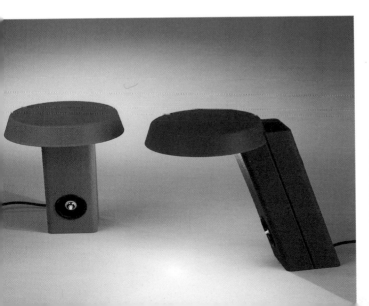

From left

2133 lamp by Gino Sarfatti, 1976

Pao lamp by Matteo Thun, 1993

600 lamp by Gino Sarfatti, 1966

Low-voltage halogen table lamp, model 607, by Gino Sarfatti, 1969 / 1971

ARTEMIDE

Lighting manufacturer

Artemide spa,
Milan

1959 founded by
Ernesto Gismondi

1995 *Compasso d'oro*

1997 *European Design Prize*

Products

1969 *Selene* plastic chair by
Vico Magistretti

1972 *Tizio* desk lamp by
Richard Sapper

1979 *Tholos* desk and wall lamp
by Ernesto Gismondi

1985 *Icaro* wall lamp by
Carlo Forcolini

1992 *Orione* table lamp by
Rodolfo Dordoni

Dedolo umbrella stand by
Emma Schweinberger-
Gismondi, 1966

Page 111

top left: *Boalum* light tube by
Livio Castiglioni and
Gianfranco Frattini, 1969

top right: *Eclisse* lamp by
Vico Magistretti, 1965

bottom left: *Echos* floor lamp by
Jan van Lierde, 1998

bottom right: *Tolomeo* desk lamp by
Michele De Lucchi
and Giancarlo Fassina, 1987

Artemide's catalogue reads like a list of design classics: **Vico Magistretti's** 1965 *Eclisse* lamp, with its pivoted reflector; **Richard Sapper's** perfectly balanced *Tizio* desk lamp of 1972; **Ettore Sottsass's** 1983 *Pausiana;* and **Michele De Lucchi** and Giancarlo Fassina's 1987 *Tolomeo* desk lamp (what architecture studio or ad agency doesn't have it?).

In the 1960s the company produced plastic furniture and accessories, including Magistretti's *Selene* and **Sergio Mazza's** *Toga* chairs (fig. p. 7). But before long, the company's energetic founder, **Ernesto Gismondi,** concentrated exclusively on lights. In addition to developing his own designs, which include the *Tebe, Utopia,* and *Aton* lamps, he has worked with **Carlo Forcolini, Rodolfo Dordoni, Gianfranco Frattini, Angelo Mangiarotti,** Hannes Wettstein and other well-known designers. Commercial lighting and a playful collection of Murano glass complement the product line. In recent years Gismondi, who sponsored the **Memphis** group in the early 1980s, has turned his company into a small design conglomerate by acquiring two related companies, **Alias** and Megalit.

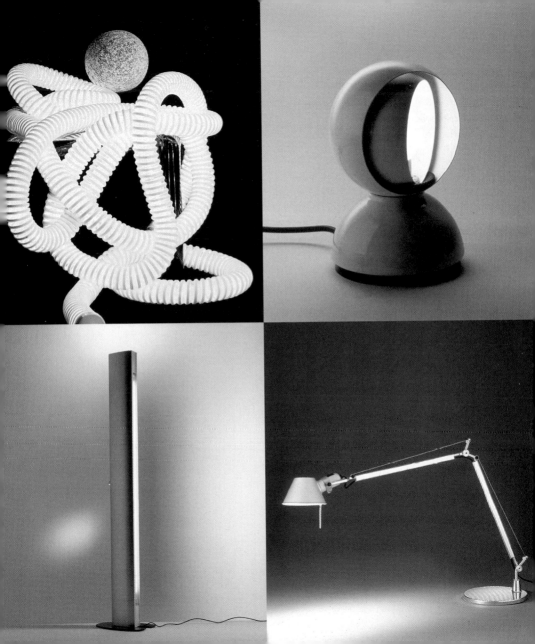

Sergio ASTI

Architect, furniture and product designer

Sergio Asti first made his mark as a designer in the mid-1950s with objects that perfectly embodied the **Linea italiana's** famous combination of organic forms and functional design. With its sleek, streamlined shape, his soda dispenser for Saccab is a perfect example of **Bel Design**. While thoroughly modern, Asti's designs were also informed by a sense of tradition, which is reflected in his preference for "old" materials such as glass, ceramics, and marble. When the **Neo-Liberty** movement emerged in northern Italy toward the end of the 1950s, Asti contributed to the rediscovery of pre-Modernist forms and traditions with pieces like his graciously curved wooden *Bertoli* table and his sculptural *Marco* vase for Salviati. Today, Asti designs furniture and exhibitions but is primarily known for elegant smaller objects, such as his bulbous *Daruma* table lamps made of hand-blown glass, and the *Profiterolle* line of silverware, vases, dishes, and faucets.

1926 born in Milan
1953 architectural office in Milan
1957 Gold medal at IX. *Triennale*
1962 *Compasso d'oro*

Products
1961 *Marco* glass vase for Salviati
1968 *Daruma* lamp for Candle
1969 *Navy* folding chair
1972 *Dada* tableware for Ceramica Revelli
1991 *Alice's* table for **Up&Up**

Soda dispenser for Saccab, 1956
Kilimandjaro table lamp for Raak Amsterdam, 1976

Antonia ASTORI

Furniture and exhibition designer

Antonia Astori, or the Search for the Perfect System: this could be the title for a book on the Milan designer, who throughout all the stylistic changes of the past thirty years has continuously come up with new systematic solutions. *Oikos,* developed in 1972 for her own company, **Driade,** uses a plain cube as the basic element of a complex architectural concept for the design of living rooms, workspaces, bedrooms, baths and kitchens. Nearly three decades later, *Oikos* stands as a classic of its genre on the strength of its clear geometry, high formal precision, and minimalist elegance. Among Astori's other successful furniture systems are *Kaos* from the 1980s and *Pantos,* introduced in 1993. She also designed numerous individual pieces of furniture for Driade and helped create the company's visual identity and graphics program. In addition, she has worked for international companies as a designer of trade show presentations, offices, and exhibitions.

1942 born in Melzo (Milan)
1968 cofounder of
Driade
1981 *Compasso d'oro* for
Driade identity and
marketing design

Products
1968 *Driade 1* system
1972 *Oikos I* system
1977 Bric system
with **Enzo Mari**
1980 *Oikos* II system
1986 *Kaos* system
1993 *Pantos* system
all for Driade

Elements from *Driade I* system, 1968

Gae AULENTI

Architect, furniture and lighting designer

1927 born in Palazzolo della Stella (Udine)

1954 graduates from architecture school in Milan

1955 editor at *Casabella*

1979 *Compasso d'oro*

1980 interior design for Musée d'Orsay, Paris (compl. 1987)

1982 interior design for Musée d'Art Moderne, Paris

1986 renovation of Palazzo Grassi, Venice

Products

1962 *Sgarsul* chair for **Poltronova**

1965 *Jumbo* table for Knoll

1967 *Pipistrello* lamp for **Martinelli Luce**

1975 *Aulenti Collection* suite for Knoll

1980 *Parola* lamp for **Fontana Arte**

1984 *San Marco* table for **Zanotta**

1991 *Tlinkit* rattan chair for **Tecno**

Geacolor lamp for Venini, 1995
April chair for Zanotta, 1972

Page 115
Tour table for Fontana Arte, 1993

As part of her project to design **Olivetti's** Paris office in the 1960s, Gae Aulenti created the flower-shaped *Pipistrello* lamp, which later went into commercial production. Indeed, most of her furniture and lighting designs developed out of larger architectural commissions. In the 1980s, when hired to transform the Gare d'Orsay in Paris into a museum and the Musée d'Art Moderne into the Centre Georges Pompidou, she not only reconceived the buildings' interior architecture but also designed display cases, lights, and all the other objects necessary to achieve "a complete harmony of all elements," as she describes it. Gae Aulenti had gotten her start as a furniture designer in the late 1950s in the context of the **Neo-Liberty** movement. With her *Sgarsul* (1962) for **Poltronova** she interpreted the quaint rocking chair as a nimble modern object.

Emphasizing the structure of her pieces, Aulenti achieved an elegant look, which in the 1960s and 1970s contributed to the international fame of Italian **Bel Design.** Among her memorable designs are the *April* folding chair (1972); the *Gaetano* glass table for **Zanotta** (1973); the crystal tables for **Fontana Arte** (1980, 1982, 1993) and the *3 Più* series of lights for Stilnovo. But her strongest impact was on architecture, with showroom designs for **Fiat** and Olivetti, the interior architecture for the Palazzo Grasso in Venice and the Catalan Museum in Barcelona, and a number of stage designs. Her writings have also been seminal in Italian architectural theory.

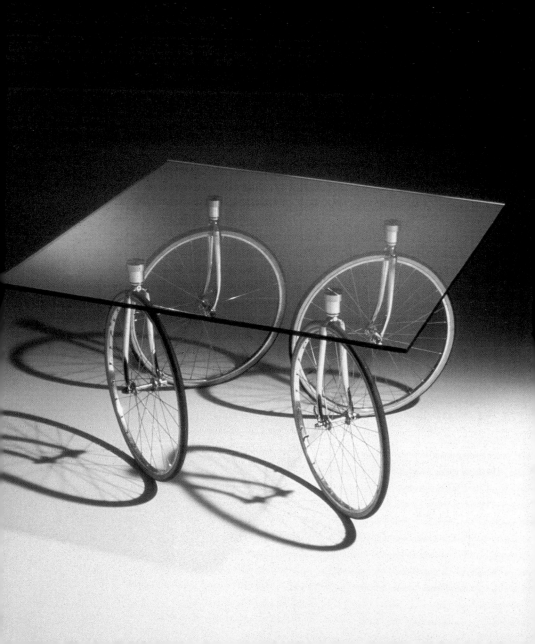

B&B ITALIA

Furniture manufacturer

B&B Italia spa, Novedrate

1966 founded by
Cesare Cassina and
Piero Busnelli as
C&B Italia

1968 establishment of
reasearch and
development center

1973 Cesare **Cassina** leaves
company; renamed
B&B Italia

Products

1966 *Amanta* chair
by **Mario Bellini**

1969 *Up* seat by
Gaetano Pesce

1974 *Tema, Quartetto,
Sestetto, Coda* tables
by **Vico Magistretti**

1980 *Sity* sofa by
Antonio Citterio

1985 *Artona* chair by **Afra**
and **Tobia Scarpa**

An odd object made its appearance in furniture showrooms toward the end of the 1960s. When its tight wrapping was opened, an amorphous foam rubber blob popped out and expanded, as if by magic, into a rounded form. As unconventional as it appeared, **Gaetano Pesce's** *Up* chair series was the result of intensive research in the laboratories of C & B Italia. Founded in 1966 by Cesare Cassina and Piero Busnelli, the young company's furniture made of cold-foamed polyurethane quickly made it a trendsetter, and in 1968 it established a large research center headed by **Francesco Binfaré.** An illustrious group of graphic designers, including Enrico Trabacchi, **Bob Noorda,** Roberto Svegliado, **Pierluigi Cerri,** and **Oliviero Toscani** worked on B & B's strikingly clean-looking corporate identity. The company's name had changed to B & B Italia when Cassina left the company in 1973, but its approach has not, continuing to emphasize experimentation in design and innovative materials, if perhaps in slightly less flamboyant style. Among the company's current designers are **Afra** and **Tobia Scarpa, Antonio Citterio, Paolo Nava, Mario Bellini,** and **Vico Magistretti.** B & B Italia produces about 80 percent of the polyurethane seating sold globally, but also uses rattan, wood, and fiberglass in its products.

Diesis sofa by Antonio Citterio
and Paolo Nava, 1980

Page 117

top *Alanda* table, 1982

bottom left: *Arcadia* chair, 1985

both by Paolo Piva

bottom right: *Le Bambole* chair
by Mario Bellini, 1972

BALERI ITALIA

Furniture manufacturer

Baleri Italia was founded by **Enrico Baleri** and Marilisa Baleri Decimo in 1984 during a period of profound changes in the Milan design scene brought about by the rise of **Nuovo Design.** Enrico Baleri was already known as a trendsetter; he had been one of the founders of the cutting-edge furniture company **Alias** in 1979, and had also created pieces for **Gavina, Flos,** and Knoll. Some of his designs for Baleri Italia are committed to the kind of free experimentation evident in his minimalist, egg-shaped *Tato* chair, designed with **Denis Santachiara**. Others make reference to the Modernist heritage; with its austere lines, his *Molly* sofa is clearly in the tradition of Le Corbusier and Mies van der Rohe, while adapted to today's living environments.

The overall look of the company's furniture is not specifically Italian but reflects Baleri's international approach. Along with Italians like **Riccardo Dalisi, Angelo Mangiarotti,** and **Alessandro Mendini,** the Frenchman Philippe Starck, the Austrian Hans Hollein, and the Swiss Hannes Wettstein have all contributed pieces to the Baleri collection, which, while showing each designer's individual sensibility, generally maintains a purist line. In 1994 Baleri and Baleri Decimo founded a second company, the lighting manufacturer Gloria.

Baleri Italia Spa, Lallio (Bergamo)

1984 founded by
Enrico Baleri and
Marilisa Baleri Decimo

1994 Enrico Baleri and
Marilisa Baleri Decimo
found lighting company
Gloria

Products

1985 *Richard III* chair by
Philippe Starck

1986 *Bristol* sofa by
Enrico Baleri

1994 *Bill Club* sofa by
Hannes Wettstein

1996 *Ypsilon* shelf unit by
Angelo Mangiarotti

1997 *Tato*, *Tatino*, and
Tatone seats by
Enrico Baleri and
Denis Santachiara

T-table by Angelo Mangiarotti, 1998

Page 119
left: *Ad Iovis* lamp by Angelo Mangiarotti für Gloria, 1998
top right:. *Mama* chair by Denis Santachiara, 1995
bottom right: *Mimì* chair by Enrico Baleri, 1991

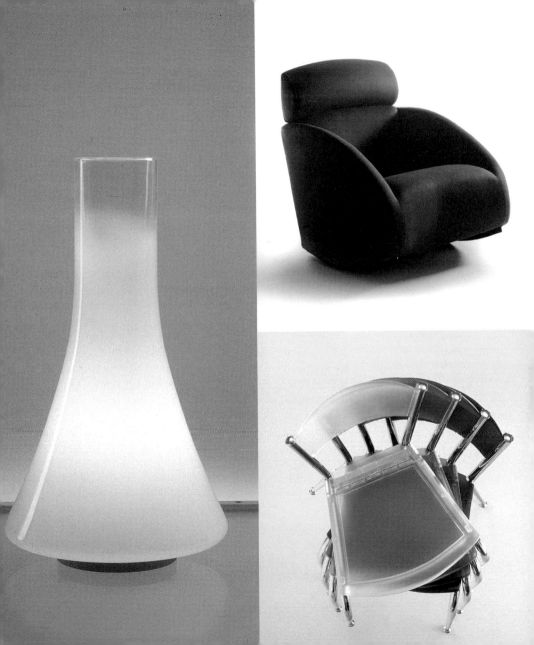

BARILLA

Pasta manufacturer

Barilla G. e R. F.lli spa,
Holding of Barilla Group,
Parma

1877 Pietro Barilla makes pasta and breads

1910 pasta factory

1952 *Golden Palm* advertising award for **Erberto Carboni's** *Con Pasta Barilla è sempre domenica* campaign

1964 *C'è una gran cuoca in voi e Barilla la rivela* (A great chef lies asleep in you and Barilla awakes her)

1987 *Golden Lion* for TV commercial at Cannes International Advertising Festival

Page 121

top left: *Farfalla, Fusillo, Penna*

top right: Advertisement by Erberto Carboni, 1956

bottom left: *Multicoloured Totem,* trade fair display by Erberto Carboni, 1957

bottom right: Advertisement by Erberto Carboni, 1952

Barilla is a leading manufacturer of Italy's most common mass-produced design product: pasta. Pasta-making is a classic example of product design, a craft rooted in centuries-old traditions. Farfalle, penne, linguini, and spaghetti are just four of the more than 300 different kinds of pasta, many of which are made by Barilla. The design of each type follows culinary criteria: how it feels in the mouth and how its shape makes it more or less suitable for different kinds of sauces or recipes.

It is in the field of marketing and communications, though, that Barilla has won several important design awards. In the 1920s and 1930s, its postcards and calendars, many of them designed by **Erberto Carboni,** were sought-after collector's items. After the war, Carboni continued to shape Barilla's public image. His 1952 campaign, with the slogan *Con Pasta Barilla è sempre domenica* (With Barilla pasta, it's always Sunday), became a classic of Italian advertising. Carboni created the company's oval, red and white logo, and used simple, modern graphics for advertisements and packaging: images of noodles, silverware, and pots silhouetted on a blue background (fig. p. 37). In the 1960s and 1970s, Barilla hired celebrities such as playwright Dario Fo, the popular singer Mina, and Richard Lester, director of the Beatles movies, for its popular *Carosello* series of TV commercials. During the 1980s, campaigns by TBWA and Young & Rubicam and TV spots by filmmakers such as David Lynch, Ridley Scott, and Nikita Michalkoff were equally successful. Paired with effective management, such well-conceived publicity efforts made Barilla (which today consists of some thirty companies) Europe's largest pasta producer.

...è sempre quella minestra...

levatevi questo chiodo dalla testa

con pasta Barilla non potete più dire
...è sempre quella minestra...
La pasta Barilla non è soltanto
l'alimento ricco e leggero, semplice
ed economico a tutti gradito e consigliato, ma anche quello che
consente ai cuochi e alle massaie
la maggiore varietà di tipi e di formati

Barilla con pasta Barilla è sempre domenica

la pasta del buon appetito

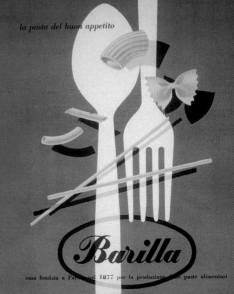

Barilla

casa fondata a Parma nel 1877 per la produzione delle paste alimentari

BBPR

Architecture and design studio

One of the first commissions realized by BBPR after the Second World War was a monument to the victims of German concentration camps for Milan's Cimitero Monumentale. The history of the firm's principals made this a highly personal project: Gian Luigi Banfi, Lodovico Barbiano di Belgiojoso, Enrico Peressutti, and **Ernesto N. Rogers** had all fought in the anti-Fascist resistance movement; Banfi had died in a concentration camp. Their moral integrity and conviction that design and architecture had important social tasks to fulfill invested them with an authority that "made Italy's cultural world tremble," as **Alessandro Mendini** put it. Although the group developed numerous product designs (seating furniture for **Arflex;** *Spazio,* a flexible office furniture system for **Olivetti;** faucets for **Olivari;** and furniture for **Azucena**), their influence was strongest in architecture and theory. Rogers, who was editor-in-chief of *Domus* (1946–47, with **Marco Zanuso**) and *Casabella–continua* (1953–64), fought for the realization of the social ideas that had once informed Modern architecture and for the principle of "usefulness plus beauty."

1932 founded in Milan by Banfi, Belgiojoso, Peressutti and Rogers

1936 development plan for Aosta valley (compl. 1973); interior design for conference hall at VI. *Triennale*

1946 memorial for victims of German concentration camps, Milan

1954 interior design for **Olivetti** offices in New York

Products

1950 Electric clock for **Solari**

1954 *Urania* chair for **Arflex**

1955 TV set for CGE Electric Co.

1960 *Arco* office furniture system for Olivetti

Elettra side chair and club chair for Arflex, 1954

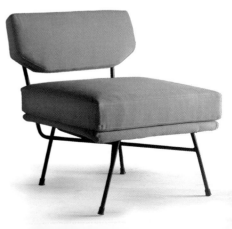

Mario BELLINI

Architect, industrial and furniture designer

There is "a greater difference between a computer and a chair than there is between a chair and a cathedral," according to Mario Bellini. Machines have a short life span, due to continuous technological innovation, and their form always depends on the conditions of their use. Furniture, on the other hand, is tied to semantic values and integrated into the context of cultural traditions.

Throughout his career, however, Bellini has focused on both machines and furniture. The situation, which he feels can be "schizophrenic," has been a recurring theme in his theoretical writing, in general, and in his work as editor of *Domus* magazine (1986–91) in particular. In the field of "machine design," his work includes the *Totem* stereo system and the *Triangular TV* set for **Brionvega** in the 1960s, as well as the look and feel of numerous **Olivetti** products produced from the 1960s to the 1980s. For his *Divisumma 18* calculator of 1972 (fig. p. 16), the first pocket-sized device in a category hitherto full of clunky desktop boxes, he

1935 born in Milan

1959 graduates from architecture school in Milan; works at **La Rinascente's** design office (until 1961)

1962 architecture and design studio; *Compasso d'oro* (also in 1964, 1970, 1979, 1984)

1963 consultant for **Olivetti**

Cab chair for Cassina, 1977
Monitor 15 TV set for Brionvega, 1975

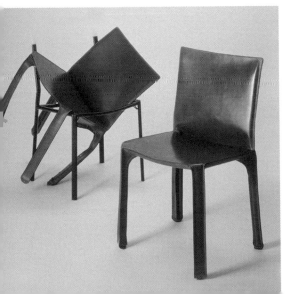

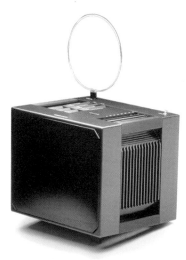

Mario BELLINI

completely wrapped the sensitive inner works in a thin orange membrane. In addition to its practical function and the visual pleasure of its rounded shape, the *Divisumma* gave its user a tactile, vaguely erotic bonus in the softly yielding feel of its keys. Bellini also designed architectural, angular products like the *Logos* series of calculators and the *Lettera 92* typewriter for Olivetti, and the *TC 800* upright tape recorder for Yamaha.

Bellini applied the principle of wrapping to furniture as well. A leather cover was pulled over a skinny metal frame and then zipped tight for his famous 1978 *Cab* chair for **Cassina**. He designed numerous other pieces of furniture for Cassina and **B & B Italia**, including the sumptuously pliant *Le Bambole* chairs and the monumentally solid tables *Il Colonnato* and *La Basilica*.

Be it a calculator or a chair, Bellini rejects an overly functionalist doctrine: "Each design implies the possibility of other designs." In his products, clear function always goes hand in hand with emotional value. He is well aware of the cultural dimension of design and architecture, and he synthesizes both fields in an approach that aims at the design and reorganization of larger environments. His is a design with an architectural scope and vision—whether he develops office furniture for Vitra, cars for Renault, lights for **Artemide** and Erco, fountain pens, or espresso makers. In all of this, he has been undeniably successful: in 1987, Bellini was the first living designer since Charles Eames to be given a major retrospective at New York's Museum of Modern Art.

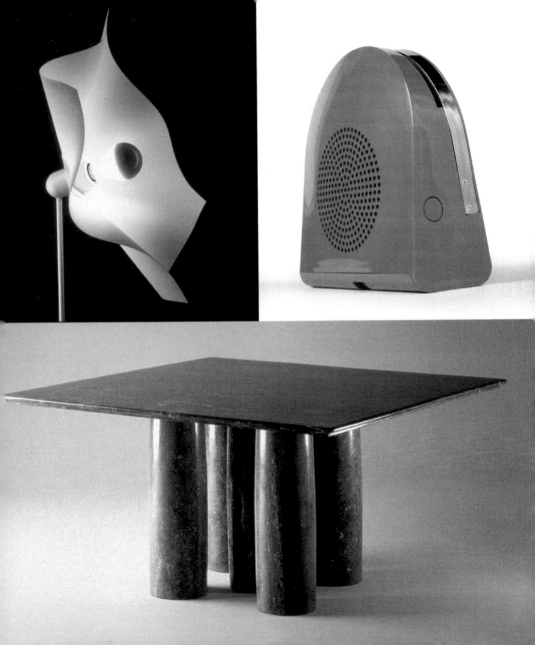

BENETTON

Clothing manufacturer

Benetton Group spa,
Ponzano (Treviso)

1966 founded by **Luciano Benetton** in Ponzano

1984 *All the Colors of the World* campaign

1990 *United Colors of Benetton* campaign

1992 *HIV Positive* campaign

1993 campaign with Bosnian soldier's blood-soaked t-shirt

1998 *Enemies* campaign

left: *Colors*, magazine cover, 1997
center, right: Advertisements, 1992

Images of racial discrimination, war, hunger, and AIDS are among the many prize-winning photos **Oliviero Toscani** has used in his advertising campaigns for Benetton since 1984. The one that won the most awards was a 1989 shot of a white baby suckling on a black woman's breast. Time and again, Toscani's campaigns have proved to be as controversial as the social issues they depict. On occasion, the company has even backed up its apparent commitment to social causes with actual activities: a few years ago, company owner Luciano Benetton distributed condoms in his stores; another time he appeared nude to collect clothes for needy people with the slogan, "Give Me Back My Clothes!" But the campaigns have also created remarkable publicity. It is questionable whether sweaters and sportswear alone would have made Benetton the corporate giant it is today; with annual sales of some 4.2 trillion lire, the Benetton group now owns well-known brands such as Rollerblade, Kästle, and Asolo, is active in Formula 1 racing, and in 1993 founded the **Fabrica** academy for thepromotion of art and design.

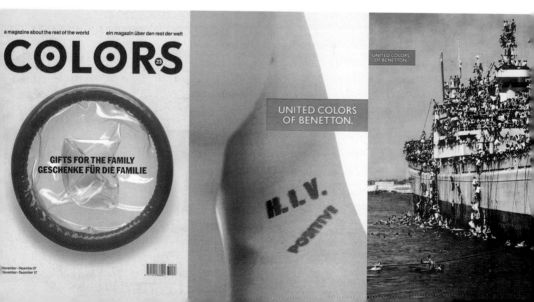

Furniture manufacturer

Bernini's history reaches back to 1904, when the company was founded as a cabinetmaking business in the Brianza region, then and now the center of Italy's furniture industry. The firm first made its mark in design in the 1960s with beautifully made, solid wood furniture, and through its elegant use of plastics and metal. The 1969 Maia desk, designed by **Giotto Stoppino**, has a double wooden top with compartments for writing materials in the back that can be concealed under a sliding cover. The desktop rests on a tubular steel frame, which is also used for the matching chairs.

Bernini's designs combine modern, sophisticated form with exquisite materials. Conceived as timeless, durable pieces, many of the company's table, chair, and bed designs have been in production for some thirty years. In the 1970s the firm proved its expertise in the manufacture of high-quality wood furniture when it produced a number of subtly elegant designs by the architect **Carlo Scarpa,** including the symmetrical Zibaldone

Bernini spa,
Carate Brianza

1904 founded as carpenter's workshop

1964 furniture with plastics

Products

1969 *Combicenter*
by **Joe Colombo**

1971 *Quattro quarti 700* elements by **Rodolfo Bonetto**

Maia table and chairs by Giotto Stoppino, 1969

1974 *Zibaldone* shelf unit
by **Carlo Scarpa**

1981 *Practica* shelf unit
by **Gianfranco Frattini**

1995 *Gambadilegno* collection
by **Ugo La Pietra**

1995 *543 Broadway* chair
by **Gaetano Pesce**

783 chair by Carlo Scarpa, 1977

Table from *Serie 1934*
by Carlo Scarpa

shelving unit. With its many intricately designed drawers, **Gianfranco Frattini's** 1981 *Practica* unit has an equally timeless, distinct beauty, coupled with a high degree of functionality and flexibility. The firm's successful designs of the 1990s include **Gaetano Pesce's** *543 Broadway* chair, which is made of transparent, iridescent plastic and has skinny legs ending in springs—giving the chair a somewhat shifty feeling under the weight of a body.

Designers who have worked for Bernini also include **Achille Castiglioni, Rodolfo Bonetto, Joe Colombo,** Toshiyuki Kita, **Paolo Nava, Ugo La Pietra,** and **Leila** and **Massimo Vignelli.**

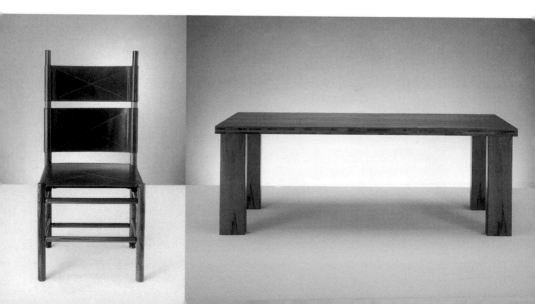

Enzo BERTI

Artist and furniture designer

Enzo Berti's furniture for La Palma and Montina, and his kitchens for **Arc Linea** are purist designs. Born and educated as a fine artist in Venice, Berti pursues the "correct" synthesis of form and function. But his wood, leather, metal, and textile objects always contain an aesthetic punchline: instead of merely being "correct" they surprise us with disturbing details. Only a close look reveals the shimmering layer of sand under the glass top of Enzo Berti's *Dune* table, prompting a heightened appreciation of that "inferior" material's qualities. To the asymmetric edges of the modular *Zoom* shelving system, additional box elements can be attached, so that it can easily grow to any size. The wooden *Passepartout* chair subverts its own apparent simplicity with a geometric window in the backrest, which unexpectedly turns the chair into a minimalist sculpture.

1950 born in Venice

studies at the Accademia delle Belle Arti di Venezia; studies industrial design in Venice

Products

1993 *Passepartout* chair
for Montina;
Nest chaise
for Montina

1995 *Zoom* expandable shelf unit for La Palma;
Dune metal table with glass and sand for La Palma

1996 *Cuba* stacking chair

1997 *Fenj* chair
both for La Palma;
Clubhouse furniture series for Montina

1998 *Up* folding chair for La Palma

Tables from *Club House* series for Montina, 1997

BERTONE

Car body designer

"If the car has a soul, the battle is almost won."

—Nuccio Bertone

Along with his student **Giorgetto Giugiaro** and **Sergio Pininfarina, Nuccio Bertone,** who died in 1997, is one of the greats of Italian car design. He knew that the battles of the highly competitive automobile market are often decided by a car's impact on the emotions. So his primary goal was to overcome mediocrity, especially in sports cars. His **Lamborghinis**—the *Miura, Espada,* and *Countach*—**Ferrari** *Dino 308 GT 4,* **Alfa Romeo** *Carabo,* and **Lancia** *Stratos* zipped along racetracks and roads like arrows, with extremely pointed fronts and compact backsides.

Since the 1930s, Bertone had systematically turned the bodyshop opened by his father, Giovanni, in 1912 into a modern company, styling such luxury cars as the *Fiat 2800 Cabriolet.* His breakthrough came in 1954 with the modest but elegant Alfa Romeo *Giulietta Sprint* (fig. p. 36), which was originally designed for a limited series of 500 but went on to be in production for thirteen years. Other classic Bertone designs include the 1964 **Fiat** *Spider 850* and the low-slung, sporty 1972 *Fiat X1/9.* In more recent years Bertone's company designed the Opel *Kadett Cabrio* (1987), the Opel *Astra Cabrio* (1993), and the Fiat *Punto Cabrio* (1994).

Carozzeria Bertone spa, Grugliasco (TO)

1912 Giovanni Bertone opens workshop for car-body parts

1934 his son, **Nuccio Bertone** (1914–1997) joins the firm

Products

1921 **Fiat** *501* racing car

1954 **Alfa Romeo** *Giulietta Sprint*

1958 NSU *Prinz Coupé*

1961 Alfa Romeo *2600 Sprint*

1962 BMW *3200 CS*

1964 Fiat *850 Spider*

1966 **Lamborghini** *Miura*

1972 Fiat *X 1/9*;
Lamborghini *Countach*

1975 VW *Polo*

1982 Citroen *BX*

1985 Volvo *780 Coupé*

1994 Fiat *Punto Cabrio*

1999 BMW *C1* motorcycle

Lamborghini *Miura*, 1966

Page 131
top: Fiat *2800* convertible, 1939
bottomright: Fiat *X 1/9*, 1972

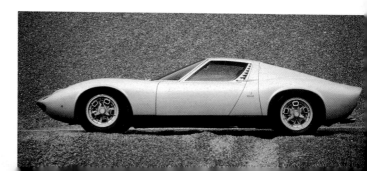

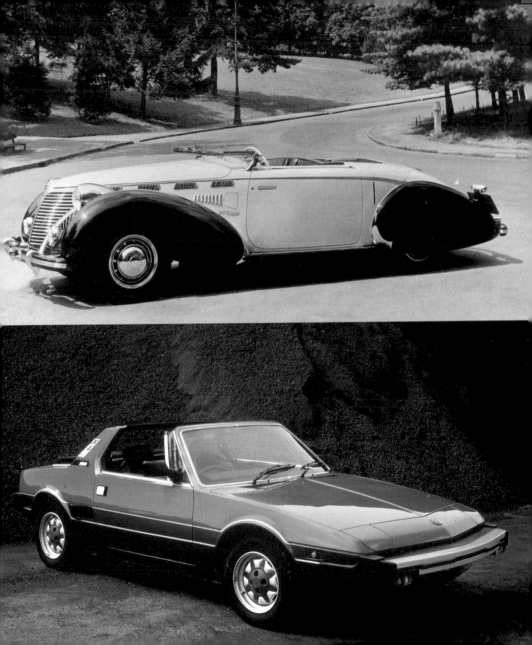

Cini BOERI

Architect, furniture and lighting designer

The title of Cini Boeri's book, *Le dimensioni umane dell' abitazione* (The human dimension of habitation), defines her entire career. For more than four decades, her theoretical and practical work has centered on humans and their needs. Boeri's one of the few women acknowledged as major forces in Italian design. Interestingly, she says she learned more from her mentor, **Marco Zanuso,** than she ever did at architecture school.

Her product designs encompass a variety of fields but have several things in common: they make life easier in a casual, relaxed manner; are often modular and available in several variations; and are made to fit changing requirements. Her *Borgogna* easy chairs on castors of the early 1960s anticipated today's home office. The armrests accommodated writing utensils and a telephone and were fitted for a reading light and manuscript holder. A 1967 stainless-steel cart did multiple duty as

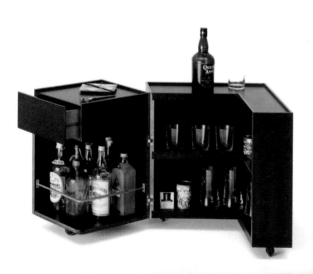

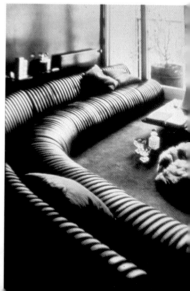

a serving tray, laundry basket, and sideboard. In the early 1970s, her *Serpentone* seating snake (fig. p. 30) for Arflex became famous. Based on a simple rubber module, it could be configured in any length or layout, fitting a cultural moment that had temporarily leveled the distinctions between sitting and lying down. For Arflex, Boeri also designed the frameless *Bobo* chair, made of polyurethane, which could be manufactured in different "degrees of softness," and the *Strips* seating units, which had conveniently removable zippered covers. In addition, Boeri has designed lights for **Artemide, Arteluce,** and Stilnuovo; door handles for Fusital; furniture for **Fiam;** and prefabricated houses. As an architect, she designed public and private buildings as well as showrooms for Knoll International in Milan (1984), **Arflex** in Tokyo (1981), and **Venini** in Frankfurt (1988).

Products

1964 *Borgogna* chair

1967 *Bobo* monoblock chair

1971 *Serpentone* seating system; all for **Arflex**

1973 *Lucetta* table lamp for Stilnovo

1976 *Talete* tables

1979 *Strips* chairs; both for Arflex

1982 *Tre B* door handle for Fusital; *Ditto* table lamp for Tronconi

1983 *Malibu* table for Arflex; prefabricated house for Misawa Homes, Tokyo; *Shadows* table series for ICF

1986 *Brontes* table lamp for **Artemide**

1987 *Voyeur* glass partition for **Fiam**

1988 *Palo Alto* table

1989 *Feltro* hanging lamp for **Venini**

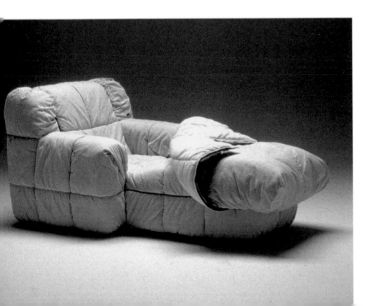

From left
Cubotto-Bar, 1967
Serpentone seating system, 1971
Strips chair, 1979
all for Arflex

Studio BOGGERI

Graphic design studio

At the beginning of modern Italian graphic design there is a musician: Antonio Boggeri, was a trained violinist. As the founder of Studio Boggeri, though, he came to use photos and fonts instead of notes.

In 1924, Boggeri happened onto a job with the Milan printing establishment of Alfieri & Lacroix, where he deepened his knowledge of lithography and typography. After intensively studying the techniques and possibilities of photomontage, he decided in 1933 to set up his own studio, which quickly became a hotbed for up-and-coming graphic artists, including **Max Huber, Bob Noorda, Xanti Schawinsky, Bruno Monguzzi, Bruno Munari,** and **Erberto Carboni.** All of them contributed to the extraordinary reputation the studio gained, which peaked in the late 1950s and early 1960s. The cover for **Olivetti's** brochure on the *M 42* typewriter is an excellent example of the studio's principles:

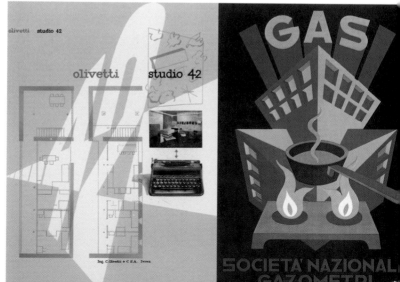

1934 Brochure for *M40*

Huber superimposed technical sketches on typographic elements and added a silhouetted, colorized photograph of the typewriter and a photo of the office situation, in which it was to be used. The result was a multilayered design that put the advertised product in a meaningful context.

Boggeri once said that graphic art is like theater: it has to create the same surprise and fascination as a rising curtain. In this metaphoric scenario, he took the role of a theater principal who gave his directors all the artistic freedom they needed. Through Huber and Schawinsky, the Swiss school of graphic design and late Bauhaus typography had an indirect influence on the Studio's work for clients like Olivetti, Roche, Glaxo, Dalmine, and **Pirelli.** Throughout the 1960s, 1970s, and 1980s, the Swiss Bruno Monguzzi, in particular, distinguished himself with exceptional designs for Boggeri.

typewriter for **Olivetti** by **Xanti Schawinsky**

1936 *Bantam* poster for Cervo by **Erberto Carboni**

1945 Brochure cover for Studio Boggeri by **Max Huber**

1956 Logo for Olivetti (also 1970)

1962 *Guanti Satinati,* advertisement for **Pirelli** by **Bruno Monguzzi**

1972 Advertisements for Pirelli tennis balls by Bruno Monguzzi and **Roberto Sambonet**

1979 Logo for IGA 83 by Bruno Monguzzi

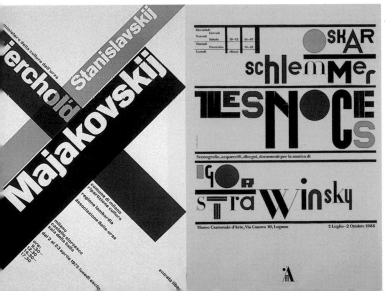

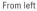

From left

Cover design for Olivetti's *M 42* typewriter, 1942, by Max Huber

Poster for Società Nazionale Gasometri by Fortunato Depero, 1934

Exhibition poster for the Milan department of culture, 1975, by Bruno Monguzzi

Poster for an exhibition on Oskar Schlemmer and Igor Stravinsky at the Museo Cantonale d'Arte. Lugano, 1988, by Bruno Monguzzi

Pierantonio BONACINA

Furniture manufacturer

Pierantonio Bonacina snc,
Lurago d'Erba

1898 founded

Products

1957 *Egg* suspended chair
by Nanna Ditzel

1960 *Martingala* chair
by **Marco Zanuso**

1963 *Continuum* chair
by **Gio Ponti**

1964 *Nastro* chair
by **Joe Colombo**

1988 *Atlantic* sofa
by Franco Bizzozzero

1991 *Flûte* wicker lamp
by Marco Agnoli

1993 *Cosy Ton* chair
by Giuseppe Viganò

Page 137

top l. *Continuum* chair
by Gio Ponti, 1963

top r. *Martingala* chair
by Marco Zanuso, 1960

bottom *Nastro* chair
by Joe Colombo, 1964

Pierantonio Bonacina is known for combining traditional and newer materials—rattan, rush, wood, leather, tubular steel, and fabrics—in decidedly modern designs. In the early 1960s, the firm began to cooperate with some of the biggest names in modern Italian furniture design. The architect and designer **Tito Agnoli,** in particular, became a central figure in its development. Approached by company owner Pierantonio Bonacina after his designs had won gold medals at the 1959 and 1961 wicker furniture expositions at Lurago d'Erba, where Bonacina is based, Agnoli helped transform the firm into a modern industrial manufacturing business and radically updated its aesthetics. His designs for Bonacina include the delicate *S.21* chair, with its finely-woven seat and backrest, and the cubic *S.23* chair.

During the early 1960s, Bonacina also worked with designers such as **De Pas/D'Urbino/Lomazzi** and **Joe Colombo,** whose uncompromisingly industrial aesthetics are evident in the boldly curved *Nastro* chair. **Gio Ponti** contributed the comfortable *Continuum* chair, with its gracefully curving armrests, and **Marco Zanuso** his famous *Martingala* wicker chair. Today, a number of younger designers, including Franco Bizzozzero, Joey Mancini, Marco Agnoli, and Giuseppe Viganò, continue to develop the firm's design strategy. Tables and lights have been added to Bonacina's elegant product line, though the priority is still on seating.

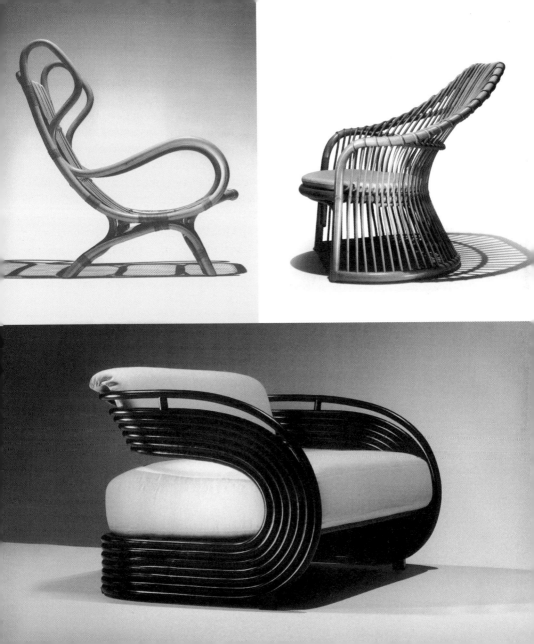

Rodolfo BONETTO

Industrial designer

Unlike Italy's numerous architect-designers, Rodolfo Bonetto has always focused exclusively on industrial design. And he came to the profession not from architecture school but after a career as an internationally successful jazz drummer. Few of his peers fought as passionately for their vision of a design culture as Bonetto did. His goal was nothing less than perfection: to achieve an entirely flawless design solution in cooperation with the client, and to invest the product with its own cultural dignity. It is not surprising that he considered **Marco Zanuso** and **Marcello Nizzoli** his spiritual teachers— they too had developed their concept of industrial culture in close collaboration with their corporate clients. His main focus was on the design process, which for him was firmly anchored in mass production.

Never a snob, Bonetto took on even seemingly unattractive projects, such as the design of measuring instruments, plumbing fixtures, and technical equipment. In the 1960s he became an indispensable consultant for **Olivetti's** instrument division; in **Fiat's** styling center he developed the *Fire engine* for the *Uno* subcompact; and for **Borletti Veglia** he designed gauges for cars as well as his first great popular success, the *Sfericlock* alarm clock. By the end of Bonetto's life, there was hardly a product that he hadn't worked on: his projects ranged from furniture to audio equipment and musical instruments. He particularly loved cars. Indeed, it was in **PininFarina's** car-body workshop that he had started his design career at the suggestion of his uncle, Felice Bonetto, who later died when his *Lancia 3300* crashed during the Carrera Messicana rally.

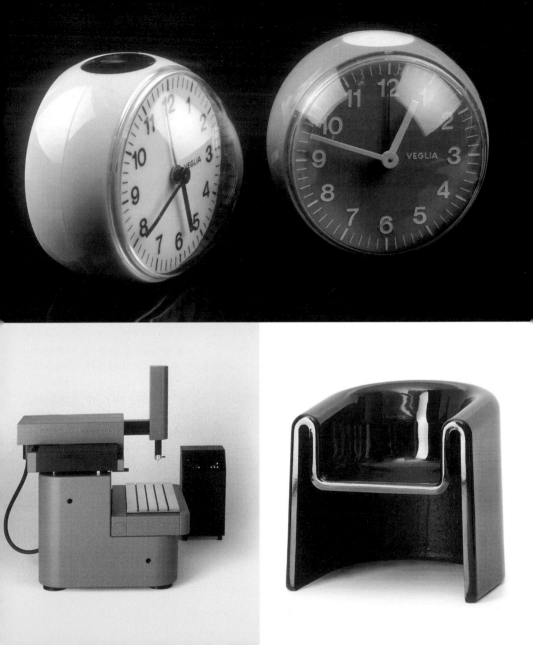

Renata BONFANTI

Textile designer

1929 born in Bassano
del Grappa

in the 1950s, studies
design at Kvinnelige
Industriskole in Oslo

1954 begins working as textile
designer

1962 *Compasso d'oro*

1966 Arts Prize of Bassano

Products

1961 first rugs of *Algeria* series

1962 *JL* fabric

1963 *Tancredi, Brianza, Siena*
rugs

1968 *Normandia 1* rug

1974 *Bengale* textile series

1989 *Fiandra* rug series

1991 *Cannete* wall rug

Page 141

top *Cipro* bedspread, 1985

bottom *Algeria 25* fabric, 1997

"I do not think that hand looms can only be used to make individual items for the arts and crafts market, that they have no business in industrial production," the textile designer Renata Bonfanti said in 1975. "I have always tried to organize my work in a way that makes use of both techniques, and my studio is consequently equipped with different kinds of looms." Based in the Italian province of Vicenza, Bonfanti has successfully straddled the worlds of fine art and industrial design. And with her unflagging commitment to experimentation, Bonfanti has continuously given fresh impulses to Italian textile design. Her work has been featured in international art exhibitions such as the 1961 show *Contemporary Italian Art,* which traveled from Oslo to Stockholm and Copenhagen. At the same time, she has been recognized as a great industrial designer; in 1962 she won a *Compasso d'oro* for her airy *JL fabric.*

Many of Bonfanti's textiles seem almost Scandinavian in their austere aesthetic. In fact, the designer spent some time in Norway in the early 1950s after graduating from art school in Venice. Studying at Kvinnelige Industriskole in Oslo, she was strongly influenced by Northern European techniques and formal ideas before returning to Italy. In 1961 she attracted attention with her *Algeria* series of rugs, whose amorphous fields of color were scattered across the fabric in powdery patches. Like many of her rugs, her 1974 *Bengal* series could be used on floors and walls alike.

Osvaldo BORSANI

Architect and furniture designer

1911 born in Milan
1937 graduates from architecture school in Milan
1953 establishes **Tecno**
1966 launches *Ottagono* magazine
1985 dies in Milan

Products
1954 *D 70* pivoting sofa; *P 40* chair
1956 *P 32* swivel chair
1961 *AT 16* clothes tree
1968 *Graphis* office system; all for Tecno

At the tenth Milan **Triennale,** in 1954, Osvaldo Borsani introduced his *P 40* recliner, which could be adjusted to 486 different positions, thanks to a modular inner support structure and a patented mechanism that widened or narrowed the angle between seat and backrest in minute increments. This kind of seamless interplay between technology and design fascinated Borsani, who believed that good design was not so much a matter of brilliant inspiration, but primarily the result of intensive research and development. Each of his furniture designs was the solution to a concrete problem. His *D 70* sofa, for example, designed for a house on *Lago Maggiore,* could be flipped over so that its occupant could either look at the fireplace or enjoy the beautiful view on the opposite side.

Borsani worked exclusively for **Tecno,** a company he had founded; most of his furniture is still being produced. He also designed Tecno's factory building and the company's Milan offices, and was one of the founders of the journal Ottagono.

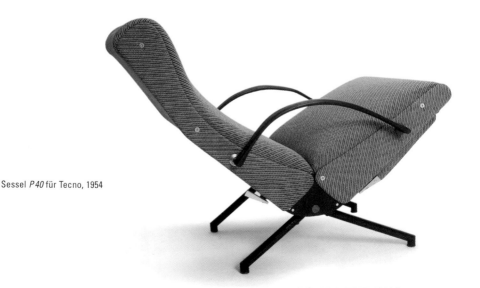

Sessel *P 40* für Tecno, 1954

Fabio BORTOLANI

Furniture and industrial designer

Fabio Bortolani has a special knack for receptacles and holders. He designs modest little objects like the *Semplice* ashtray, the low *Opus* tables, with their integrated compartments for pens and paper, and the colorful *Quaderno* sketchbooks for Authentics. His useful household items are extremely simple constructions, some of them bordering on non-design—his *Multiplos* toilet paper holder, for example, consists of a couple of joined wooden sticks. His most remarkable designs offer ingenious solutions to common problems: his *Bucatini* system for **Agape** consists of simple wall-mounted loops that can hold bathrooms utensils of different sizes, from toothbrushes to cups and bottles. In their stripped-down material aesthetics—raw wood, translucent plastic, and shiny metal prevail—Bortolani's products perfectly suit the purist tastes of the 1990s.

1957 born in Spilambert
 studies design in Florence

1997 *Segreta,* exhibition at
 Victoria and Albert
 Museum, London

1998 *Intorno Alla Fotografia,*
 exhibition

Products

1991 *Terranea* bench for
 Crassevig

1996 *Semplice* ashtray

1997 *Clips* tables and teacart
 for Hoffmann

1998 *Quaderno* sketchbook
 for Authentics; *Opus* table
 for La Palma

Bucatini holders for Agape, with
Ermanno Righi, 1997

Andrea BRANZI

Architect, designer, and writer

Andrea Branzi has described design as a practical as well as philosophical task. As an independent thinker, mentor, critic, and exhibition organizer, he has been on the cutting edge of Italy's design discourse for the last three decades. He helped launch the Radical Design movement in 1966 as a cofounder of the Archizoom group, which humorously criticized the doctrine of functionalism with pieces like the oversized Dream-Beds and the wave-shaped Superonda crinkle leather sofa for Poltronova. And with his designs and writings he has put his stamp on virtually every important new movement that has followed. Emphasizing the aesthetic language of individual objects over stylistic dogmas, he contributed to the educational Global Tools project in the mid-1970s, and was among the founders of Alchimia and Memphis. Branzi has also worked for Cassina, Alessi, Zanotta, and Rossi & Arcandi, for whom he designed the popular Labrador gravy boat.

1938 born in Florence

1966 graduates from architecture school in Florence; cofounder of **Archizoom**

1971 editor at *Casabella* (until 1974)

1973 collaborates with **Massimo Morozzia** and **C.T. Castelli** (CDM) (until 1981); primary design and color concepts

1979 *Compasso d'oro* (also in 1987)

1983 director of Domus Academy (until 1987); editor in chief of *Modo* (until 1987)

1984 book, *La casa calda,* publ.

1987 *Compasso d'oro*

Products

1980 *Ginger* chair for **Alchimia**

1982 *Labrador* sauceboat

1986 *Berlino* chair and sofa for **Zanotta**

1992 *Mamma-ò* tea kettle for **Alessi**

Muzio console for Alchimia, 1979

Furniture sculpture from *Archi, fusi, e forcelle* series, 1988 (prototype for Cassina)

Home electronics manufacturer

There are noticeable parallels between Brionvega and the German electronics manufacturer Braun. Each company's distinct design aesthetic was developed in the 1960s, and each has produced stereo sets that have become objects of almost fetishistic veneration among high-tech connoisseurs. And Brionvega's slogan, "Technology in its most beautiful form," could easily have been invented by Braun. But unlike Braun's designs, Brionvega's products, while formally immaculate, also evoke playful instincts. There is something poetic in the way they make technology and function visible.

Brionvega's unmistakable look was developed by some of Italy's best designers, particularly the team of **Marco Zanuso** and **Richard Sapper,** the **Castiglioni** brothers, and **Mario Bellini.** They all started working for Brionvega in the early 1960s, formulating a consistent, adventurous design strategy which, along with innovative technology, catapulted a company that had been around since 1945 to the forefront of its industry. Brionvega dared

1945 founded as manufacturer of radios
1952 production of TV sets
1970 *Compasso d'oro*
1992 Brionvega liquidated

Black ST 201 TV set by Marco Zanuso and Richard Sapper, 1969

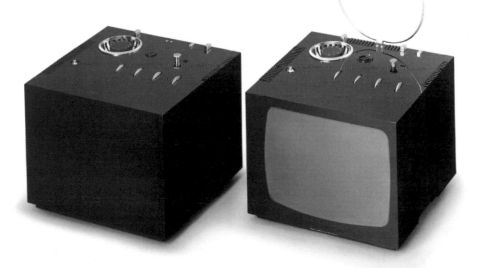

Products

1962 *Doney* TV set

1964 *TS 502* radio; *Algol* TV set;
all by **Marco Zanuso**
and **Richard Sapper**

1966 *RR 126* stereo set by
Achille and **Pier Giacomo**
Castiglioni

1969 *Black ST 201* TV set
by Marco Zanuso and
Richard Sapper;
Volans TV set

1970 *Astor 20* TV set

1979 *TVC 26* stereo system;
all by **Mario Bellini**

Page 147

Algol TV set by Marco Zanuso
and Richard Sapper, 1964

TS 502 radio by Marco Zanuso
and Richard Sapper, 1964

to break with established and seemingly normative forms, encouraging its designers to practically reinvent the TV set and the radio. The results were quite spectacular: the small *TS 502* radio by Marco Zanuso and Richard Sapper revealed its function only when snapped open; the team's compact 1962 *Doney* television set was Italy's first transistor-equipped TV and the precursor of the *Algol* models (fig. p. 4) in the Pop style of the 1960s and 1970s. In 1960 Zanuso and Sapper developed the *Black* TV set, a mysterious all-black cube that came to life when the screen lit up—slowly creating a contrast between solid frame and electronic image, a vivid demonstration of the magic of technology. Another successful Brionvega product was Achille and Pier Castiglioni's *RR 126* radio and turntable. An oblong box whose panel looked like a friendly cartoon face with raised eyebrows, it came on a stand with wheels. To save floor space, it was also equipped with mounts to which the speakers could be attached.

Brionvega gradually lost its competitive edge as the importance of design was eclipsed by the trend toward microelectronics, and in 1992 the company was liquidated.

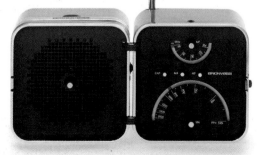
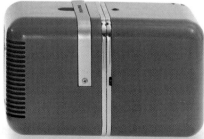

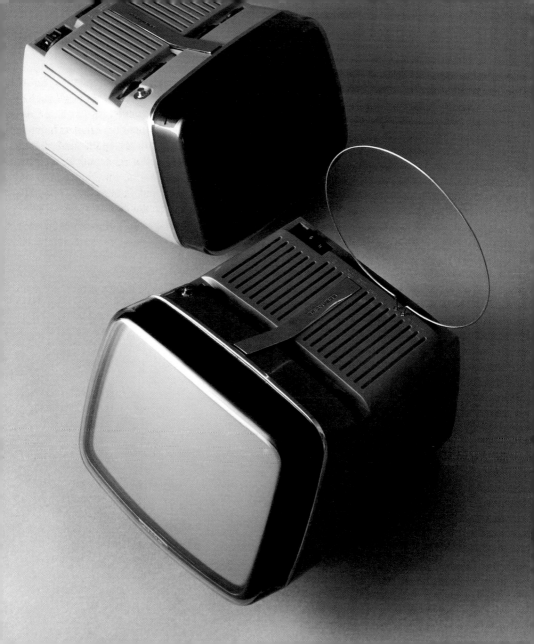

Carlo BUGATTI

Cabinet maker

Carlo Bugatti's fame was on a more modest scale than that achieved by his son, Ettore, and grandson, Jean, two of the twentieth century's most celebrated car builders and race car drivers. Between 1880 and 1904, the elder Bugatti worked as a cabinetmaker, creating richly ornate pieces in a Moorish style, which gave way to Art Nouveau around the turn of the century. His style became so much in demand that it gave rise to a whole genre of "Bugatti furniture." The trade press praised his interiors, which included the "Snail Room," which featured parchment-covered furniture painted red and gold. The crowning event of Bugatti's career occurred at the 1902 *International Arts and Crafts Exhibition in Turin,* where he was given the first prize. His artful inlay work has secured him a place alongside such masters of the craft as Henry van de Velde, Antonio Gaudí, Charles Rennie Mackintosh, and Peter Behrens. In 1904 he gave up cabinetry to dedicate himself to painting and silverwork.

1856 born in Milan

1888 opens workshop; participates in crafts exhibition, Milan (and international exhib. in Antwerp, Amsterdam and Turin, 1894, 1895 and 1902)

1900 *Silver Medal* at Paris World's Fair

1902 participates in *International Arts and Crafts Exhibition,* Turin

1904 moves to Paris

1910 turns to painting

1940 dies in Dorlisheim (Bas-Rhin)

Products

1900 Furniture for the Khediven's palace in Istanbul

1902 "Snail Room," Turin

1904 Silverware

Bench made of wood, metal, and parchment, c. 1900

Architect, furniture, lighting, and product designer

Luigi Caccia Dominioni was not only an important architect but also a pioneer of modern Italian industrial design. His 1938 Caccia cutlery set, designed in collaboration with **Livio** and **Pier Giacomo Castiglioni,** was so far ahead of its time that **Alessi** added it to its product line decades later. Today, no one would guess that it is a design from the thirties. Caccia Dominioni and the Castiglionis' innovative Bakelite radio for Phonola, introduced at the 1940 Milan *Triennale,* marked a similarly radical departure from convention at a time when radios still resembled cabinets. After the war, Caccia Dominioni designed harmonically balanced furniture for **Azucena,** including his famous *Catilina* chair of 1949, with its supple leather cushion resting in a slender, rounded metal frame, and the simple *Sasso* and *Base Gisa* floor and table lamps. More recent designs include his symmetrical *Toro* sofa of the 1970s and the gracefully curved *Cristallo* door handle of the 1980s.

1913 born in Milan

1936 graduates from architecture school in Milan

1948 opens **Azucena** store in Milan with **I. Gardella** and C. Corradi Dell'Acqua

1960 *Compasso d'oro*

1970 Chase Manhattan Bank, Milan

Products

1938 *Caccia* silverware set

1959 School furniture for Palini; both with **Livio** and **Pier Giacomo Castiglioni**

Radio for Phonola with Livio and Pier Giacomo Castiglioni, 1939
Catilina chair for Azucena, 1949

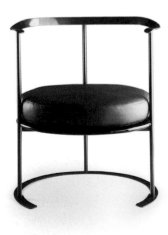

CAPPELLINI

Furniture manufacturer

No furniture company celebrates design in quite the spectacular fashion as Cappellini. To own a Cappellini piece means to partake of its exclusive aura, to possess not simply a costly object but a sculpture. The firm's displays at furniture fairs attract crowds; its catalogues and brochures resemble lifestyle glossies. Shiro Kuramata's "dancing" *Side 1/Side 2* chest, Tom Dixon's sinuously curved *S Chair,* and Jasper Morrison's elegantly minimalist *Three Sofa System* have become design icons. With this rarefied philosophy Cappellini has touched on the sensibilities of a younger generation of affluent sophisticates to whom designers are stars and designed objects are fetishes.

Giulio Cappellini has a unique eye for talent. He has discovered promising young designers from all parts of Europe, and his firm has helped launch the careers of many of them. Among the designers working for Cappellini are Marc Newson, James Irvine, and Werner Aisslinger, as well as **Michele De Lucchi, Rodolfo Dordoni, Alberto Meda, Anna Gili,** and **Piero Lissoni.** The company, based in Arosio, seems to provide a particularly stimulating working environment, where designers feel free to fully realize their personal vision. Many Cappellini pieces look like ideas fully developed to their essential form. Though this implies certain risks for the company, since the market is not always receptive to experimental products, Cappellini has never let such considerations upset his design policy.

The company was founded in 1946 as a furniture manufacturer rooted in the crafts tradition. By 1970, Cappellini had transformed it into a high-powered design factory, organizing production in different workshops and coordinating everything from product development to marketing and distribution. The highest technological capabilities enable the company to produce furniture that tests the limits of manufacturing techniques.

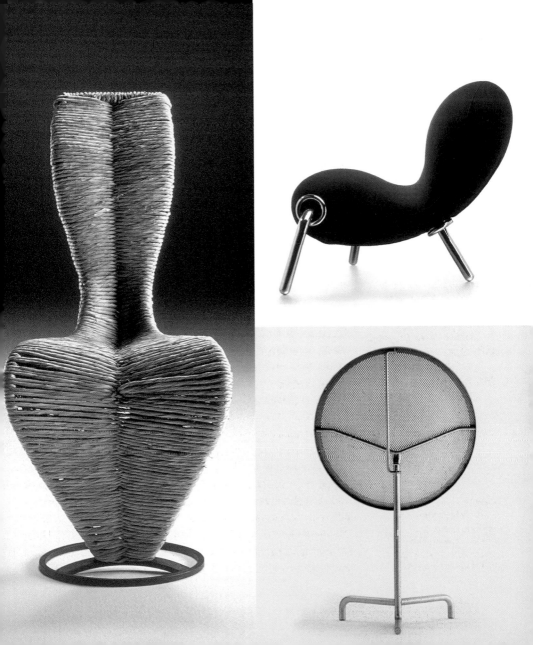

1991 *Tonda* chair by **Anna Gili**

1992 *S-Chair* by Tom Dixon

1993 *Three Sofa System* by Jasper Morrison

1994 *ABC* aluminum shelf unit by **Alberto Meda**; *Eight Chair* by Ross Lovegrove

1995 *Alfabeto System* by Jasper Morrison and James Irvine; *Jaipur* and *Jodhpur* sofas by Jasper Morrison; *Statuette* plastic chair by Lloyd Schwan

1996 *Juli* chair by Werner Aisslinger

1998 *Embryo Chair* by Marc Newson

As diverse as the company's output is, a tendency toward minimalism is apparent in all its products, from Giulio Cappellini's own *Cenacolo* tables, alternatively made in marble or wood, whose special flair lies in the contrast between their stout legs and skinny top, to Jasper Morrison and James Irvine's *Alfabeto* shelving system, with its cubic modules. But Cappellini also challenges his designers to include divergent elements—the use of bold colors and curved lines is part of the overall repertoire, as Ross Lovegrove's *Eight Chair* and Christophe Pillet's *Y's Chair* show.

Jasper Morrison's *Thinking Man's Chair* is perhaps the best example of the Cappellini concept. The British designer redefined the classic lounge chair by replacing soft cushions with hard steel; an extremely long seat provides the necessary comfort. Radically simple in its materials, the chair looks by no means bloodless or sober, but conveys a sense of quiet, natural elegance.

In 1987 Cappellini, **Paola Navone,** and Rodolfo Dordoni founded a subsidiary, **Mondo,** to focus on reeditions of classic residential furniture and on reviving traditional manufacturing techniques, such as wire plaiting.

Page 153

top left: *Juli* chair by Werner Aisslinger, 1996

bottom left: *Thinking Man's Chair* by Jasper Morrison, 1988

right: *Pyramid* chiffonier by Shiro Kuramata, 1998

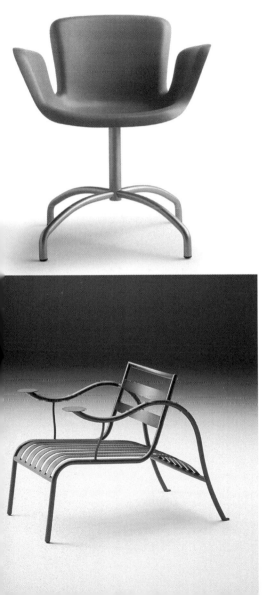

CASSINA

Furniture manufacturer

In 1957 Cassina produced the *Superleggera,* touted as the lightest chair in history. Its designer, **Gio Ponti,** had partially modeled it after chairs he had seen in the Italian fishing village of Chiavari. He kept those pieces' traditional materials—wickerwork and wood—but reduced the structural elements so drastically that the chair was ideally suited for mass production. A worldwide success, the *Superleggera* became a shining example of the new, modern Italian furniture design.

The *Superleggera* blended tradition and modernity on several levels. It is this special synthesis that has characterized the company since 1945, when it began to become a seminal design force. Cassina was founded in 1927 as a traditional manufacturer of upholstered furniture and developed a reputation for its high standards of craftsmanship. The Meda-based company has since evolved into a technologically advanced furniture producer, but the same dedication to quality still applies, and is one of the cornerstones of its success.

A sense of tradition is also important at Cassina; it's clearly present in the company's *I Maestri* series of classic furniture by Le Corbusier, Frank Lloyd Wright, Charles Rennie Macintosh, Gerrit Thomas Rietveld, and Gunnar Asplund. Introduced in the

Chair by Angelo Mangiarotti, 1963

Page 155
AEO chair by Paolo Deganello, 1973

mid-1960s, these reeditions now account for a third of Cassina's total sales and have solidified the firm's reputation as a guardian of the modern heritage. In its own designs, Cassina has been committed to innovation since the early 1950s, when it established close relationships with important contemporary designers such as **Franco Albini** and Gio Ponti. This embrace of modern design, which completely transformed the firm's profile, had been preceded by a large contract from the Italian shipbuilding industry. Between 1947 and 1952 Cassina furnished the luxury liners *Andrea Doria, Raffaelo,* and *Michelangelo.* The huge volumes this commission involved paved the way to mass production.

Cassina has continued to work with well-known designers, who today include **Mario Bellini, Vico Magistretti, Afra** and **Tobia Scarpa,** and Philippe Starck. But in the late 1960s, the company's energetic owner, Cesare Cassina, also started to search out young nonconformists like **Gaetano Pesce** and **Paolo Deganello** and to produce designs that defied convention. One radical example is Deganello's *AEO* chair of 1973, a literal deconstruction of a traditional upholstered chair. It easily disassembles into a base, cushions, two frames for the seat and backrest, and a tent-like slipcover. The form and look of Pesce's *Dalila* chair, made of polyurethane with a polyester cover, changed with every new production run; his *I Feltri* chair (fig. p. 25) has "wings" that can be spread out or pulled closer. In such projects, Pesce expressed his criticism of the uniformity of furniture design.

The company, now headed by Franco Cassina, has continued to be successful internationally; today, some 80 percent of its seating, tables, and shelving units are exported.

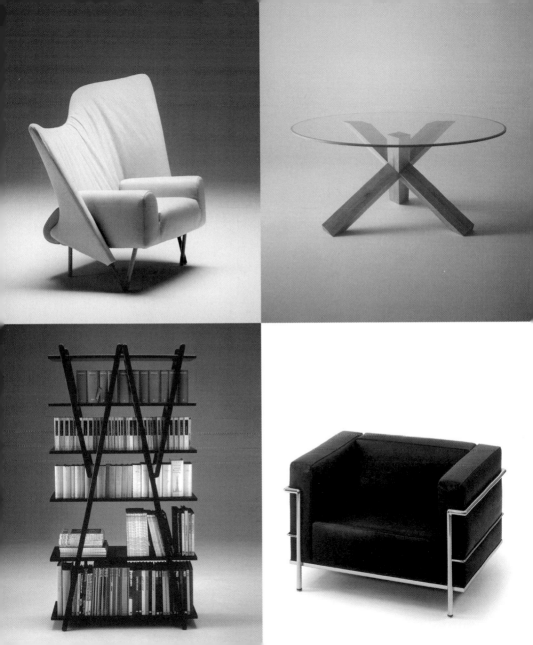

Anna CASTELLI FERRIERI
Architect and designer

Page 159

In her book *Interfaces of Material,* published in 1991, Anna Castelli Ferrieri admonished designers to work responsibly and consider the environmental impact of the products they help create. But responsibility in design is not her only concern. She is also active in the human rights movement, with a particular focus on women's rights, and her ACF Officina group, an organization she founded in 1990, is committed to working with young designers.

One of the few successful women in Italian design, she first became known for her masterly use of plastics, a material closely associated with industrial technology. Castelli Ferrieri takes pride in designing highly functional objects for mass production; to her, market success means communicating with the user. In her mission to turn design into a more democratic practice that benefits many, she was strongly influenced by the strict minimalist **Franco Albini**. She gained her first working experience in his studio, and after the war joined him in his struggle to help build a democratic Italy through modern architecture and design. They also cooperated in promoting their ideas in the journal *Casabella-Costruzioni.*

From 1959 to 1973 Castelli Ferrieri and her partner, **Ignazio Gardella,** designed residential and office interiors. Even after she had become famous as an industrial designer she continued working as an architect on projects such as the **Kartell** Building in Binasco and the technical offices of **Alfa Romeo** in Arese, as well as homes, hospitals, churches, and industrial buildings. In 1966 she became a design consultant for Kartell, the company her husband, Giulio Castelli, had founded in 1949. Since then, Kartell's history has been inextricably linked to her work. For every new technology, she found an

appropriate new form that perfectly reflected its properties. Her *4970/84* container system, for example, was an entirely new type of product made of a recently introduced material, ABS plastic. A small architectural exercise, it consisted of multiple elements that could be stacked without the use of screws or clamps. And her *4822/44* stool of 1979 was not only a bestseller but also a technological breakthrough: it was the first plastic stool that had long legs. Until then, no plastic compound had been sufficiently stable; Castelli Ferrieri used a new fiberglass-reinforced polypropylene foam into which metal pieces could be inserted to make the material as solid as cement. In the 1980s, she set out to design a chair that would be elegant, lightweight, and stackable as well as ergonomically shaped, elastic, durable, and inexpensive. The result, the *4870* polypropylene chair, won her the *Compasso d'oro.*

Almost all of Castelli Ferrieri's designs are still in production, proving that she reached one of her most important goals—to create successful designs for mass production. Besides working for Kartell, in recent years she has also designed products for other companies, including cutlery sets for **Sambonet,** upholstered furniture for **Arflex,** and the *Contralto* table for Ycami, whose legs taper from wide bases to narrow points under the tabletop, turning formal convention upside-down.

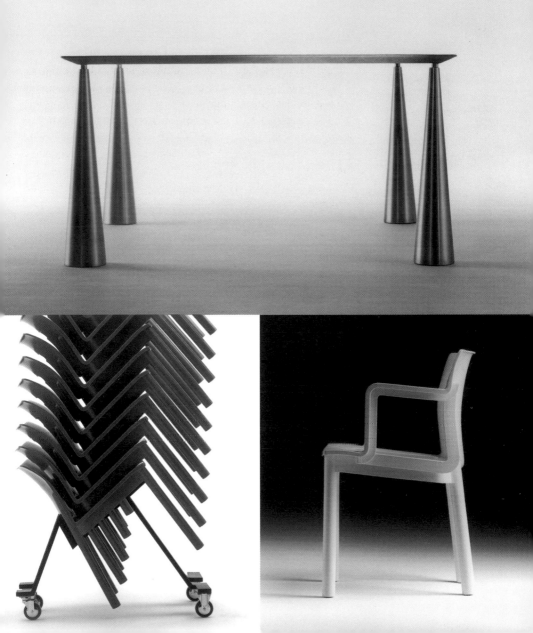

Achille & Pier Giacomo CASTIGLIONI

Architects; furniture, lighting, and industrial designers

Achille Castiglioni
1918 born in Milan
1944 graduates from architecture school in Milan

Pier Giacomo Castiglioni
1913 born in Milan
1937 graduates from architecture school in Milan
1968 dies in Milan

1945 collaboration
1947 design of *Mostre Nazionali della Radio e Televisione* in Milan
1953 Design of *National Housewares Exhibitions Italy* (until 1972)
1955 *Compasso d'oro* (also 1962, 1964, 1967, Achille Castiglioni alone, 1979, 1984, 1989)

Cumano tables for Zanotta, 1979

Page 163

Mezzadro tractor seat, 1957/1970

In 1957 a strange scene met visitors at the Villa Olmo in Como: iron bowls from the nineteenth century, a rocking bicycle seat (fig. p. 15), a stylized tractor chair, ceiling-mounted TV sets, abstract wall decorations, and portable radio telephones were casually arranged in a surreal mix of the past and the present. Achille and Pier Giacomo Castiglioni had titled this unusual exhibition of their own designs and found objects *Forme e colori nella casa di oggi* (Forms and colors in today's home). The message was clear: it is the quality and interplay of individual objects that creates ambiance, not the presumed harmony of a unified style. The Castiglioni brothers have stuck to this contextual design concept throughout their careers. (The bicycle and tractor seats have been produced by **Zanotta** since the 1970s, under the names *Sella* and *Mezzadro*.)

Their first important commission was the design of the radio exhibition at the seventh Milan *Triennale,* in 1940, to which Pier Giacomo Castiglioni, along with his elder brother **Livio** and **Luigi Caccia Dominioni,** also contributed an innovative Bakelite receiver whose form followed, rather than concealed, its technical makeup. After World War II, Pier Giacomo, Livio, and Achille produced a series of spectacular exhibits, some of which became famous events. Thousands of people came to see their perfectly choreographed shows for the Italian broadcasting company RAI, with audiovisual effects directed by Livio. (He went

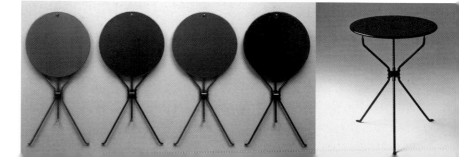

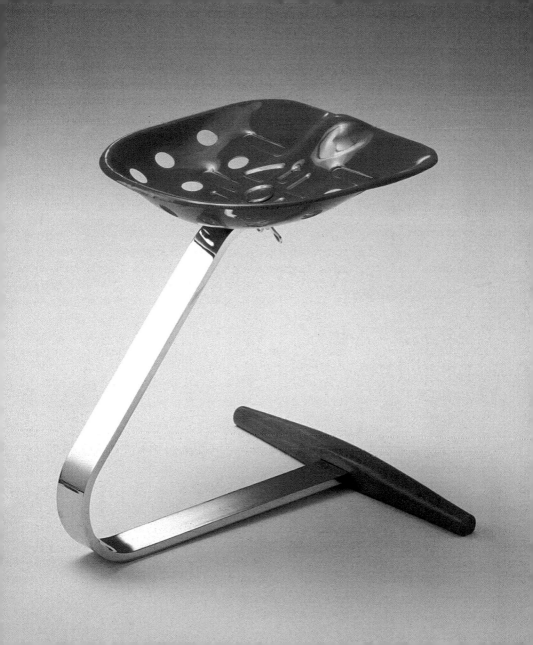

his separate way in the early 1950s.) Exhibition design continued to be an important part of Achille Castiglioni's work after Pier Giacomo's premature death in 1968.

The two brothers also started to focus on industrial products at the beginning of the 1950s. They designed household appliances like the modest *Spalter* vacuum cleaner and their first lights, which included the simple *Luminator* floor lamp of 1955. In many cases they revised existing objects or put them in a new context; Achille Castiglioni has said that "design has always existed—one looks at objects and naturally comes up with ideas to improve them." By transposing art's ready-made concept into design they often created ironic comments on Italian **Bel Design** and on overly dogmatic versions of functionalism. The reflector of his *Toio* floor lamp for Flos, for example, was originally made for automobile headlights. Another successful example is his small *Cumano* table for Zanotta, which was modeled after French bistro tables. His improvement consisted in punching a small hole near the edge so the folded-up table could be hung up on the wall. Lined up in a row, they look like mounted insects, an amusing visual effect quite separate from their everyday function.

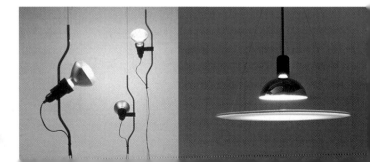

Electrical light and the techniques of its diffusion always attracted the Castiglioni brothers. Indeed, a review of their lamps and lights, most of which were developed for Flos, amounts to a lesson in modern lighting design. In 1962 they designed the *Arco* lamp, whose form was inspired by common streetlights, and the massive *Taccia* table lamp (fig. p. 2). Their lighting designs of the early 1970s include the rounded, unpretentious *Noce,* a variation on simple basement lights; *Parentesi,* the first halogen light movable along a suspended cord; and the *Frisbi* hanging lamp, with its two reflectors that focus light upward and diffuse it downward. Achille Castiglioni also designed the *Tubo* and *Ipotenusa* desk lamps, the birdlike *Gibigiano* floor lamp, and, in the 1990s, the elegant *Brera* and *Fucsia* hanging lamps.

While the Castiglioni's created an entire world of products, from their innovative 1966 *RR 126* stereo set for **Brionvega** to clocks and housewares for **Alessi** and numerous furniture designs for **De Padova, Gavina,** and Zanotta, it is almost impossible to discern a personal style that ties them all together. Their hallmarks, instead, are creative wit and a form that always follows the objects' inner logic. These qualities have won them seven *Compasso d'oro* awards.

1979 *Cumano* folding chair for Zanotta

1982 *Dry* silverware set for **Alessi**

1983 *Albero* flower stand for Zanotta

1991 *Sangirolamo* office furniture for **Olivetti** with **Michele de Lucchi**

1992 *Brera* lamp

1996 *Fucsia* hanging lamp both for Flos

From left:

Castiglietta chair for Zanotta, 1967

Parentesi for Flos, 1971, with Pio Manzú

Frisbi for Flos, 1978

Wall clock, 1965 (prod. 1996 by Alessi)

Linda plumbing fixtures

Trio for Interflex, 1991 with G. Pozzi

Page 166/167

Arco lamp for Flos, 1962

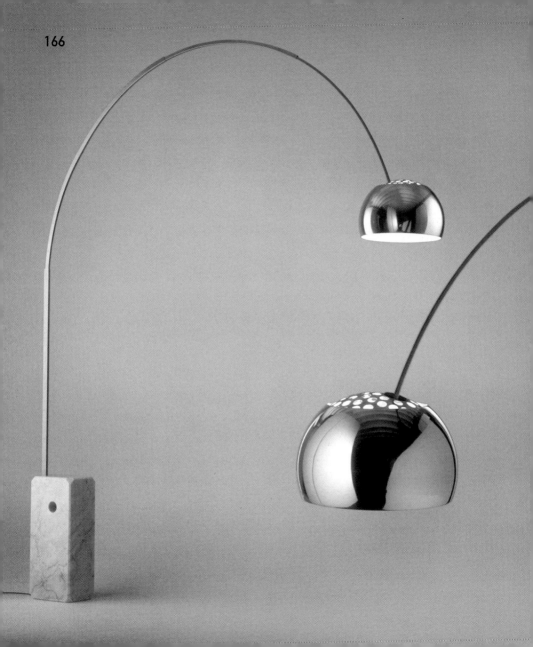

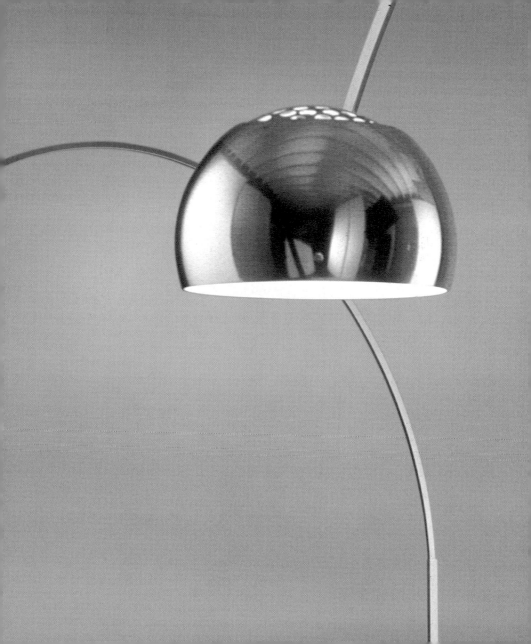

Antonio CITTERIO

Architect; furniture and lighting designer

Antonio Citterio is less concerned with putting his personal stamp on products than in fully realizing the design opportunities offered by new materials and technology. The best example of this is his 1994 *Mobil* container system for **Kartell.** Its drawer elements were made of translucent plastic (a striking novelty at the time) and were extremely restrained in their form, so the focus is entirely on the material's aesthetics. Citterio has also designed residential and commercial lighting, hospital beds, kitchens, and office furniture, an area where he has been particularly successful. His *Ad Hoc* office system, developed with Glen Oliver Loew for Vitra, consists of flexible elements that easily adapt to a constantly changing environment. He has also made a strong impact with his upholstered furniture, such as the *Sity* sofa for **B & B Italia**, which combines the traditional forms of sofa and chaise with additional cushions to create a sense of comfortable familiarity within a formal language of clean, simple lines.

Among the Italian designers of his generation, Citterio stands out as one of the most successful. The rise of **Nuovo Design** in the 1980s had little effect on his work; his style is timeless rather than of-the-moment, though he is able to give the Zeitgeist its due, as his store designs for the fashion retailer Esprit show.

1950 born in Meda
1973 studio with **Paolo Nava** (until 1981)
1975 graduates from architecture school
1987 *Compasso d'oro* (also 1995)

Products
1978 *Aria* and *Pasodouble* sofas for **Flexform**
1980 *Factory* kitchen system for **Boffi**
1982 Showroom for **B&B Italia**
1985 Esprit stores in Milan and Amsterdam
1986 *Sity* sofa for B&B Italia
1992 *Ephesos* office furniture system for Olivetti Synthesis
1996 Fausto Santini showroom in Düsseldorf
1997 *Artusi* kitchen system for **Arc Linea**

Page169
Mobil container system for Kartell, 1994
Elettra lighting system for Ansorg, 1993, with Glen Oliver Loew
Dolly folding chair for Kartell, 1997
AC Program office chair system for Vitra, 1989, with Glen Oliver Loew

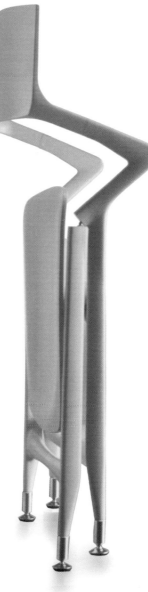

Joe COLOMBO

Furniture and lighting designer, painter, and sculptor

For Joe Colombo the designer was the "creatore dell'ambiente futuro," the creator of the future environment. To be preoccupied with mere furniture or decoration seemed backward to him, and he denounced most contemporary homes as "temples of self-glorification." He advanced his own visions and work in a career that lasted only a decade but left such a strong mark on Italian design that by the time of his early death in 1971, Colombo had become a legend.

Brimming with optimism, Colombo believed in the transforming power of design and in a civilization able to solve its problems through analytical processes and technology. The economic boom of the 1960s seemed to confirm his enthusiasm; he did not live to experience the disillusionment that followed the oil crisis, global recession, and mounting social problems of the seventies. During the 1960s, Colombo developed the idea of an "integral" design, in which each element in his product universe contributed to the overall shape. His reinterpretation of the living

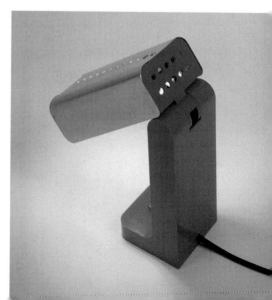

room led to complex solutions such as the 1970 Living Center, developed for Rosenthal, which consisted of lounges on wheels and a plastic unit, which looked like a spaceship's instrument panel and served as table, storage container, stereo cabinet, and minibar. The 1964 *Uomo/Donna* container system for **Arflex** held every conceivable living room accessory from ashtray, lighter, and pipe rack to lamp, books, and turntable. His 1963/64 *Carrellone Mini Kitchen* for **Boffi** integrated all necessary tools and appliances in one compact block on wheels. And the plastic living landscape he developed for Bayer in 1969 was a science-fiction utopia that epitomized the sensibilities of a generation shaped by Pop Art and a triumphant youth culture.

Colombo also expressed his enthusiasm for technology in the design of single products. His *Onda* hanging lamp is equipped with a reflector that directs the light upward as well as downward, encircling the object in a mysterious halo. His *Spider* table lamp resembles a small robot. His stackable *4867* chair,

Products

1963 *Carellone Mini-Kitchen* for **Boffi**

1963 *Elda* chair for Comfort

1964 *Uomo-Donna* modular containers for **Arflex**

1965 *Spider* lamp for **O Luce**

1966 *4801/5* plastic chair for **Kartell**

From left:
Spider lamp for O Luce , 1965
Vademecum lamp for Kartell, 1968
580 Birillo barstool for Zanotta, 1970
Poker table for Zanotta, 1968

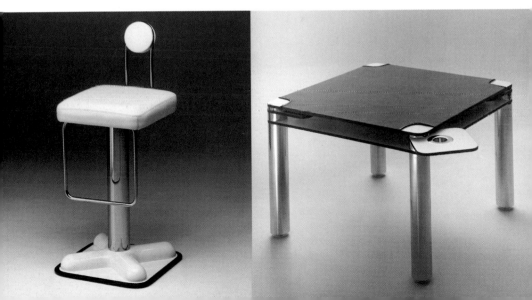

1966 *Colombo 281*
 lamp for O Luce

1967 *Additional*
 System furniture for
 Sormani

1968 *4867* plastic chair
 for Kartell; *Flash* lamp for
 O Luce; *Poker* table for
 Zanotta

1969 *Visiona 1,* environment for
 Bayer Leverkusen
 (Interzum-Messe, Cologne)

1970 *Optic* alarm clock for Ritz-
 Italora, later **Alessi**;
 Living Center for
 Rosenthal; *Boby* plastic
 container for **Bieffeplast**

1971 *Total Furnishing Unit.*
 (prototype)

introduced by **Kartell** in 1968, was one of the first chairs made entirely of plastic. Its design emphasized its production process by drawing attention to elements like the hole in the backrest, which was created when the chair was pulled out of the mold.

Colombo's designs for upholstered furniture broke with conventional ideas of refined living comfort. The *Elda* chair for Comfort, for example, was a leather-lined sitting machine on a massive base. And the *Additional System* for Sormani (fig. p. 18) had modules of varying heights that could be combined into different seating arrangements.

As passionate as Colombo was about technology, he had come to industrial design by way of fine art. As a painter and sculptor he had helped launch the Nuclear Painting movement in the 1950s, before taking up design in 1961. (In his own definition of his work, he was neither an artist nor a technologist but an "epistemologist.") His love of drawing found a new outlet in the minutely detailed construction plans he made for all his three-dimensional projects.

Unconditional faith in technology may have died years ago, but most of Colombo's creations are still in production. It is also worth noting that the things that most interested him, such as flexibility and multifunctionality, play a crucial part in much of today's furniture design.

Page 173

top left: *4867* stacking chair for
Kartell, 1968

top right: *Elda 1005*
chair for Comfort, 1963

bottom: Sessel *Tubo*
chair for Flexform prima, 1969

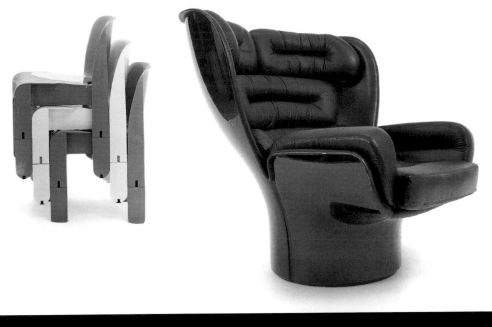

DANESE

Housewares manufacturer

When **Bruno Danese** and Jacqueline Vodoz founded their company in 1957, they wanted to produce "perfect objects." And they did achieve perfection in products such as Bruno Munari's *Cubo* ashtray, which completely swallows up cigarette butts and contains their smell, and **Enzo Mari's** *In attesa* wastebasket, whose built-up rim catches even clumsy throws. The Daneses found sympathetic designers in Munari and Mari and, later on, **Achille Castiglioni,** Kuno Prey, and **Angelo Mangiarotti.** Highly eclectic in their choice of materials, these designers developed an "industrial art" that today is considered timeless. Mari's table calendars, vases (fig. p. 47), and *Giglio* letter opener (a plain metal loop); Munari's *Falkland* lamp made of hosiery fabric stretched over a frame; and Prey's *Tino* table clock, in its concrete case, are such simple and obvious solutions that it seems amazing that no one had come up with them before. Besides housewares, Danese also produced artwork in multiple editions, including Munari's 1959 *Travel Sculpture* and *Air Machine,* and his games for children, before the company was acquired by **Alias** in 1994.

Today young designers such as **Marco Ferreri (**fig. p. 28), Alfredo Häberli, and Christophe Marchand continue to refine Danese's philosophy with new forms and materials.

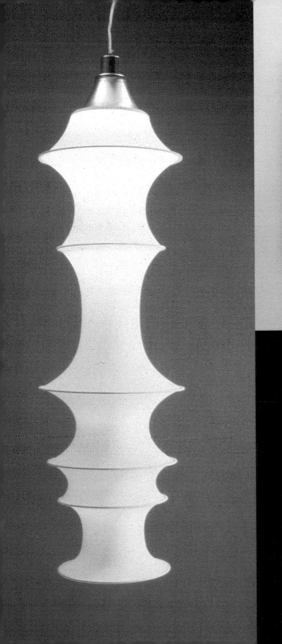

18
IX SET TEM BRE
DOM

Michele DE LUCCHI

Architect, industrial and furniture designer

Michele De Lucchi started out as an **Anti-Design** rebel but wound up a modern design entrepreneur. Dressed up as a Napoleonic general, the young architecture student stood guard outside the 1973 Milan **Triennale** with a trash bag full of products to protest against the design establishment. A short time later, he was working for **Alchimia** and **Memphis,** designing furniture, accessories, and laminates that marked a radical departure from functionalism. His First chair of 1983, for example, transforms armrests and backrest into two balls and a bright blue disk fixed to the orbit of a metal hoop—functional elements became metaphor. Memphis disbanded in 1988, but according to De Lucchi, the group created "a new notion of what's valuable" that has remained "anchored in the consciousness of all designers working today." De Lucchi has since realized his own notions of value in numerous products. His best-selling *Tolomeo* desk lamp for **Artemide,** made of matte aluminum, marked a return to functional, elegant form.

1951 born in Ferrara

1973 cofounds *Cavart* group (until 1976); experimental architecture projects

1975 graduates from architecture school in Florence

1978 member, **Alchimia**

1979 design consultant for **Olivetti**

1981 founding member of **Memphis**

1988 opens Studio De Lucchi

1992 chief designer at Olivetti

1998 founds Studio aDML with Angelo Micheli

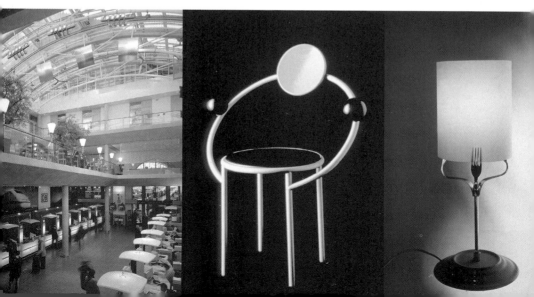

As early as 1979, **Olivetti** had hired the young dissident as a design consultant; since 1992 he has been heading the company's design department focusing on computers and other electronic appliances. In 1988, along with Angelo Micheli and Nicholas Bewick, he founded Studio De Lucchi, which has worked for large international service companies. Among other projects, the Studio developed a complete store-design program for **Mandarina Duck;** designed piazza-like interiors for branches of Deutsche Bank and for the Booking and Travel Center of Deutsche Bahn, Germany's railway company, in Frankfurt. Since 1987, De Lucchi has also realized a number of architectural projects in Japan and Europe.

De Lucchi's design philosophy emphasizes teamwork, simplicity, functionality, and consumer needs. Guided by these principles, he has turned his studio into one of Europe's most modern and successful design businesses.

Products

1981 *Oceanic* lamp;
Lido sofa;
both for Memphis

1987 *Tolomeo* desk lamp for
Artemide with Giancarlo Fassina

1988 plastic desk set for **Kartell**

1993 branch offices for
Deutsche Bank

1995 *OFX 1000* fax machine,
Echos 20 laptop PC;
both for Olivetti;
store design for
Mandarina Duck with
Geert Koster,
Mario Trimarchi
and Paolo De Lucchi

From left:
Deutsche Bahn travel center,
Frankfurt, 1997, with N. Bewick
First chair for Memphis, 1983
Tre Forchette lamp, 1997
OFX 1000 fax machine for Olivetti,
1995

DE PADOVA

Furniture manufacturer

De Padova srl, Milano

1958 founded by Maddalena
and Fernando De Padova
as a furniture import
business

Products

1983 *De Padova Edizioni*
1988 *Raffles* Sofa
1993 *Lousiana* chair with
ottoman
1997 *Safran* sofa
all by **Vico Magistretti**

Scrittarello table
by Achille Castiglioni, 1996
Silver chair
by Vico Magistretti, 1989

Maddalena De Padova has always had a preference for essential, pure forms, a no-frills approach she found exemplified in Charles and Ray Eames's house in California and in Scandinavian design. In 1958, she and her husband founded a company to import Herman Miller furniture and Scandinavian products. In the mid-1980s the firm began marketing its own line of furniture, the *De Padova Edizioni.* Timeless in style, purist in its formal vocabulary, and meticulously crafted in precious woods, metal, and textiles, the collection includes **Vico Magistretti's** *Raffles* and *Saffran* sofas, *Louisiana* easy chair and ottoman, and aluminum *Silver* chair, as well as **Achille Castiglioni's** *Scrittarello* desk. Reeditions of American Shaker furniture and Maddalena De Padova's tableware, vases, and rugs round out the company's catalogue.

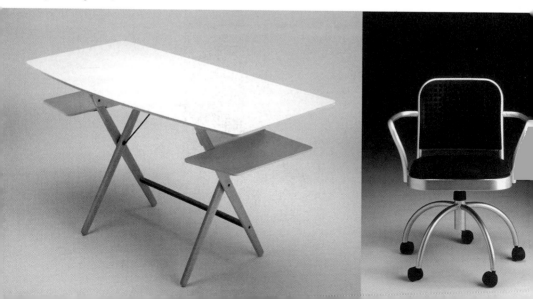

Architects and designers

In 1997, a German design magazine called Jonathan De Pas, Donato D'Urbino, and Paolo Lomazzi "veterans of Pop." Though the trio's DDL studio is still very active on the Italian design scene (minus De Pas, who died in 1992), their names are permanently tied to two early products, the first of which gained them instant fame. Their inflatable *Blow* chair of 1967, produced by **Zanotta**, was the near-weightless messenger that carried Pop into countless living rooms and brought **Anti-** or **Radical Design** to public attention. In a 1974 retrospective of the movement, *Casabella* magazine described the chair as "Italy's first inflatable design object that was widely popular outside of strictly elite circles. "Tens of thousands were sold in the United States alone, at about ten dollars a piece. DDL repeated Blow's spectacular success with their 1970 *Joe* leather chair (fig. p. 46)

1966 collaboration in architecture, urban planning and design

1979 *Compasso d'oro*

Products

1967 *Blow* inflatable chair for **Zanotta** with Carla Scolari

1970 *Joe* chair for **Poltronova**; series of inflatable household furnishings for the Italian pavillion at the *Expo* in Osaka

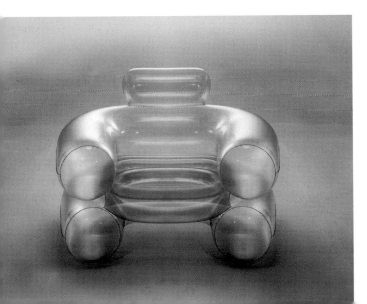

Blow chair for Zanotta, 1967

Onda sofa for Zanotta, 1985
Zerone girder system for
Quattrocchio, 1988

for **Poltronova.** Shaped like a giant baseball mitt, it was designed as an homage to Joe DiMaggio. Both chairs broke with conventional ideas of furniture, as they accommodated their era's relaxed posture and slouchy insouciance. The trio was similarly successful with its *Sciangai* coat rack, which consisted of eight wooden poles joined in the middle to resemble a jumble of chopsticks.

D'Urbino and Lomazzi have remained largely unimpressed by the market's supposedly binding laws. Their revolving *Giotto* stool of 1976 may look modest but works beautifully; the steel-and-black-leather *Onda* sofa of 1985 is a humorous variation on a famous Le Corbusier piece; and the coat racks, chairs, and tables they developed for Zerodisegno in the 1990s are as sly in their looks as they are smart in their functional design.

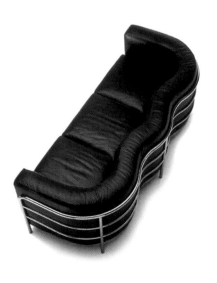

Paolo DEGANELLO

Architect, furniture designer, and essayist

In a 1997 speech, Paolo Deganello called for resistance to the dictates of the market, advocating instead smaller series of long-lasting products designed for niche markets. As a cofounder of **Archizoom,** Deganello has roots in the **Radical Design** movement of the 1960s, and his practical work has always been linked with theoretical considerations of contemporary design and its social functions. When he designed his best-known piece, the 1973 *AEO* chair for **Cassina,** he combined metal, a simple cotton fabri, and plastic. The chair's unusual form offered alternatives to both "beautiful" upholstered furniture and the raw **Anti-Design** look. He later designed the deliberately plain *Torso* sofa for Cassina. Deganello has also worked with **Driade** and **Zanotta,** for which he created the leather-and-wicker *Regina* chair, which features a peculiar, organically-shaped backrest.

1940 born in Este

1966 graduates from architecture school in Florence; cofounder of **Archizoom**

1991 teaches at Isia (Istituto Superiore Statale di Disegno Industriale), Florence

Products

1973 *AEO* chair for **Cassina**

1981 *Squash* sofa for **Driade**

1982 *Torso* sofa for Cassina

1987 *Documenta Chair* for Vitra Edition

1991 *Regina* leather-and-wicker chair for **Zanotta**

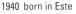

Regina chair for Zanotta, 1991
Documenta Chair
for Vitra Edition, 1987

DESIGN GROUP ITALIA

Industrial design studio

Among Italy's large industrial design studios, Design Group Italia is one of the most active, providing an international roster of clients with services from market analyses to product, graphic, and interface design. Formal versatility is part of the studio's conceptual basis. It has developed self-explanatory electrical control panels; user-friendly pharmaceutical devices such as the Jet inhaler for asthmatics and a contraceptive pill dispenser; functional writing utensils like the award-winning *Tratto pens* for Fila; housewares including the retractable *Amleto* ironing board; and futuristic racing seats, helmets, and sunglasses. Some of DGI's designs incorporate calculated ornamental details, such as the cut-out semicircle in the seat of the *Lyra* barstool for Magis; others, like the standard telephone for **Italtel,** are strikingly devoid of any decorative elements.

1968 founded in Milan, headed by Marco Del Corno, Edgardo Angelini, Ross De Salvo, Sigurdur Thorsteinsson

1979 *Compasso d'oro* (also 1991)

Products

1976 *Tratto Pen* for Fila

1989 corporate identity for ABB control panel systems

1991 *Freak* children's helmet for Uvex

1997 *Tecnic Advance* toothbrush for Elida Gibbs/Unilever

Lyra barstool for Magis, 1994
Standard telephone for Italtel, 1979

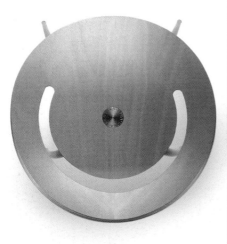

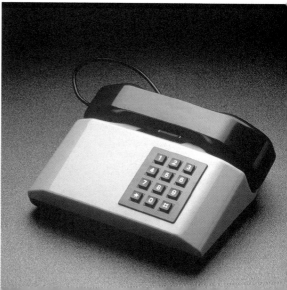

Rodolfo DORDONI

Architect; furniture and lighting designer

Rodolfo Dordoni has pioneered a friendlier rapport between design and its users. For Dordoni, the decisive questions in design are,"For whom and why?" Clean in their form and lovingly detailed, his products obligingly adapt to users' needs. His Fermo table system for **Driade,** for example, consists of inexpensive standard legs and medium density fiberboard tops that can be cut to any size. His *Paco* table lamp for **Arteluce,** whose light is filtered through a colored polycarbonate shade, features a glow-in-the-dark pull switch; the *Milo* table lamp for **Artemide** is similarly equipped. He has developed design solutions for **Cappelini, Fontana Arte,** Minotti, and **Moroso,** as well as designing interiors, including the **Dolce & Gabbana** showroom in Milan.

1954 born in Milan

1979 graduates from architecture school in Milan

Products

1986 *Cuba* sofa system for **Cappellini**

1992 *Arianna* chair for **Driade**; *Hall* sofa for Driade

1995 *Fermo* table for *Atlantide*

1998 *Braque, Delaunay, Leger, Villon, Duchamp* and *Gris* seats for Minotti

Orione table lamp for Artemide,1992
Delaunay chair for Minotti, 1998

DRIADE

Furniture manufacturer

When Driade debuted at the 1968 Milan furniture fair, the young company's peculiar Op-Art logo, designed by cofounder Adelaide Acerbi, attracted as much attention as its furniture designs. To this day, Driade is associated with the spectacular marketing efforts that accompany each product introduction. A few years ago, the company even started its own magazine, *Driade Edizioni.*

From the start, Driade's owners, Enrico and **Antonia Astori** and Acerbi, demonstrated a keen instinct for spotting trends. They made a strong early impression with Antonia Astori's pioneering modular solutions, such as the *Oikos* system, while also producing futuristic plastic furniture like **Rodolfo Bonetto's** chubby *Melaine* monoblock chair and **Enzo Mari's** slender *Delfina* chair. In the 1980s, under the influence of **Memphis,** Driade developed the landmark *Aleph* collection (1984), which included Philippe Starck's three-legged *Costes* bistro chair. The *Follies* series of accessories, also produced in the eighties, was typified by Borek Sipek's neo-Baroque, bombastic vessels. In the more modest 1990s, Driade introduced the *Atlantide* collection, for which designers such as **Marco Romanelli, Rodolfo Dordoni,** and Konstantin Grcic have created simple, straightforward products aimed at young, price-conscious buyers.

EDRA MAZZEI

Furniture manufacturer

Edra spa, Perignano (PI)
1987 founded in Perignano

Products

1988 *Wavy* seat by Zaha Hadid

1989 *Tatlin* sofa by Mario Cananzi, Roberto Semprini

1990 *Fiori* chair series, incl. *Rose Chair* by Masanori Umeda

1991 *Topolone* sofa by **Massimo Morozzi**

1993 *L'homme et la femme* sofa by **Francesco Binfaré**

1994 *Island* seat by **Alessandro Mendini**

1996 *Paesaggi italiani* closet system; *Kasimir* bookcase both by Massimo Morozzi

Pop singer Madonna was reportedly so taken with the bright red, helical *Tatlin* sofa that she bought one on the spot. Designed by Mario Cananzi and **Roberto Semprini** and manufactured by Edra Mazzei, the sofa is typical of a product line short on modest forms but rich in humor and visual trickery. It is not surprising that Edra furniture has been used as set pieces in such movies as *Wittgenstein, Star Trek,* and *Cosi Fan Tutte.* Most of the Tuscan manufacturer's chairs, sofas and wardrobes are legitimate descendants of early Pop furniture, designed not to blend in but to dominate their surroundings. Among the company's products are such eye-catching creations as Masanori Umeda's *Rose* Chair; and **Massimo Morrozzi's** *Paessaggi Italiani* closet system, whose cubic modules can be combined, Lego-like, to grow to any size or shape.

Ironic furniture's names (a sofa by **Francesco Binfaré** is called *L'homme et la femme*), product presentations with provocative titles such as *Sex for Angels,* and art director Massimo Morozzi's hypercharged marketing campaigns are all part of a philosophy that claims that "the public doesn't just want a nicely furnished home. It wants a dynamic, vivid, sensual, happy living environment."

Nuovo Domino sofa by Massimo Morozzi, 1985/1998

Page 187
top left: *Rose Chair,* 1990
top right:. *Getsuen* chair, 1990;
both by Masanori Umeda
bottom: *Vermelha* chair by Fernando and Humberto Campagna, 1993/1998

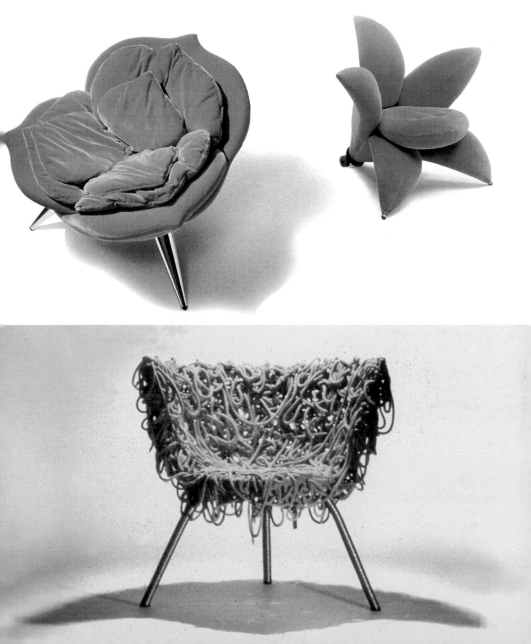

Salvatore FERRAGAMO

Manufacturer of shoes, bags, and fashion accessories

Salvatore Ferragamo's biography reads like an Italian version of the American Dream. Born the eleventh of fourteen children in a small village near Naples, young Salvatore left school at the age of nine to become a shoemaker. After an apprenticeship in southern Italy, he emigrated to the United States in 1914. There he found employment in the flourishing movie industry, making cowboy boots, Egyptian sandals, and elegant pumps for stars like Gloria Swanson and Joan Crawford, who soon wore Ferragamo's shoes off the set as well as on camera. A few years before the Great Depression he returned to Italy and set up a business in Florence. When, in 1936, the League of Nations imposed sanctions on Fascist Italy and raw materials became scarce, Ferragamo made a virtue of necessity and, in place of leather, used materials such as thin metal threads, wood, transparent plastics, felt, and the raffia fibers typical of Florentine crafts. Careful craftsmanship and the use of unconventional materials became Ferragamo's trademarks. And unique designs such as the "invisible" high-heeled sandal of 1947 made him a legend in footwear. In 1950, his workshop contained rows upon rows of custom-made lasts modeled after the feet of clients like Greta Garbo, Sophia Loren, and Audrey Hepburn. Today, under the direction of Ferragamo's children, the company has expanded its product lines to include bags, leather accessories, ties, and scarves.

1889 Salvatore Ferragamo
born in Bonito
(near Naples)

1914 emigrates to U.S.
(returns in 1927)

1937 buys Palazzo Spini
Feroni in Florence

1960 Salvatore Ferragamo
dies; his children continue
to run the firm

1995 opening of Ferragamo
Museum in Florence

1996 Salvatore Ferragamo buys
Emanuel Ungaro

1997 joint venture with Bulgari
(perfume and cosmetics
products)

Page 189

top: Pump, 1962

bottom right: *Calipso* sandal , 1956,
and pump, 1934

Shoe, 1941
Uppers made of cellophane strings

FERRARI

Automobile manufacturer

Ferrari (now Fiat spa), Turin

1947 founded by Enzo Ferrari in Modena

1969 **Fiat** acquires a 50% stake in Ferrari

1988 increases stake to 90%

Models

1947 Type *125*

1953 *212 Inter*

1958 *250 GT Coupé*

1959 *Testarossa 250*

1960 *250 GT SWB*

1962 *250 GTO*

1967 *Dino 206 GT*

1968 *365 GTB/4 Daytona*

1975 *308 GTB*

1984 *Testarossa*

1987 *F 40 Berlinetta*

Shiny red metal, an aggressive radiator grill, and the famous bucking-horse logo are the images that come to mind when one hears the name Ferrari. And, of course, speed. Since the company was founded by Enzo Ferrari, a former race car driver, after the war, its cars have won more than 5,000 racing trophies. Ferrari's very first model, the twelve-cylinder *125* of 1946, became a benchmark for all sports cars that followed it. Unabashedly sexy in their design, Ferraris came to be used as symbols of erotic power in countless movies and TV series, from Miami Vice to Magnum, P.I. Their aura was not based on mere looks but on Ferrari's superior engines and the enormous success of its racing teams. Body design mattered, of course, and the cars' power was translated by **Pininfarina** into aerodynamic lines and sharply contoured details. In the 1950s and 1960s, rounded, organic forms characterized models such as the *250 GT SWB* (fig. p. 42/43), the *250 GTO* (dubbed a "phallus on wheels"), and the *365 GTB/4 "Daytona."* The cars became more angular in the 1970s. The only lapse in Ferrari's otherwise immaculate styling was the flashy *Testarossa,* now considered a symbol of the excesses of the 1980s.

Ferrari *250 GT*, 1963

Page 191
top: Ferrari *Mythos*, 1989
bottom: Ferrari *328 GTB*, 1985;
all by Pininfarina

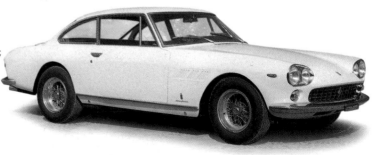

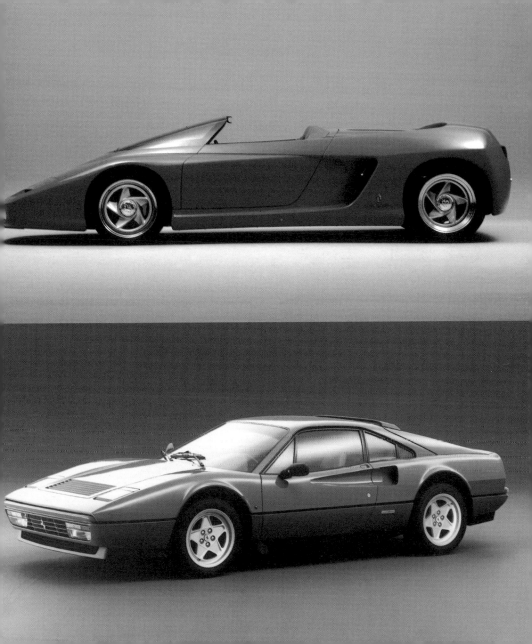

Gianfranco FERRÉ

Fashion designer

An Italian in the French shrine of couture—Gianfranco Ferré's appointment as Christian Dior's artistic director in 1989 caused quite a stir in fashion circles. Despite his critics' dire predictions, Ferré's ideas proved to be perfectly compatible with the house's venerable tradition, winning him the *Golden Thimble,* France's highest fashion award, in his first year at Dior. His sensuously elegant gowns typify his signature combination of simplicity and Mediterranean flair.

With a degree in architecture from Milan's polytechnic university, Ferré has an educational background shared by many Italian furniture designers, but few couturiers. After graduation he designed accessories, and in 1974 created his first collection for Baila. In 1978 he introduced his own label and eight years later joined the top ranks of fashion designers with his *Ferré Couture Collection,* which was discontinued after his appointment to Dior.

1944 born in Legnano near Milan

1969 graduates from architecture school in Milan

1978 founds company, Gianfranco Ferré, with Franco Mattiolo

1985 *Cutty Sark Men's Fashion Award*

1989 artistic director of Christian Dior, Paris (until 1996); *Golden Thimble*

Products

1984 perfume, *Gianfranco Ferré*

1986 men's perfume, *Gianfranco Ferré*; haute couture for women

1987 *Studio 000.1 by Ferré*

1993 *Pitti Immagine Uomo*

1990 *Lorenzo il Magnifico* award, Florence

1991 *Ferré by Ferré,* second women's perfume

Dress from 1992/1993 collection
Drawing from 1998/1999 collection

Marco FERRERI

Architect, designer of furniture, accessories, and lighting

Price-consciousness and the exploration of new technologies and materials are important aspects of Marco Ferreri's design philosophy. "I'm interested in pushing the limits of materials," he says, explaining that his goal is "to produce something that is already inherent in the material and/or the construction process." This approach is exemplified in designs like the translucent *Antipodi* plastic bowls for **Danese,** with their organically swelling forms, and the *Less* chair for Nemo. Part of a furniture series titled *Less is More,* the chair's seat is made of Softwood, an experimental plywood-and-fabric compound. A thin sheet of wood is applied over a layer of cushioning material, so that the apparently hard surface yields, surprisingly, to the body's weight. One of Italy's most versatile designers, Ferreri has also created bathroom fixtures, faucets, and containers, such as the *Roll-Box* for garden waste.

1958 born in Imperia

1981 graduates from architecture school in Milan

1984 opens studio

Products

1990 *Zan-Zo* lamp for **Fontana Arte**

1993 *Less* stacking chair, *Is* stool, *More* table for Nemo/BPA International

1994 *Libro letto* cushion for Interflex with **Bruno Munari**; *O'Key* keychain for Robots; *O* bathroom faucets for **Agape**

1996 *Antipodi* bowls for **Danese**

1997 *Flirt* sofa for Adele C.

Antipodi bowls for Danese, 1996
Less chair for Nemo/
BPA International, 1993

FIAM

Furniture manufacturer

Fiam has liberated glass from its old, subordinate function and given it an autonomous role in furniture design. In 1984 the company achieved a technological breakthrough: the monolithic *Ragno,* designed by company founder Vittorio Livi, was the world's first table consisting of a single sheet of bent glass. Though is not that unusual for a manufacturer to focus on just one material, glass tends to follow its own rules. It is entirely due to Fiam's research and development efforts that it could be harnessed to realize designs like **Cini Boeri** and Tomu Katayanagi's throne-like *Ghost* chair, Danny Lane's sculptural *Shell* and *Atlas* tables, and **Massimo Morozzi's** *Hydra* table, which resembles a giant insect. Fiam is also the leading supplier of glass to the Italian furniture industry, with production capabilities ranging from glass-blowing to laser-cutting.

Fiam Italia spa, Tavullia
1973 founded by Vittorio Livi

Products
1984 *Ragno* glass table by **Vittorio Livi**
1987 *Ghost* glass chair by **Cini Boeri** and Tomu Katayanagi
1988 *Hydra* table by **Massimo Morozzi**; *Shell* and *Atlas* tables by Danny Lane
1992 *Illusion* table by Philippe Starck
1996 *Cler* glass cabinet by Ron Arad

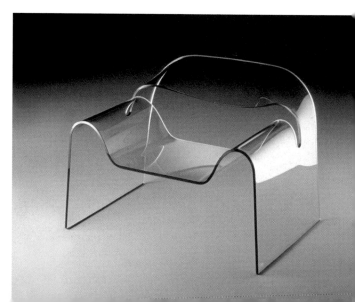

Ghost glass chair by Cini Boeri and Tomu Katayanagi, 1987

FIAT

Automobile manufacturer

If **Alfa Romeo** and **Ferrari** have made Italian cars famous for their luxurious, sporty design, Fiat has turned Italy into a nation of motorists. The Turin automobile manufacturer's *500* (fig. p. 48), developed by **Dante Giacosa**, was introduced in 1936 at a widely affordable price of 8,900 lire. With its thirteen-horsepower engine and light, 1,100 pound weight, the *"Topolino"* was the world's smallest car; by 1954 half a million had been sold. The popular model was twice relaunched in updated versions, first as the *Nuova 500* in 1957 and again in the 1990s as the *Cinquecento*.

The Fabbrica Italiana Automobili Torino was established in 1899. Like many other car manufacturers it concentrated on the production of expensive luxury vehicles and race cars during its early years. Giovanni Agnelli, one of the company's founders, quickly came to recognize the industry's broader potential, and in 1912 the Fiat Zero series went into production, Italy's answer to

Fiat Auto spa, Turin

1899 founded by Giovanni Agnelli and others in Turin

1919 Lingotto plant (until 1921)

1939 Mirafiori plant

1945 Senator Giovanni Agnelli dies

1958 Centro Stile design center established

1963 Giovanni Agnelli, Giovanni's grandson. becomes managing director and, in 1966, chairman

1968 City Taxi by **Pio Manzú** at Centro Stile

Fiat *Nuova 500* by Dante Giacosa, 1957 (mahogany model)

Fiat *124 Sport Spyder*
by Pininfarina, 1966

Page 187
top: Fiat *Uno*, 1983
bottomright: Fiat *Punto*, 1993;
both by Giorgetto Giugiaro

Ford's *Model T*. By the early 1930s Fiat had developed into Italy's leading car manufacturer and began to focus on an emerging mass market with family sedans like the 1932 *Balilla*. But Fiat also continued to make luxury cars, hiring car-body stylists like **Bertone** and **PininFarina** to design sleek sports cars such as the elegantly streamlined Fiat *1500* of 1935.

With the economic boom of the mid-1950s, a golden era began for the carmaker. In 1961, 90 percent of all cars sold in Italy were made by Fiat; between 1969 and 1973 the company more than doubled its output. After the 1974 oil crisis, low fuel consumption was suddenly as important as attractive design. Two hugely successful models were introduced in the eighties: the 1980 Fiat *Panda,* designed by **Giorgetto Giugiaro,** made a stir with its stripped-down look that emphasized the car's practical value. It was followed by Giugiaro's inexpensive 1983 Fiat *Uno,* which became the quintessential subcompact.

In recent decades, the Fiat group has taken over its former competitors **Lancia** and Alfa Romeo, and acquired a majority stake in Ferrari. In addition to cars, it manufactures trucks, buses, and utility vehicles, constructs dams, tunnels, satellites, and rocket engines, and develops pacemakers, lighting, robot technology, and computer systems for the health-care industry.

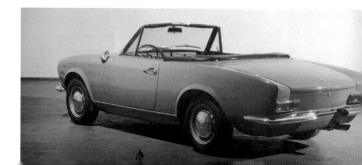

FIORUCCI

Fashion and accessories manufacturer

Fiorucci srl, Milan/
Edwin International Inc.,
Tokyo

1935 Elio Fiorucci born in Milan

1967 first Fiorucci store
in Milan

1974 opening of Fiorucci store
on Via Torino, Milan

1976 Fiorucci store in New York

1990 Fiorucci brand bought by
Edwin International Inc.,
Japan, Elio Fiorucci
continues as creative
director and PR manager

When Elio Fiorucci opened his first store in the Galleria Passarella in 1967, he gave Milan's teenagers their first taste of the street fashions of Swinging London. Fiorucci imported Ossi Clark's and Zandra Rhodes's mod styles to Milan and developed his own designs, which soon became wildly popular. With inexpensive jeans, T-shirts, and accessories, he created a distinctive look that was as sexy, romantic, and exuberantly colorful as the company logo's Raphaelite putti, while a slew of advertising brochures turned the Fiorucci style into an ongoing statement on Italian youth culture (fig. p. 26). The Fiorucci stores that opened all over the world in the 1970s were gigantic playgrounds, hedonistic temples to the joys of fashion and bric-a-brac, food, music, and art. As the prime exporter of a new, post-sixties Italian dolce vita, Fiorucci became a trendsetter in sportswear and successfully marketed his brand in international licensing deals. The brand was acquired by Edwin Inc. of Japan in 1990, but Elio Fiorucci has remained as head of its creative development and marketing departments.

Shoe from 1998 collection

Page 199
top left: Fiorucci's "Angels" logo
top right:, bottom right: 1997/1998
collection
bottom left: platform shoes, 1970s

FLOS

Lighting Manufacturer

Flos spa, Bovezzo
1962 founded by Dino **Gavina** and **Cesare Cassina**
1995 *Compasso d'oro*

Products
1961 *Splügenbräu* ceiling light
1962 *Taccia* table lamp;
Arco floor lamp;
Toio floor lamp;
all by **Achille** and **Pier Giacomo Castiglioni**
1968 *Biagio* table lamp
by **Tobia Scarpa**
1970 *Parentesi* lamp
1972 *Noce T* floor and table lamp
1976 *Ipotenusa* table lamp;
all by Achille Castiglioni

From the tall *Arco* floor lamp, which curves to provide overhead lighting, to the ready-made aesthetic of the upright *Toio* lamp, with its car headlight mounted on a skinny pole; from the *Frisbi* ceiling light, which shoots direct light downward and diffused light outward, to the monumental *Taccia* table lamp, the list of **Achille** and **Pier Giacomo Castiglioni's** creations for Flos reads like a history of modern lighting design. The two brothers defined the profile of the company, which was founded in 1962 by **Dino Gavina** and Cesare **Cassina**. In recent years, Achille, whose brother died in 1968, has contributed such elegant designs as the Brera and Fuscia hanging lamps to the Flos collection.

Tobia Scarpa (occasionally in cooperation with his wife, **Afra**) and, more recently, Philippe Starck have also made designs for the company. Scarpa's designs are predominantly simple, airy constructions, like the *Ariette 1-2-3* ceiling light, with a shade of

Luminator floor lamp by Achille and Pier Giacomo Castiglioni for Gilardi and Bazarghi, 1954, now produced by Flos

Taraxacum 88 C-W lamp by Achille Castiglioni, 1988

semitransparent fabric that reveals the electrical cord above it when the light is switched on; and the Butterfly floor lamp, whose glass reflector resembles a paper accordion. Since the 1980s Starck has contributed a number of humorous interpretations of traditional forms, including the *Rosy Angelis* floor lamp, where a piece of fabric is casually thrown over the light source, and the inexpensive, solid-colored *Miss Sissy* lamp, which looks like a toy-town version of a bar lamp.

In 1974, Flos bought its competitor **Arteluce,** which had been founded by Gino **Sarfatti.** Today, *Arteluce by Flos* comprises an independent line of lighting by younger designers, including **Marc Sadler, Rodolfo Dordoni,** and **Matteo Thun,** as well as Gino Sarfatti's legendary models from the 1950s and 1960s. The company also produces the Flos Murano glassware line in a joint venture with **Venini,** commercial lighting under the *Flight* label, and the Arteluce Bagno lighting systems.

1988 *Arà* table lamp
1989 *Luci Fair* wall lamp
both by Philippe Starck
1990 *Pierrot* desk lamp by Afra and Tobia Scarpa
1991 *Miss Sissi* table lamp by Philippe Starck
1992 *Brera* lamp by Achille Castiglioni
1994 *Rosy Angelis* floor lamp by Philippe Starck
1996 *Fucsia* hanging lamp by Achille Castiglioni; *Romeo Moon* and *Romeo Babe* hanging lamps by Philippe Starck

Fucsia hanging lamp by Achille Castiglioni, 1996
Arà table lamp by Philippe Starck, 1988

FONTANA ARTE

Lighting and furniture manufacturer

Fontana Arte has a long, if temporarily interrupted, tradition of design. The famous architect and designer **Gio Ponti** founded the firm in 1932 as the artistic arm of Luigi Fontana's glass factory. Ponti, as well as **Pietro Chiesa**, contributed high-quality glass furniture and lamps to the Fontana Arte collection. The company lost its distinctive profile when it was acquired, after the war, by the French St. Gobain group. In 1979, Carlo Guglielmi bought Fontana Arte and revived its former cachet by collaborating with a number of renowned designers. **Daniela Puppa** and **Franco Raggi** created exhibits for trade fairs; **Pierluigi Cerri** designed the visual communication, and **Gae Aulenti** was appointed art director. In the 1980s and '90s the company developed outstanding furniture and lighting collections that reaffirmed Fontana Arte's status as a leading force in Italian design. Its Schopenhauer collection comprises exquisite tables and chairs, including Aulenti's famous Tour glass table on wheels. In addition, Fontana Arte produces the Candle and Naskaloris lighting collections.

Fontana Arte spa, Corsico
1932 founded by **Gio Ponti**
1998 *Compasso d'oro*

Products
1931 *0024* hanging lamp
by Gio Ponti (reintrod.)
1967 *Pirellina* table and floor
lamp by Gio Ponti
1971 *Daruma* table lamp by
Sergio Asti (Candle)
1985 *Tea* hanging lamp by
Pierluigi Cerri
1989 *Franceschina*
table and hanging lamp by
Umberto Riva
1991 *2892 Small*,
3064 Medium, 2850 XL
table lamps by
Daniela Puppa
1992 *Piccola San* table lamp by
Daniela Puppa
1993 *Tour* table by **Gae Aulenti**
1996 *3094 Alzaia* hanging lamp
by **Vico Magistretti**

Glass table by Pietro Chiesa, 1932

Page 203

left: *Luminator 0556* floor lamp by
Pietro Chiesa, 1933

top right: *Congo* container by
Rodolfo Dordoni, 1998

lower right: *Bilia* lamp by Gio Ponti,
1931 (reintrod.)

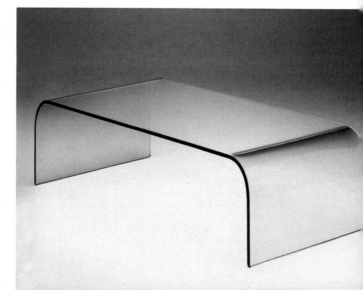

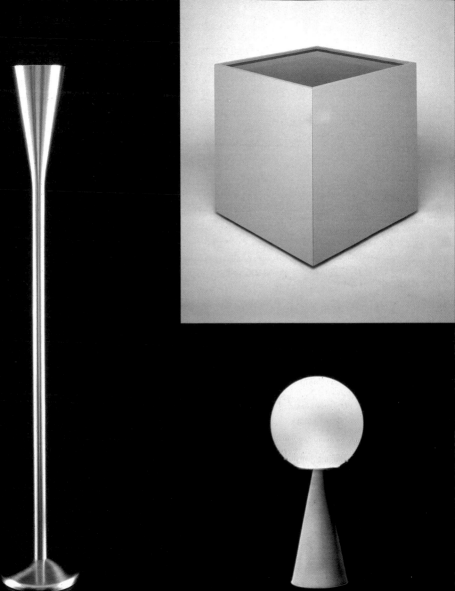

Piero FORNASETTI

Product and graphic designer, artist, and illustrator

Suns, fish, flowers, and architectural motifs populate the design world of Piero Fornasetti, a self-taught, all-around genius who covered every conceivable product—from plates and cups to vases, textiles, wallpaper and buttons—with his trompe l'oeil imagery. All told, Fornasetti, whose works transform the visible world into a magical realm of surrealistic effects and illusion, created more than 11,000 decorative designs.

Expelled from Milan's Brera art school because he wouldn't accept its educational ideas and values, Fornasetti went on to become a painter, sculptor, artisan and decorator, and a set, costume, exhibition, graphic, and product designer. Ironically, his rise to fame came in the 1950s, when the new functionalist Italian design experienced its first great successes. An especially fertile relationship developed between Fornasetti and **Gio Ponti,** whom he had met at the 1940 *Triennale* and who published his works in *Domus* magazine. Fornasetti decorated many of Ponti's furniture and interior designs with his motifs (fig. p. 39). In 1950, they cooperated in the design of the casino in San Remo.

A renewed interest in surfaces made Fornasetti popular once more in the 1980s. Since Fornasetti's death in 1988, his son, Barnaba, has carried on his work. Products in the typical Fornasetti style can be seen in his Milan showroom on Via Manzoni.

1913 born in Milan
1930 studies art at Accademia di Brera, Milan (expelled in 1932)
1950 interior of casino in San Remo with **Gio Ponti**
1951 interior of Dulciora bakery, Milan
1970 opens store in Milan
1988 dies in Milan

Products
1940 cover designs for *Domus* magazine
1951 *Architettura* series
1952 collaborates on interiors for cruise ship *Andrea Doria*
1954 twelve plates with Adam-and-Eve motifs
1955 *Stanza Metafisica* (until 1958)

Page 205
left: *Dedicato a Piero e Gio* by Barnaba Fornasetti, 1990
top right: Platter, c. 1950-55
bottom right: *Quattro stagioni* chair, c. 1955

Architettura coffee set, 1960s

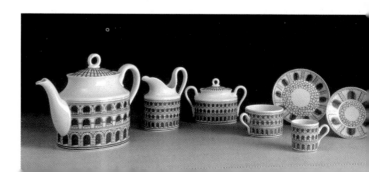

Gianfranco FRATTINI

Architect, furniture and lighting designer

Gianfranco Frattini's design philosophy crystallized in the 1950s under the influence of the Scandinavian school, which he greatly admired. He shares the Nordic designers' sense for detail and their love of carpentry—qualities apparent in his elegant wooden furniture for **Cassina** and **Bernini,** including the *804* bureau of 1961 and the wooden *Practica* bookcase of 1981.

Though they have sometimes been called unspectacular, Frattini's designs are more aptly described as deeply serious. He has consistently stuck to the conviction that the design process does not end with the completed drawing but continues until the final phase of production. With his thoughtful, meticulous approach, Frattini has also helped pioneer the use of industrial materials in innovative designs, such as his well-known set of plastic tables for Cassina and the *Boalum* snake light, a rather spectacular coil of luminescent tubing that he created for **Artemide** in collaboration with Livio Castiglioni.

1926 born in Padua

1952 collaboration with **Gio Ponti** (until 1954)

1953 graduates from architecture school in Milan

1956 cofounder of **ADI**

Products

1961 *804* bureau for **Bernini**

1966 *780* set of tables for **Cassina**;desk for Bernini;*Damecuta* sofa and chair for **C&B Italia**

1970 *Boalum* light tube for **Artemide** mit **Livio Castiglioni**

1974 *Kioto* table for Ghianda

1978 *Megaron* floor lamp for Artemide

1980 office chair for **Fantoni**

1981 *Practica* shelf unit for Bernini

1988 office system for Knoll

Kioto table for Ghianda, 1974

Page 207

Megaron Terra floor lamp for Artemide, 1979

804 bureau for Bernini, 1961

Maestro table for Acerbis, 1996

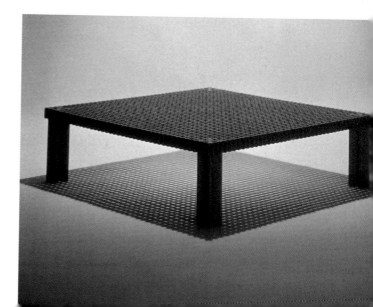

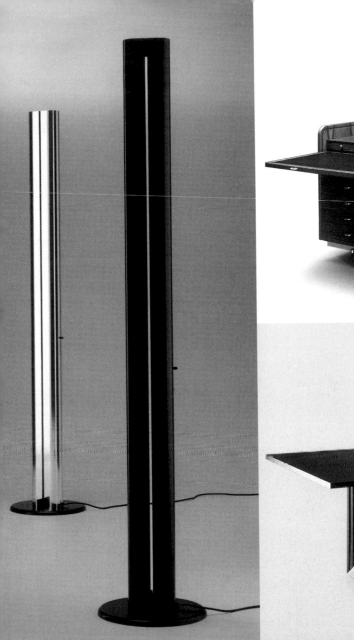
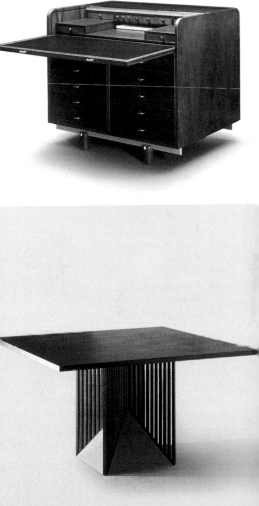

Futurism was one of the most radical movements within the European avant-garde. In his seminal 1909 manifesto, Futurism's spokesman, Filippo Tommaso Marinetti, proclaimed its course: "We declare that the world's glories have been enriched by a new beauty: the beauty of speed. A racing car, its body adorned by great pipes like snakes with explosive breath . . . a roaring car that seems to run on grenades is more beautiful than the Nike of Samothrake." The Futurists rigorously denounced *"il passatismo,"* the adherence to the past and to the ossified educational and aesthetic ideals of the nineteenth century, and instead propagated free, unbridled inspiration. They enthusiastically embraced the age of the machine (including the machines of war, which made them spiritual fathers of Fascism) in a country that was still predominantly agrarian.

While the big city, with its crowds of people and ceaseless traffic, was its central theme, Futurism had little impact on architectural practice. The movement did have an architect in **Antonio Sant'Elia,** but while his 1914 study, *La nuova città,* shows towering high-rises, underpasses, and transparent glass-and-steel structures, its true focus is on the movement of traffic.

Futurism was also not a design movement—industrial design was still decades in the future. Still, the Futurists were interested

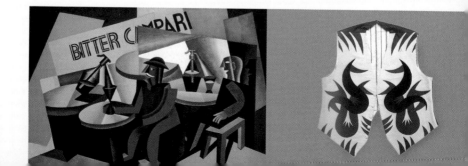

in utilitarian objects and their form. In his 1914 Futurist manifesto, **Fortunato Depero** wrote, "We must destroy traditional clothing . . . We must invent Futurist clothing." The garments he had in mind were supposed to be "dynamic," "aggressive," "violent," and "astounding." In 1914, the futurist painter **Giacomo Balla** presented clothing designs whose pointed shapes and sharply angular patterns were inspired by Cubism.

By the end of the First World War, Futurism was well past its prime, but Futurist ideas and stylistic aspects—such as the representation of dynamic processes—persisted in graphic design, advertising, and applied arts throughout the 1920s and 1930s. After 1919, Depero designed posters for **Campari** as well as toys, wallpaper, lamps, rugs, and rather rustic-looking wooden furniture. During those years, **Marcello Nizzoli** \and **Bruno Munari** also worked for Campari. After the Second World War, Futurism, with its ideological ties to Fascism, was passé.

A resurgence of Futurism's formal aesthetics occurred in the late 1980s, when the **Bolidismo** movement, formed around the designer **Massimo Iosa Ghini** and a group of architects from Bologna, appropriated its dynamic lines in their sofa and kitchen designs.

"From Futurism, Italian design has inherited the ability to continuously put objects in relationship to the metropolis, the ›metropolis‹ being a stage that gives meaning to the modern sign."

Andrea Branzi

From left:

Poster by von Fortunato Depero for Campari, 1920s

Vest by Fortunato Depero, 1924

If Rain Were Campari Bitter, poster for Campari, 1926

Tea set by Giacomo Balla, 1928

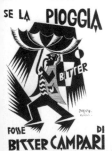

GAVINA
Furniture Manufacturer

Dino Gavina's once had business cards printed that read simply, "Dino Gavina-Revolutionary." A passionate art lover, Gavina founded a small furniture company in 1949 and used it to fight, with missionary zeal, for a modern, poetic design liberated from an overly rationalist straightjacket. Always open to experiment, Gavina enthusiastically embraced the new ideas formulated by such architects as Carlo Mollino, Carlo De Carli, Carlo Scarpa, and Franco Albini, whom he met in Milan in the early 1950s. Between 1955 and 1960 he produced furniture ranging from Achille and Pier Giacomo Castiglioni's San Luca chair in the Neo-Liberty style to Marco Zanuso's Milord chair. To find spiritual fellow travelers was always more important to him than commercial success. Success found him, however, when in 1962 Gavina reintroduced Marcel Breuer's tubular steel furniture to international acclaim. (That year he also cofounded another design company, the lighting manufacturer Flos, with Cesare Cassina.) He also produced Carlo Scarpa's furniture, including the nine-foot-long Doge table, made of flat steel and crystal. In 1968 Gavina sold his company to Knoll and established Simon International.

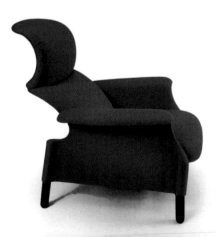

Sanluca chair by Achille and Pier Giacomo Castiglioni, 1960

Romeo GIGLI

Fashion designer

Romeo Gigli is a stylistic globetrotter, a fashion designer whose poetic and sometimes cerebral creations, which often incorporate ethnic motifs, attest to his sensitivity to other cultures. After dropping out of architecture school, Gigli traveled throughout Asia, North Africa, and South America before becoming an apprentice at the studio of the New York couturier Dimitri. Upon his return to Italy he worked as a designer for Callaghan, and in 1984 created his first collection. In the late 1980s Gigli presented luxurious, gold-embroidered coats inspired by clothes worn by the Byzantine empress Theodora. And in 1989 he stirred up the Paris fashion crowd when he went against prevailing trends by eliminating shoulder pads in favor of a soft, feminine silhouette with unusual necklines and high waists. Gigli has since returned to simpler lines and cuts.

1950 born in Faenza

1979 works for Dimitri, New York

1985 Collaboration with Zamasport

1986 international breakthrough

1988 Spazio Romeo Gigli iopens in Milan

1989 Collaboration with Ermenegildo Zegna; presentation in Paris

1990 *Woolmark Award*

1997 Japanese investors support Gigli's company

Products

1984 first collection under Gigli

1986 first menswear collection

1989 perfume *Romeo di Romeo Gigli; Teodora* collection

1990 *G Gigli collection*

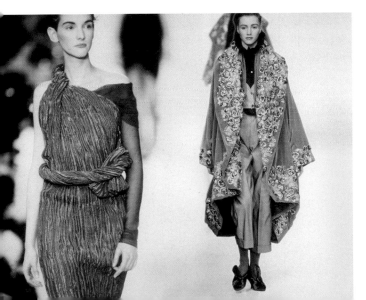

Donna collection 1989/90 (*Teodora*)

Stefano GIOVANNONI

Architect, furniture, and product designer

As a young boy, Stefano Giovannoni was so fascinated by the sea creatures he saw at the beaches and in the markets of his hometown, La Spezia, that he made them the subjects of small picture stories. Since the late 1980s he has created a similarly fanciful world of products that strike a peculiar balance between utilitarian function and a design vocabulary inspired by science fiction, movies, and comic strips. A nutcracker takes the form of a squirrel named *Nutty the Cracker;* his *Lilliput* salt and pepper shakers are egg-shaped homunculi; the *Merdolino* toilet brush (all for **Alessi**) sits in a flower pot; and a barstool for Magis comes with a Hula Hoop that serves as a footrest. Brightly colored, they appeal to playful instincts and reflect a design approach in which form follows fun. When Giovannoni worked with **Guido Venturini** in the 1980s, their studio was named **King-Kong.** "We were never afraid to be kitschy," Giovannoni has said. Their disrespect for the rules of good taste paid off. King-Kong's *Girotondo* series of kitchen utensils and tableware, decorated with a round dance of perforated little figures, became a huge success, selling more than a million pieces.

1954 born in La Spezia
1978 graduates from architecture school in Florence
1985 collaboration with **Guido Venturini** in **King-Kong** studio (until 1989)

Products
1986 *Iguana Jeans* for Levi's
1987 *Girotondo* series with Guido Venturini
1993 *Fruit Mama* bowl; *Merdolino* toilet brush; *Lilliput* salt and pepper set and *Nutty the cracker* all for **Alessi**
1996 *Roller Ball* wristwatch for Seiko

Girotondo series for Alessi, 1987, with Guido Venturini
Bombo barstool for Magis, 1996

Automobile and industrial designer

Introduced in 1974, the Volkswagen *Golf* (called the Rabbit in the U.S. until 1985) quickly become one of the most successful German cars in history. It had been designed by Giorgetto Giugiaro, one of Italy's leading body makers. At the time, Giugiaro could already look back at an impressive career. As an automobile designer at **Fiat's** Centro Stile and later at **Bertone** and **Ghia,** he had specialized in luxury cars. In 1968 he established his own firm, **Italdesign,** with Aldo Mantovani. Italdesign ushered in a new era in automobile design—the company offered an unprecedented range of preproduction services, from the development of models and prototypes to the calculation of production schedules and processes to plans for automation and implementation. Since then, Italdesign has worked for BMW, Hyundai, Renault, and Audi and has developed such highly successful models as the *Alfasud,* Fiat *Panda,* Fiat *Uno,* VW *Passat,* and VW *Scirocco.*

In the early 1970s, Giugiaro realized that the market, suffering from the effects of the oil crisis and a general recession, was

1938 born in Garessio Cuneo

1955 joins Centro Stile **Fiat** after graduating from school of art and technology, Turin

1959 joins **Bertone**

1965 becomes director at **Ghia**

1968 **Italdesign** founded

1981 **Giugiaro Design** founded; *Compasso d'oro* (also 1984, 1991, 1995)

1987 Giugiaro spa founded: accessories, clothing

Bugatti *EB 112,* 1993

ready for inexpensive small and mid-sized cars. And he has always held that the automobile industry, where large quantities of a very expensive object must be sold in a highly competitive market, needs to subject the design process to a continuous reality check. Giugiaro believes that "within a company's decision-making structure, the designer must have the courage to question whether it makes sense to launch a new product, whether it will appeal to the consumer. This may sound like marketing theory but without good design marketing is rarely successful."

His firm, **Giugiaro Design,** founded in 1981, is committed to functional, user-oriented products, and has developed cameras, watches, dishwashers, furniture, racing boats, trains, sewing machines, and even a new pasta shape. The firm emphasizes technological innovation; for example, its *F4* for Nikon, developed in 1988, was the first camera equipped with autofocus. The firm's work does not end with the development of a product but extends to naming, packaging, and promoting it. In recent years, Giugiaro has further broadened his scope by establishing Giugiaro spa, which produces clothing and accessories. His daughter, Laura, following in Giugiaro's footsteps, has recently introduced successful fashion and jewelry collections of her own.

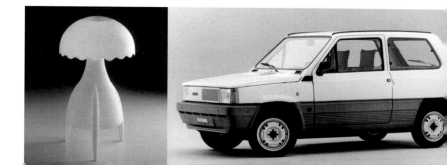

GRUPPO (Cinelli/Columbus/Tecno Tubo Torino)

Manufacturer of bicycles and bicycle accessories

Gruppo spa, Caleppio
di Settala (MI)

1930 Columbus founded;
Cinelli founded
in 1940s

1961 Tecno Tubo Torino founded

1996 merger under new name,
Gruppo

Products

1991 *Laser Evoluzione* bicycle
(*Compasso d'oro*)

1995 *Rampichino* mountain bike

1996 *Spinaci,* handlebar
extension; all by Cinelli

Page 217

Laser Evoluzione bicycle, 1991
Spinaci handlebar extension, 1996

Soft Machine bicycle, 1998 (Cinelli)
Altec² *Megatubes*, 1998 (Columbus)

In Italy, **Cinelli** is synonymous with bicycling in the same way that Ferrari stands for car racing. Fidel Castro and Bruce Springsteen own bicycles by Cinelli; Simon Lessing used Cinelli handlebars in his successful run for the 1995 World Triathlon title, as did Chris Boardman when he set a new world record by riding 56.375 kilometers (34.95 miles) in one hour.

Founded in the early 1940s, Cinelli has continuously come up with technological innovations, such as its recently introduced *Aliante* bicycle frame, which weighs a mere three pounds. In 1985 the company introduced mountain biking to Italy with the sleek *Rampichino* model. A love of cycling and enthusiasm for design have always gone hand in hand at the Milan company, which has worked with designers like **Matteo Thun** and the **Alchimia** studio. The company won a *Compasso d'oro* in 1991 for the *Laser Evoluzione* racing bike, a true technological marvel; its *Spinaci* handlebar extension, which reduces the strain on riders' bodies, combines ergonomic form and function with a riot of colors and wild patterns. In 1996 Cinelli merged with **3 T (Tecno Tubo Torino),** Italy's leading producer of handlebars, and the frame manufacturer **Columbus** to form Gruppo. Gruppo produces racing, mountain, and touring bikes, though its backbone is its wide range of colorful accessories.

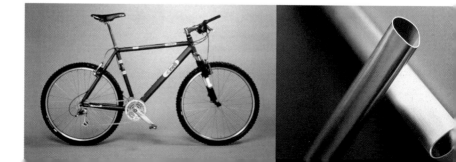

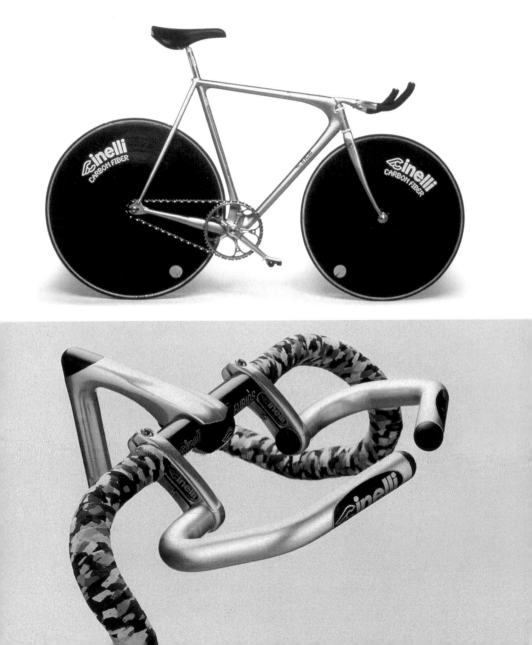

GRUPPO IND. BUSNELLI

Furniture manufacturer

Gruppo Industriale
Busnelli spa, Misinto

1953 founded in Meda

1969 establishment of Centro
Studi e Ricerche; use of
plastics

1972 moves to Misinto

Products

1955 *Bilux* convertible sofa by
Augusto Managhi and
Alessandro Terzaghi

1966 *Miranda* chair
by **Bruno Gecchelin**

1984 *Flessuosa* sofa and chair
by **Ugo La Pietra**

1992 *Rock bergère* chair by
Giotto Stoppino

The design historian Anty Pansera's once described Gruppo Industriale Busnelli as "200,000 square meters of seating." With its large-scale production of seating furniture, the company, whose methods are taken straight from automobile manufacturing, is the exception within a furniture industry characterized by smaller firms. Founded in 1953, the company is a conglomerate of 240 firms, ranging from textile and metal manufacturers to computer labs. In 1972 it moved to Misinto and has since been the leading player in the development of the surrounding region. Always open to technological innovation, Busnelli experimented with **Pirelli's** new steel-reinforced foam rubber in the 1950s and with plastics in the 1960s. *Argin,* an amorphous sculpture created in 1974 by Studio Libidarch, was among the more unusual results of the company's R&D efforts. Today, renowned designers such as **Bruno Gecchelin, Ugo La Pietra,** and **Giotto Stoppino** ensure the formal variety of Busnelli's products.

Libro chair by Gruppo DAM, 1970
Sessel *Fiocco* chair by G 14,
1970 (reintroduced in 1987)

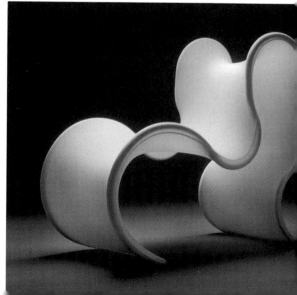

GUFRAM

Furniture manufacturer

When furniture dealers started offering Gufram's *Multipli* objects around 1970, their shops and windows suddenly resembled surrealist landscapes. Customers marveled at the bright red *Bocca* "lip sofa," the *Pratone* polyurethane turf (fig. p. 20), the inflatable *Cactus* clothes tree, and the *Capitello* seat, which looked like the capital of a Greek column but was made of soft plastic. Produced in limited editions, these pieces were pure Pop design, inspired by the **Radical Design** movement of the 1960s. Far from being appropriate, sensible, elegant solutions, their forms were freely taken from contexts outside of design. The creative minds behind this strange furniture were a group of young Turin designers and artists, including Studio 65, **Gruppo Strum,** the design duo of **Guido Drocco** and **Franco Mello,** and Piero Gilardi. Since 1978, Gufram has also designed furniture for movie houses, theaters, hotels, and universities.

Gufram srl, Balangero (TO)
1966 founded
1968 production of *Multipli* design objects in limited editions

Products
1971 *Pratone* artificial turf by Ceretti, Derossi, Rossi; *Bocca* sofa by Studio 65
1972 *Cactus* clothes tree by **Guido Drocco/Franco Mello**; *Capitello* seat by Studio 65
1974 *Massolo* by Piero Gilardi

Cactus clothes tree by Guido Drocco/Franco Mello, 1972
Bocca sofa by Studio 65, 1971

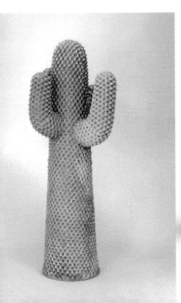

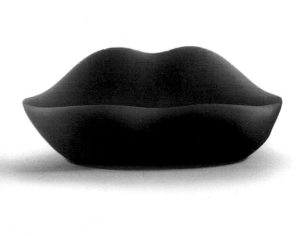

Isao HOSOE

Furniture and industrial designer

Trained in Tokyo as an aerospace engineer, Isao Hosoe compares the design process with a tornado: though full of tempestuous force, it is calculable to a certain degree, and the energy ultimately gathers in one single point. It is this point, the ideal result, that Hosoe is seeking, with the close cooperation of his team of designers, clients, and students. There is no "Hosoe style"; his solutions always follow the project's specific requirements, though often with an unexpected twist. His small plastic ashtray for **Kartell,** for example, revolves and works from either side. And the *Heron* desk lamp is highly functional, but looks like a friendly bird, in order to brighten up the workday.

Hosoe has also designed public transportation, such as the *Spazio* bus for Iveco (with Antonio Barrese, Pietro Salmoiraghi, Angelo Torricelli, and Antonio Locatelli), furniture, and office solutions.

1942 born in Tokyo

1967 studies space technology in Tokyo

1970 *Compasso d'oro* (also 1979, 1998)

Products

1971 melamine ashtray for **Kartell**

1977 *Spazio* bus for Iveco Carozzeria Orlandi with Antonio Barrese, Pietro Salmoiraghi, Angelo Torricelli, Antonio Locatelli

1996 *Gyra* lamp for **Luxo Italia**

1997 *Cosmo* office chair for BIF, Korea

1998 *HOI* lamp for Luxo Italia with Peter Salomon

Flo TV stand for Tonelli, 1997
Interior of *Spazio* bus for Iveco Carozzeria Orlandi, 1977

Massimo IOSA GHINI

Architect, furniture and product designer

In his comic strips for the magazines *Frigidaire, Fashion News,* and *Vanity* in the early 1980s, Massimo Iosa Ghini depicted the adventures of a spy named Capitano Sillavengo in a futuristic urban landscape. It wasn't long before he turned his imagination toward real products. Ghini came to product and furniture design by way of television, for which he created studio sets and graphic inserts. He got his professional start with the **Memphis** group in 1986, at the same joining forces with other Bologna architects to invent **Bolidismo,** a style that borrowed freely from **Futurism** with additional flashbacks to the American streamline look and 1950s aesthetics. Curves, ellipses, and boldly receding lines characterized his first collection of upholstered furniture for Moroso, which was introduced under the title *Dinamic* in 1986 and made him instantly famous. Iosa Ghini has continued to work with **Moroso,** while also designing kitchens, sunglasses, and comprehensive corporate identity programs, as well as showrooms for **Fiorucci,** Renault, **Ferrari,** Maserati, and Ominitel.

1959 born in Bologna

1982 studies architecture in Florence and Milan

1985 works for RAI

1986 collaboration with **Memphis**/12 New; cofounder of Bolidismo in Bologna

Products

1989 *Newtone* collection for **Moroso**

1991 *Philips Design Edition*

1993 *Big Mama* chair for Moroso

1994 Showrooms for **Ferrari**

1998 store designs for Omnitel

Rodi screen for Lisar, 1991
Dinamic Collection for Moroso (bench, chair and table), 1986

KARTELL

Manufacturer of plastic furniture and accessories

Page 223

top left: *Bookworm* by Ron Arad, 1994

bottom left: *K 4999* children's chair by Marco Zanuso and Richard Sapper, 1964

right: *4970/84* container elements by Anna Castelli Ferrieri, 1967

In the mid-1990s a bookshelf appeared that sold by the running yard. Today, the brightly colored *Bookworm* can be spotted winding its way along the walls of trendy shops, apartments, offices and lobbies all over Europe. Its inventor, Ron Arad, is thrilled by how his invention has multiplied. Originally designed in steel, *Bookworm* became an overwhelming success when it was produced in thermoplastic polymer.

Plastic, of course, is as inexpensive as it is durable, but for a long time it was stigmatized as a cheap, inferior material. The fact that such perceptions have changed is in great part due to the pioneering work of Kartell and the vision of its founder, the chemist and engineer Giulio Castelli, who is still a vital force in his company's management. He once said, "if people are afraid of the new, give them something even newer." He has done just that. In 1953, his company, which had previously focused on car accessories, began bringing a fresh new look and bright colors to Italy's hopelessly dull housewares industry. Company designer **Gino Colombini** revolutionized the design of these small, inexpensive items, winning numerous awards for his attractive juicers, garbage cans, storage containers, and other kitchen utensils (fig. p. 23)

In the 1950s it was not yet possible to make plastic furniture, due to the material's softness, but by the early 1960s technological advances allowed the production of the first plastic chair. The cheerful *K 4999* polyethylene children's chair, designed in 1961 by **Marco Zanuso** and **Richard Sapper** and introduced in 1964, did not reveal the long hours of research that Kartell's laboratories had put into its development. Stackable, weather- and shock-resistant, it ushered in a decade when plastic furniture became the rage in Italy and soon the rest of the world.

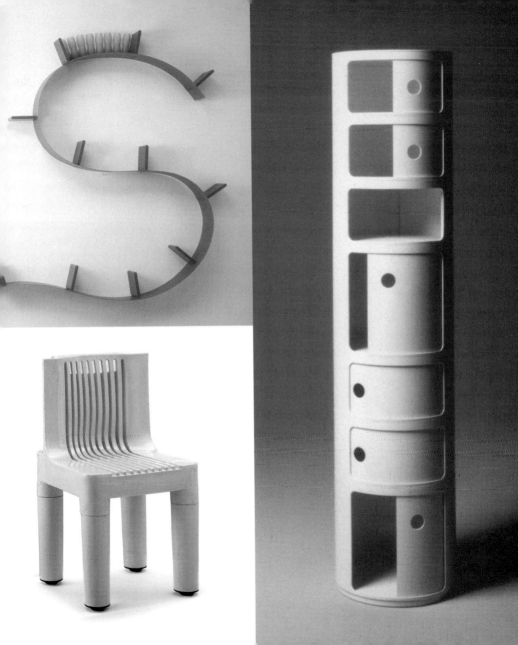

Products
1953 thermos
1955 plastic garbage can
1959 lemon juicer;
all by **Gino Colombini**
1964 *K 4999* children's chair by
Marco Zanuso and
Richard Sapper
1967 *4970/84* container
elements
1968 *4867* chair;
4630 ashtray;
both by **Joe Colombo**
1976 salad servers
1979 *4822/44* stool
1986 *4873* plastic chair
all by **Anna Castelli
Ferrieri**

Page 225
top left: *4822/26* stool, 1979
bottom left: *4870* chair, 1986
top and bottom right: *4310* table,
1983; all by Anna Castelli Ferrieri

As political protest movements and the emergent pop culture swept the Western world, traditional notions of a classic, elegant lifestyle eroded or at least gave room to fresh interpretations. Furniture makers—and consumers—freely experimented with new forms and colors, and plastic became the preferred material as it opened up entirely new possibilities for furniture design. Kartell laid the groundwork with a continuous output of innovative patented plastics and new products created by the best contemporary designers, including **Joe Colombo, Gae Aulenti, Vico Magistretti, Anna Castelli Ferrieri, Ignazio Gardella, Achille Castiglioni, Giotto Stoppini, Sergio Asti, Centrokappa,** among others. Colombo's *4867* of 1968 was one of the first large chairs made of ABS plastic. Chubby and stackable, it hit a nerve with the public and quickly became a bestseller.

Anna Castelli Ferrieri joined Kartell in the mid-1960s and remained the defining force behind the company's products well into the 1980s. For each new plastic the company developed, she found it an appropriate form. Her *4970/84* stacking containers of 1967, made of ABS plastic, worked without screws or braces. In 1976 she demonstrated how elegant and beautiful plastic salad servers could be; three years later she designed the first plastic stool with long legs—made possible through a unique combination of polypropylene and metal; and her *4870* and *4873* polypropylene chairs of 1985–86 offered a graceful alternative to the blandness of conventional white plastic patio furniture.

Plastics have become a sophisticated material. Since the 1980s, Kartell has added furniture by younger international design stars to its collections, including Philippe Starck's *Dr.*

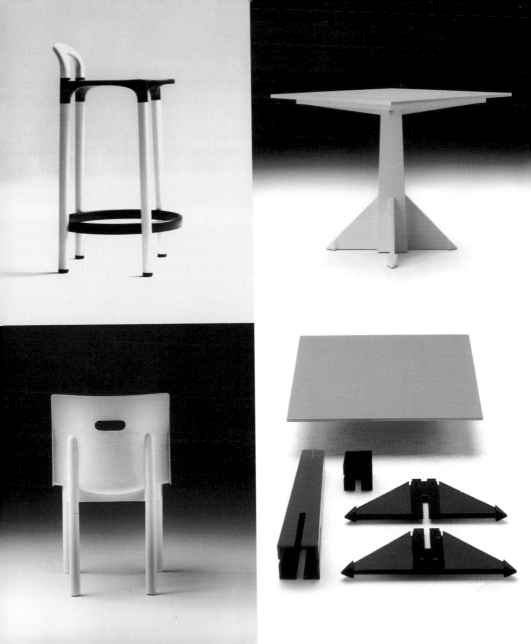

Glob chair. More recently, the company has produced Starck's *Miss Tripp,* an inexpensive chair that jauntily combines wood with pastel-colored plastic and comes disassembled, to be put together at home. Arad's *Bookworm* and Antonio Citterio's elegant *Mobil* container system, made of translucent plastic, became design icons of the 1990s. But even the old masters of Italian design continue to explore new directions. Like most of Kartell's products, Vico Magistretti's molded *Maui* chair is available in many colors, and it seems set to become as popular as Arne Jacobsen's famous *Ant* chair, whose form it echoes.

From material to design—this formula has fueled Kartell's new, affordable solutions for more than five decades, a longevity that makes the company an exception in international furniture manufacturing. Kartell's current managing director, Claudio Luti, once called the firm's staff and designers "missionaries for plastic." Their commitment benefits not only the development of furniture and housewares—Kartell also produces supplies for laboratories and research institutions, which make up almost half of its total sales.

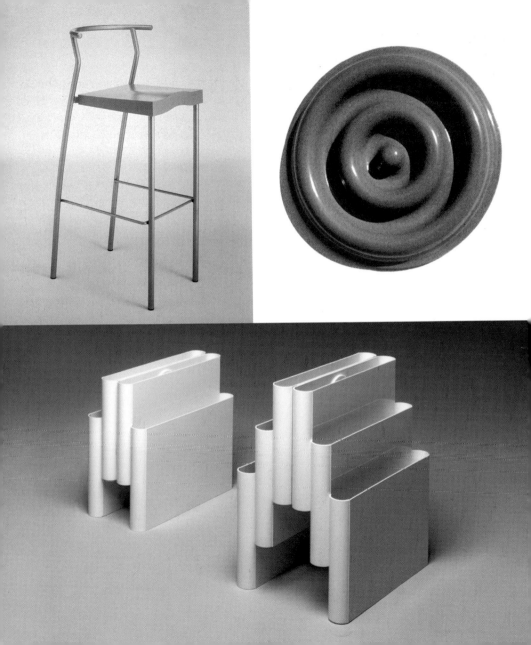

KING-MIRANDA

Industrial, furniture and lighting designers

In 1996, for the first time in its history the renowned Danish lighting manufacturer Louis Poulsen turned to a non-Scandinavian studio to design a new outdoor light. Perhaps it was King-Miranda's mix of British understatement and Spanish temperament that prompted the decision. The result of the cooperation was a high-tech creation named *Borealis,* which now illuminates areas like the plaza in front of the La Défense arch in Paris.

The studio of Perry A. King and Santiago Miranda, which has been based in Milan since the mid-1970s, specializes in a combination of serious design research, a talent for presenting technology in a beguiling package, and the courage to use suggestive forms to satisfy emotional needs. King-Miranda have designed computer interfaces and photocopiers for Olivetti, as well as chairs and corporate identity programs. They are particularly fascinated by light; the best known of their many designs for Arteluce is probably the *Donald* desk lamp, a friendly homage to Disney's cartoon duck. In addition to their numerous research projects, they have also established the European Designers Network, EDEN.

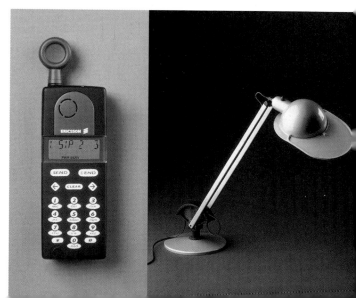

GSM cellphone for Ericsson, 1995
Donald lamp for Arteluce, 1978

KRIZIA

Fashion designer

Mariuccia Mandelli took her professional alias, Krizia, from a Platonic dialogue that denounces the vanity of women. Interested in fashion from an early age, she followed her parents' wishes and became a teacher before designing her first practical clothes for young women in 1954. A decade later she became famous overnight when she won the *Critica della Moda* prize for her presentation at the Palazzo Pitti in Florence. In the 1960s she experimented with Op Art elements and in 1970 dressed her models in hot pants, which became a European fashion hit the following year.

One of Krizia's trademarks are animal motifs, which have accompanied her collections since the 1960s; every year a new animal shows up on her T-shirts, sweaters, or dresses as a good-luck charm. Krizia has consistently offered a range of designs from which any woman can chose pieces that suit her personal style. Her work has significantly contributed to the success of Italian ready-to-wear fashion.

1933 Mariuccia Mandelli born in Bergamo

1954 makes her first tops and skirts

1964 presents collection in Florence and wins *Critica della Moda* prize

1970 introduces hot pants

1971 *Tiberio d'oro* prize

1986 appointed *Commendatore della Repubblica Italiana*

1995 *Krizia. Una storia,* exhibition in Milan

Products

1964 Op-Art collection

1967 *Kriziamaglia* knitwear collection

1970 Hot pants

1978 pleated raincoats

1991 *Krizia Uomo* menswear collection

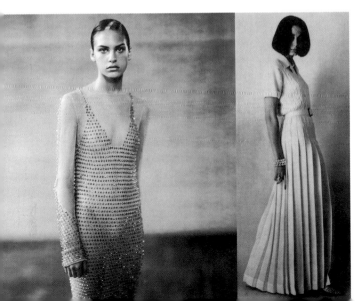

left: Dress from summer collection 1997

right: Dress, 1964, received the *Premio Pitti Critica della Moda*

Ugo LA PIETRA

Artist, architect, furniture and lighting designer

1938 born in Tirino (Pescara)

1964 graduates from architecture school in Milan

1973 cofounder of **Global Tools**

1979 *Compasso d'oro*

1981 editor at *Domus* (until 1985)

1985 art director for **Gruppo Industriale Busnelli**

Products

1969 *Uno sull'altro* bookcase

1975 *Telaio* bed with canopy

1983 *La casa telematica*, exhibit at Milan furniture fair

1984 *Pretenziosa* chair; *Agevole* chair; both for Gruppo Ind. Busnelli

1988 marble table for **Up&Up**

1997 *A bocca aperta* mirror

Plants shoot out of a tabletop; a vase, rather than serving as a vessel for cut flowers, offers a flat surface to grow a small garden. With "moral recklessness," in the words of Pierre Restany, Ugo La Pietra illustrates his conviction that art objects and utilitarian items have moved toward a synthesis outside the notion of "arts and crafts."

A designer, artist, filmmaker, exhibition organizer, critic, and philosopher, La Pietra describes himself as a researcher exploring the relationships between individuals and space, between humans and their urban context. His examination of the "system of immbalance" made an important contribution to the **Radical Design** of the 1960s and 1970s. La Pietra's "fantastic" objects and installations have indeed thrown the world of design off balance, serving as irritants that raise new questions and trigger new ways of looking at things. Many of his designs are mass-produced by **Zanotta, Gruppo Industriale Busnelli, and Poggi.**

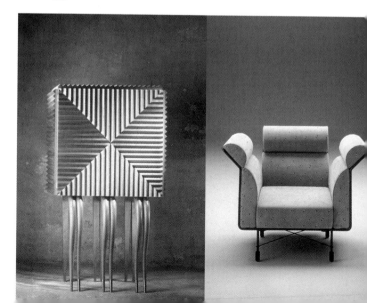

Liquor cabinet for *Sellaro*, 1988
Agevole chair for Gruppo Ind. Busnelli, 1984

LA RINASCENTE

Department store chain

The history of La Rinascente, which today is Italy's largest department store chain, is closely associated with the birth of Italian industrial design in the 1950s. In 1954 the store instituted the *Compasso d'oro design* award to "encourage industrialists and artisans to improve their production on the technical as well as the aesthetic level," in the words of its owner, Aldo Borletti. Founded in 1865 by Ferdinando Coccone as Italy's first ready-made clothes emporium, the rapidly growing company was sold to Borletti, a businessman, in 1918. After the Second World War, La Rinascente became a creative hotbed for talented young designers. The graphic artists **Max Huber** and **Albe Steiner** developed the firm's new identity and advertising (fig. p. 45); such artists and designers as **Bruno Munari** and **Tomàs Maldonado** worked on window displays and special presentations; and many young industrial designers, including **Mario Bellini**, started their careers at the in-house design department. Even **Giorgio Armani** is among the store's alumni—he once worked as a buyer in its fashion department.

1865 Ferdinando Bocconi opens first Italian store for ready-to-wear clothes on Via Santa Radegonda in Milan. Four years later, store moves to Piazza del Duomo

1917 store is sold to Senatore Borletti; the poet Gabriele d'Annunzio invents new name, La Rinascente

1918 destroyed in fire

1921 reopening

1943 destroyed in bomb attack

1950 reopening

1954 La Rinascente institutes *Compasso d'oro*

1967 *Compasso d'oro*

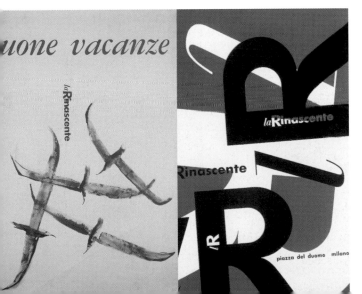

Buone Vacanze, poster by Roberto Sambonet, 1958

Advertisment by Max Huber, 1951

LANCIA

Automobile manufacturer

While **Alfa Romeo's** cars project a fast, racy image, Lancias have always embodied a more sophisticated lifestyle. Favored by illustrious clients such as Prince Rainier of Monaco, Brigitte Bardot, and Marcello Mastroianni, the company's impeccably elegant models included the 1952 *Aurelia,* the 1954 *Aurelia B 24 Spider,* and the 1956 *Flaminia* luxury sedan, with its panoramic windshield.

The company was founded in 1906 by the race driver Vincenzo Lancia, and throughout the 1930s was highly successful in the Grand Prix and Rallye circuits while also developing an impressive roster of luxury automobiles. Lancia produced such milestones of automotive history as the 1921 *Lambda,* the first car with an integral body, and the 1937 *Aprilia,* with its flowing lines, which, in **Pininfarina's** coupé version, became an Italian answer to American streamline design. After the war, Lancia reclaimed its tradition of racing victories and its reputation for superior design by producing cars codeveloped with **Bertone,** Pininfarina, Touring, and Zagato. Lancia, which today is known for elegant mid-sized cars, was acquired by **Fiat** in 1969 but continues to exist as an independent brand.

Lancia *Lambda IV,* 1924

Page 233
top: Lancia *Aurelia Spider,* 1954
bottom: Lancia *Stratos* by Bertone,
1971

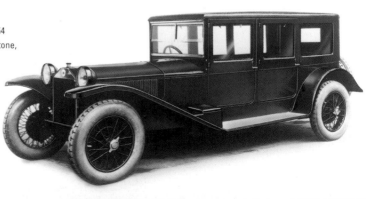

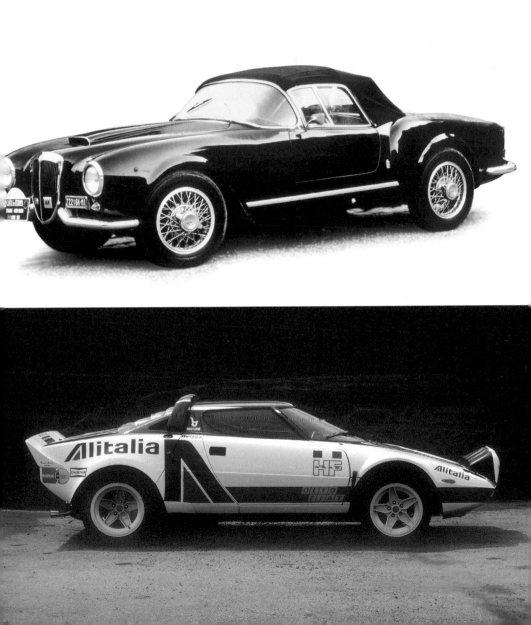

Piero LISSONI

Architect and furniture designer

1956 born in Seregno
studies architecture in Milan

1977 collaborates with G14 studio, Milan (until 1984)

1984 opens studio in Milan

1998 showroom for **Cappellini** in Milan

Products

1984 corporate image for **Molteni & C.**

1989 *Esprit* kitchen for **Boffi**

1993 *Filoti* lamp for **Artemide**

1995 *Atlantic* bed and *Met* sofa for **Cassina**

1996 *Bench-Sofa* for Living Divani

Modern system for Porro, 1996

Piero Lissoni dislikes design's cult of personality and fetishistic celebration of objects. He finds most of the resulting products rather hard to live with. As an antidote, he creates products with a "silent quality." His comfortable *Frog* chair and restrained *Village* and *Box* sofas for Living Divani; his Basics bed and modular *Modern* wall cabinet system for Porro; the *Esprit, Works,* and *WK 6* kitchens for **Boffi**; and his sofas for **Cappellini** and **Cassina** are all impeccably simple and functional in their discreet use of the formal vocabulary.

Lissoni names Charles Eames, Ludwig Mies van der Rohe, and Eileen Gray as his historical touchstones. Like them, his goal is to reach an ideal synthesis of design, material, and construction. Lissoni describes his concept—an integral effort to design every aspect of a given project—as "medieval." His studio develops interior architecture and furniture as well as public relations programs for companies such as Boffi, Lema, Cappellini, and Units. In 1998 he also designed Cappellini's new showroom in Milan.

LUCEPLAN

Lighting manufacturer

Visitors to Luceplan's factory at the edge of Milan seem to happen upon a dissection: the company's high-tech products are exhibited in a carefully disassembled state. The presentation is about transparency, a constructive principle shared by all the lighting products developed here. Everything at Luceplan looks up-to-the-minute: the technologically-oriented forms, the clean corporate identity, the bold presentations. The aesthetics are spare, though that does not exclude spectacular effects; at the 1996 *Euroluce* trade fair the firm showed technical drawings and two-dimensional studies but not one actual product.

Luceplan is one of the most advanced lighting laboratories of the 1990s, and its designers include some of the most promising talents of the last decade. Two of them, **Paolo Rizzatto** and the **Alberto Meda**—one trained as an architect, the other as an engineer—have worked with the company from its beginning and given its products their unmistakable look. Their designs include the iridescent *Titania* hanging lamp (fig. p. 38), with its

Luceplan spa, Milan
1978 founded by Riccardo Sarfatti, **Paolo Rizzatto** and Sandra Severi

Products
1980 *D 7* by Paolo Rizzatto
1985 *Berenice* by **Alberto Meda** and Paolo Rizzatto
1986 *Costanza* by Alberto Meda and Paolo Rizzatto
1987 *Lola* by Alberto Meda and Paolo Rizzatto

Berenice desk lamp by A. Meda and P. Rizzatto, 1985

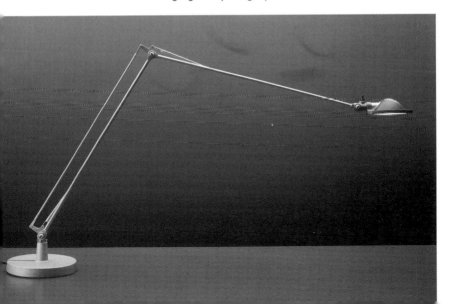

Page 237
top left: *On Off* table lamp, 1988
bottom left: Elements for *Titania* hanging lamp, 1989
right: *Lola* floor lamp, 1987

exchangeable color filters; the delicate *Berenice* desk lamp, a smart new take on traditional library lamps with a softly gleaming green or blue shade; and the geometric, radically simple *Costanza* table lamp. Jean Nouvel, Häberli & Marchand, Dante Donegani, **Denis Santachiara,** and Ross Lovegrove have also designed lighting for Luceplan.

One of the firm's newer products, Rizzatto's *Glassglass* hanging lamp, is equipped with a clever holding device. Different shades—colored or clear, round or pointed—can be snapped into an aluminum ring attached to a clamp that secures the electrical cord. The shades can be easily exchanged or cleaned, a design that is typical of Luceplan's commitment to offering flexible solutions for different needs and tastes. Despite their metallic aesthetic, the designs are far from frigid, and there is no shortage of bold colors.

Long, extensive research precedes the introduction of each new product, and there is a strong accent on teamwork. The company was founded in 1978 by three architects: Riccardo Sarfatti, the son of lighting pioneer **Gino Sarfatti;** Paolo Rizzatto; and Sandra Severi (Alberto Meda has since joined them as a partner). Architecture remains the central point of reference for the group, who made a name for themselves by planning the lighting for Milan's Linate and Malpensa airports before setting up their own design and manufacturing company. Commercial and architectural lighting are still an important part of Luceplan's business, as is the belief that good design is best combined with reasonable prices.

Italo LUPI

Graphic designer

Italo Lupi works on the border between art and communication. He has helped shape the profile of contemporary Italian graphic design without following accepted rules. He became extraordinarily successful with his designs for the Vatican Museums, the lighting company **bTicino,** and Italy's broadcasting company RAI, but is perhaps best known for his work as an art director for **Domus** and **Abitare** magazines.

Lupi's style is characterized by his refusal to use standardized grids. "One comes to realize that some graphic problems may have a three-dimensional solution," he says. In his layouts, he often presents complex, upbeat combinations of typography, drawings, and photographs, as in his 1991 calendar, whose pages are flooded with colorful numbers. He designs for alert, active users to whom chromatic finesse is more important than quick orientation.

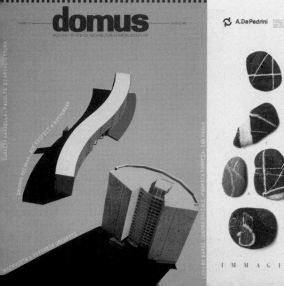

In 1996 Lupi designed the exhibition *Latin Lover* for the *Pitti Immiagine* fashion fair. Set in an abandoned railroad station, the show was a memorable success. "After the exhibition you are left not merely with a catalogue, but with memories of a spectacular act of communication," said **Achille Castiglioni,** one of the doyens of Italian design. Ironic and lusty, the presentation moved along an axis that ended in a pavilion dedicated to the quintessential Latin lover, Rudolph Valentino. That final destination was preceded by a gallery of the "Latin man per se,"shown in forty-eight photographs, which Lupi had "toppled"—they were lying on soft sand from Adriatic beaches, their "work base."

Lupi is currently the art director and managing editor of *Abitare* magazine. In 1998 he won the *Compasso d'oro* for his design of **Olivetti's** company magazine, *If.*

1986 art director of *Domus*

1989 art director of *International Design Conference* in Aspen, Colorado

1992 publisher and art director of *Abitare*

1998 *Compasso d'oro*

Projects

1988 poster for *Moda Italia,* exhibition, New York; design for *Triennale* with **Achille Castiglioni** and Paolo Ferrari; *Printed in Italy,* book project

1990 poster for Museo Di Storia Contemporanea, Milan

1996 exhibition design for *Latin Lover – a sud della passione* in Florence

From left:

Cover for *Domus* magazine, 1990

Poster for De Pedrini illustrating the alphabet, 1992

Two calandar pages for Grafiche Mariano (1991–1996)

Vico MAGISTRETTI

Architect and designer

"I have always tried to not produce any oddities," Vico Magistretti once said. His work avoids all formal excesses, fashionable trappings, and ephemeral ideas. Designers, he believes, need to develop lasting solutions.

An éminence grise of Italian postwar design, Magistretti is reserved as a person and as a designer. His works' subtle qualities gradually reveal themselves through daily use. Magistretti first made a name for himself in the late 1950s; inspired by rustic furniture, his wooden *Carimate* chair, with a woven raffia seat, marked the beginning of a fertile relationship with Cassina and earned him a reputation as a master of simple, austere forms. His many designs for **Cassina** include the cozy *Sinbad* seating furniture, which developed from the idea of a horse blanket thrown over a trestle.

In the 1960s, when the material properties of plastic inspired wild experiments, Magistretti decided to tackle the new possibilities with a distinctly different approach—an attempt to find elegant form for a material often denounced as tacky. In contrast to **Joe Colombo's** famous 4867 chair for **Kartell** (1968), which Magistretti thought "looked like an elephant," he set out to design a chair with slender legs, cast in one piece. The experiment proved successful: his *Selene* chair, which is still produced by **Artemide,** helped change the perception of plastic being an inferior material.

For Artemide, Magistretti also designed the small *Eclissi* lamp in 1965. Playful in appearance, it is cleverly designed with a simple but ingenious mechanism that allows the user to regulate the intensity of light by turning the curved shade to the "half moon," "full moon," and "new moon" positions. Magistretti has also designed lighting for **O Luce,** including the 1977 *Atollo* table lamp (fig. p. 34), a masterpiece of geometric composition that

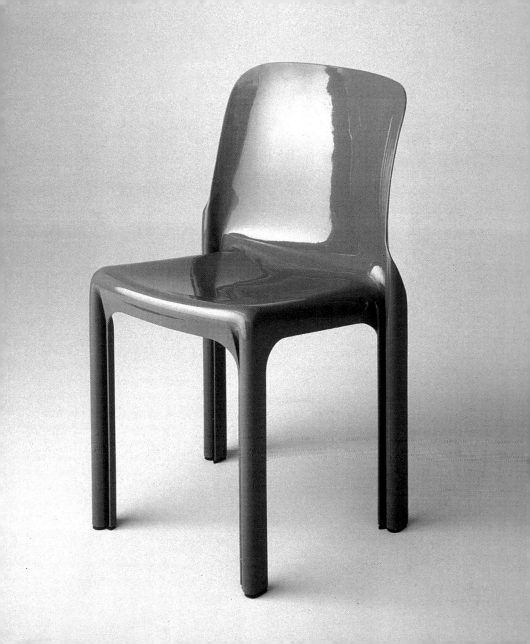

Rosenthal

features an illuminated hemisphere seemingly hovering over a cylinder, also illuminated. Since the mid-1980s, Magistretti has created many furniture designs for De Padova, a company that shares a preference for the classic, elegant lines epitomized in his aluminum-and-plastic *Silver* chair, a redesign of Marcel Breuer's 811 wooden chair for Thonet (1925). One of Magistretti's most successful recent designs is the *Maui* chair for Kartell, a plastic variation on the simple molded-wood chair perfected by Arne Jacobsen.

Magistretti began his career as an architect in the 1950s, and despite all his success in product design, architecture has remained his true passion. If it seems surprising that he continues to develop small, everyday objects, an explanation may be found in his understanding of design as a way of communicating with humanity at large.

Maralunga sofa
for Cassina, 1973

Page 243
Lousiana chair
for De Padova, 1993
Mezzachimera floor lamp
for Artemide, 1966
Golem chair for Poggi, 1970

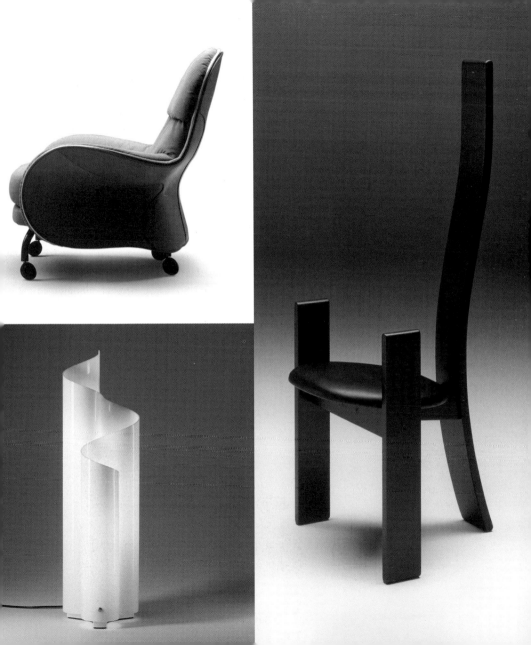

MANDARINA DUCK

Manufacturer of bags and accessories

Plastimoda spa, Cadriano
di Granarolo Emilia (BO)

1968 founded in Bologna

1977 brand name Mandarina
Duck introduced

Products

1977 *Utility* collection

1981 *Tank* collection

1988 *Hera* collection

1994 *Wink* collection

Mandarina Duck is proof of the theory that acting against prevailing trends is often the key to success. In 1977, when natural materials and muted colors dominated the accessories industry, the company launched its exuberantly colorful, brazenly synthetic *Utility* line of bags. Today Mandarina Duck is Italy's market leader, and its bags and backpacks, from the casual *Tank* and elegant black *Hera* lines to the playful *Wink* collection, have become ubiquitous fashion statements among younger women. In a recent survey, the Bologna-based company's products were named as "quintessential objects," taking their place alongside Levi's 501s, the Fiat *500,* **Brionvega's** *TS 502* box radio (fig. p. 146), and the Coca-Cola bottle.

Mandarina Duck continuously researches and develops new materials and has registered some eighty patents. Close cooperation with renowned designers is central to the firm's success. For the corrugated-rubber look of the Tank collection, Richard Sapper borrowed a special inflation process from the automobile industry to stabilize the material. Under the direction of **Mario Trimarchi,** the **De Lucchi** studio developed the firm's graphic identity program; De Lucchi also designed the interiors of the company's stores. Mandarina Duck also produces timepieces, writing utensils, and textiles.

Suitcase for *Tank* series by Alberto
Meda, 1989

Page 245

top: *Linea Twice* bag, 1998

bottom left: *Wink* knapsack, 1994

bottom right: Store design
by Studio De Lucchi, 1996

Angelo MANGIAROTTI

Architect, furniture and product designer

Eros marble table for Skipper, 1973

Page 247
Chicago fiberglass chair for Skipper, 1980
Clizia seats for Skipper, 1990
Incas stone table for Skipper, 1977
Askos pitcher for Colle Cristalleria, 1986

"Material is to design what the brain is to thought," Angelo Mangiarotti says, explaining his highly considered use of wood, plastic, glass, and metal. For him, each design project is primarily a transformation of materials. In his opalescent *Lesbo* glass lamp for **Artemide** and in the *Eros* and *Fiorera* marble tables for **Skipper,** the *Chicago* fiberglass chair, and the *Ergonomica* flatware set, the final form did not follow the designer's fancy but rather the peculiar language of the material.

Mangiarotti has rarely mixed materials, almost obsessively insisting on keeping them pure. Technology, in his approach, provides the syntax while design controls the relationship between theme and variation. "The correctness of the design process is almost more important than the quality of the product," he says. Mangiarotti discovered his love of materials through architecture, which has remained the main focus of his career. But with his research into fabrication processes and materials, particularly plastics, he has been giving new directions to Italian design since the 1950s.

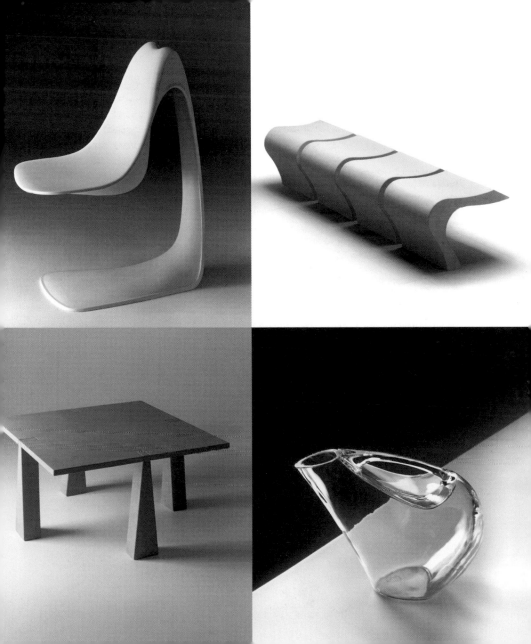

Enzo MARI

Artist, theorist, furniture and product designer

"When I have designed an object and people say to me, 'Oh, good job!' I cannot help but wonder, what did I do wrong? If everybody likes it, it means that I have affirmed reality as it exists, which is precisely what I do not want." Enzo Mari's position is a principled antithesis to the contemporary design industry, which he deplores for its excess production of useless, kitschy products.

Mari maintains a vision of design that is informed by Karl Marx's critique of capitalism and the French Revolution's ideal of equality. Trained as a fine artist, Mari published his first theoretical writings on the psychology of visual perception, aesthetics, and design in 1952, when he was just twenty years old. In his more than 1,400 objects and furniture designs, he has given his thinking material shape and formulated his demand for good, affordable design for everyone. His iron *Putrella* bowl, wooden games, and plastic objects for **Danese** (fig. p. 47) all take advantage of their material's properties to arrive at graceful formal solutions. Usefulness is always the ruling principle,

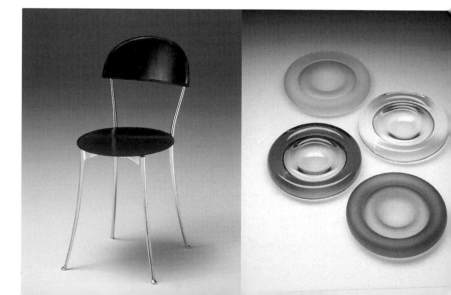

whether Mari is designing book covers, housewares, or tiles. The furniture he has developed for **Driade** and **Zanotta** includes such functional pieces as the lightweight *Delfina* stacking chair and the *Day-Night* sofa bed.

In 1993 Mari was appointed director of design at Berlin's venerable Royal Prussian Porcelain Manufactory, KPM. In close cooperation with the company's artisans he has been developing small numbers of archetypal forms, which are then produced in elegant variations. An idealist at heart, he has little tolerance for designers whose sights are trained on fame and fortune: "A designer's most important task is to define his own model of an ideal world," he says, "not to create an aesthetic one. If he doesn't have his own ideology he is a fool who only lends form to other people's ideas." Whether he has succeeded in realizing his ideas will ultimately be decided by the consumer—Mari's products are not among the least expensive, but certainly among the most beautiful.

Products

1958 *Putrella* bowl

1966 *Timor* table calendar;
both for **Danese**

1968 *Elementare* tiles
for **Gabbianelli**

1970 *In Attesa* waste-paper
basket for Danese

1971 *Sof-Sof* chair

1974 *Delfina* chair;
both for **Driade**

1984 *Giglio* letter opener;
Sixteen Fishes, game for
children;
both for Danese

1996 *Berlin* tableware set for
KPM

From left:
Tonietta chair for Zanotta, 1985
Delos glass ashtray
for Danese, 1981
Putrella bowl for Danese, 1958

Sergio MAZZA, Giuliana GRAMIGNA
Architects, furniture and product designers

1961 Sergio Mazza and Giuliana Gramigna found SMC Architettura

Products

1969 Mazza:
Toga plastic chair for **Artemide**

1989 Gramigna:
Giuliana faucet for **Olivari**

1995 Flamen and Flamina lamps for Quattrifolio

Bacco plastic container for Artemide, 1967

Marlia lamp for Quattrifolio, 1989, both by Sergio Mazza

From furniture to lighting and faucets, Sergio Mazza and Giuliana Gramigna's designs come alive in the dynamic space between creative inspiration and industrial process. They see themselves as architectural designers who develop each object in the context of its environment. On this common conceptual basis, they work on individual or joint projects such as their numerous geometric lighting solutions for Quattrifoglio and their furniture for Cinova, Full, and Frau. Modernism and minimalism are unmistakable influences on their designs. Mazza's comfortable Poker chair, for example, consists of four identical pieces that serve as sides, back, and seat.

Mazza first made a name for himself as a pioneer of plastics technology with his throne-like 1969 Toga chair (fig. p. 7) for **Artemide,** an undisputed classic of Pop design. Gramigna is best known for her purist collection of faucets for **Olivari.**

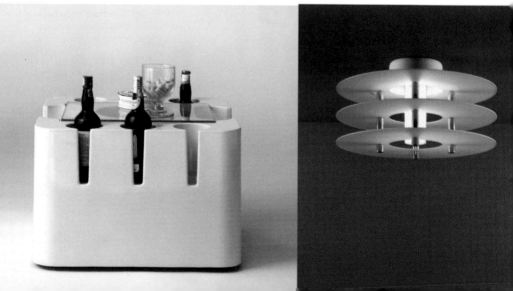

Industrial and furniture designer

Unlike most Italian designers, Alberto Meda is not an architect but an engineer by training. His most important source of inspiration is modern technology, which he describes as a "supermarket of creative possibilities." For his design of the *Tank* luggage collection for **Mandarina Duck,** he adapted a blowing technology used in the automobile industry for producing gas tanks. (Meda worked as a consultant to **Alfa Romeo** for several years.) The resulting series of suitcases is not only extremely sturdy and pressure-resistant but also extraordinarily lightweight. Transparency is another central theme of Meda's work, particularly in furniture. In 1987 he designed the *Light Light* chair for Alias as a successor to Gio Ponti's 1957 *Superleggera,* once touted as the world's lightest chair. Made of carbon fibre and aluminum, the chair proves equal to its name with a weight of a little over two pounds.

Meda has consistently focused on exploring new material possibilities and giving them adequate form. He gathered much of

1945 born in Lenno Tremezzina (Como)

1969 graduates from engineering school in Milan, assistant at Magneti Marelli (until 1973)

1973 technical director at **Kartell** (until 1979)

1979 independent designer, collaboration with **Franco Raggi** and **Denis Santachiara**

1982 designs for **Alfa Romeo** (until 1986)

1984 collaboration with **Italtel**

1987 collaboration with **Alias** and **Luceplan**

1989 *Compasso d'oro* (also 1995)

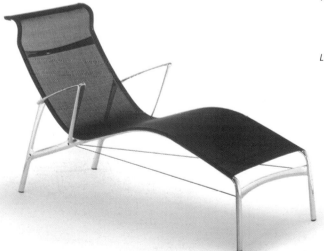

Longframe chaise for Alias, 1994

the requisite know-how in the 1970s as the technical director of **Kartell,** a company whose pioneering research and development of plastic materials has added several important chapters to the history of design. From this orientation toward technology, Meda has developed a poetic formal language. This is perhaps most strikingly evidenced in his lighting designs for **Luceplan,** which include such celebrated pieces as the *Lola, Berenice,* and *Metropolis* lights. His most successful design, the *Titania* hanging lamp (developed with **Paolo Rizzatto)**, while uncompromisingly high-tech in its construction, is also reminiscent of a mysterious, hovering UFO (fig. p. 38).

From Charles Eames, Meda learned that the correct starting point for a project is a constructive idea, not a formal one. And his designs always appear simple and unpretentious, following his paradoxical statement that "the more complex a technology is, the better it is suited for simple utilitarian objects." This is beautifully demonstrated in the small *On-Off* table lamp, a lopsided object that is turned on or off by tilting it. The idea of creating light by a gesture has rarely been conveyed so well. The *Meda office* and *Conference chair* for Vitra, which has won the designer numerous awards, is a similarly pellucid solution to a far more complex technological challenge. His ability to humanize new technologies and translate them into light and simple forms has made Meda one of the most interesting designers of the 1990s.

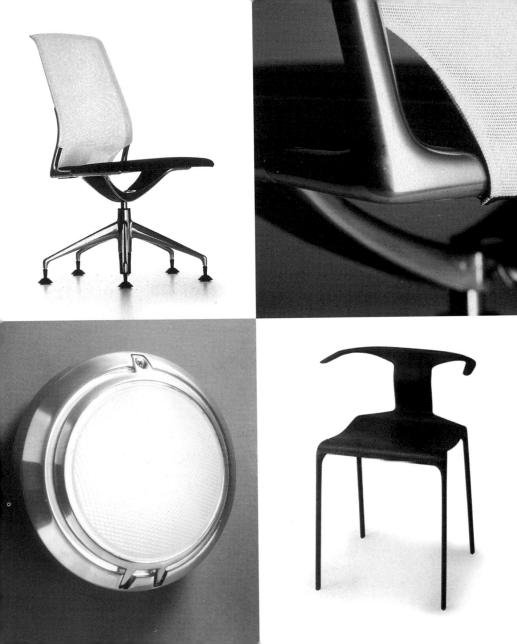

MEMPHIS
Design group; also name of collection and company

Memphis delivered a jolt that left the previously sedate world of design in turmoil. After seeing the group's first exhibition of furniture, hand-crafted objects and lights in Milan in 1981, the *Chicago Tribune's* design critic, Nancy Adams, wrote that whatever else the show may be called, it was the opposite of boring. A development that had been started by the **Radical Design** movement and the **Alchimia** group in the 1960s and 1970s suddenly erupted into wide popularity, with the media doing its best to fan the flames. The orthodoxy of functional beauty in design was called into question, and even appeared obsolete. But despite its revolutionary effects, Memphis did not share the overtly political agenda of the early design renegades.

In its first exhibition and in the many that followed it, Memphis presented multifunctional, colorful, ambiguous objects: shelf units that didn't look like shelves, such as **Ettore Sottsass's** *Carlton* (fig. p. 12) and *Casablanca;* lamps that were really illuminated toys, like Martine Bedin's *Super,* a small

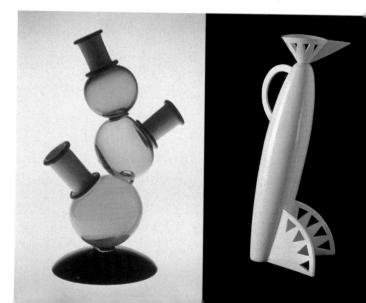

Antares vase
by Michele De Lucchi, 1993

Danubio vase
by Matteo Thun, 1982

Page 255
Casablanca shelf unit
by Ettore Sottsass, 1981

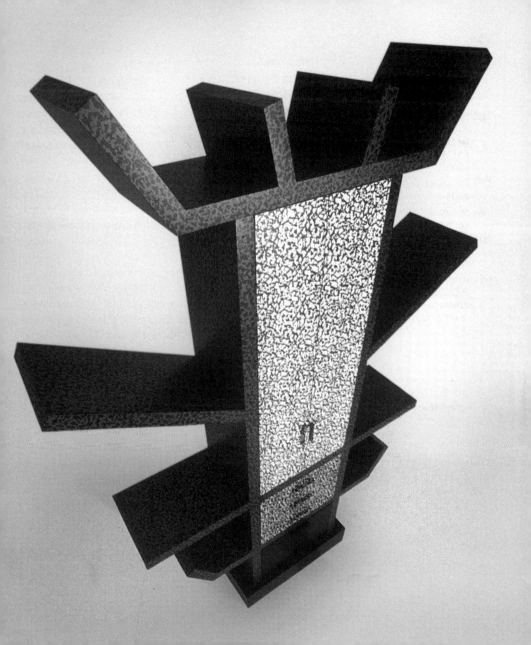

object on wheels equipped with colored bulbs; and vases, plates, and other housewares that broke with conventional forms. Everything seemed possible in Memphis's celebration of shapes, colors, and ideas. The design of surfaces took precedence over the commandment that form follow function. In close cooperation with **Abet Laminati,** Memphis designers created wild patterns for the company's plastic laminates, which provided their objects' signature look.

Ettore Sottsass was the central figure of Memphis, which formed as a loose association of international designers and architects, including **Michele De Lucchi, Andrea Branzi,** Michael Graves, **Aldo Cibic,** Nathalie du Pasquier, Hans Hollein, **George J. Sowden,** Shiro Kuramata, Javier Mariscal, **Marco Zanini,** and Daniel Weil. The group, which found an enthusiastic sponsor in **Ernesto Gismondi,** the head of **Artemide,** came upon its name by accident—Bob Dylan's "Memphis Blues" was played on the stereo during one of their informal meetings. They initially focused on producing objects in small series and questioned criteria such as feasibility, usability and profitability. But Memphis did not remain anti-industrial for long. The "Memphis style" was soon widely imitated and heavily marketed. More and more designers jumped on the bandwagon, and numerous furniture and lighting manufacturers began offering postmodernist conversation pieces. Before long, the original Memphis designers moved on, and in the late 1980s, the group dissolved, though the Memphis collection still exists. Still, by the time of its demise, Memphis had fundamentally changed international design culture and permanently undermined the blind faith in a rigid set of "correct" design parameters.

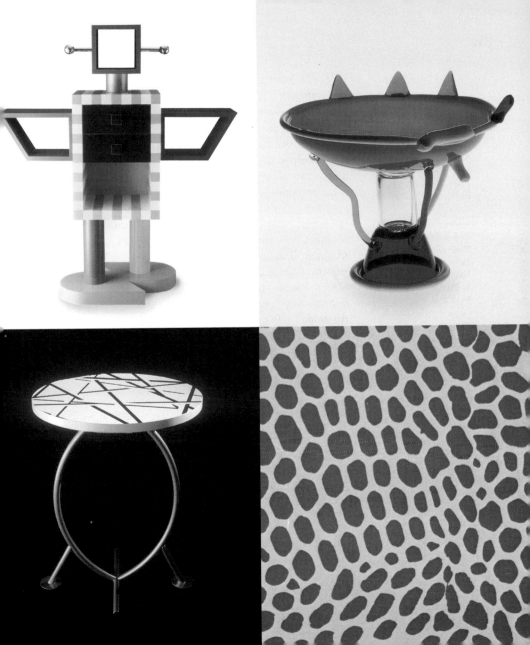

Alessandro MENDINI

Architect, designer, and theorist

In the 1960s no one would have expected that Alessandro Mendini, then a designer and architect at the serious-minded firm of **Nizzoli** Associati, would become one of the most flamboyant and controversial figures in alternative design. It was not until the early 1970s that he stepped forth to vigorously promote a design liberated from all industrial constraints. A tireless worker, he developed his ideas in a variety of forums and functions: as a writer of numerous essays for *Casabella, Modo,* and *Domus* magazines, as a sponsor of the **Global Tools** design school, founded in 1973, and as the head theorist of the **Alchimia** group.

Since the end of the 1970s, Mendini's name has been associated with the concepts of **Re-Design** and **Banal Design,** exemplified in his ironic alterations of classic Thonet and Bauhaus chairs, which he decorated with flags and ornaments. Decorative elements have continued to play an important part in Mendini's work. Ornament covers his portly *Poltrona di Proust* chair (fig. p. 14), the hand-crafted objects of his *Collezione*

Privata, and the surfaces he designed for **Abet Laminati**. As an art director, Mendini also helped develop the product concept of the Swiss watch manufacturer Swatch. Since the 1980s, Mendini has worked as a consultant for **Alessi**; he restructured the housewares manufacturer's entire line, created the famous *Anna G.* corkscrew (fig. p. 44), and designed a house for Alberto Alessi, the *Casa della felicità* on Lago di Orta.

Mendini's designs often appear strange and impenetrable. Stylistically diverse, they have never conformed to the notion of functional design, but instead invite questions about design's meaning and purpose. In that respect, they serve a communicative function. In recent years Mendini, along with his brother Francesco, has dedicated more time to architectural projects. An antithesis to neutral exhibition spaces, his exuberant Groningen Museum, built in 1993, again raises many questions and is thus typical of his gently rebellious work.

1989 opens Studio Mendini in Milan with his brother, Francesco; Paradise Tower in Hiroshima with Yumiko Kabayashi

1993 museum in Groningen

Products

1978 *Poltrona di Proust* chair for **Alchimia** (reintrod. in 1993 by **Cappellini**)

1983 tea and coffee set for **Alessi**

1984 *Dorifora* chair for Zabro

1990 *Cosmesis* and *Metroscape* wristwatches for Swatch

1994 streetcar stop for *Busstop* project, Hanover; *Anna G.* corkscrew for Alessi

From left:
Scala chair for Mastrangelo, 1996
Vassilij chair for Alchimia, 1978
Kandissi sofa for Alchima, 1979

MISSONI

Fashion designer

"Who says there are only colors? There are also sounds!" legendary *Vogue* editor Diana Vreeland reportedly exclaimed when Rosita Missoni showed her a sampling of her creations she had brought along in a large trunk. Vreeland's enthusiastic comment proved a door opener for the Missonis; the 1969 meeting became a milestone in the history of one of Italy's most successful fashion houses.

Originally a cloth and knitwear factory based in Gallarate, the company had been owned by the Missoni family for decades when Rosita joined it in the early 1950s. Even before they met, her husband Ottavio Missoni, a successful track-and-field-athlete, had been interested in fashion. Together with a friend he had designed the official track suits for the Italian Olympic team of 1948. After their marriage, Ottavio and Rosita set up a studio in Milan and focused on creating knitwear.

The Missonis quickly established themselves with designs that were a far cry from knitwear's traditionally drab image. They initially produced fashions for the boutique Biki, then for the **La Rinascente** department store, before coming out with their own label in 1966.

With influences ranging from African cultures to Op Art, they designed youthful, casual knitwear with refined patterns and sophisticated color combinations—qualities that have remained hallmarks of the Missoni style. They became famous for their zigzag patterns, a recurrent theme in their fashions. Their sweaters, produced in relatively limited numbers, have become exclusive fashion statements popular with such celebrities as Tom Hanks and Luciano Pavarotti.

Carlo MOLLINO

Architect, engineer, photographer, and designer

When Carlo Mollino decided to learn to ski, he tackled the task with such determination and success that within a short time he was one of Italy's best skiers. He also became the director of the Italian Winter Sports Association and in 1951 published a pioneering book on modern skiing techniques. In the 1950s, Mollino turned his attention to motor sports and won numerous international car races, including several victories at Le Mans, while designing his own race cars, including the sleek *Bisiluro.* He distinguished himself as a passionate stunt pilot and airplane builder but also as a gifted photographer of nudes and other subjects. He designed elegant women's fashions and shoes, and as a successful inventor, registered some fifteen patents, including a control system that could be programmed for aerial stunt maneuvers. In addition, Mollino designed stage and movie sets and wrote numerous essays. Finally, he was one of Italy's most unusual architects and furniture designers. In the late 1940s, *Interiors* magazine described the highly personal style he had developed as "Turinese Baroque."

Mollino had nothing in common with the **rationalist** approach of the Milan designers. His specialty was a patented process for bending plywood at low temperatures. He had developed it himself and was not shy in exploring its possibilities. Swelling and tumid, meandering and sinuous, his organic forms were often dismissed as lapses of taste. He indulged in extravagant formal experiments such as three-legged, oddly curved chairs, and imitated the female anatomy with reckless abandon: the backs of his chairs echo female torsos; bipartite seats resemble luscious buttocks. Several of his table legs, some of which he dressed in stiletto-heeled shoes, were modeled after dancers at the *Crazy Horse* in Paris. If there is such a thing as "erotic design," Mollino was its most inspired representative. But in his furniture's visual language there are also reflections of ski tracks in the snow or aerobatic figures.

Mollino's life and work blended into an opulent synthesis. From his father Eugenio, a Turin architect, he inherited an urge for

Page 263

Desk, c. 1951-54

left: Chair for Apelli & Varesio, 1950

right: Chair for architecture school
in Turin, 1962

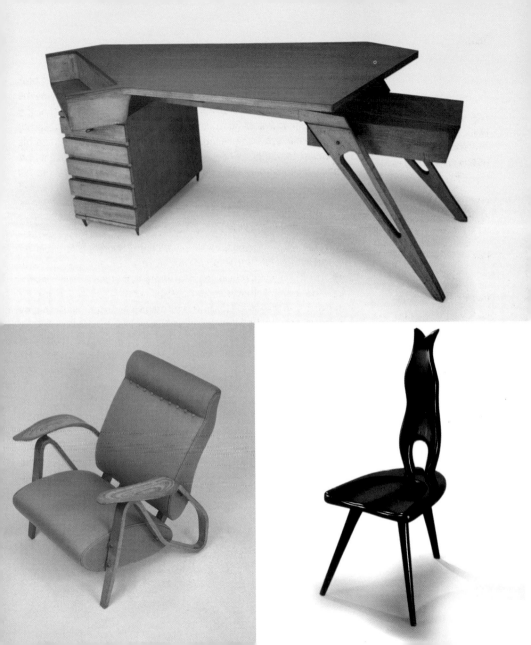

perfection. In all its mannered splendor, Mollino's furniture follows precise constructive principles (fig. p. 31) that were often adopted from airplane and automobile design. However, his furniture was not made for mass-production—it was usually developed for a specific context, such as the Casa Orengo and Casa Minola in Turin, which Mollino furnished in the 1940s.

Mollino lived in Turin throughout his life, and in his work he expressed his love for the Baroque traditions and woodworking techniques of the surrounding Piemont region. For this he reaped small thanks: his hometown permitted the demolition of some of his most important buildings, including the Ippica Equestrian Club of 1937; his bold chairlift station on Lago Nero, built in 1946, was simply abandoned.

Products

1940 chair for Lisa and **Gio Ponti**

1949 interiors and furniture for Casa Orengo, Turin

1950 *Arabesque* furniture series

1953 red-velvet chair for RAI auditorium

1954 *Osca 1100* racing car

1955 *Bisuluro* racing car

1957 furniture for XI. *Triennale* in Milan

1965 women's wear collection

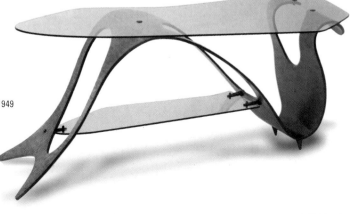

Table from *Arabesque* series, 1949

MOROSO

Furniture manufacturer

From Ron Arad's amorphous organic bulks and Javier Mariscal's cheerful, fifties-style chairs and chaises to the cool elegance of **Massimo Iosa Ghini's** sofas, Moroso's collection mirrors the eclectic sensibilities of the 1990s. Working with internationally renowned younger designers, the company produces seating furniture for an upscale market with sophisticated tastes. That strategy evolved only in the 1980s, when Moroso shifted away from the traditional upholstered furniture it had produced since 1952. The high quality of its fabrics and craftsmanship remain the same, but are now ensured by advanced production technologies. Moroso, whose most important market is Germany, makes furniture for the home as well as for public buildings and offices.

Moroso spa,
Crespano del Grappa

1952 founded in Cavallico di
Tavagnacco (Udine)

Products

1986 *Dinamic Collection*
by **Massimo Iosa Ghini**

1989 *Saruyama*
by Toshiyuki Kita

1990 *Waiting Collection*
by **Rodolf Dordoni**

1991 *Spring Collection*
by Ron Arad

1993 *Gluon* by Marc Newson

1995 *Los mueblos amorosos*
by Javier Mariscal

1996 *Jules e Jim*
by **Enrico Franzolini**

Newtone sofas
by Massimo Iosa Ghini, 1989
The 21 Hotel chair
by Javier Mariscal, 1997

Massimo MOROZZI

Architect, furniture and product designer

"The problem is not to create useful things that are also beautiful. It is to create objects that possess beauty despite perhaps being ugly."

Massimo Morozzi has been on a mission to liberate design from aesthetic value judgments since 1966, when he cofounded **Archizoom,** a collective of Florentine architects who set out to break the functionalist dogma. During the 1970s, Morozzi conducted systematic design research, then focused once more on the design of furniture and objects for **Driade, Alessi,** and other companies in the 1980s. Many of his designs, including the meandering *Paesaggi Italiani* cabinet system for Edra Mazzei, are strikingly witty and colorful. But as fellow designer **Alessandro Mendini** notes, their crucial quality lies in the fact that Morozzi approaches each project by meticulously analyzing its specific requirements. In recent years, Morozzi, who in 1987 became the art director of **Edra Mazzei,** has increasingly focused on communication design.

1941 born in Florence
1966 cofounder of
Archizoom
1967 graduates from
architecture school in
Florence
1972 moves to Milan;
design research at
Centro Design, Montefiore
(until 1977)
1979 *Compasso d'oro* for
design research
1982 opens Massimo Morozzi
Design
1983 establishes O.T.E., a
company specializing in
medical instruments

1987 art director
at **Edra Mazzei**

Products
1983 *Bibì Bibò* bed for **Driade;**
300 Tangram table
1985 *950 Domino* sofa;
both for **Cassina**;
Pasta Set for **Alessi**
1986 *Orchidea* table for **Edra**
1990 *Vapor Set* for Alessi
1991 *Topolone* sofa for Edra

Paesaggi italiani closet system
for Edra, 1996

Motorcycle manufacturer

Moto Guzzi's success is based on a reliable line of large one-cylinder, classic V-2 engines, and on the thoroughly functional design of its motorcycles. In the 1920s, the company paved the way for the large-scale production of motorcycles when it broke from the traditional "motorized bicycle" look. For its committed fan base of "Guzzisti," a Moto Guzzi is the essential heavy road bike—as opposed to the stripped-down, aggressively racy models of the company's domestic competitor, **Ducati** (fig. p. 24). Nonetheless, it was the distinctive roar of its engines as well as its 3,329 racing victories that made the company famous. (It left the racing arena in 1957.) Some of its most notable models are the *Falcone* (1950s and 1960s), the powerful V7 (since the late 1960s), the sleek *Le Mans* and best-selling *California* (since 1970) series. Among the company's most loyal customers is the Italian police, who used the classic *Falcone* bikes throughout the 1950s and 1960s and, in the late 1960s, equipped its motorcycle units with V7s.

Moto Guzzi spa., Mandello del Lario

1921	founded by Carlo Guzzi and Giorgio Parodi in Mandello del Lario
1967	subsidized by Italian government
1997	annual production reaches 6,300 motorcycles

Models

1921	*Tipo Normale*
1925	*Tipo Sport*
1936	*Airone* (until 1957)
1939	*Alce* with sidecar (until 1945)
1954	*Falcone* (until 1967)
1967	introduction of *V7* series
1970	*California* series
1991	*Daytona*
1997	*California Anniversary*

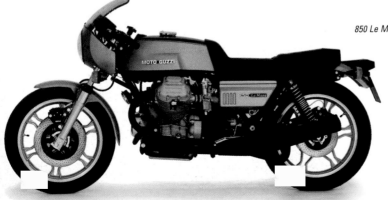

850 Le Mans, 1978

Bruno MUNARI

Artist and designer

Page 269
Cubo ashtray
for Danese, 1957

"Give me four stones and a sheet of tissue paper and I'll build you a wonderland," Bruno Munari once said. His poetic world includes *Useless Machines* and *Illegible Books,* cleverly designed lights and furniture and extensive studies on visual perception. When he died in 1998 at the age of ninety-one, the self-taught artist and designer had been giving given new impulses to Italy's cultural life for some seven decades. In addition to his many accomplishments in product design, he was one of Italy's most important representatives of Op Art (in 1962 he organized a large exhibition on kinetic art for **Olivetti**), a gifted poet, theorist, and teacher, and an innovative graphic artist known to a large audience for his groundbreaking children's books and games, which were designed to educate through playful experimentation.

Munari started out in the 1920s as a painter fascinated by **Futurism.** In 1930 he created his first three-dimensional object, a large red, white, and black mobile made of wood and metal. Titled *Macchina aerea,* it was designed to be set in motion by the slightest breeze. In 1933 he began working on his series of *Macchini inutili* (useless machines), which included a mobile constructed of painted cardboard (1934) and a sculpture made of wire and wooden balls. In their modest simplicity they stood in marked contrast to Futurism's bombastic celebrations of progress. For Munari, the *Macchine inutili* signaled his growing doubt in the traditional concept of art. After breaking with Futurism in the 1930s, he worked as a graphic artist, creating advertisements for such companies as Olivetti and **Campari** (which remained an important client after the war).

Munari's career as a product and environmental designer began in the postwar years, when he created such pieces as the sleek, formally immaculate *TMT* ice bucket (fig. p. 19) and

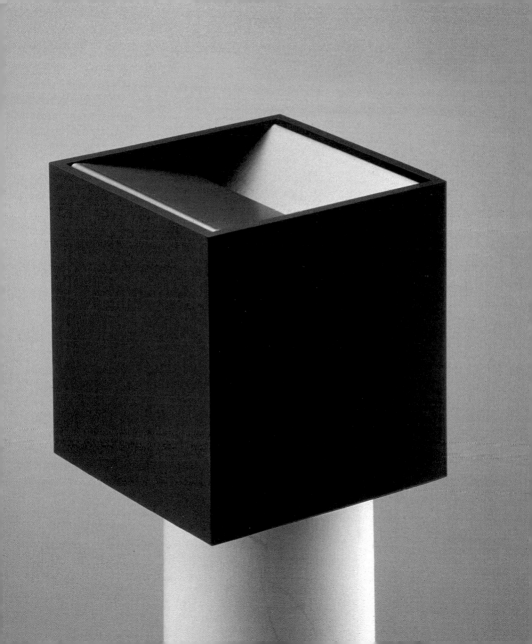

Page 271

top left: *Vademecum* cart for
Robots, 1974

top right: Advertisement for
Campari, 1964

bottom left:. *Illegible Book*, 1953
(red-and-white pages)

bottom right: *Zizi* for Pigomma, 1953

designed exhibitions and store windows for retailers including **La Rinascente.** A particularly fertile relationship developed in 1957 between Munari and the housewares manufacturer **Danese,** for which he designed the legendary *Cubo* ashtray, a black cube into which a strip of aluminum is folded; the *Falkland* hanging lamp, consisting of nylon stocking fabric stretched over hoops of different sizes; and many other useful and beautiful objects. Danese also issued Munari's art multiples, games, and children's books, the first of which were created in 1943 and 1945. Innovative in their formal design, they used devices like fold-out pages to actively involve their readers in the stories they told. Munari's *Positive-Negative* Images and *Proiezioni dirette*, which had developed out of his research into sense perception, formed the basis of a 1959 game in which children could explore light and its effects with the help of transparent and semitransparent materials.

While his objects were usually not created for mass-production, Munari was an important figure for industrial design. In the early 1950s, he invented a small bendable toy monkey named *Zizi,* which made perfect use of **Pirelli's** new type of foam rubber. In the 1970s, he designed the *Abitacolo* steel unit for **Robots,** which combined the functions of bed, bench, and desk in a proposal for the redefinition of living space. Consistently following his own imagination, Munari always steered clear of the design industry's hustle and bustle. His objects are quiet, modest invitations to explore and contemplate the world that surrounds us.

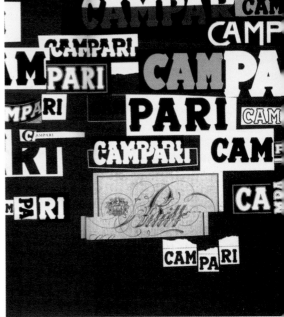

Marcello NIZZOLI

Painter, architect, graphic and industrial designer

When **Olivetti** introduced Marcello Nizzoli's *Lexikon 80* typewriter in 1948 it was instantly acclaimed as a classic. The curators of New York's Museum of Modern Art were so taken by its beauty that they immediately acquired an example for their permanent collection. Like the legendary *Vespa,* introduced the same year, the *Lexikon 80* had an independent shell that covered the mechanical innards like a removable dome. The combination of organic, sculptural form and functional design are a hallmark of Nizzoli's work.

Nizzoli was a consummate industrial designer. Meticulously developing each element of his designs with an eye to the manufacturing process, he put a distinctive aesthetic stamp on Olivetti's products of the 1950s. Nizzoli's machines, such as the portable *Lettera 22* typewriter and the *Tectactrys* calculator, reveal their symmetric perfection from every perspective and stand as defining examples of the **Linea italiana,** with its

1887 born in Boretto
(Reggio Emilia)

1913 graduates after studying art and architecture in Parma

1924 works as graphic artist and painter

1931 collaboration with **Giuseppe Terragni** and **Edoardo Persico** (until 1936)

1934 Parker showroom in Milan (with E. Persico)

1954 *Compasso d'oro* (also 1957)

1963 office building for **Olivetti** in Ivrea

1969 dies in Milan

Products

1926 Posters for **Campari** Bitter and Cordial

1940 *MC 4S Summa* calculator

1948 *Lexikon 80* typewriter

1950 *Lettera 22* portable typewriter

1952 *Studio 44* typewriter; all for Olivetti

1953 *Supernova BU* sewing machine for Necchi

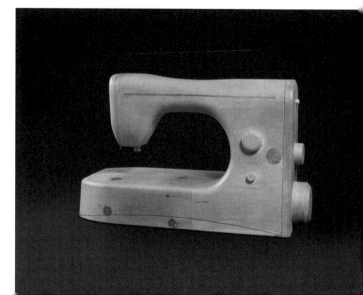

organically rounded forms. At the end of the decade Nizzoli made his first foray into a more angular look with the *Diaspron* typewriter, introduced in 1959.

Nizzoli had started out in the 1920s as an abstract painter and graphic designer influenced by **Futurism.** After designing posters for **Campari,** in 1938, Adriano Olivetti hired him to work in his company's advertising department, which at the time employed some of the best graphic artists in the world. In 1940, Nizzoli designed his first product, the *MC 4S Summa* calculator. But it was not until after the war that he came into his own as a product designer, working not only for Olivetti but also for the sewing machine manufacturer **Necchi,** for which he developed such lucid designs as the *Mirella* of 1957. And Nizzoli's accomplishments in product design should not obscure his significance as an architect: in the 1950s he designed workers' housing, and in the 1960s, office buildings for Olivetti.

1956 *Tectactrys* calculator for Olivetti

1957 *Mirella* sewing machine for Necchi

1959 lighters for Ronson; *Diaspron 82* typewriter for Olivetti

1960 gas pump for **Agip**

Wooden model of *Mirella* sewing machine for Necchi, 1957 (model built by Giovanni Sacchi)

Lexikon 80 typewriter for Olivetti, 1948

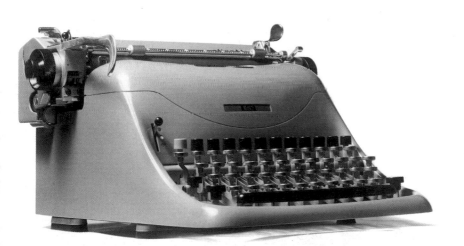

O LUCE

Lighting manufacturer

During the 1960s, O Luce established itself as one of Italy's leading lighting manufacturers. This success was largely due to the work of three very different designers. **Joe Colombo** contributed an experimental, cutting-edge sensibility with such creations as the boldly curved *281* Plexiglas light, the robot-like *Spider* lamp and, in 1971, the *626,* which was the first halogen floor lamp made in Italy. **Vico Magistretti** brought a more discreet, classic look. His geometric *Atollo* table lamp (fig. p. 36) has remained O Luce's best-known product, and his symmetrical *Snow* and *Sonora* hanging lamps have inspired countless copies. **Bruno Gecchelin** rounded out the collection with such restrained, ergonomically designed products as the arching *Dogale 512* desk lamp and the *Gemma* floor lamp.

Since the 1980s, O Luce has also worked with younger designers, including Hannes Wettstein, **Marco Romanelli** and **Marta Laudani, Riccardo Dalisi**, Sebastian Bergne, and Hans Peter Weidemann.

O Luce spa.,
San Giuliano Milanese
1948 founded in Milan

Products

1966 *Colombo 281; Spider;*
both by **Joe Colombo**

1974 *Snow* by **Vico Magistretti**

1976 *Sonora* by Vico
Magistretti (metal version)

1977 *Atollo* by Vico Magistretti;
Dogale 512 by **Bruno
Gecchelin**

1990 *Sister* floor and wall lamp
by **Riccardo Dalisi**

1992 *Gemma* floor lamp
by Bruno Gecchelin

1998 *Lid* hanging lamp by
Sebastian Bergne

Personal 230 desk lamp by Bruno
Gecchelin, 1988

Page 275

top left: *Lanterna* hanging lamp
by Marco Romanelli and Marta
Laudani, 1998

bottom left: *Colombo 281*
by Joe Colombo, 1966

right: *626* floor lamp
by Joe Colombo, 1971

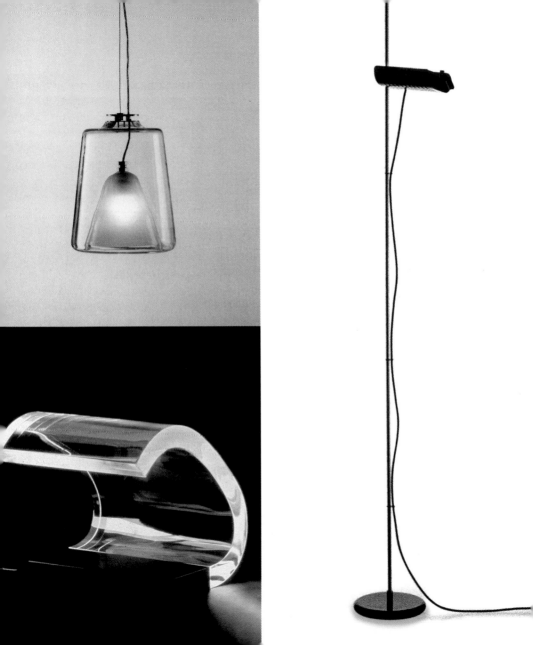

OLIVETTI

Manufacturer of office machines, computers and office furniture

"Typewriters shouldn't be parlor items with ornaments of questionable taste, but should look serious as well as elegant." Camillo Olivetti's simple verdict contains, in a nutshell, the design principle on which the company he had founded in 1908 rose to global prominence. Its consistent design philosophy not only ensured the success of its product lines but also made Olivetti a pioneer in the creation of a unified corporate culture.

The company's first product, the *M1,* designed by Camillo Olivetti in 1911, was also the very first typewriter made in Italy. Conceived with a view to American methods of standardized production, the typewriter's design did away with all superfluous elements—an early example of form following function. But it was Camillo's son, Adriano, who led the company to global fame in the 1930s with his energetic implementation of a comprehensive design strategy. A central component of his vision was Olivetti's advertising and development department, which was established in 1932 and attracted a staff of collaborators that included the Bauhaus artist **Xanti Schawinsky,** Renato Zveteremich, **Bruno Munari, Marcello Nizzoli, Studio Boggeri, Erberto Carboni, Franco Albini,** Giovanni Pintori, the Rationalist architects of the **BBPR** studio, **Luigi Figini,** and **Gino Pollini.** They all helped create a comprehensive corporate identity that encompassed the firm's functional product designs as well as modern advertising graphics, company magazines (including *Tecnica ed Organizzazione,* launched in 1937, and the architectural journals *Urbanistica* and *Zodiac*), and the starkly elegant look of its glass-and-steel production plants, designed by Figini and Pollini. Adriano Olivetti also created an extensive social infrastructure for his employees, providing them with housing, libraries, and day-care centers for their children. The basis of Olivetti's rapid growth and exemplary corporate culture was its

Olivetti spa, Ivrea

1908 founded by Camillo Olivetti in Ivrea

1925 Adriano Olivetti travels the U.S. before joining the firm in 1926

1932 establishment of advertising and development department

1933 Adriano Olivetti becomes general manager

1936 **Marcello Nizzoli** is hired

1937 **Giovanni Pintori** is hired to later become head of advert. dept.

1939 workers' housing and factory buildings by **Luigi Figini** and **Gino Pollini**

1943 Camillo Olivetti dies

1952 Olivetti exhibition at MoMA, New York

1954 Olivetti showroom in New York opens (designed by **BBPR**)

Page 277
top: *Lettera 22,* 1950
bottom left: *Divisumma 14,* 1948
bottom right: Poster for Diaspron, 1959; all by Marcello Nizzoli

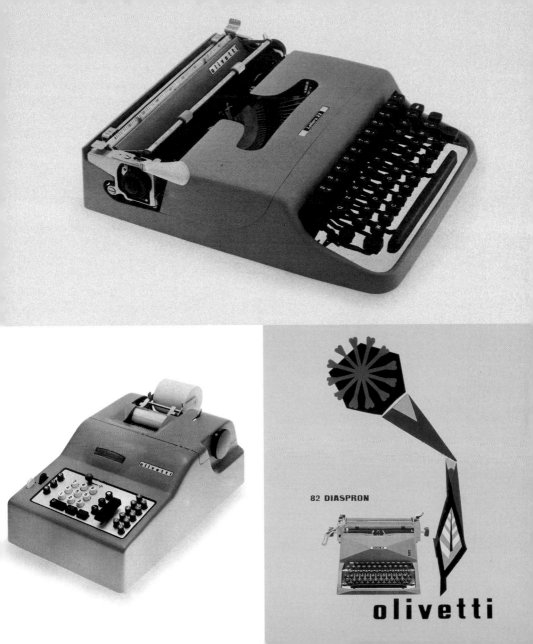

82 DIASPRON

olivetti

Page 279

top: *Spazio* office furniture system
by BBPR, 1960

bottom left: *Valentine* portable
typewriter by Ettore Sottsass and
Perry A. King, 1969 (model)

bottom right: *Tekne 3* typewriter
by Ettore Sottsass and
Hans von Klier, 1963

pioneering combination of functional design and efficient manufacturing processes, which resulted in highly successful products, such as the flat *MP1* portable typewriter of 1932, the *Studio 42* of 1935, and the *MC 4S Summa* calculator (fig. p. 32), designed by Marcello Nizzoli in 1940.

After the end of the Second World War, Nizzoli's organically-shaped typewriters and calculators defined the look of Olivetti. In 1948, he presented the groundbreaking *Lexikon 80* typewriter, whose top shell was the first to be entirely independent of the inner mechanical structure. He followed that in 1950 with the *Lettera 22*, a flat, lightweight, compact typewriter, which, in 1959, was chosen as the best industrial product of the last hundred years by an international jury of one hundred renowned designers.

With the industrial boom of those years, Olivetti became a household name, globally identified with outstanding design. Its ads lived up to the standards of Nizzoli's products. Headed by **Giovanni Pintori,** the company's advertising department became a forum for modern Italian graphic design in the 1950s. And the company was also known for its showrooms, designed by Studio BBPR, Franco Albini and **Franca Helg, Carlo Scarpa,** and **Gae Aulenti;** its growing international network of production plants; and its cultural center, which began organizing art exhibitions in 1950.

At the end of the 1950s, **Ettore Sottsass** replaced Nizzoli as Olivetti's chief design consultant. The appointment, made by Adriano Olivetti shortly before his death, brought in an energetic free spirit who led the company into a new, fruitful period of creative development. Sottsass's debut project was the spectacular *Elea 9003* mainframe computer, designed as an extremely user-friendly control room. In the 1960s, Sottsass created the elegant *Tekne 3* and *Praxis 48* (with Hans von Klier) and the unconventional red *Valentine* (with **Perry A. King**) typewriters,

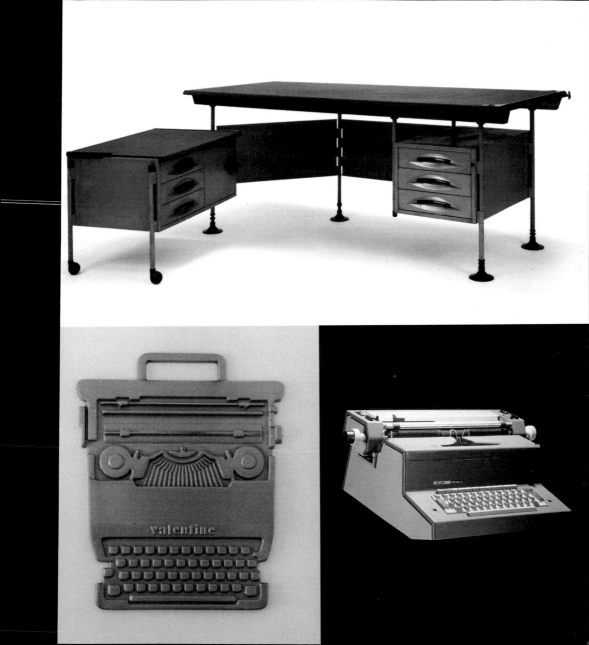

Products

1911 *M1* typewriter
by Camillo Olivetti

1935 *Studio 42* typewriter
by **Xanti Schawinsky**,
L. Figini and **G. Pollini**

1940 *MC 4S Summa* calculator

1948 *Lexikon 80* typewriter

1959 *Diaspron 82* typewriter;
all by **Marcello Nizzoli**;
Elea 9003 computer
by **Ettore Sottsass**

1964 *Praxis 48* typewriter
by Sottsass / von Klier

1969 *Valentine* portable
typewriter by Ettore
Sottsass and **Perry A. King**

1973 *Divisumma 18* calculator
by **M. Bellini**

1992 *Ephesos* office furniture by
Antonio Citterio

1995 *Fax 1000; Echos 20* laptop
computer;
both by Studio **De Lucchi**

Page 281

top: *Praxis 35* typewriter by Mario
Bellini, 1980

bottom left: *TCV 250* terminal
by Mario Bellini, 1967

bottom right.: *Filos 33* notebook
computer by Studio De Lucchi, 1993

as well as office furniture for the *Olivetti Synthesis* line. Hans von Klier took charge of the corporate identity in 1969. Together with C. Castelli and Perry A. King, he put together the legendary "Red Books," graphic standards manuals for all of Olivetti's publications, packaging, and products. In the mid-1960s, **Mario Bellini** joined the company's design team. One of his most striking ideas was to cover the innards of machines like the *Divisumma 18* calculator (fig. p. 16) with a thin orange "skin." He also developed the *Logos* series of calculators and the *ET 101* typewriter.

Despite the success of its designs, Olivetti slipped into a serious financial crisis in the 1970s. A new general manager, Carlo De Benedetti, hired in 1978, reversed the downward slide through rigorous restructuring measures. In the 1980s, the company successfully entered the new fields of office automation and telecommunications. **Michele De Lucchi** and his team created a sleek, technology-oriented look for its fax machines, laptop computers, and multimedia equipment. In 1993, though, the company was again shaken by a severe crisis; one year later several of its top executives were arrested on charges of corruption. Olivetti has since recovered and is now organized as a holding company with numerous international subsidiaries that include the telecommunications firm Oliman, a joint venture with the German Mannesmann group.

Terri PECORA

Fashion, furniture, and product designer

When Terri Pecora moved from California to Milan in the late 1980s, she brought with her a wide range of experience. Trained as a fashion designer, she had also created furniture and eyewear, areas she has continued to explore in her work for **Edra Mazzei,** Interflex, Silhouette, and L.A. Eyeworks.

Design in Pecora's understanding is akin to witchcraft, a magical process that conjures up solutions to everyday problems. Her firm, Plumcake Kids, founded in 1996 with Marian de Rond, focuses on products for children, a long-neglected niche market between design and fashion. "There are plenty of uncomfortable chairs for grown-ups," Pecora says. "It was time that someone designed warm and cozy chairs for smaller children." Other products include *Sleeping Bag,* which easily opens up into a blanket to play on, and a baby carrier that can be comfortably worn on the parent's body.

Eyewear for Silhouette
Children's blanket for Plumcake Kids, 1997

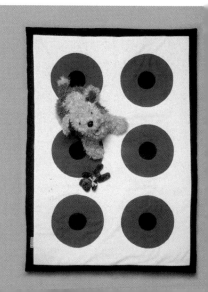

Gaetano PESCE

Artist, architect, furniture and product designer

"I believe that death makes us all alike, and that being alive means to be different. The objects that surround us during the short time of our existence should help us enjoy that prerogative." Gaetano Pesce, who switched from fine art to design in the 1960s, tries to encourage interaction between products and their users. In order to address each user's individuality, he has developed product lines with built-in variations. An emphasis on difference rather than standardization may not be the best qualification for an industrial designer, but Pesce was never eager to fit into that particular mold. He has always been far more interested in the meaning of his objects than in their mere function.

In the late 1960s, Pesce found a mentor in Cesare **Cassina**, who gave the young designer the opportunity to develop numerous experimental pieces. One of his first products became a milestone of design history: made of polyurethane foam, the 1969 *Up* chairs for **C & B Italia** popped out of their wrapping to spring into rounded,

1939 born in La Spezia
1959 cofounder of artists' group N
1961 contacts with Hochschule für Gestaltung, Ulm
1965 graduates from architecture school in Venice
1971 works for **Cassina**
1993 first large architectural project in Osaka, Japan
1996 Pesce exhibition at Centre Georges Pompidou, Paris

543 Broadway chair for Bernini, 1995

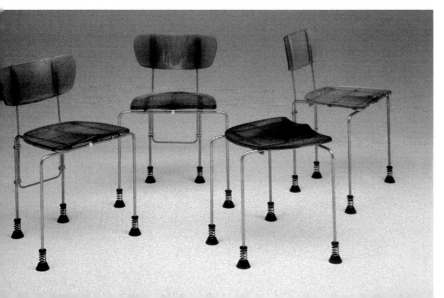

Products

1969 *Up* chair for **C&B Italia**; wall sculptures (*Fioreinbocca*) and *Yeti* chair for Centro Cesare Cassina

1972 *Moloch* lamp for Bracciodiferro

1975 *Sit down* chair

1980 *Sansone* chair; *Dalila* chair series; *Sansone* synthetic resin table;
all for Cassina

1987 *Green Street Chair* for Vitra; *I Feltri* chair for Cassina

1995 *Umbrella Chair* for Zerodisegno; *543 Broadway* chair for **Bernini**

Page 284

top: *Up 5 Donna* chair for C&B Italia, 1969

bottom left: *Dalila* chair for Cassina, 1980

bottom right: *Vertical Loft* New York (model)

body-like shapes. Pesce instantly became one of the most exciting figures within the anti-functionalist **Radical Design** movement. He also designed the 1980 *Dalila* series for Cassina—slightly amorphous chairs, each of which differed from the next by minute formal peculiarities. That same year, Cassina introduced Pesce's *Sansone* synthetic resin tables, with tops whose color and form were decided, within a set spectrum, by the workers who fabricated them. Another notable design for Cassina was the *I Feltri* series of felt chairs (fig. p. 25), which had cloak-like backs. More figurative forms emerged with the 1987 *Green Street Chair* for **Vitra**, a spider-legged, dark-gray object that seemed to have sprung from a monster movie. In the 1990s, he continued to create ingenious surprises such as the aptly named *Umbrella Chair* and the *543 Broadway* chair, which moves slightly under the weight of the body, to remind the sitter of its presence.

Now based in Paris and New York, Pesce has focused on architecture in recent years. Commissioned in 1993 to design a building in Osaka, he created an "organic" structure whose blood-red facade is interspersed with giant containers filled with plants that fill the atmosphere with oxygen. "Over the last thirty years, I have tried to restore to architecture its ability to be meaningful," Pesce says. "I have done this by using recognizable, figurative images reflecting street life and popular culture, and by creating new typologies . . . I have tried to convey feelings of surprise, discovery, optimism, stimulation and originality."

PININFARINA

Car-body designer

In 1995, Sergio Pininfarina received the *Compasso d'oro* for lifetime achievement. Pininfarina had "succeeded in applying a sense of continuity as well as innovative ideas to automobile design," the posthumous award speech declared. "With his designs for Ferrari he has also made a significant contribution to Italy's image in the world." Pininfarina in fact defined the entire look and style of **Ferrari's** sports cars, from the organically shaped *250 GT SWB* of 1960 (fig. pp. 42/43) and the *GTB4 "Daytona"* of 1968 to the flashy 1984 *Testarossa* and the futuristic *Mythos* of 1989.

Founded in 1930 by Sergio's father Battista "Pinin" Farina as a bodymaking workshop for luxury automobiles, the company today employs more than 2,000 people, but has essentially remained a family business. Sergio's children are now in charge of management. The overwhelming number of its designs for **Alfa Romeo, Lancia,** and Ferrari, and more recently for international manufacturers like Peugeot, Rolls-Royce, Audi, Cadillac, and Jaguar, were highly successful.

Pininfarina's early creations, such as the meticulously designed, streamlined Alfa Romeo *6 C 2300 "Pescara" Coupé* and the sleek, aerodynamic Lancia *Aprilia Coupé* from the 1930s are now celebrated as legends of luxury carmaking. After the Second World War, Battista Farina's *Cisitalia Coupé,* with his voluptuously rounded, flowing form, set a new standard for Italian car design. Battista's reputation reached such heights that, in 1961, Italy's president, Giovanni Gronchi, made his nickname official, changing the name of the family, and thus the firm, to "Pininfarina."

While Battista and Sergio were always the haute couturiers of car design, they also created such successful mass-produced models as the Lancia *Aurelia B 20 Berlinetta,* the *Peugeot 405*, and the *Alfa Giulietta Spider,* 27,000 of which were sold.

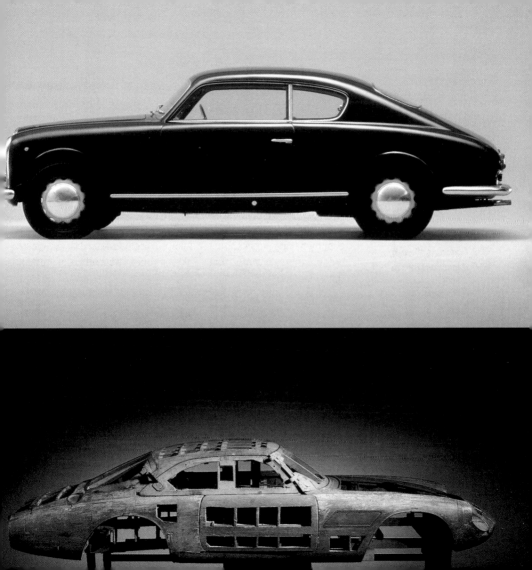

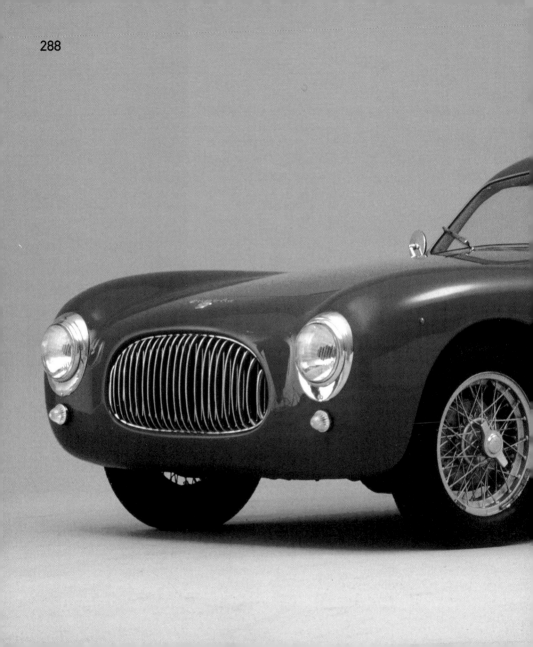

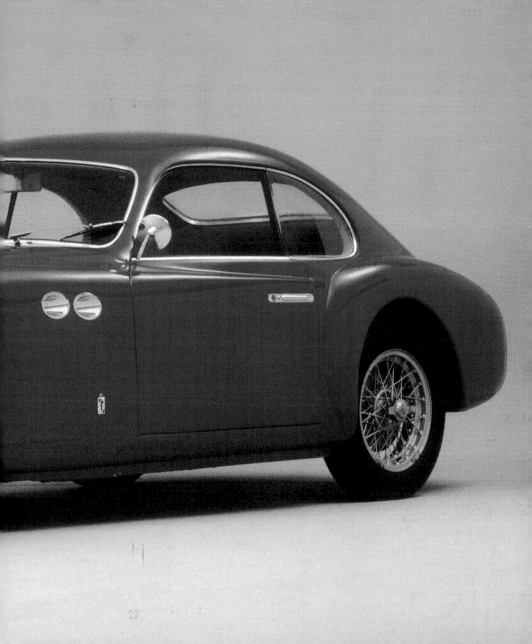

PIRELLI

Manufacturer of tires and rubber products

Pirelli spa, Milan

1872 founded by Giovanni Battista Pirelli

1938 Pirelli Holding S.A. established

Products

1949 *Giocattolin Gommapiuma*, toy figure with internal metal skeleton by **Bruno Munari**

1958 gas container by **Roberto Menghi**

Design by Armando Testa, 1955
Poster by Bruno Munari, 1953

Founded in 1872 as a company "manufacturing and selling elastic rubber goods," Pirelli secured its place in design history not so much with its car tires and cable sheathing but with its modern advertising. **Albe Steiner, Bob Noorda,** and **Massimo Vignelli** were among the designers who created the company's promotional graphics in the 1950s and 60s, and **Armando Testa's** aggressive "elephant" poster and **Bruno Munari's** subtle geometric layouts have lost none of their visual power.

Another important innovation came when Pirelli manager Aldo Bai and his team asked **Marco Zanuso** to explore possible applications for their new foam rubber, *gommapiumo*. Zanuso used the material to develop his famous *Lady* chair, whose success led to the establishment of **Arflex** in 1951. Munari soon created toys out of *gommapiumo,* and **Gio Ponti** designed the Pirelli Tower in Milan (1954–56), one of the most important landmarks of modern Italian architecture.

POGGI

Furniture manufacturer

Poggi was founded over a hundred years ago as a traditional carpenter's workshop, and throughout its history, the quality of its woodworking has been the company's hallmark. Poggi initially specialized in building furniture for exclusive interiors designed by architects. The transformation from custom workshop to manufacturer came in the late 1940s, when Poggi began working with **Franco Albini,** one of the most important representatives of modern furniture design. With its geometric structure, Albini's *Luisa* chair of 1950 is typical of the minimalist look of Poggi's early products. Until 1968, the chairs, tables, and shelves the company built were all designed by Albini; in later years it also began producing designs by **Achille Castiglioni, Vico Magistretti,** and **Afra** and **Tobia Scarpa.** Poggi's output has always been small, its production capacity limited by choice rather than necessity. Proud of its history and committed to the highest standards of craftsmanship, the firm is a living example of the inspirational role traditional carpentry has played in Italian furniture design.

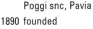

Poggi snc, Pavia
1890 founded

Products
1950 *Luisa* chair
1951 *Cavalletto* folding table
1952 folding chair
1956 *PS 16* chaise;
suspension shelves;
all by **Franco Albini**
1970 *Golem* chair by
Vico Magistretti

PL 19 chair by Franco Albini and Franca Helg, 1957

POLTRONOVA

Furniture manufacturer

Poltronova srl, Montale
1957 founded

Products
1962 *Sgarsul* rocking chair
by **Gae Aulenti**
1964 *Saratoga* suite of chairs,
sofas and cabinets by
Massimo and **Lella**
Vignelli
1965 *Loto* table by **Ettore**
Sottsass;
Multi-use shelf unit by
Angelo Mangiarotti
1966 designs for laminate
furniture by Ettore
Sottsass
1967 *Superonda* seating
elements by **Archizoom**
1970 *Mobili Grigi* by Ettore
Sottsass
1971 *Joe* catcher's mitt chair
1976 *Insieme* suite;
both by **De Pas/**
D'Urbino/Lomazzi
1997 *Able* table
by Tim Power;
Nella chair by
Biagio Cisotti

According to **Radical Design** connoisseur Gianni Pettena, it was **Ettore Sottsass** who triggered the stylistic revolution at Poltronova, with his "lights and colors and the way he enlightened the world of design." Pettena refers to a moment in the 1960s when Sottsass presented his *Mobili grigi* (Gray furniture), which was indeed made of gray glass but bathed in the glaring light of colorful neon frames. Sottsass, who also experimented with laminates and ceramics, paved the way for other leaders of the Radical Design movement, who joined Poltronova in the late 1960s and early 1970s. The company's products of the period include such spectacular pieces as **De Pas/D'Urbino/Lomazzi's** *Joe* chair, which is in the shape of a giant baseball mitt (fig. p. 46); **Archizoom's** *Safari* seating landscape, arranged like a flower's petals but upholstered in leopard print; and **Superstudio's** altar-like *Desino* table. But there were also a number of classical, elegant pieces in Poltronova's collection: in 1962, **Gae Aulenti** had contributed the *Sgarsul* bentwood rocking chair; and **Massimo** and **Lella Vignelli's** purist *Saratoga* sitting-room suite, constructed of square and oblong elements, was introduced in 1964. In more recent years, Poltronova has produced designs by **Ron Arad, Prospero Rasulo, Michele De Lucchi,** and **Franco Raggi.**

Saratoga suite by
Massimo and Lella Vignelli, 1964

Architect, designer, and publisher

"Let us return to chair-chairs, house-houses, works without labels or adjectives, to real, true, natural, simple and spontaneous things," Gio Ponti wrote in his article *Senza aggettivi* (without adjectives), published in 1952 in *Domus* magazine. The chair-chair, which he designed the same year and which came onto the market in 1957, was the *Superleggera* for **Cassina.** Modeling his design after a simple chair he had seen in the fishing village of Chiavari, Ponti retained the vernacular's materials—wickerwork and wood—but reduced the structural elements so drastically that the result was a transparent, elegant piece ideally suited for mass production. Hailed at the time as the world's lightest chair, it also became one of the most famous.

As a bridge between past and present, the *Superleggera* epitomizes Ponti's design philosophy. While he was committed to Italy's traditions of artisanship, his interest in new technologies and manufacturing processes made him a pioneer of industrial design. He is often described as Italy's first product designer, a

1891 born in Milan

1921 graduates from architecture school; opens studio with Emilio Lancia and Mino Fiocchi

1923 artistic director at **Richard-Ginori** (until 1930); participates in *Biennale*, Monza (later director of 1933 *Triennale* in Milan)

1926 **Novecento** group founded

1928 *Domus* magazine founded (editor-in-chief until 1979, except 1941–44 and 1946–47)

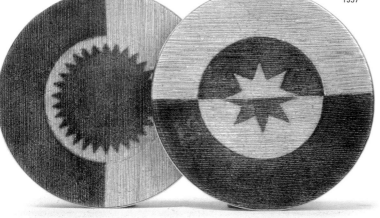

Piatti in smalto del campo plates, 1957

term that did not yet exist in the 1920s and 1930s, when Ponti was already fully engaged in the activity it came to describe. He designed fabrics for Vittorio Ferrari and interiors for trains as well as lighting and furniture for **Fontana Arte,** including the geometrically balanced *Bilia* table lamp, which consists of a globe resting on a cone, and the famous *0024* hanging lamp, with its glass-encased cylindrical shade. At the ceramics manufacturer, **Richard-Ginori,** he was in charge of what would today be called art direction, redesigning the entire product line and preparing it for large-scale production. For Ponti, there were no "good" or "bad" materials. Whether it was marble, wood and glass, or plastics and aluminum, he found them all *meraviglioso,* wonderful.

Design was only one of Ponti's many abilities. It was his architectural work that first brought him to international attention. **Alessandro Mendini** once called him the father of modern Italian architecture and ranked him alongside Le Corbusier, Alvar Aalto, and Oscar Niemeyer; his 1936 Montecatini building and 1954 **Pirelli** Tower in Milan are today considered landmarks. In his architecture as well as in his designs, Ponti tried to strike a balance between the contemporary and the traditional; he once said, "the past does not exist, everything is contemporary. In our culture only the present exists in the ideas we form of the past as well as in our anticipation of the future." In 1926 he was among the founders of the **Novecento** movement, which, unlike the adherents of **Rationalism,** integrated classical elements in their architecture. Ponti was never a radical modernist but always a modernizer of traditional values.

Ponti was also committed to communicating and discussing new ideas and developments. In 1928, he founded the architectural magazine *Domus,* still one of the most important international publications of its kind, and, with two brief

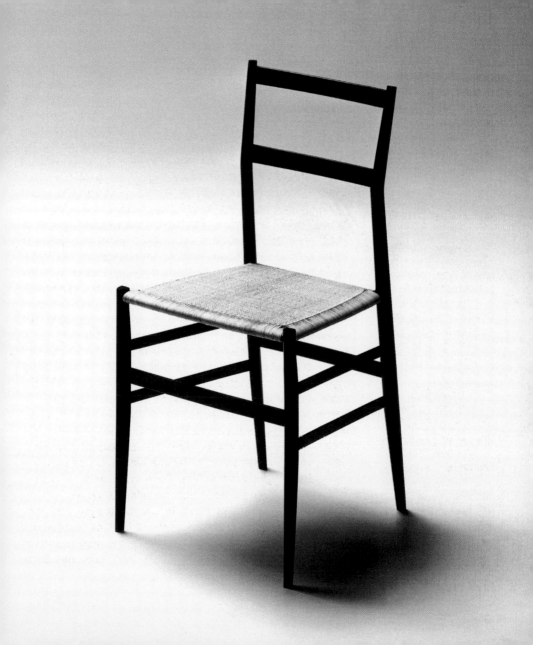

Products

1927 *Serliana* porcelain urn
for Richard-Ginori

1930 wood and crystal tables

1931 *Bilia* lamp;
0024 hanging lamp;
both for **Fontana Arte**

1949 espresso maker
for **La Pavoni**

1951 *Superleggera* chair
(prod. from 1957)

1953 *Distex* chair;
both for **Cassina**;
plumbing fixtures for
Ideal Standard

1957 *Mobile autoilluminante*

1967 colored ceramic
tableware for Ceramica
Franco Pozzi

1969 *Polsino* lamp
for **Guzzini**

1970 *Apta* furniture series for
Walter Ponti

1978 silver objects for **Sabattini**

Page 297

top l.: *Pirellina* lamp
for Fontana Arte, 1967

top r.: *0024* lamp
for Fontana Arte, 1931

bottom l.: Table for Arredoluce,
1954

bottom r.: *Distex* chair for Cassina,
1953

interruptions (1941–44 and 1946–47), served as its pub-lisher until his death in 1979. In *Domus,* he discussed new currents in modernism and published the works of international architects as well as Italian product designers like **Piero Fornasetti,** with whom he would later collaborate (fig. p. 39), and **Carlo Mollino.** After the Second World War it was Ponti who introduced the work of Charles Eames and other American designers to Italy.

Ponti's crucial contributions to Cassina's postwar collections included not only the *Superleggera* but also the *Distex* chair, with its distinctive, sloping armrests, as well as other seats. The range of his projects in the 1950s, 1960s and 1970s was as wide as it had been in the 1930s. He designed plumbing fixtures for **Ideal Standard;** chrome-plated espresso makers for **La Pavoni;** lamps and luminous objects for Arredoluce and Reggiani; elegant chairs and tables for Walter Ponti; ceramics, silverware, and glass objects for **Venini;** and numerous interiors.

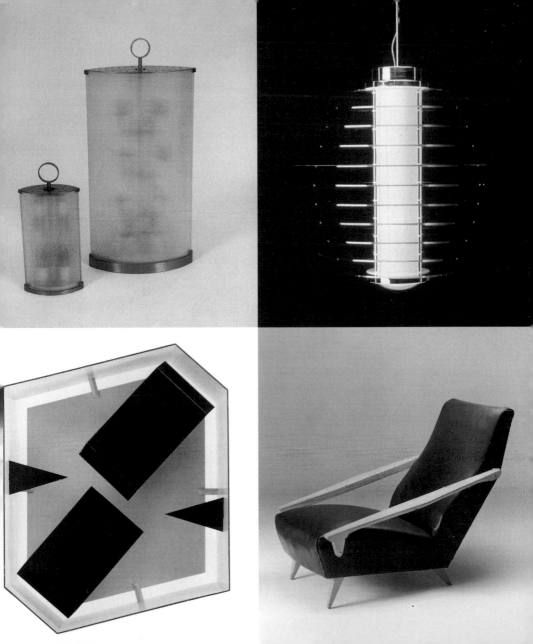

"We wanted to bring into the house everything that had been left outside: calculated banality, willful vulgarity, urban elements, and vicious dogs," the members of the **Archizoom** group—**Andrea Branzi, Massimo Morozzi, Paolo Deganello,** and others—wrote about their overdone, "tasteless" *Dream* Beds of 1967. With a mixture of quotes from Art Deco, pure kitsch, and pompous clutter they and others railed against Italian **Bel Design,** which was at the peak of its success. Along with groups like **Superstudio** (with **Adolfo Natalini**), **UFO** (with **Lapo Binazzi**), and **Strum, Archizoom** was a driving force in the **Radical Design** movement, which emerged in the late 1960s as an offspring of Architettura Radicale (a term coined by Germano Celant in 1966). Against the backdrop of student protests and the radical changes in art marked by the advent of conceptual art and Arte Povera, the young rebels used a comprehensive critique of society to rigorously question the marriage of design and industry and to attack the dogmatic belief in the formal prescriptions of **Rationalism** and functionalism. (This antagonistic attitude was also dubbed **Anti-Design.**)

In their exhibition, *Italy: The New Domestic Landscape,* held at the Museum of Modern Art in New York in 1972, Superstudio presented a vision of a life without objects, shown in sketches, collages, and photomontages. This was typical of the movement,

which took the city and urban planning as its main frame of reference. Consequently, much of Radical Design's work focused on developing alternative environments and living spaces rather than designing new products. **Ettore Sottsass,** who had questioned the unchanging cycle of production and consumption since the early 1960s, and artists like **Ugo La Pietra** and **Gaetano Pesce** also participated in the movement, which quickly became the dominant topic in the design world.

But there was also a more optimistic side to Radical Design's incendiary agenda. By opening up new formal possibilities, the movement set off a wave of joyful experimentation that resulted in designs like **Gatti/Paolini/Teodoro's** *Sacco* beanbag chair, **De Pas/D'Urbino/Lomazzi's** giant *Joe* baseball mitt, and **Gufram's** *Cactus* clothes tree and *Lip Sofa.* Pop design was born, and companies like **Cassina, C & B Italia,** and **Zanotta** had the courage to produce its innovative creations, which have since become icons of design.

By the mid-1970s Radical Design was past its peak, its hopes of social change through design and architecture unfulfilled. In hindsight, though, the movement paved the way for a new approach that led to Pop design, **Alchimia,** and **Memphis,** effecting a comprehensive renewal of Italian design.

"Every day, our industries produce cubic miles of city in the shape of mass-produced goods, and every day many of these molecular urban units are put in circulation to be consumed and transformed into trash within the cold, inert city of stone."
Andrea Branzi

From left:

Mirror and bed from *I Mobili grigi* by Ettore Sottsass for Poltronova, 1970

No-Stop-City project by Archizoom, 1970

Prospero RASULO

Artist, furniture and accessories designer

In the 1970s **Alessandro Mendini** asked Prospero Rasulo to work with **Alchimia**, the laboratory of new Italian design. A sculptor at the time, Rasulo later said that the experience was "a liberation from the constraints of fine art." With a new sense of creative freedom he collaborated with Mendini in developing alternative design concepts, such as **Re-Design** and **Banal Design,** as well as furniture and accessories.

Rasulo has remained committed to Alchimia's lighthearted approach to form, color, and materials. Experimenting with porcelain for Costantino in 1996, he designed the *Orbis* shelf unit and the *Orbis Trolley,* using the material's inherent resistance to angular forms as an aesthetic element. "I was trained as an artist, which is perhaps the reason for my interest in the symbolic value of color and the power it can lend to even the most simple things," Rasulo says, describing the idea behind such vibrant objects as his graceful *Albera* clothes tree for BRF, the eccentric red *She* chair for **Poltronova,** and the colorful *Mollys* bathroom accessories for Antonio Lupi. "In the last few years the object has become the main attraction; it is trying to speak to us at all costs." Rasulo believes in the transformative power of the object, which is perhaps why an Italian magazine called him "the last romantic." In 1998, he and Mendini set up a tent outside the grounds of the Milan furniture fair to introduce their *Eco Mimetico Collection,* a series of glasses, vases, mirrors, furniture, and rugs covered in a camouflage print. It conveyed their belief that design could redirect meaning—in this case, changing camouflage from a signifier of war into a symbol for the return to living in harmony with nature.

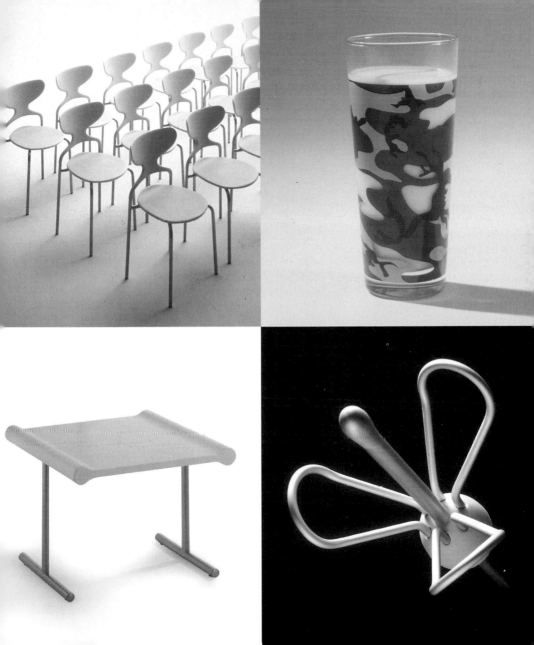

RATIONALISM

Lira chair by Piero Bottoni, 1934 (prod. by Zanotta)

Olivetti factory in Ivrea by Luigi Figini and Gino Pollini, 1937

Rationalism was the Italian and Spanish version of European modernism. But as **Andrea Branzi** has pointed out, "there was one respect in which the Italian rationalists differed from their European counterparts: they were Fascists." While they may not have been among Fascism's leading proponents, the rationalists openly supported its goals in the 1920s and early 1930s. Mussolini, who came to power in 1926, attached great importance to architecture and the applied arts but didn't issue any formal or ideological directives for the development of a "Fascist style." So the rationalists and the more classically oriented Novecento movement entered into a fierce rivalry that came to head at the *Triennale* of 1933. In the mid-1930s, Mussolini finally took the side of the **Novecento** group, lauding their emphasis of genuinely "Italian" elements as opposed to rationalism's more "international" approach. In the process, many rationalists began to disassociate themselves from Fascism.

Rationalism began as an architectural movement. In 1926, its early proponents also included **Luigi Figini, Gino Pollini,** and **Giuseppe Terragni,** had formed the Gruppo 7. Terragni designed the Fascist Party's headquarters in Como, which was built in 1934–36. His design also included distinctly

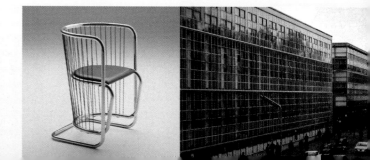

rationalist furniture, like the *Lariana* chair, constructed of a bent steel tube that holds the seat and backrest. (The chair is now produced by Zanotta.) In the 1930s, Figini and Pollini designed new factory buildings for Olivetti, boxy glass-and-steel structures without even a hint of ornament.

Out of the context of the new architecture, rationalist lighting and furniture designs began to emerge. **Piero Bottoni, Giuseppe Pagano,** Gino Levi Montalcini, and **Gabriele Mucchi** did away with the traditional stately look and, following the example of the German Bauhaus, experimented with new industrial materials such as tubular steel and chrome. In addition to metal furniture, rationalist designs also included such impressive objects as **Luciano Baldessari's** towering *Luminator* light column of 1929. However, many designs never went beyond the prototype stage, as the workshops were not equipped technically to realize them. After the Second World War, rationalist principles inspired an intellectual elite of leftist architects, among them the **BBPR** studio, **Franco Albini, Ignazio Gardella, Alberto Rosselli,** and a younger group that included **Marco Zanuso** and **Anna Castelli Ferrieri.** Postwar design remained rooted in the modernist tradition until the late 1960s when, in the wake of the Radical Design movement, a new generation began to question the functionalist dogma.

"Rationalism remains (...) highly significant as a reflection of Italy's internationalist ambitions at a time of strong nationalism, and as an expression of the complex relationship between politics and design that developed in Italy during those years."

Penny Sparke

Lariana chair by Giuseppe Terragni, 1936 (prod. by Zanotta)
MB 48 cabinet system by Franco Albini and Franca Helg, 1950s

Umberto RIVA

Architect, furniture and lighting designer

"I cannot design. I don't have a designer's mental structure. In my view a designer should be able to create a need, to invent an object that doesn't yet exist, and to enter it into the cycle of production. Designers in that sense are rare; it takes intelligence and a certain cleverness," Umberto Riva says.

Riva designs furniture and lighting only when his architectural work leaves him time; in many cases, the designs are by-products of architectural projects. "I always succeed in designing objects that don't sell," he says. Riva's products do not necessarily look expensive, but they usually are, due to his preference for costly materials; the *Veronese* lamp for Barovier & Toso, for example, is made of colored Murano glass.

A perpetual outsider, Riva is not interested in designing for contemporary tastes, which in the age of marketing-through-

design must seem rather old-fashioned. That adjective, however, hardly applies to objects like Riva's *E 63* lamp, designed in 1963 for a competition organized by **Artemide**. Strikingly timeless in its clear proportions, the design went through a long odyssey before it was finally produced by **Fontana Arte** in 1991. For his Victor bureau for Schopenhauer/Fontana Arte, Riva used alder and beechwood. In its self-assured elegance, the piece recalls **Carlo Scarpa's** material aesthetics, while its pure, refined form is reminiscent of Scandinavian design. That can also be said of his *Agio* armchair for Bellato, with its geometric structure and segmented, blondewood frame. But Riva would never design a side chair—that, he says, is a difficult project, for which Thonet and Aalto have already found perfect solutions.

Products

1985 *Veronese*
and *Tesa* table lamps for
Barovier & Toso

1989 *Franceschina* table lamp

1991 *E 63* table lamp
(designed in 1963);

both for **Fontana Arte**

1992 *Ala* desk for **Driade**

1993 *Agio* chair and side table
for Bellato

1994 *Victor* bureau for
Fontana Arte (Schopen-
hauer)

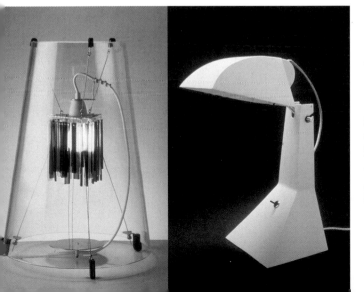

From left:

Lem table lamp for Ve-Art, 1973 (re-edition by Fontana Arte as *Dilem*, 1991)

Tesa lamp for Barovier & Toso, 1985

E 63 lamp for Ve-Art, 1963 (re-edition by Fontana Arte, 1991)

Paolo RIZZATTO

Architect, furniture and lighting designer

Paolo Rizzatto and **Alberto Meda's** delicate *Berenice* desk lamp, made of glass, aluminum, and plastic for **Luceplan** (which is co-owned by Rizzatto) is a contemporary, technology-inspired interpretation of the classic library lamp. The principle of blending past and present is also apparent in Rizzatto's *Dakota* chair for **Cassina,** whose aluminum seat is upholstered in a combination of leather and polypropylene. "I don't have a problem with mixing different materials, styles, or approaches, nor do I care whether they are considered old or modern," he says. His furniture for **Alias** and **Molteni** and designs like the *Lola, D 7,* and *Titania* (fig. p. 38) lights for Luceplan often seem like highly condensed statements: simultaneously complex and minimal, they stand apart from loud postmodern experimentation and the anemic products of the fashionable new simplicity.

Donald System for Joint, 1998, with Carlo Forcolini

Costanza table lamp for Luceplan, 1986

Marco ROMANELLI

Architect, furniture and lighting designer

One of the most active figures in Milan's design scene since the mid-1980s, Marco Romanelli has made a name for himself as a critic (for *Domus, Abitare,* and other magazines), exhibition organizer, and designer. Romanelli's designs reveal their high functionality in an almost casual way, creating a poetic balance between minimalist form and imaginative play. For **Up & Up** he created a washstand and console made of pale marble and airy wickerwork in a nimble, innovative interpretation of two traditional materials. For **Driade's** *Atlantide* collection, which reflects a younger generation's nomadic lifestyle, he designed wooden furniture on wheels and a wall cabinet with a front panel that comes as either a mirror or a blackboard. Working as **O Luce's** art director, he also developed, with his frequent collaborator Marta Laudani, the *Lanterna* lamp, whose Murano glass shade is contained, like a precious object or an exhibit, in a glass jar.

1958 born in Trieste

1983 graduates from architecture school in Genoa

1986 editor at *Domus* (until 1994)

1995 art director at **O Luce** editor at *Abitare*

1996 art director at **Montina**

Products

1988 *Trame* table for **Arflex** with Marta Laudani

1997 *Saudade* lamp for O Luce with Marta Laudani and Massimo Noceto

1998 *Lanterna* lamp for O Luce with Marta Laudani

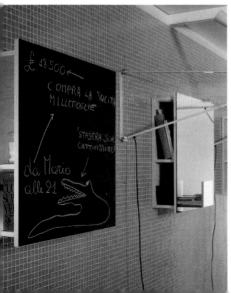

Materco wall cabinet for Driade (*Atlantide*), 1996

Francescano shelf unit for Driade (*Atlantide*), 1995, with Marta Laudani

Alberto ROSSELLI

Architect and industrial designer

A theorist, architect, and designer, Alberto Rosselli thought of his work as a service to the new society that emerged from the ravages of the Second World War. He demonstrated his vision of modern, simple, beautiful, and inexpensive design in his 1951 *Kitchen for a Two-person Household*. Functional and efficient, it was a response to the cramped living quarters typical of those years.

Rosselli considered it vital to strengthen the cooperation between designers and manufacturers; when he founded a design magazine in 1953 he gave it the title, *Stileiundustria*. [TRANS. TK] Though the magazine occasionally fetishized industrial products, it was an important forum for contemporary design discourse before it folded in 1962. From the 1950s through the 1970s, Rosselli designed gas water heaters, electric hairdryers, plumbing fixtures, coffeemakers, clocks, and furniture. And together with **Isao Hosoe,** he developed the *Meteor* bus in 1970.

1921 born in Palermo

1947 graduates from architecture school in Milan

1950 forms Studio PFR with **Gio Ponti** and Antonio Fornaroli in Milan

1953 founds *Stileindustria* magazine

1954 **Pirelli** Tower, Milan with Gio Ponti, Antonio Fornaroli and Valtolina Dell'Orto (compl. 1956)

1956 first president of **ADI**

1961 vice president of ICSID (until 1963)

1970 *Compasso d'oro* (also 1987)

1976 dies in Milan

Products

1951 *Kitchen for a Two-person Household* for Alberto Bazzani

1954 espresso maker for **La Pavoni**

1957 plastic bathroom elements for **Montecatini**

1970 *Meteor* bus for Orlandi with **Isao Hosoe**

1973 bathroom unit for **ICS**

Jumbo chair for Saporiti, 1960

Architect and industrial designer

Aldo Rossi was singularly consistent in treating product design as architecture on a smaller scale. This is particularly apparent in his coffeepots for Alessi. Like Rossi's buildings they are composed of geometric forms: his *La Conica* pot is a cylindrical tower with a conical roof for the flat landscape of the coffee table; the *La Cupola* espresso maker of 1988 has a domed top. His chairs, like the *Capitolo* series for **Molteni** and the *Parigi* for **Unifor,** are also modeled after classic architectural forms.

Rossi's rigorous adherence to a restricted formal vocabulary was based on a theory he developed in his book, *L'architettura della città,* published in 1966. Contrasting his own model of an architecture reduced to archaic forms with organic and functionalist approaches, the book became a fundamental text in the debate over postmodern architecture.

Rossi's architectural projects include the town square and memorial fountain in Segrate, near Milan; the Il Palazzo Hotel in Fukuoka, Japan; and the Bonnefanten museum in Maastricht, the Netherlands.

1931 born in Milan

1955 editor at *Casabella* (until 1964)

1959 graduates from architecture school in Milan

1966 *L'architettura della città* published

1971 San Cataldo cemetary in Modena

1994 Bonnefanten Museum, Maastricht

1997 dies in Milan

La conica espresso maker for Alessi, 1994

Cartesio bookcase for Unifor, 1996/1996

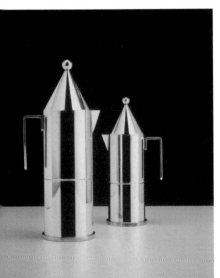

Roberto SAMBONET

Painter, graphic and product designer

Many of Roberto Sambonet's elegant housewares, such as his *Center Line* set of stainless-steel bowls and crystal glasses for Baccara, can be stacked or nested, creating visual patterns that have often been photographed in extreme close-up views. Though influenced by his friend Alvar Aalto and by Frank Lloyd Wright, the main point of reference in his work as a graphic and product designer was not architecture but art. Sambonet believed in a fundamental relationship between art and design. He had staged successful exhibitions of his paintings and drawings in Europe and Brazil before he turned to product design. In the early 1950s he opened a design studio in Milan, and in 1956, founded his own company, Sambonet spa, transforming an existing traditional workshop into a modern manufacturer of sophisticated stainless-steel goods at a time when such products were still largely neglected by designers. The best known example of his organic, sculptural style is the *Pesciera* fish platter, which won numerous awards. For other firms he also designed glass, crystal, and porcelain objects. As a graphic artist, he collaborated with **Bruno Monguzzi, Max Huber** and **Bob Noorda** on the packaging for his company's products and other projects. He also created graphics for such clients as **La Rinascente, Pirelli, Alfa Romeo,** and the architectural magazine *Zodiac*.

1924 born in Vercelli

1945 graduates from architecture school in Milan

1956 art director of *Zodiac* magazine (until1960); *Compasso d'oro* (also 1970, 1979, 1995); establishes Sambonet spa

1960 consultant for **La Rinascente**

1995 dies in Milan

Page 311

top left: *Center Line* bowls, 1965 (until 1971)

top right: Logo for Lombardy region, 1974, with Bob Noorda and Pino Tovaglia

bottom left: *Empilage* glasses for Baccarat, 1971

bottom right: Packaging for stainless-steel flatware for Sambonet, 1959

Pesciera fish platter, 1957

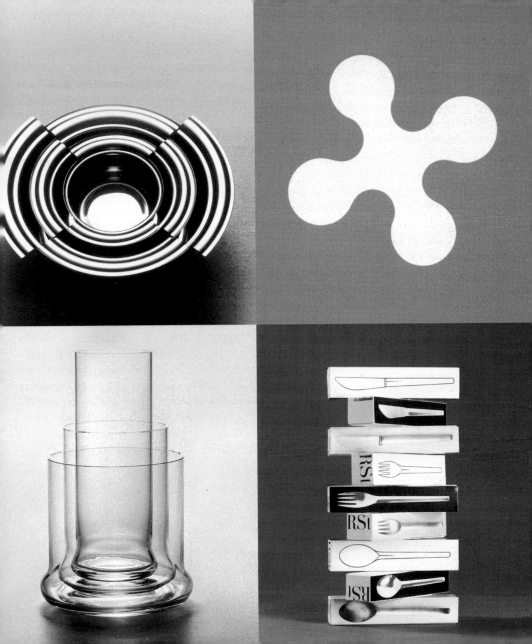

Denis SANTACHIARA

Industrial, furniture, and lighting designer

Denis Santachiara's *Sister Chairs* for Vitra (1987) are peculiar creatures. *Timida* blushes when "she" is talked to, *Espansiva* puffs up when warmed by a person's body, and *Volubile* changes color on contact. Interaction between object and user and unconventional ways of using technology have always fascinated Santachiara, who says that "the more tricks a magician knows, the more he can amaze and delight his audience."

Unlike most of his peers, Santachiara didn't study at Milan's prestigious Polytechnic. Instead, he started out as a self-taught automobile designer in the mid-1960s, when he was sixteen years old. Motion is still a recurrent theme in his designs: he has developed a blow-dryer whose airstream can be precisely controlled (and is also fragrant); and his *Notturno Italiano* bed lamp provides first light and then help for insomniacs by projecting a procession of little sheep onto the wall. Many of Santachiara's

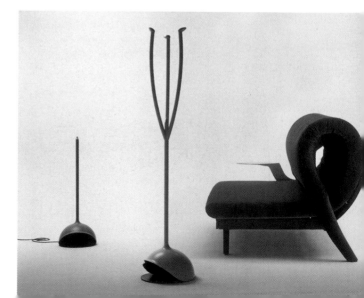

designs have remained prototypes, small poetic creations not necessarily fit for mass production. Despite that, his work has been supported by companies like Italtel, for which Santachiara, along with **Franco Raggi** and **Alberto Meda,** developed a multifunctional *Workstation* in 1986. For Stil Resine he designed a *Plastic Bicycle,* equipped with a horn that plays tunes from five Verdi operas and a counter for calories burnt pedaling.

Santachiara's animated designs are not simply fun objects; they reveal different, unaccustomed aspects of familiar functions, and thus sharpen the perception for undiscovered possibilities. Or, as Santachiara puts it: "As a designer I am not interested in the material marvels of technology but in its immaterial extensions." One of his most recent inventions is the *Pisolò* ottoman, which, with the help of a built-in electric motor, turns into a bed-and-table unit.

1989 *Oxalis* chair for **Cidue**;
Mama chair for **Baleri**;
Astro seat for Campeggi;
plastic bicycle for
Stil Resine

1990 *Domodinamica*
oggeti animari per la casa
Collection

1993 *Notturno Italiano*
lamp for Domodinamica

1997 *Pisolò* convertible ottoman
for Campeggi

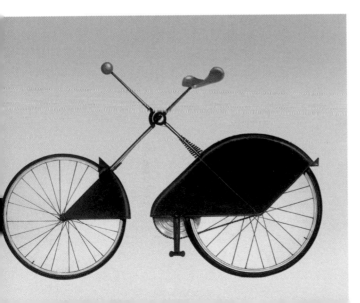

From left:
Sciuscia furniture
Trans chair for Campeggi
Bicycle for Stil Resine, 1989

Richard SAPPER

Industrial designer

In 1970, **Artemide** owner **Ernesto Gismondi** received a call from Richard Sapper. "Remember when you asked me to design an extremely functional, innovative light?" the designer asked. Then he announced that he was ready to present his solution. The solution turned out to be the prototype for *Tizio,* one of the most famous lamps in design history. With its perfectly balanced system of weights and counterweights, the lamp could be adjusted with unprecedented ease and precision; it was also one of the first desk lamps equipped with a low-voltage halogen bulb, ideal for spotlighting specific areas.

Born in Germany and now based in Milan, Sapper has been a vital part of the Italian design world for the last forty years. He is an industrial designer in the fullest sense; the products he has developed range from furniture, clocks and espresso makers to faucets, cars, and bicycles. To him, designing means problem-solving with the goal of "giving meaning to form." In 1964, as a designer for **Kartell,** he explored plastic furniture production with his mentor, **Marco Zanuso.** He also designed some of the most compact and formally adventurous electronic equipment of the 1960s with Zanuso, including the *Black, Algol* (fig. p. 4), and *Doney* television sets and the *TS 502* box radio for **Brionvega.** More recently, Sapper won a *Compasso d'oro,* the ninth in his career, for his aluminum *Zoombike,* which can easily be folded and carried on trains or buses. While all his designs are impeccably functional, many of them come with an extra twist, like his famous teakettle for **Alessi,** which instead of a shrill whistle emits a pleasant chord.

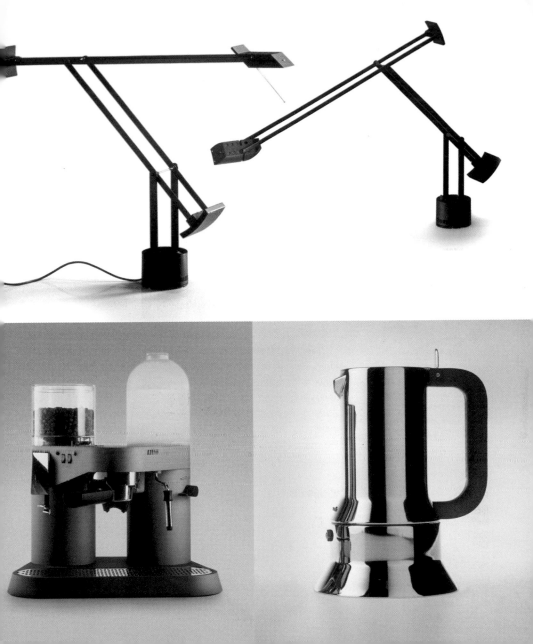

SAWAYA & MORONI

Furniture and accessories manufacturer

When Beirut-born William Sawaya and Paolo Moroni founded their company in Milan in 1984, they invited such international architects as Michael Graves, Charles Jencks, Oswald Matthias Ungers, Zaha Hadid, and Jean Nouvel to design furniture and silverware. There were no further conditions or requirements, except that each architect follow his or her unique stylistic ideas.

Jean Nouvel contributed the *TBL Inox table,* an austere purist design, while **Toni Cordero's** velvet *Faia* chair, with arms made of blue cords, was an opulent, ironic commentary on the longing for the "good old days." Marcello Morandini designed his *Bine* chair (fig. p. 21) as a dizzying sculpture of black and white lines, and Sawaya himself created *Wienerin,* an homage to the classic Viennese café chair. He also designed the *Acqua di Fuoco* liquor cabinet, a dangerous-looking piece whose back panel aggressively thrusts up into the air. In addition, the collection

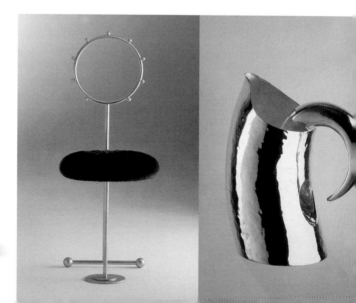

includes elegant silver objects such as Matthew Hilton's hand-shaped *Mano* ashtray and Zaha Hadid's *Tea and Coffee Set,* whose parts are reminiscent of rough-hewn crystals. Sawaya's glass objects take a special position in the company's program: his *Dialetti impossibili* and *Fleur Du Mal* vases are sumptuous, sensual creations that stretch limits of the material's possibilities. *Le Possedé* consists of an orb from which red glass tubes stretch out like greedy arms, and the milky body of his *Hymne à la beauté* is covered with bee-like clusters of ornaments.

Modesty is certainly not an attribute of Sawaya & Moroni's collection; instead, it is a bold statement on the stylistic diversity in architecture at the end of the twentieth century. In that sense, the company resembles a sophisticated design gallery rather than a conventional manufacturer.

1995 *I Dialetti Impossibili* glass vases by William Sawaya

1997 *Tea and Coffee Set* by Zaha Hadid

1998 *Spring* collection, incl. *MY 98* chair by Michael Young, *Povera* chair by William Sawaya and *Lintaro* furn. object by Makoto Kawamoto

From left:

Drum side table by Marco Mencacci, 1991
Santa chair by Luigi Serafini, 1990
Le Diable en Tête pitcher, 1995
Ex Libris bookcase, 1997
Patty Diffusa chair, 1993;
all by William Sawaya

Afra & Tobia SCARPA

Architects, furniture and lighting manufacturer

1960 design and architecture studio established in Montebelluna

1970 *Compasso d'oro*

Products

1961 *Bastiano* sofa for **Gavina** (now prod. by Knoll)

1962 *Vanessa* bed for Gavina; *Fantasma* floor lamp for **Flos**

1963 *Modell 917* chair for **Cassina**

1968 *Biagio* table lamp for **Flos**

1969 *Soriana* chair for Cassina

1970 *Bonanza* chair for **B&B Italia**

1984 *Poligonon* table series for B&B Italia

1986 *Marly* shelf unit for **Molteni**

"You don't instantly know whether a product really works. It must pass the test of time," Tobia Scarpa says. Longevity and a sensitive use of materials are crucial in the work of Tobia and Afra Scarpa, who met at architecture school in Venice. The couple's approach owes a debt to Tobia's father, **Carlo Scarpa,** who was famous for his masterly treatment of exquisite materials, and to Tobia's early experiences at the glass-blowing workshop of **Venini.** A gentle austerity characterizes all their products, like the *Biagio* lamp, which is cut by hand from a massive block of marble, and the airy *Ariette 1-2-3* ceiling light (both for **Flos**), with its diffuser made of a semitransparent piece of fabric. For their archaic-looking *Africa* chair for **B & B Italia** and the *Bastiano* sofa for **Gavina** (one of their earliest designs), they used massive pieces of wood. The Scarpas have also developed furniture for **Cassina** and **Molteni** and designed buildings for **Benetton** (1966) and **C & B Italia** (1968).

Ariette 1-2-3 ceiling light for Flos, 1973 by Tobia Scarpa

Carlo SCARPA

Architect and furniture designer

In the 1930s, when the young Venetian architect Carlo Scarpa was fiercely attacked for his modernist restorations of historic buildings, he withdrew to the workshop of **Paolo Venini,** a close friend and seminal innovator of the art of glass-blowing. During those years of seclusion, Scarpa designed exquisite vases and bowls (fig. p. 27), reinterpreted traditional materials, and "invented" two new kinds of glass: one heavy and opaque, the other light and composed of two layers.

The love of precious materials, especially those with a long history, and a deep commitment to cultural traditions would later resurface in all Scarpa's projects. His most important works were in the field of architecture, although the academic world long refused to acknowledge their greatness. He made a name for himself as a brilliant exhibition designer with projects such as the Paul Klee retrospective at the 1948 *Biennale,* the 1957 **Olivetti** showroom in Venice, and the Venezuela pavilion on the grounds of the Biennale. In the early 1970s Scarpa also designed the family

1906 born in Venice

1926 graduates from architecture school in Venice

1931 Casa Asta, with the painter Mario De Luigi

1942 exhibition architect for *Biennale di Venezia*

1951 meets Frank Lloyd Wright in Venice

1956 **Olivetti** prize for architecture

1957 Olivetti showroom in Venice

1960 Frank Lloyd Wright exhibition in Milan

1978 dies in Sendai (Japan)

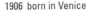

Murrine opache glass bowls for Venini, 1940

Zibaldone shelving system for
Bernini, 1974

cemetery for the Brion family in Treviso. It wasn't until the late 1960s that Scarpa began designing objects for mass production. But he never really embraced its principles of scale and auto-mation—they were simply too far removed from his own involvement with each material's aesthetics, his practice of developing designs out of a concrete context, and his commitment to meticulous workmanship.

Scarpa designed his furniture to last, possibly forever. There is an aura of permanence to pieces like the steel-and-crystal *Doge* table for Simon, a company owned by his friend, **Dino Gavina** (the table was originally designed for the dining room of the Zentner House in Zürich); the marble *Delfi* table (with Marcel Breuer); and the monumental *Valmarana* wooden table. In the 1970s, Scarpa also created designs for Bernini, including the *Zibaldone* bookcase, with doors made of crystal glass.

Furniture and textile designers

At Sigla, three key skills are embodied in the design studio's founders. Marina Bani used to be in charge of **Zanotta's** product development; Marco Penati still heads its technology department; and Patrizia Scarzella is an architect and journalist. They use their combined experience to develop functional, technically brilliant solutions. The *Wiz* desk for Penalto, to name one example, improves on a familiar design by putting a kidney-shaped top on two three-legged saw-horses made of tubular steel.

One of the studio's specialties is the development of new textiles. The *Spezie* upholstery fabric for Zanotta is made of natural fibers and has a strikingly rich texture. The studio also curates exhibitions, such as the 1997 show *Bello Quotidiano* (Everyday Beauty), on the history of Italian furniture design. Sigla also designs upholstered furniture for Zanotta, beds for **Flou,** and lighting for **Fontana Arte** and Barovier & Toso.

1994 studio established by Marina Bani, Patrizia Scarzella and Marco Penati in Milan

Products
1995 *Ito* table series; *Nilo* table both for **Arflex**
1997 *Est* sofa; *Nadir* sofa
1998 textile collection; all for **Zanotta**; *Atlante* bed for **Flou**

Upholstery fabric from *Spezie* series for Zanotta
Wiz table for Desalto, 1997

Ettore SOTTSASS jr.

Architect, furniture and industrial designer

Page 323

Hanging lamp for Arredoluce, 1957

Fruit bowl, 1952

Svincolo floor lamp for Alchimia, 1979

As a young student of architecture in the 1930s, Ettore Sottsass Jr. experienced the great architectural movement of **Rationalism** in the office of his father, who was one of the modernist style's leading proponents. At the time there were no indications that, a few decades later, the son would be a central figure in a movement that first rigorously questioned rationalism, and finally replaced it with a completely new understanding of design.

In the early 1950s, Sottsass realized his first architectural projects in Milan. He became known to a wider public in 1959 when he designed the *Elea 9003,* the first Italian mainframe computer, for **Olivetti.** He arranged the computer's countless controls in a clear, user-friendly way, and color-coded them for easier orientation. Sottsass became Olivetti's chief consultant for office machines, and in the following years designed equipment such as the *Tekne 3,* the small red *Valentine,* and the *Praxis* typewriters, as well as office furniture. Still, he was never an organization man, either at Olivetti or in his later work for other employers.

Sottsass moved between the two poles of art and industry with great freedom. While he held his position at Olivetti, he also designed his *Ceramics of Darkness* and *Ceramics for Shiva,* which were inspired by a trip to India and marked an attempt to return to primal cultural forms.

By the beginning of the 1960s Sottsass had begun to dissociate himself from purely functional design. When **Radical Design** emerged in Italy, he was among those who harshly criticized design's dull formalism and subservience to industrial clients. He started experimenting with laminate-covered furniture, designing the *Mobili grigi* (Gray furniture) prototypes for **Poltronova**—a series of fiberglass beds and mirrors framed in glaring neon tubes. In 1972, he contributed a micro-environment consisting of variously combinable furniture units to the New York

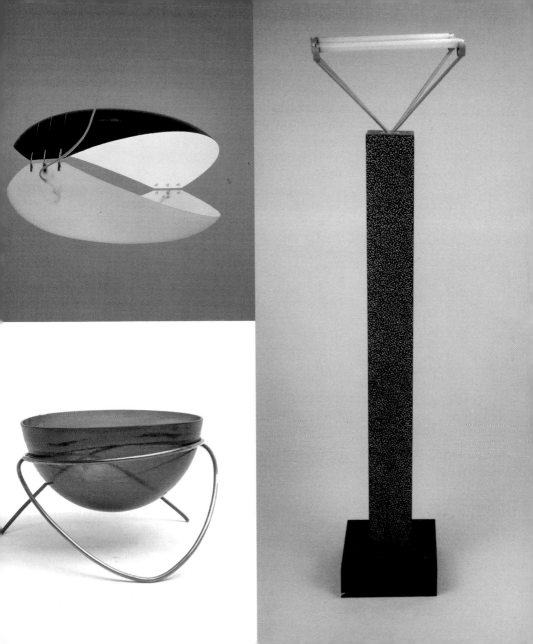

1988 Bischofberger house,
Zürich (compl. 1989)

1990 gas stations for Italian oil
company ERG (until 1997)

1995 Malpensa 2000 airport
(public areas),
Milan (compl. 1998)

1996 urban planning studies in
Seoul (until 1998)

Products

1963 *Ceramics of Darkness*

1964 *Ceramics for Shiva*;
Praxis 48 typewriter;
Tekne 3 typewriter;

both typewriters for
Olivetti with **Hans von
Klier**

1965 *Loto* table for **Poltronova**

1969 *Valentine* portable
typewriter for Olivetti,
with **Perry A. King**

exhibition *Italy: The New Domestic Landscape.* In 1973 he was among the founders of the alternative design school **Global Tools,** and a short time later he created **Banal** and **Anti-Designs** for the **Alchimia** studio.

Then, in 1981, Sottsass founded the movement that made him famous—**Memphis.** His *Carlton* shelf unit (fig. p. 12), covered in colorful laminates, and numerous other furniture objects, lights, and accessories, defined the Memphis style and message, which declared that the form of a product is not its ultimate purpose, but rather a starting point from which to establish a relationship with its users. The first Memphis exhibition made a tremendous splash in the design world. "To me, designing doesn't mean to give shape to a more or less stupid product for a more or less indifferent industry. For me, design is a way to discuss life, social

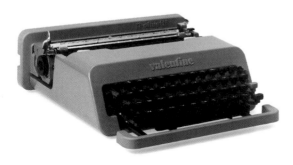

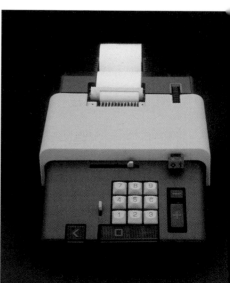

relationships, politics, food, and even design itself," Sottsass wrote at the time. For an international group of mostly young architects and designers, Sottsass became a mentor, promoter, and central source of new ideas. In 1981 he founded Sottsass Associati, a professional studio for architecture and graphic and industrial design, which was joined by **Marco Zanini,** James Irvine, and Johanna Grawunder, among others.

Sottsass is still one of the most protean figures in international design. He continues to develop electronic appliances, lights, office furniture, writing instruments, and ceramics. And he has stuck to his belief that form is not an end in itself but a means for interaction with the consumer. Among his clients and friends are **Alessi, Artemide, Abet Laminati,** Vitra, Zumtobel, Siemens, Apple, and Yamagiwa.

1970 *Mobili grigi* (GrayFurniture); *Elledue* fiberglass bed and *Ultrafragola* fiberglass mirror, all for Poltronova

1979 *Le strutture tremano* table for **Alchimia**

1981 *Carlton* shelf unit for Memphis

1985 Esprit store in Cologne

1988 *Mobile giallo* for Design Gallery Milano

1992 wristwatches for Seiko with **Marco Zanini** and **Marco Susani**

From left:

Valentine typewriter for Olivetti, 1969, with Perry A. King

Summa 19 calculator for Olivetti, 1970

Callimaco floor lamp for Artemide, 1982

Sirio vase for Memphis, 1982

Camomilla fruit bowl, 1987

Albe STEINER

Graphic designer

From 1933, when he designed a brochure for the motorcycle manufacturer Atala, to his death in 1974, Albe Steiner gave important new directions to Italian graphic design. Steiner's work was always intertwined with his political commitment. He believed that "freedom is culture," and he fought for his convictions as a self-taught graphic designer and as an ardent communist who, along with his wife Lica, had joined the party in 1939 and worked in the anti-Fascist resistance movement. After the Second World War, Steiner served as the Italian Communist Party's secretary and helped shape its public image with his powerful poster and publication designs. He was also active as the director of the Scuola del Libro all'Umanitaria in Milan, the founder of the Italian artists' union, Sindacato Artisti, and a cofounder of the **ADI** and other designers' associations. As deep as his convictions ran, Steiner was flexible enough to work for large companies if they had a strong cultural identity or gave him the opportunity to create one for them. For the **La Rinascente**

1913 born in Milan

1939 begins collaborating with his wife, Lica; joins communist party of Italy; resistance fighter in Garibaldi brigades

1946 stay in Mexico; campaign against illiteracy with Hannes Meyer

1948 return to Italy; political commissar of communist party

1952 contributor to *Realismus* magazine

1959 director of Scuola del Libro

1974 dies in Raffadali

1998 *Compasso d'oro* (posthumous)

Projects

1941 cover designs for *Note Fotografiche* magazine

1945 poster for exhibition, *Mostral della Ricostruzione*, on postwar reconstruction

1950 designs for **La Rinascente** (until 1954), incl. 1953 poster, *L'estetica del prodotto*

1956 logo for Pierrel

1959 book covers for *Le Comete* series, Edizioni Feltrinelli

mostra della ricostruzion i C.L.N. al lavoro

Carpi Castello dei Pio 14 ottobre 1973
Museo Monumento
al deportato politico e razziale
nei campi di sterminio nazisti

A cura del
Comitato di Liberazi
all'ex Arengario

department store, he designed posters (fig. p. 45), helped develop the corporate graphics program, and created the logo for the *Compasso d'oro* award, which La Rinascente instituted in 1954. With a clear graphic concept, he revolutionized the packaging design of the pharmaceutical company Pierrel; and in 1962 he created the retail identity for Italy's first supermarket, the Coop market in Reggio Emilia, convinced that this new type of store would raise the living standards of the masses. He also designed for **Pirelli, Olivetti,** Italy's broadcasting network, RAI, and several pharmaceutical manufacturers. Throughout his career, Steiner cooperated with magazines and book publishers in editorial and design projects. With his expressive, partly abstract and partly figurative book and poster art, he was a driving force in the formation of modern Italian graphic design.

1962 store design for first Italian supermarket

1968 poster for XIV. *Triennale*

1972 poster for thirty-sixth *Biennale di Venezia*

From left:

Poster for exhibition, *Museo Monumento al deportato politico e razziale nei campi di sterminio nazisti*, 1973

Poster for exhibition, *Mostra della Rico-struzione*, 1945

Detail from poster raising awareness for tumorous diseases, 1959

Poster for XIV. *Triennale*, 1968

Giotto STOPPINO

Architect, furniture, lighting, and industrial designer

One of Giotto Stoppino's earliest successes was the art nouveau–inspired *Cavour* chair, with a bentwood frame. He had developed the piece with his partners, **Vittorio Gregotti** and **Lodovico Meneghetti,** in 1960, giving the **Neo-Liberty** movement one of its defining designs. A short time later, Stoppino began experimenting with virtually every material that was available. All of his designs, from furniture, lighting, and glasses to razors, bookends, and magazine racks have since shared one distinctive quality: the advanced technologies they are based on completely recede behind clear lines, smooth surfaces, and clever details to create an impression of perfect balance and harmony. This is evident in his small, three-legged stacking chairs made of ABS plastic, which he designed in the mid-1960s for **Kartell;** in the *Maia* tubular steel chair for Bernini, whose delicate look barely betrays its robust construction; and in the *Alessia* door handle for Olivari, which is solid where the hand grips it and hollow where it doesn't. His *Sheraton* sideboard for **Acerbis** is an exercise in symmetry, with a simple top that seems to hover contemplatively over a rectangular module.

Sheraton sideboard for Acerbis, 1977, with Lodovico Acerbis

SUPERSTUDIO
Architects and designers

Superstudio was one of the most important groups within the **Radical Design** movement, which set out to end the dogmatic functionalism and subservience to industrial needs that dominated design. Founded in 1966 in Florence by two young architects, **Adolfo Natalini** and Cristiano Toraldo di Francia (they were later joined by Piero Frassinelli and Roberto and Giancarlo Magris), Superstudio's utopian designs were proposals for new housing and living structures. In their 1968 project *Monumento continuo,* they overlaid cities and landscapes with an endless grid that was meant to replace existing structures and serve as a matrix for the construction of a new environment where everyone was assigned a neutral space free from objects and consumerist pressures. In 1971 they covered small tables with a black grid on white laminate. Again, the squares were essentially blanks to be filled in—the *Quaderno* (notebook) tables for **Zanotta,** like the 1977 *Desino* table for **Poltronova,** were reflections on an open-ended design.

1966 founded in Florence
1972 contribution to *Italy: The New Domestic Landscape,* MoMA, New York
1973 collaboration with **Global Tools** (until 1975)
1978 group dissolves

Products
1967 *Gherpe* table and floor lamp for **Poltronova**
1969 *Il monumento continuo* project
1971 *Quaderna* tables for **Zanotta**
1977 *Desino* table for Poltronova

Quaderna table
for Zanotta, 1971

TECNO

Furniture manufacturer

Tecno, the name **Osvaldo** and Fulgenzio **Borsani** decided on for the firm they had founded in 1953, is a reference to the Greek word "techne," which means art as well as technology. The word perfectly matched their ideas, which were translated by Osvaldo, who, for several decades, was the company's sole designer. His very first designs, the adjustable *P 40* chair and the *D 70* folding sofa, were true technical marvels. The brothers' father, Gaetano, had been a renowned furniture builder before the war and had taught them how to work with wood. From this base, they expanded their expertise into new materials including glass, plastics, and metal. In the 1950s and 1960s, Tecno developed sophisticated, comprehensive design solutions, such as the *Graphis* office furniture system of 1968. Now headed by Paolo and Valeria Borsani and specializing in furniture for offices and public buildings, the company has worked with such renowned international architects as Norman Foster and **Gae Aulenti**.

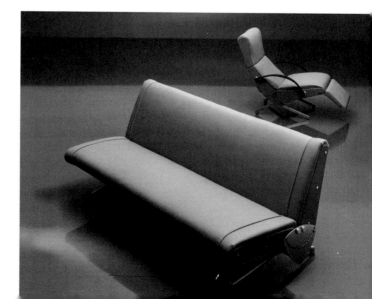

P 40 chair and *D 70* sofa by Osvaldo Borsani, 1954

Architect, furniture, accessories, and product designer

"Less is more" is certainly not a principle that Matteo Thun would subscribe to, at least as far as his product design is concerned. Born in the alpine Alto Adige region of Italy, Thun is far more interested in the visually apparent than in the discreetly concealed: the grips of his *Hommage à Madonna* silverware set (1986) are decked out in rings, the stems of his *Tiffany Gin Gin* goblets are shaped like ornamental columns, and his **Memphis** coffeepots resemble cartoon animals. The antifunctionalist ideas Thun developed as a member of Memphis in the 1980s are aimed at establishing communication between user and object. His ceramic products for firms like Rosenthal, Villeroy & Boch, and Arzberg are a central part of his work. In addition to his housewares, lighting, and bathroom furnishings, Thun also designs much more functional office furniture and prefabricated houses, as well as retail identities for firms like Swatch, **Missoni**, and **Fiorucci**, and architectural exteriors for Coca-Cola, which play off the companies' overall identities.

1952 born in Bolzano

1975 graduates from architecture school in Florence

1981 member of Sottsass Associati (until 1984)

1984 opens studio in Milan

1990 art director for Swatch (until 1993)

Products

1982 *Corvus Corax* pitcher for **Memphis**

1987 *Le petit café* set for Arzberg; *Walking Coffee Pots* for WMF

1993 *Pao* table lamp for **Flos (Arteluce)**

1996 *O Sole Mio* cups for Rosenthal; *Sole Mio* prefab. house for Griffner Haus (compl. 1997)

Chad ceramic for Memphis, 1982
Lola chair for Martin Stoll, 1993

Mario TRIMARCHI, Marco SUSANI
Architects and product designers

Mario Trimarchi and his partner, Marco Susani, belong to a new generation of Italian industrial designers who carry out a kind of poetic technology research. Instead of inventing new forms, they try to change everyday modes of behavior through their products. Their wardrobe-like piece of furniture, for example, with its wood fiber–cushioned panels and glass door, doesn't look at all like a fridge. It works like one, though: named *Keep-it-cool*, it needs no electricity, offers an attractive, stripped-down alternative to the customary metal behemoths, and keeps things chilled for up to two days, which is enough for most fresh products. "You don't need a Ferrari to go shopping, either," Marco Trimarchi says. He and Susani use technology to create new modes of interaction between appliances and their users. At the research center of the Domus Academy in Milan they directed the development of the *Movaid* robot, which helps people with disabilities perform household chores. Their *New Tools* for Philips, which include a juicer, an egg boiler, and a toaster, are equipped with storage batteries and a special recharging device to use electricity only as needed.

Keep-it-cool refrigerator, 1997

Office furniture manufacturer

In 1970, when the market for office furniture was defined by dull, unexciting uniformity, newcomer Unifor sounded a fresh note with its enormously successful *Modulo 3* program, designed by **Bob Noorda** and **Franco Mirenzi**. With its focus on technically sophisticated, high-quality products, the company has since followed up with other complex, formally reductive programs such as the *Master* and *Mats* office furniture by **Afra** and **Tobia Scarpa,** and Fernando Urquijo and Giorgio Macola's *Mood* system. Unifor's choice of designers reflects the company's commitment to functionality and elegance. Unifor has produced furniture by the architects Jean Nouvel, **Aldo Rossi,** and Renzo Piano and the technology-inspired industrial designer **Richard Sapper** as well as **Luca Meda,** a master of clear lines, and Angelo **Mangiarotti,** who is famous for his purist approach to materials. Unifor has furnished the offices of many large corporations, including IBM, Hewlett-Packard, Rank Xerox, Deutsche Bank, Hong Kong Telecom, and Volkswagen.

Unifor spa, Turate (CO)

1970 founded as division of **Molteni** group

Products

1989 *Mood* office furniture system by Fernando Urquijo and Giorgio Macola; *Parigi* chair by **Aldo Rossi**

1990 *Progetto 25* office furniture system by **Luca Meda**

1994 *Less* desk and cabinet by Jean Nouvel

Naos system by Pierluigi Cerri, 1993

VALENTINO

Fashion designer

The gown Jacqueline Kennedy wore at her wedding to Aristotle Onassis in 1968 was designed by Valentino. The master of Roman haute couture had been picked to design the bride's dress for the most glamorous wedding of the year, and he enthusiastically dedicated an entire new collection to her, the all-white *Collezione Bianca.*

Valentino had decided early on to devote his life to fashion, and after graduating from high school he studied fashion design in Milan and Paris. After working for Jean Dessès and Guy Laroche, he opened his own studio in 1959. His breakthrough occurred in 1962, when he made a splash with his elegant, luxuriously tailored designs at the Florence fashion shows at the Palazzo Pitti. Another crucial moment came when he was awarded the *Neiman Marcus* fashion prize in 1967, which confirmed his elevated rank among Italian designers, particularly within haute couture.

Valentino's trademark has been an elegant opulence that has made his haute couture presentations the climactic events of many *Alta Moda* shows in Milan. The basic components of Valentino's creative language are geometric cuts in black and white fabrics, animal prints, and especially a recurring shade of red that even many other designers now call "Valentino red." He is one of the most recognized living fashion designers; a 1994 exhibition of his work in New York attracted more than 70,000 visitors in two weeks. And for almost four decades he has dressed the rich and the beautiful, from Elizabeth Taylor and Audrey Hepburn to Sharon Stone.

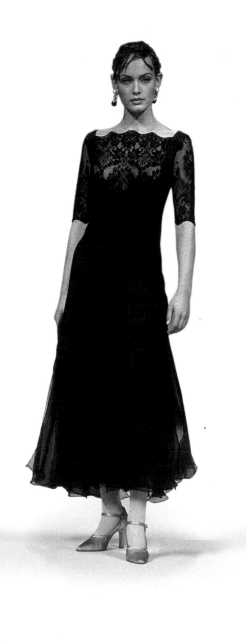
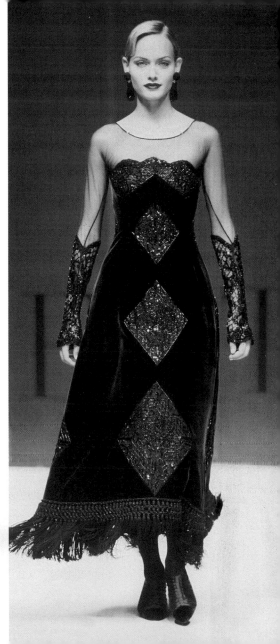

Gino VALLE

Architect and industrial designer

Gino Valle never reached celebrity status, but his products became part of the everyday lives of millions of people in the 1950s and 1960s. He designed timetable displays for train stations and airports and some of the first digital clocks, as well as household appliances. Although Valle saw himself primarily as an architect (he realized numerous important building and urban planning projects), he was also a committed industrial designer. His focus was never solely on the beautiful object—he repeatedly declared that he didn't intend to "fall in love with objects"—but always on the entire design process, from initial idea to mass production. His work with **Zanussi,** which continued from the 1950s to the 1970s, allowed him to fully develop his design concepts. While electric appliances had previously been unremittingly bland, he created a unified, simple, white design with clear controls, giving products like the *202* washer and the *170 TS* refrigerator a distinctive look and giving Zanussi a significant competitive advantage.

Valle's designs are always developed with the users' needs in mind. His appliances for Zanussi and his digital clocks for Solari have virtually redefined entire product categories. His *Cifra 3* desk clock of 1966, for example, became a bestseller that is still universally recognized. Valle, who studied art before switching to architecture, was among the pioneers who bridged the gap between design's formal goals and the requirements of an expanding manufacturing industry after the war. One of the first design consultants in the proper sense of the term, he applied his comprehensive vision not only to the design of new products but also to help define the corporate culture of his clients.

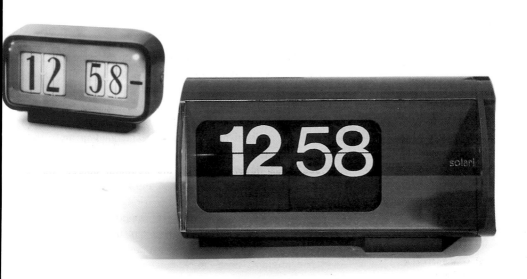

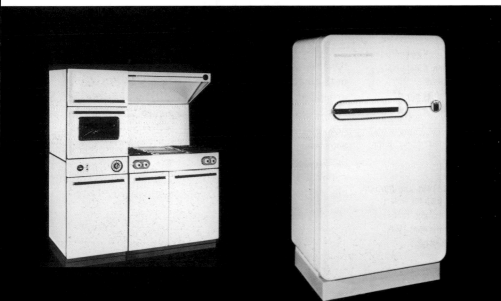

VENINI

Glass manufacturer

When **Paolo Venini** abandoned the practice of law in 1921 to open a glass-blowing workshop in Venice, he brought new style to an old craft. Compared to the overbearing pomp of conventional Murano glasswares, his vases, mosaics, and lamps looked like precious jewels in a sea of glittering baubles. With their restrained abstract forms and deliberate, bold use of color, his products made a strong impression at the 1923 *Biennale* in Monza—modernism had entered glass design. From those early days to his death in 1959, Venini, who also explored new manufacturing techniques, worked with designers who were known for their sensitive use of glass. In the 1920s and 1930s, his collaborators included Napoleone Marinuzzi, **Gio Ponti,** and **Carlo Scarpa,** who contributed to his *Tessuti* string glasses and artistic vases (fig. p. 27). After 1945 he also cooperated with Ken Scott, **Franco Albini,** and **Massimo Vignelli,** and later with **Alessandro Mendini, Tobia Scarpa,** and Tapio Wirkkala. Among Venini's most famous products are **Fulvio Bianconi's** 1952 *Pezzati* vases, made of a patchwork of small colored rectangles, and the *Vaso Fasoletto,* or "handkerchief vase," with its distinctive pinched corners.

Hand-blown *Flor Do Sul* vase by Marco Zanini, 1997

Vecchia Dama, *Elisir* and *Donna Campigliesca* bottles by Gio Ponti, 1956

Page 341
Decoro A Fili vase by Carlo Scarpa, 1942 (re-edition, 1993)

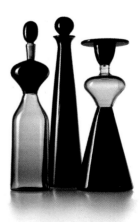

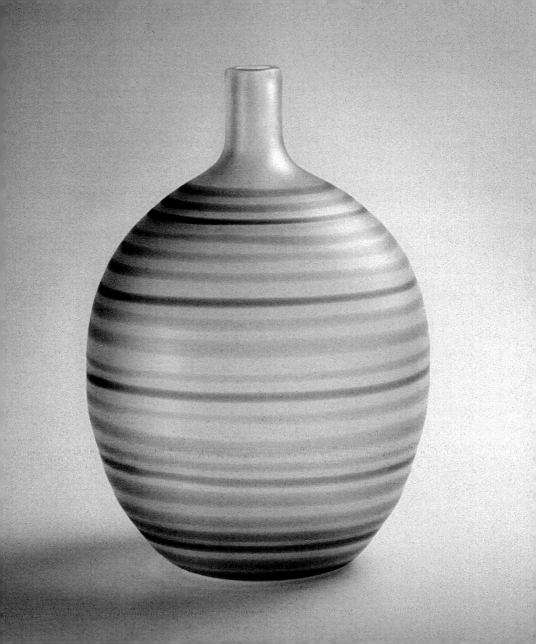

Gianni VERSACE

Fashion designer

News of Gianni Versace's violent death in 1997 cast a temporary pall over the entire fashion industry. It had lost a designer whose creative imagination had circled around the themes of power and eroticism in an entirely unprecedented way. Versace had fashioned himself into a modern Renaissance prince, with a medusa emblazoned on his coat of arms. The very lushness of his colors, forms and patterns, taken to near excess in his accessories and textiles for the home, reflected his preoccupation with, and extensive knowledge of, history and art.

In his hands, even the most unlikely combinations—leather and silk, lace and denim—turned into felicitous, exciting inventions. His book projects and numerous designs for opera and ballet productions by Maurice Béjart, Robert Wilson, and others testified to a creative freedom that knew few boundaries. His extravagant, exuberantly colorful clothes represented only one aspect of his work, which also extended to timeless evening gowns, often black and with elegantly austere lines.

Versace learned the basics of tailoring as a child in his mother's studio, and it wasn't long before he proved his skills in collections for Callaghan, **Genny,** and **Complice**. In 1978, he founded his own company, and by the early 1980s, Versace was a star in the international fashion scene. The most famous models and the best photographers were eager to add glamour to his collections. After Versace's death, his sister, Donatella, became the company's creative director, while his brother, Santo, has remained in charge of management.

Massimo & Lella VIGNELLI

Industrial, furniture, and graphic designers

1960 Massimo and Lella Vignelli
establish studio in Milan

1964 *Compasso d'oro*
(also 1998)

1965 move to U.S. and form
corporate identity firm
Unimark

1971 Vignelli Associates
founded in New York

Products

1955 *Fungo* table lamp by
Massimo V. for **Venini**

1964 graphic designs for
Piccolo Teatro in Milan

1966 corp. ID for Knoll
International

1967 corp. ID for American
Airlines

1978 corp. ID for **Lancia**

1985 *Serenissimo* table
for **Acerbis**

1990 *Handkerchief Chairs*
for Knoll

1997 corp. ID for **Ducati**;
signage system for
Guggenheim Museum
Bilbao

Page 345

Metafora 1 table for Casigliani, 1979

Corp. ID for International Design
Center New York, 1984

Ciga Silverware, 1979

New York subway map, 1970

Red or black type on a white ground, often a combination of all three colors, set in large letters—whenever one encounters this distinctive look in logos (for Knoll International, Cinzano, or Milan's trade fair company, **Cosmit,** for example) or in promotional materials (such as the posters for Milan's Piccolo Teatro [fig. p. 22]), chances are that it was designed by Vignelli Associates. Massimo and Lella Vignelli's graphic work has always been characterized by a careful use of typography to establish a lucid structure and a reduced formal vocabulary to ensure clarity. As part of this overall concept they often use a classic book font, Bodoni. The Vignellis approach each design challenge with a strong historical consciousness—working for **Lancia,** for instance, they reinstituted the company's old logo instead of creating a new one.

Since the mid-1960s, the Vignellis have lived and worked in New York, putting their mark on many of its public spaces: they designed the way-finding system for the city's subway, and corporate identity programs for the International Design Center and Bloomingdale's, among others. Still, Europe, and especially Italy, has remained a focus of their activities. For **Poltronova** they designed the austere *Saratoga* furniture collection in the 1960s; in the 1980s they created the massive *Serenissimo* and *Creso* tables for **Acerbis**. For **Artemide** and **Poltrona Frau** they have designed exhibition booths and salesrooms as well as lighting and other products. Following **Ernesto N. Rogers'** dictum that the field of design should encompass everything "from spoons to cities," they have always approached design in terms of public service and social responsibility rather than mere embellishment.

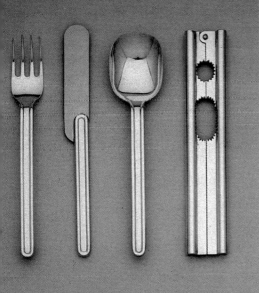

ZANI & ZANI

Housewares manufacturer

Zani & Zani's roots reach back to the nineteenth century, when Serafino Zani created exquisite silver tableware. Today, Zani & Zani is still a family business that caters to sophisticated tastes with elegantly functional table and kitchen products made of stainless steel and aluminum. Thanks to Franca and Luigi Zani's superior technical knowledge, the company is able to fabricate even the most difficult forms and is thus an ideal match for **Enzo Mari.** The designer is a master of fine small products; he created much of Zani & Zani's collection, including the *Smith e Smith* system of pots and other kitchen items, which are conveniently suspended from a rod. Mari's *Piuma* silverware, which hangs from a small stand, casually invites diners to help themselves. The company's products also include **Bruno Munari's** *TMT* ice bucket, made of aluminum and glass wool (fig. p 19), and a more recent line of tablecloths, aprons, and bathrobes in natural fabrics, as well as Claudio La Viola's soft vinyl vases.

Zani industria
dell'acciao spa,
Toscolano

1922 founded; crafts tradition goes back to 19th century

1960 specializes in flatware and other tableware

Products

1954 *TMT* ice bucket
by **Bruno Munari**

1976 *Roswita* silverware set by Carla Nencioni, Armando Moleri

1987 *Smith e Smith* kitchen objects

1990 *Copernico* set of pots; both by **Enzo Mari**

1993 *Vesuvio* espresso maker by **Gaetano Pesce**

1995 *I Vasi Morbidi* (soft vinyl vases) by Claudio La Viola

Opasis oil-and-vinegar set by Enzo Mari, 1986

Page 347
Piuma silverware by Enzo Mari, 1992/1996
Chopping knife
Cheese grater; both from the *Smith e Smith* series by Enzo Mari, 1987

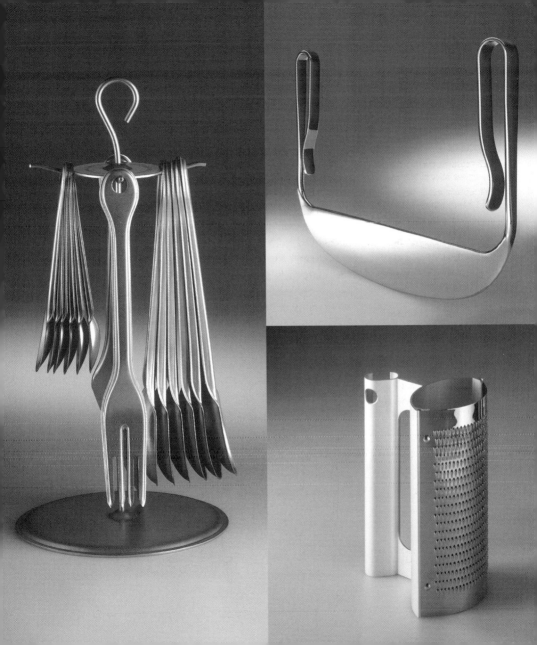

ZANOTTA

Furniture manufacturer

Zanotta spa.,
Nova Milanese

1954 founded in Nova
Milanese

Products

1968 *Blow* chair by **De Pas /
D'Urbin o / Lomazzi**;
Sacco by
Gatti / Paolini / Teodoro

1970 *Mezzadro* (design:1957)

1983 *Sella* (design: 1957);
both by **Achille** and **Pier
Giacomo Castiglioni**

1985 *Tonietta* chair

1994 *Novecento* glass cabinet
both by **Enzo Mari**

1997 *Nadir* sofa by **Sigla**

Page 349

Albero flower stand by Achille
Castiglioni, 1983

Lariana chair by Giuseppe
Terragni, 1936, reprod. 1982

Giotto stool by De
Pas/D'Urbino/Lomazzi, 1975/76

Servomuto table
by Achille Castiglioni, 1974/1975

Pages 350/351: *Sciangai* clothes
tree by De Pas/D'Urbino/Lomazzi,
1973/1974, and *Spiffero* screen by
Bruno Munari, 1989

When Aurelio Zanotta, a ten-year veteran of furniture manufacturing, discovered Willie Landels's prototype of a frameless chair in London in 1965, it was the spark that ignited his passion for innovative design. Zanotta immediately decided to produce the unusual seat, giving it the name *Throw Away*. Since then, his firm has established itself as an open-minded platform for avant-garde design. **Emilio Ambasz,** who curated the 1972 New York exhibition Italy: *The New Domestic Landscape,* once remarked that "it would be impossible to write a history of Italian design without referring to the pieces produced by Zanotta." The list of the company's collaborators a Who's Who of contemporary furniture design, including the likes of **Achille** and **Pier Giacomo Castiglioni, Ettore Sottsass, Joe Colombo, Marco Zanuso, Enzo Mari, Alessandro Mendini, and Gae Aulenti.**

Never afraid to take risks, Zanotta produced, in the late 1960s, **Gatti/Paolini/Teodoro's** *Sacco* beanbag chair (fig. p. 40), which defied all notions of graceful home design and became an international bestseller. Equally unpredictable successes followed when Zanotta introduced the inflatable *Blow* chair and the bundle of oversize jackstraws that masqueraded as the *Sciangai* clothes tree (both by **De Pas/D'Urbino/Lomazzi**). Zanotta also produced two ready-mades Achille and Pier Giacomo Castiglioni had designed in the 1950s, the *Mezzadro* tractor seat and the *Sella* bicycle seat (fig. p. 15). Classic 1930s tubular steel furniture by **Giuseppe Terragni, Gino Levi Montalcini, Giuseppe Pagano,** and **Gabriele Mucchi** were later added to the collection, which has also come to include more traditionally styled upholstered furniture, tables, chairs, and accessories.

Marco ZANUSO

Architect, furniture and industrial designer

Asked once what his most important quality was, Marco Zanuso answered, "curiosity." Following his inquisitive spirit, the young architect gladly accepted an invitation from **Pirelli** to experiment with a new foam rubber. The result of his research was the *Lady* chair, with its now-famous kidney-shaped arms. Introduced in 1951, the chair was awarded a gold medal at the Milan **Triennale** and led to the formation of **Arflex,** a company for which Zanuso also designed other successful furniture, such as the 1954 *Sleep-o-matic* convertible sofa and the 1964 *Woodline* chair, made of bent plywood and leather.

In many respects, Zanuso is one of the founding fathers of Italian industrial design. In addition to his practical work, he became influential as a theorist and copublisher of *Domus* and *Casabella* magazines; along with the **BBPR** studio, **Alberto Rosselli, Marcello Nizzoli, Franco Albini,** and the **Castiglioni** brothers, he dominated the postwar discussion about the redefinition of modernism in design and architecture.

Grillo telephone for Auso Siemens, 1966, with Richard Sapper

Zanuso's enthusiasm about new industrial technologies had been fostered early on by an uncle who had a passionate interest in obscure technical and astronomical instruments. At a time when large parts of Italy's industrial sector still consisted of traditional workshops, Zanuso demonstrated his special ability to translate new industrial possibilities into products with a distinctively modern look. Though trained as an architect, he was a "true" industrial designer for whom design had nothing to do with decoration but was all about "compact, precise, useful objects." With good-humored envy, **Alessandro Mendini** once described Zanuso's products as "so umimpeachably correct that it is downright irritating."

In the 1960s, Zanuso and his partner, **Richard Sapper,** created entirely new product types, such as the *Grillo* telephone, which integrated handset and dial in a single piece. For **Brionvega,** Zanuso and Sapper redefined the look of audio and video equipment with such revolutionary designs as the *TS 502* fold-up radio; the *Doney,* Italy's first transistor-equipped TV set; and the compact *Algol* (fig. p. 4), whose screen was tilted up to give it a somewhat pug-nosed profile. That piece was later followed by the *Black* TV set, a mysterious black cube that revealed its

Products

1951 *Lady* chair

1954 *Sleep-o-matic* sofa
both for **Arflex**

1956 *1100/2* sewing machine for Borletti

1958 *Lambda* chair for **Gavina**

1962 *Doney* TV set

1963 design for car's frontal part for **Alfa Romeo**

1964 *Algol* TV set;
both TV sets for **Brionvega**;
Woodline chair for Arflex;
K 4999 plastic children's chair for **Kartell**

1965 *TS 502* radio for Brionvega

1966 *Grillo* telephone for Auso Siemens;
last three with **Richard Sapper**

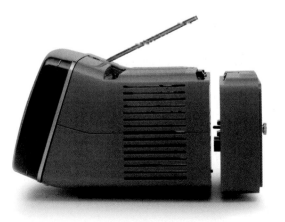

Algol TV set for Brionvega, 1964, with Richard Sapper

function only when the screen lit up. With this product, the designer was successful in two significant respects: he liberated an entire product category from its ponderous formal boundaries by rigorously reducing the equipment's size and emphasizing its communicative function, and he created an unmistakable corporate identity for Brionvega.

Zanuso also designed one of the first plastic chairs, the *K 4999* children's chair for **Kartell**; sewing machines for **Borletti Veglia**; coffee grinders; tiles; airplane seats; and car bodies. All his products were developed with an eye on the market but also with a strong sense that it is necessary to take risks in order to succeed. In recent years, Zanuso has concentrated primarily on architecture, saying that "design is something for young people." Among Zanuso's best-known architectural projects are the large factory buildings in Italy and South America he designed for **Olivetti** in the 1950s. He also designed production plants for IBM as well as museums and convention centers.

Fourline chair for Arflex, 1964

Manufacturer of home appliances

Today, Zanussi markets a "designer series" of products, such as the mint-green, paunchy and flat-footed *Oz* refrigerator, by the company's chief designer, Roberto Pezzetta, and the *Zoe* washing machine, whose rounded lines and minimalist control panel exude an equally friendly and comfortable aura. But while such self-conscious marketing may reflect current trends, the company, founded in 1914 by Antonio Zanussi as a repair shop for kitchen appliances, has pursued a clear design policy since the 1950s.

It began in 1954, when Lino Zanussi commissioned **Gino Valle** to design washing machines, refrigerators, and stoves that would stand out from the bland uniformity of conventional white "elettrodomestici." Valle restructured the company's product lines and developed a unified, clean look that emphasized controls. The results were so successful that in 1962 Zanussi for the first time outsold its German competitors, who had previously dominated the market. Valle's partner at Zanussi was Gastone Zanello, who headed the company's

Zanussi spa.,
Pordenone

1916 founded by Antonio Zanussi as a repair shop for home appliances in Pordenone, Zanussi soon starts producing his own "elettrodomestici"

1954 **Gino Valle** is hired as design consultant

1958 design dept. headed by **Gastone Zanello** (until 1981)

1960 production of TV sets

1976 Andries van Onck hired as design consultant (until 1989)

1981 *Compasso d'oro*

1982 **Roberto Pezzetta** succeeds Gastone Zanello

1984 merger with Electrolux

Stove from *700* program by Gastone Zanello, 1960

Black refrigerator from *Wizard* collection by Roberto Pezzetta, 1986

Products

1957 *202* washing machine;
 gas and electric stoves

1958 *170 TS* refrigerator
 all by Gino Valle

1986 *Wizard* collection of
 refrigerators by Roberto
 Pezzetta

1995 prototype for *Oz*
 refrigerator by
 Roberto Pezzetta
 (prod. since 1998)

1996 prototype for
 Zoe washing machine by
 Roberto Pezzetta

design department, which had been established in 1958, and developed the first modular built-in systems for kitchens. In the mid-1970s, Zanussi hired another external consultant, the Dutchman Andries van Onck, a graduate of the Ulm School of Design. Van Onck created distinctive design concepts for the company's growing number of products, which were now organized in *"family lines."* In the 1980s, a failed expansion into the stereo market caused a severe crisis, which ultimately led Zanussi to refocus on its core business and put a renewed emphasis on design. The results were mixed: Roberto Pezzeta's 1986 *Wizard* refrigerator, which looked like a miniature campanile with a pretentious little flag on top, was a commercial flop but won numerous design awards.

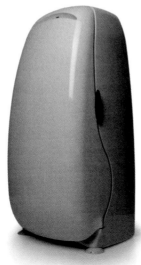
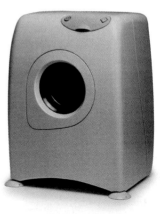

Oz refrigerator, 1995
Zoe washing machine, 1996

Design group and furniture manufacturer (Zeus Noto)

In 1984, Zeus, a group of young designers, introduced their first collection of furniture, which used a severely reduced vocabulary of archetypal and geometric forms. Roughly welded from black square-edged steel and laconically named *Sedia* (side chair), *Poltrona* (easy chair), *Sgabello* (stool), and *Savonarola,* **Maurizio Peregalli's** pieces used deliberate artlessness to communicate the group's opposition to **Memphis's** postmodern fireworks of form and color. "If the Memphis object is an affirmation of the transitory, the luxurious, the superficial, a costly and amoral object," wrote **Paolo Deganello,** "the Zeus object is a modest, moral object with transcendental tendencies. As such it reaffirms an absolute quality, which the industrial product has always had."

But even Peregalli, Zeus's art director, and his partners **Davide Mercatali** and Roberto Marcatti, have taken advantage of an expanded repertoire of forms and materials pioneered by Memphis,

Noto-Zeus srl, Milano

1984 founded by Sergio Calatroni, Roberto Marcatti, Ruben Mochi and **Maurizio Peregalli**

1988 Noto becomes production company of *Zeus Collection*

1989 *Sottosuolo* magazine launched

From left: *Golia* barstool by Maurizio Peregalli, 1993

Hotel Zeus TV stand by Ron Arad, 1992

MDF stool by M. Peregalli, 1993

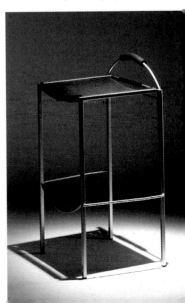

Products

1984 *Millepunte* furniture series
1986 *Musa* floor lamp,
 both by Maurizio Peregalli

1994 *Orb* stool series by
 Jasper Morrison;
 Crab stool series by
 Maurizio Peregalli;
 Anonimus stools and side
 tables by Ron Arad;
 Little Sister chairs
 by Andreas Brandolini

1995 *Anais Porta-
 Abiti* clothes rack by
 Robert Wettstein;
 Alice furniture series by
 Claudi Nardi;
 Artú table by Andreas
 Brandolini

including linoleum and Pirelli rubber flooring. Originally, the Zeus group also designed clothes, small objects, and graphics and showed their work in a small Milan gallery as part of an overall concept that stressed communication. They still publish their own newsletter, and Zeus's parties at the Milan furniture fair are annual get-togethers of the entire alternative design scene.

Since the mid-1980s, their furniture and lighting collections have been produced by Noto, while Zeus has become a forum for a small, select circle of young international designers, including Ron Arad, Jasper Morrison, Robert Wettstein, and Andreas Brandolini. The black and gray of the early years has given way to a broader color spectrum, and there is a greater formal variety in their designs. Nonetheless, Zeus continues to be a symbol of the post-Memphis generation's return to basics.

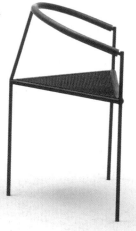

Chair and stool from *Millepunte*
series by Maurizio Peregalli, 1984

Page 359
left: Donna collection,
1989/90 (*Teodora*)
right: Uomo collection,
1998/99 both by Romeo Gigli

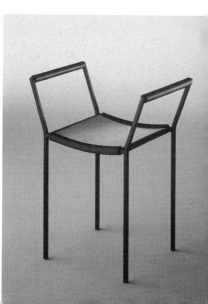

Guide

Sites, Museums, Showrooms

Sights and Culture in the Milan Area

Although Milan is Italy's design capital, there is no museum devoted to collecting and showing design. There are, however, a number of smaller collections where visitors can get information on specific aspects of product history (in some cases, by appointment only), as well as several interesting institutions and galleries.

TRIENNALE
Palazzo dell'Arte, Via Alemagna 6, Milan. The Triennale is an institution that has made design history. Since 1933 it has regularly presented major product shows. Today it features exhibitions on architecture, design, urban planning and arts and crafts as well as large international expositions. The building was designed by Giovanni Muzio and completed in 1933. The new interiors were designed by architects including Umberto Riva, Cini Boeri and Gae Aulenti.

COLLEZIONE "GLI ANNI DI PLASTICA"
Montedison s.p.a., Foro Bonaparte 31, Milan. A private collection of historic plastic products, established by Montedison, one of Italy's largest chemical manufacturers (by appointment only).

COLLEZIONE LORENZI
Via Montepoleone 9, Milan. The collection includes 1,400 scissors, razors and knives from the 17th century to the present.

COLLEZIONE SAMBONET
Fondazione Sambonet, Foro Bonaparte 44/a, Milan. More than 4,000 pieces of silverware, including antique artifacts as well as contemporary products by Sambonet.

DESIGN GALLERY MILANO
Via Manzoni 46, Milan. Located in an old palazzo, the gallery features regular sales exhibitions of works by renowned designers.

ASSSOCIATION JACQUELINE VODOZ ET BRUNO DANESE
Via S. Maria Fulcorina 17, Milan. Changing exhibitions on art and design in a beautiful old palazzo.

CIVICO MUSEO D'ARTE CONTEMPORANEO
Palazzo Reale, Piazza del Duomo, Milan. Opened in 1984, the museum has a collection of primarily Italian art from the 19th century to the present. Its main focus is on works by Futurists, such as Umberto Boccioni, and abstract art, but it also includes works by Giorgio Morandini and a selection of international artists.

PINOTECA DI BRERA
Via Brera 28, Milan. Milan's largest collection of paintings is housed in the 17th century Palazzo di Brera. In addition to major baroque paintings there are works by important modern Italian artists, incl. Boccioni or Carrà. The neighboring Accademia di Brera art academy counts among its alumni such designers as Enzo Mari, Joe Colombo and Piero Fornasetti.

MUSEO SIRM
Via Tirano 18, Palazzolo Milanese. This small museum of industry near Milan shows the world's largest collection of gas pumps and related objects. A metal-and-oil monument to industrial modernism, it is also an homage to Enrico Mattei, the legendary head of Agip who annoyed the Anglo-American oil giants in the 50s, turned Agip into a model company (with a corporate identity by Marcello Nizzoli) and died in a plane crash.

MUSEO STORICO ALFA ROMEO
Centro direzionale 1, Arese. Opened in 1976, the museum illuminates Alfa Romeo's company history, showing some seventy-five historical and contemporary automobiles.

COLLEZIONE CASSINA
Via Busnelli 1, Meda. Collection of over one hundred Cassina prototypes (not open to public).

COLLEZIONE CANDY
Via Eden Fumagalli, Brugherio. Documents the history of Candy's products and the development of electronic household appliances.

MUSEO DELLE PORCELLANE DI DOCCIA
Richard-Ginori s.p.a., Via Pratese 31, Sesto Fiorentino. Presents, on 13,000 square feet, the most important products of the venerable company Gio Ponti worked for in the 1920s.

COLLEZIONE STORICA KARTELL
Viale dell'Industria 1, Noviglio. Giulio Castelli founded this museum, which documents Kartell's product history (by appointment only).

MALPENSA 2000 AIRPORT
From Milan in the dir. of Varese / Switzerland. The airport is quite a drive from Milan, but the trip is rewarded by its impressively pleasant ambiance. The public areas were in large part designed by Ettore Sottsass.

METRO, LINE 1
Milan, inner city. The subway stations along the Nr. 1 line were designed by the architects Franco Albini and Franca Helg in the early 1960s. The wayfinding system is by Bob Noorda.

PIRELLI TOWER
Pirelli industrial park on Milan's northern periphery.
Architect Gio Ponti saw this tower, which was built in 1954-1956, as his "tribute to work." Its spectacular shape, reminiscent of an upright knife, makes it one of the most significant landmarks of Italian modernist postwar architecture. Paolo Cevini described the building as an "extraordinary expression of capitalist industrial culture at its peak."

Showrooms in Milan/Furniture

Shopping at the source: Milan is the city with perhaps the highest density of design studios, furniture and lighting companies, fairs and showrooms in Europe. They are all located within a relatively small area that can easily be explored by foot. Here is a selection of the most interesting:

ARTEMIDE; Corso Monforte

B&B ITALIA; Corso Europa 2

BALERI ITALIA; Via Cavallotti 8

CAPPELLINI; Via Statuto

CASSINA, Via Durini 18

DA DRIADE; Via Manzoni 30

DE PADOVA; Corso Venezia 14

FLOS; Corso Monforte 9

KARTELL; Via Turati/Via Carlo Porta 1

MOROSO; Via Pontaccio 8/10

SAWAYA & MORONI; Via Manzoni 11

ZANOTTA; Via Durini 3

ZEUS; Corso S. Gottardo 21/9

Showrooms in Milan/Fashion

Milan is an international fashion capital. Virtually all major Italian fashion designers are based here and present their collections in elegant showrooms. Prada, Dolce&Gabbana Romeo Gigli, Gucci, Escada, Armani, Ferré and many others are all tightly clustered around the Piazza San Babila, on Via Montenapoleone and Via della Spiga.

MISSONI; Via T. Slavini 1

KRIZIA; Via Manin 19

DOLCE & GABBANA; Piazza Umanitaria 2

Stores in Milan
GALLERIA VITTORIO EMANUELE II
Main entrances on Piazza del Duomo and Piazza della Scala. Designed by Giuseppe Mengoni in the 19th century, this world-famous shopping gallery is called "il salotto di Milano," "Milan's salon," by the locals. Elegant boutiques (including the original Prada store), restaurants and cafés attract a fair share of the city's rich and beautiful. The steel-and-glass roof, topped by an enormous dome, was the first construction of its kind in Italy. Another impressive feature is the design of the floors with its mosaics and zodiac motifs.

CARLA SOZZANI
Corso Como 10. Owned by the sister of *Vogue* Italy's editor-in-chief, the store offers an ultrahip mix of ethno-pop, fashion and books. The upper-floor gallery shows changing exhibitions of art and design.

FORNASETTI IMMAGINAZIONE
Via Manzoni 45. This store exhibits and sells Piero Fornasetti's numerous designs – sun, animal, or architectural motifs on plates furniture and foulards.

LA RINASCENTE
Piazza Duomo. The flagship of the elegant department store chain with its impressive facade is right across from the Milan cathedral.

MH WAY
Via Durini 2, Bags, knapsacks and art supplies in a mix of

Italian and Japanese styles—Makio Hasuike has made quite a splash with his company and products over the last few years.

Sights and Culture in the Turin Area

FIAT FACTORY
Turin-Lingotto; The legendary Fiat factory from the 1920s hasn't been operating for many years but is definitely worth a visit for the spiral ramp that leads around the building and up to the rooftop test track. Today this landmark of industrial architecture serves as a cultural and convention center.

MUSEO DELL'AUTOMOBILE CARLO BISCARETTI DI RUFFA
Corso Unità d'Italia 40, Turin; One of the world's largest automobile museums; besides numerous models from all phases of automotive history, it features an extensive library.

MUSEO PININFARINA
Via Nazionale 30, Cambiano; Presentation of many of the bodymakers famous models for Alfa Romeo, Cisitalia, Ferrari and Lancia (by appointment only).

ASSOCIAZIONE ARCHIVIO STORICO OLIVETTI
Via delle Miniere, Ivrea; The Olivetti Archive was opened in 1998 in Ivrea, the company's traditional base near Turin. The firm's history is exhaustively documented in a large exhibit of products and graphics, a photographic archive, and an extensive library that includes books as well as video and audio material (by appointment only).

SALA DA BALLO
Via Stradelle, 10, Turin; Old public dance hall in Turin, still with its original interior designed by the famous architect Carlo Mollino.

Other Destinations in Italy

MUSEO ALESSI
Crusinallo (Como); Alessi's vast archive of prototypes, early products, drawings and documents, collected since the firm's establishment in 1921, has recently moved into this new building designed by Alessandro Mendini. The museum, with some 6,000 square feet of exhibition space, is located in Crusinallo, near idyllic Lago Maggiore. The collection will initially be open only to researchers and journalists. In neighboring Omegna another Alessi museum, also designed by Mendini, will soon be open to the general public.

COLLEZIONE LAGOSTINA
Via IV Novembre 45, Omegna; Housewares manufacturer's historical collection.

MUSEO MOTO GUZZI
Via Parodi 57, Mandello del Lario; Collection on the history of the motorcycle manufacturer.

COLLEZIONE GUZZINI
Località San Leopardo, Recanati; Collection of products by Fratelli Guzzini (not public).

Page 363

Cassina showroom in Milan

Gas pump, Italy, 1935. Museo Sirm

Galleria Ferrari, Maranello. Gateway by Massimo Losa Ghini

364

COLLEZIONE AEREI PIAGGIO
Piaggio, Via R. Piaggio, Finale Ligure. Aircraft museum documenting Piaggio's.aeronautical history since 1919 (by appointment only).

GALLERIA FERRARI
Via Dino Ferrari 1, Maranello; Automobile museum illustrates the exclusive carmaker's history with different Ferrari models, historical documents, trophies and curiosities. Some of the exhibits were designed by Massimo Iosa Ghini.

MUSEO DEGLI ARGENTI CONTEMPORANEI
Piazza L. da Breme 4, Sartirana; The museum, which opened in 1992, shows works of Italian silversmiths' from the 1970s to the present.

MUSEO DELL'ARREDO CONTEMPORANEO
S.S. San Vitale 253, Russi. Shows outstanding examples of contemporary Italian furniture and lighting production.

MUSEO DELLA CERAMICA
Palazzo Perabò, Laveno Mombello Cerro;. Opened in 1970, the museum documents Italian ceramics production from the middle of the 19th century to the postwar era.

PALAZZO GRASSI
Canale Grande, Venice; Fiat bought this Venetian palazzo and turned it into a gallery for outstanding art exhibitions. The interiors were designed in the 1980s by Gae Aulenti.

LA BIENNALE DI VENEZIA
Giardini, Venice; Renowned biennial art and architecture exhibition.

MUSEO SALVATORE FERRAGAMO
Via Tornabuoni 2, Florence; A magnificent building showcasing the ingenious creations of shoe designer Salvatore Ferragamo. The collection includes more than 10,000 historical shoes from the 1920s to the present.

Page 365
Oihos I System
by Antonia Astori
for Driade, 1973

ABET LAMINATI 88, 256, 259, 325

ABITARE Architecture and design mag.; founded 1962. Editorial focus on professional practice. Aimed at architects and designers as well as a wider readership interested in the subject. 238

ACERBIS Furniture manufacturer; founded 1870. Family-owned; modern furniture design since 1968. Acerbis collection (living room furniture); lower-priced *Morphos* collection for younger customers (since 1983), *Bed Side* collection (bedrooms). Designers: Giotto Stoppino, Lodovico and Marco Acerbis, Mario Bellini, Michele De Lucchi and Andrea Branzi. 328, 344

ADI (Associazione per il Disegno Industriale) Italian design association; founded 1956. Over 600 members, including industrial, furniture and graphic designers, design-oriented companies, journalists, writers and critics.). Mission is to promote industrial and graphic design by fostering contacts between designers and industry and cooperating with cultural institutions (exhibitions, conferences, seminars). Organizes the *Compasso d'oro* awards and exhibition. 64, 326

AGAPE Manufacturer of faucets and bathroom accessories; founded 1973; Mantua. Works with such designers as Giampaolo Benedini but also with a younger group incl. Fabio Bortolani, Marco Ferreri and Carlo Tinti. 143

AGIP (Azienda Generale Italiana dei Petroli) Govermt.-owned oil and energy company; founded 1926. Visual image defined by Marcello Nizzoli (electromechanical gas pump, 1950–52. 1952, company logo by Giuseppe Guzzi. In the 1970s, Unimark redesigned the corporate identity.

AGNOLI, Tito b. 1931, Peru. Painter, architect and product designer. Lamps for O Luce; beds for Rondo; chairs *(THF, Europa 80), 9000* modul. seating system for Arflex; seats and tables *(Boulevard, IDC)* for Poltrona Frau. Defined collection of furniture manuf. Pierantonio Bonacina. 136

ALBINI, Franco 89, 57, 60, 64, 104, 109, 156, 158, 210, 276, 291, 303, 340, 352

ALCHIMI 79, 88, **92,** 94, 102, 144, 176, 216, 254, 258, 299, 300, 324

ALESSI 78, **94,** 96, 144, 149, 165, 212, 259, 266, 314, 325

ALFA ROMEO 52, 54, 65, **98,** 130, 158, 195, 232, 251, 286, 310

ALIAS 78, **101,** 110, 118, 174, 251, 306

AMBASZ, Emilio b. 1943, Argentina. Architect, furniture and lighting designer; 1970–77, curator at Mus. of Modern Art, NY *(Italy: The New Domestic Landscape,* exhib., 1972); 1977, indep. designer; 1981, studio in New York. Worked for Tecta, Castelli, Artemide and Erco. 1981, 1991 *Compasso d'oro.* 71

ANTI-DESIGN Design movement formed in the mid-1960's .in opposition to the doctrines of "good taste" and functionalism. Products incl. *Sacco* beanbag and *Joe* catcher's-mitt chairs by De Pas/D'Urbino/Lomazzi; *Blow* chair by Gatti/Paolini/Teodoro. Anti-Design and Radical Design are nearly conterminous, except for the added political agenda of Radical Design and its protagonists (incl. Archizoom, Superstudio). 102, 176, 179, 181, 298, 324

ARC LINEA Kitchen manufacturer; founded 1925 by Silvio Fortuna as a workshop. Company name "Arc Linea" since 1960. Italian market leader. First big success in 1963 with *Claudia* kitchen (first Italian kitchen with built-in electric appliances). Recent designs by Antonio Citterio. 129

ARCHITETTURA RADICALE 72, 298

ARCHIZOOM; 102, 144, 181, 266, 292, 298

ARFLEX; 62, 90, **104,** 122, 132, 160, 171, 290, 352

ARMANI, Giorgio 80, **106,** 231

AROLDI, Danilo and **Corrado** b. 1925 and 1936. Furniture and lighting designers. Joint studio in Milan. The Aroldi brothers are best known for their kitchens and lighting for Campi e Caligari, Luci, Pabis, Zetamobili, Tonon, and Delta.

ARTELUCE 63, **108,** 133, 183, 184, 228

ARTEMIDE 78, 101, **110,** 124, 133, 176, 183, 206, 240, 246, 250, 256, 305, 314, 325, 344

ASTI, Sergio 112, 224

ASTORI, Antonia 113, 184

ATLANTIDE; 183, 184

AULENTI, Gae 66, **114,** 202, 224, 278, 292, 330, 348

AURORA Manufacturer of fountain pens; founded 1919. First Italian fountain pen. Combination of technical perfection and innovative design.

AZUCENA; Furniture and lighting manufact.; founded 1947 by Luigi Caccia Dominioni, Ignazio Gardella and Corrado Corradi Dell'Acqua. First furniture company focusing on

modern design after World War II. Close cooperation with traditional workshops. Designs by Caccia Dominioni (*Imbuto* table lamp, 1953; *Catilina* chair, 1958; *Melanzana* door handle, 1960), Gardella/Corradi Dell'Acqua (*Coppa Vetro Chiusa* wall and floor lamp, 1954). 122, 149

B&B ITALIA 82, **116**, 124, 168, 318

BALDESSARI, Luciano 1896–1982. Architect, painter, graphic and set designer. Influenced by Futurism and Rationalism. 1929, *Luminator* lamp in rationalist. style. Famous for his dynamic exhibition designs of the 1950s. Worked with Le Corbusier, Walter Gropius, Alvar Aalto, Oskar Niemeyer. 303

BALERI, Enrico b. 1942. Furniture and lighting designer, entrepreneur. Founded companies Pluri (1968), Alias (1979), Baleri Italia (1984) and Gloria (c 1990); produced designs by Philippe Starck, Alessandro Mendini and Hans Hollein. Created desigs for Gavina, Flos, Knoll. 118

BALERI ITALIA 79, **118**

BALLA, Giacomo 1871–1958. Futurist. painter and product designer; 1915, interior design for Löwenstein house in Düsseldorf. In the 1920s ceramics and lamps. 53, 208

BANAL DESIGN refers to non-designed everyday objects. The term was coined in the 1970s by Alessandro Mendini who believed that banal forms could give impulses to design. 258, 300, 324

BARILLA 120

BARTOLI, Carlo b. 1931. Architect and furniture designer in Milan and Monza. 1959–81, architectural office. Designs for Arflex (*Gaia* chair, 1966), Arc Linea, Confalonieri, UCG, Con & Con, Kartell, Oscam, Rossi di Albizzate, Tisettanta.

BBPR 122, 276, 352, 303

BEL DESIGN Italy's "beautiful design," characterized by extraordinary formal and technological innovation. Bel Design's prime lasted from the beginning of the economic miracle in late 1950s when the industrial sector strove to differentiate its products through high functionality and formal beauty, until the 1970s, when these values were questioned by young design rebels (Radical Design, Global Tools, Alchimia). Numerous classics illustrate the Bel Design concept: Marco Zanuso's and Richard Sapper's TV- and radio sets for Brionvega and *Grillo* telephone for Siemens; Mario Bellini's typewriters and calculators for Olivetti and

chairs for Cassina; Vico Magistretti's *Selene* chair for Artemide and *Atollo* table lamp for O Luce are only a few distinguished examples. 66, 92, 102, 112, 114, 164, 298

BELLINI, Mario 116, **123,** 145, 156, 231, 280

BELOTTI, Giandomenico b. 1922. Architect, furniture designer and sculptor. One-family homes, industr. and public buildings. Has worked for Alias since 1979 (*Spaghetti* chair, *Hommage à Man Ray* chair, *Four Balls* table).

BENETTON 126, 318

BERCHICCI, Guglielmo b. 1957. Architect, product, furniture and lighting designer. Studio in Milan since 1986. Has worked for Kundalini (*Loto* lamp, 1997).

BERNINI 127, 206, 284, 320, 328

BERTI, Enzo 129

BERTONE; 65, 100, **130,** 196, 213, 232

BETTONICA, Franco Product and lighting designer; cofounder of Cini & Nils.

BIAGIOTTI, Laura b. 1943. Fashion designer. In 1962 started working in her mother's fashion studio in Rome (collections for Schuberth and Capucci). Since 1972 she has produced her own collections.

BIALETTI now Bialetti Industrie spa. Manufacturer of espresso makers. 1933 Alfonso Bialetti designed and produced the famous octagonal *Moka Express* stovetop-espresso maker,. 250 million of which have since been sold.

BIANCHI Bicycle manufacturer; founded 1885. In 1901 began producing automobiles and motorcycles. Stopped prod. of cars during World War II, of motorcycles in 1964. Has since concentrated exclusively on bicycles. Division of Piaggio since 1976.

BIANCONI, Fulvio b 1915. Graphic designer and illustrator. Designed books, dust jackets, record covers, theater programs and advertisements for Fiat and Pirelli. Famous for his glasses (for Venini), drawings and lithographs.

BIEFFEPLAST Lighting and furniture manufacturer; founded around 1980 by Anna Anselmi; division of Bieffe. Works with metals and plastics; research focus on. CAD/CAM automation of furniture production. Designers: Michele de Lucchi, Rodney Kinsman and Matteo Thun. 78

BINAZZI, Lapo b. 1943. Product designer and author; representative of Radical Design. Cofounded Gruppo UFO. Opened studio for objects and architecture in Florence in 1975. Writes for *Domus* and *Modo;* produced videos and films; designed ceramics for Eschenbach and silverware for Pampaloni.

BINFARÉ, Francesco b. 1939. Architect and furniture designer. Headedf B&B Italia's research center (establ. 1968) for many years. Now designs for Edra Mazzei (*L'homme et la femme* sofa). 116, 186

BOERI, Cini 104, **132,** 194

BOFFI Manufacturer of kitchen and bathroom furniture; founded 1947. In the 1950s, modular kitchen systems. Produced pioneering solutions such as Joe Colombo's 1966 *Carrellona* compact kitchen or Antonio Citterio and Paolo Nava's 1980 *Factory* kitchen. Designers also include Marc Sadler (*Totem, Alu Kit)* Luigi Massoni, Piero Lissoni. 171, 234

BOGGERI 134

BOLIDISMO Design and architectural movement formed in 1986 by 15 young architects, incl. Massimo Iosa Ghini, in Bologna. The "Bolidistas" were interested in a flexible and "fast" lifestyle. They took their formal cues from Futurism, American streamline-style and 1950s aesthetics to create a boldly dynamic look (Iosa Ghini's *Dinamics Collection* for Moroso, 1986, and Bolido dance club in New York, 1986). Largely lost its relevance in the stylistically purist 1990s. 208, 221

BONACINA 90, **136**

BONETTO, Rodolfo 128, **138,** 184

BONFANTI, Renata 140

BORLETTI VEGLIA Manufacturer of clocks and measuring instruments; founded 1896. Temporarily manufacturer of sewing machines; worked with Marco Zanuso (*Superautomatica 1100/2* sewing machine, 1956), Rodolfo Bonetto (*Sfericlock* with graphics by *Max* Huber, dashboard displays for Fiat (*131, Ritmo, Cromo*) and Giorgetto Giugiaro. Owned by Citizen. 138, 354

BORSANI, Osvaldo 142, 330

BORTOLANI, Fabio 143

BOTTONI, Piero 1903–1973. Architect and furniture designer, cofounder of Movimento Italiano per l'Architettura Razionale (MIAR). *Lira* tubular steel chair, 1934 (prod. by Zanotta, 1986). *Curator of Triennale* 1946. 55, 61, 303

BRANZI, Andrea 77, 92, 102, **144,** 256, 298, 302

BREDA FERROVIE Large Italian railroad company; founded 1886. Important force in Italian industrialization in 19th century. In the 1930s, first electric, streamlined train, *Etr 200 Breda* by Giuseppe Pagano; in 1949, famous *Etr 300 Settebello* train.

BRIONVEGA 123, **145,** 165, 244, 314, 353

bTICINO Manufacturer of light switches.; founded c. 1950 as Bassani Ticino. Since the 1960s very design-oriented in product and communications strategy (*Magic* and *Living* series).

BUGATTI Automobile manufact.; founded by *legendary* car builder Ettore Bugatti (son of cabinetmaker Carlo Bugatti). Firm became famous for its racing models (*Typ 35,* 1924) and elegant touring cars. Gradual decline of the company after Ettore's death in 1947. Sold to Hispano-Suiza in 1963.

BUGATTI, Carlo 56, **148**

BUSNELLI 218

BYBLOS Fashion line by Genny.

C&B ITALIA 116, 283, 299, 318

CACCIA DOMINIONI Luigi **149,** 162

CAMPAGNOLO Bicycle manufacturer; founded 1933 by Tullio Campagnolo. The in-house design dept. received a *Compasso d'oro* for bicycle accessories in 1995.

CAMPARI Beverage company, Milan. Since the 1920s innovative advertising campaigns by renowned graphic designers and artists, incl. Futurist painter Fortunato Depero, Marcello Nizzoli, Bruno Munari. 209, 268, 273

CAMPI, Antonia b. 1921. Product and furniture designer. Designs for Richard-Ginori and Ermenegildo Collini. 1959, *Compasso d'oro* (for scissors).

CANDY Manufacturer of household appliances, incl. refrigerators and washers; founded 1945. Worked with Marco Zanuso (who introduced new conceptual priorities such as energy efficiency, durability, and sensitive pricing),

Rodolfo Bonetto (1972–1975), Mario Bellini (*Primato 440, Primato 971* washing machines, 1978), Giorgetto Giugiaro (aggressive graphics for *Domino* series, 1983).

CAPPELLINI 82, **150,** 183, 234

CAPPIELLO, Leonetto 1875–1942. Graphic designer. Numerous posters around 1900.

CAPRONI Aircraft manufacturer; founded 1910. During the World Wars production of war planes; in 1940, first Italian jet airplane.

CAPUCCI, Roberto b. 1930. Fashion designer. Opened studio in Rome in 1950; moved to Paris in 1962; returned to Italy in 1968.

CARBONI, Erberto b. 1899. Graphic and furniture designer. Designs for Montecatini, Agip, Campari, Motta, RAI, Barilla, Olivetti and Arflex (*Delfino* Sessel, 1954). Known for making abstract concepts vivid in his exhibition designs (Chemistry Exposition, 1952 in Milan). Coined the term "atomico" for the isolation of parts in a dynamic design concept. Numerous advertising awards. 104, 120, 134, 276

CARMINATI TOSELLI & C. Streetcar manufacturer, founded 1899. 1927, famous 1500 series aka *tipo 1928* by Giovanni Cuccoli; many of the streetcars built in 1928–31 are still in operation today.

CASABELLA Magazine; important forum of contemporary discussions in architecture and design, especially from the 1950s through the 1970s. Essays on a high theoretical level (former editors include Pierluigi Cerri, Anna Castelli Ferrieri, Marco Zanuso, Vittorio Gregotti, Aldo Rossi, Alessandro Mendini).

CASATI, Cesare Furniture and product designer. Student of Gio Ponti. Studio D.A. with Emanuele Ponzio; furniture for hotels, banks, convention centers. Designs for Phoebus, Nai Ponteur and Autovox.

CASSIA, Antonio Macchi b. 1937. Industrial designer. Worked for Studio Bonfanti-Macchi Cassia-Porta from 1968–70; from 1968–71, consultant for Olivetti and Steiner International. Designs for Olivetti (*Divisumma 18* and *28* calculators, *Copia 2000* copier, *M 20* personal computer), Arteluce, Stilnovo, Totalglas, Condor and Radiomarelli.

CASSINA 57, 63, 78, 124, 144, **154,** 181, 206, 234, 240, 283, 293, 299, 306, 318

CASTELLI Furniture manufacturer; founded 1877 by Cesare Castelli in Bologna. One of Europe's leading furniture companies; produces designs by Giancarlo Piretti (*Plia* Plexiglas chair, 1968), Rodolfo Bonetto and Richard Sapper. Development of modular office systems.

CASTELLI FERRIERI, Anna 89, **158,** 224, 303

CASTIGLIONI, Achille 61, 96, 128, 145, *162,* 174, 178, 200, 210, 224, 239, 291, 348

CASTIGLIONI, Livio 1911–1979. Architect and product designer; brother of Achille and Pier Giacomo. Joint projects with his brothers included audio-visual environments and exhibits for RAI. Single projects from 1952, incl. lighting and electronic appliances. Designs for Fiat, Olivetti and Brionvega. 54, 63, 149, 162

CASTIGLIONI, Pier Giacomo 54, 61, 63, 64, 145, 149, **162,** 200, 210, 348

CENTROKAPPA Independent creative division of Kartell. Worked for Kartell as well as other companies; dissolved in the late 1980s. 224

CERAMICA BARDELLI Tiles manufact.; founded 1962. Works by Gio Ponti (tiles series, 1966) and Piero Fornasetti (*Sole* and *Luna* tiles, 1990).

CERRI, Pierluigi b. 1939. Architect, graphic, furniture and lighting designer. Graphic and exhib. design with Gregotti Associati. Editor at *Casabella* and *Rassegna;* since 1982 artistic director of B&B Italia; Lighting and furniture for Poltrona Frau and Fontana Arte. 1995 *Compasso d'oro.* 202

CHIESA, Pietro 1892–1948. Opened glass workshop in 1921; founded, with Gio Ponti, furniture and lighting co. Fontana Arte as artistic division of Luigi Fontana in 1932; numerous furniture and lighting designs (incl. *0556* floor lamp, 1933). 202

CIBIC, Aldo b. 1955. Interior architect, furniture and product designer; student of Ettore Sottsass. Opened studio in 1991. Designs for Memphis (*Belvedere* sideboard, 1982); furniture systems (*Standard* program); watches for Tissot; Esprit stores. 256

CIDUE Furniture manufacturer; founded 1970. produces works by younger designers, incl. Rodolfo Dordoni and Roberto Lazzeroni.

CIMINI, Tommaso b. 1947. Lighting designer. Engineer at Artemide; founded his own company in 1978; best-known work is *Daphine* lamp (with M. de André) for Lumina.

CINELLI 216

CINI & NILS Lighting manufact.; founded 1969 by Mario Melocchi and Franco Bettonica. Packaging designer Melocchi initially produced objects inc. table sets and magazine racks; with Bettonica's *Cuboluce* cubic lamp (1972) shift of focus to lighting.

CITTERIO, Antonio 88, 116, **168,** 226

COLNAGO Bicycle manufacturer; founded 1954. Originally custom workshop with limited output; today production of racing and mountain bikes (1983, star-shaped *Master* frame, 1993, *C 35* bicycle).

COLOMBINI, Gino b. 1915. Designed formally varied, colorful plastic housewares in the 1950s. Since 1949 techn. director at Kartell. Multiple *Compasso d'oro*. 51, 64, 222

COLOMBO, Joe (Cesare) 88, 128, 136, **170,** 224, 240, 274, 348

COLUMBUS 216

COLUMBUS MOBILI Former furniture manufact.; founded 1919. Originally specialized in steel tubes for cars, bicycles and airplanes; in the 1930s produced high-quality tubular-steel furniture by Marcel Breuer and Italian Rationals, incl. Piero Bottoni, Lugi Figini, Gino Pollini and Giuseppe Terragni; Discontinued furn. prod. c. 1970. Part of Gruppo. **216**

COMPASSO D'ORO Prestigious Italian design award. Instituted in 1954 by La Rinascente department store on the suggestion of Gio Ponti. Awarded by prominent ADI-appointed panel in irregular intervals since 1959 for outstanding products, services and research projects. 51, 64

COMPLICE Fashion line by Genny. 342

COPPOLA, Silvio 1920–1986. Architect, product and graphic designer. Designed furniture, faucets and spoons, winning numerous awards. Consultant for Bayer Italia, Monteshell, Montecatini, Cinzano and Laminati Plastici.

CORDERO, Toni b. 1937. Architect, lighting and furniture designer. 1985, Alpine stadium, 1987, Automobile museum in Turin. Designs for Artemide, Driade and Sawaya & Moroni.

COSMIT Milan trade show company, which organizes furniture, office furniture and lighting fairs.

CRASSEVIG Furniture manufacturer since 1960s. Specializes in bent solid wood. Collaboration with designers incl. Gigi Sabadin, Rodolfo Dordoni, Enrico Franzolini, Carlo Bartoli and Fabio Bortolani.

CUNEO, Marcello b. 1933. Architect, industrial and product designer. Designed office buidings, dept. stores, government buildings, museums and churches. Diverse product designs, incl. lighting for Gabbianelli, furniture for Arflex and Cassina.

DALISI, Riccardo b. 1931. Architect, product designer and theorist; Radical Design. Lives, teaches and works in Naples; was member of Mitglied of Global Tools; realized projects for Alchimia; designed furniture for Zanotta and Baleri and coffee makers for Alessi; *Compasso d'oro* 1981. 118, 274

DANESE 101, **174,** 193, 248, 270

D'ASCANIO, Corradino 1891-1981. Engineer and aircraft engineer. Designed legendary *Vespa* scooter for Piaggio (produced in 1946) and built helicopters after designs by Leonardo da Vinci. 59

DDN (Design Diffusion News). Large-sized furniture magazine aimed at dealers, producers and other business insiders.

DE CARLI, Carlo 1910–1971. Architect and furniture designer. In the 1950s, innovative furniture designs with new materials for Cassina and others. 210

DE LUCCHI, Michele 77, 88, 92, 110, 150, **176,** 244, 256, 280, 292

DE PADOVA 178, 242

DE PAS / D'URBINO / LOMAZZI 179, 136, 292,299, 348

DE PAS, Jonathan; 1932–1991; Architekt und Möbeldesigner. 88, 136, **179,** 292, 299, 348

D'URBINO, Donato b. 1935. Architect and furniture designer. 88, 136, **179,** 292, 299, 348

DE VECCHI Silverware manufacturer; founded 1962. Company founder Gabriele De Vecchi designed *T8* candleholder (Gold medal at *Triennale* 1947); in the 1950s, works by Piero Bottoni, Guglielmo Ulrich and Gio Ponti, later by Sergio Asti, Ugo La Pietra, Enzo Mari.

DEGANELLO, Paolo 82, 102, 156, **181,** 298, 357

DEPERO, Fortunato 1892–1960; Painter, graphic designer,

author, set and textile designer. 1914, member of Roman Futurists (*Futurist Reconstruction of the Universe, manifesto).* Designed stage sets, book illustrations, posters, interiors and furniture. 208

DESIGN GROUP ITALIA 182

DIULGHEROFF, Nicolai Bulgarian, 1901–1982. Painter, ceramic and furniture designer. Studied at Bauhaus. Went to Italy in 1920s; Futurist in Turin.

DOLCE & GABBANA Milan fashion company; founded 1985 by Domenico Dolce and Stefano Gabbana. Quotes from Italian fashion and cultural history. 1990–1994, designs for Complice. 80, 183

DOMODINAMICA 312

DOMUS Magazine for urban planning, architecture, art and design; founded 1928 by Gio Ponti, who was editor-in-chief until 1979, with few interruptions (other editors in chief included Mario Bellini, Vittorio Magnano Lampugnani, François Burkhardt). Highly influential publication. 1970 *Compasso d'oro.* 238

DOMUS ACADEMY Private sachool for advanced training; founded in 1982 in Milan. Courses in Industrial and fashion design.

DORDONI, Rodolfo 82, 109, 110, 150, **183**, 184, 201

DORFLES, Gillo b. 1910. Univ. professor and influential art and design critic; prominent scholar of Italian design history. 1956, member of ADI; professor of aesthetics in Trieste. Spokesman of International Congress of Industrial Designers (ICSID). Speaker at numerous conventions. 1970 *Compasso d'oro.*

DRIADE 78, 113, 181, 183, **184**, 240, 200, 307

DROCCO, Ouido b. 1942. Furniture designer, Radical Design. Known for multifunctional furniture (*Cactus* clothes treee for Gufram, 1972). Worked with Franco Mello. 219

DUCATI Motorcycle manufact.; founded. 1926 by Antonio Cavalieri Ducati and family. Initially produced portable radios, then, after World War II, calculators, electric razors, film cameras, and finally motorcycles. Known for stripped-down, high-tech motorcycle design. New Logo by Massimo Vignelli in 1996. 267

EDEN (European Designers Network); founded 1990 by BRS

Premsala Vonk (Amsterdam), MetaDesign (Berlin), Elene Design (Kopenhagen) and King-Miranda (Milan). 228

EDRA MAZZEI 79, **186**, 266, 282

ELAM Manufacturer of upholstered furniture; founded 1954. Clear design strategy from the 1950s, then long hiatus in creative output until the mid-1990s when the company began presenting new functional designs (by Gae Aulenti, Michele De Lucchi, Alessandro Mendini and others).

FANTONI Furniture manufacturer based in Osoppo near Udine; founded 1882 as a workshop for period furniture. Rapid growth from 1950s. Fantoni was the first European company to produce medium density fiberboard. Focus on office furniture since the 1970s. Designers include Gino Valle (who also built Fantoni factory), Herbert Ohl. 1998 *Compasso d'oro.*

FERRAGAMO, Salvatore 56, **188**

FERRARI 65, 130, **190**, 195, 221, 286

FERRÉ, Gianfranco 192

FERRERI, Marco 174, **193**

FIAM 83, 133, **194**

FIAT 52, 54, 65, 114, 130, 138, **195**, 213, 232

FIGINI, Luigi b. 1903. Architect and industrial designer; was member of Gruppo Sette and Movimento Italiano l'Architettura Razionale. Worked with Gino Pollini. 1935–57 at Olivetti (*Studio 42* portable typewriter with Alexander Schawinsky). Designed offices, industrial buildings and church in Milan. 53, 276, 302

FILA (Fabbrica Italiana Lapis e Affini). Manufacturer of writing instruments; founded 1920 in Florence, now based in Milan. Since the 1970s collaboration with renowned designers, incl, Design Group Italia (*Tratto Pen* and *Tratto Clip,* 1977 and 1978).

FIORUCCI 198, 221, 331

FLEXFORM Furniture manufacturer; founded 1959 by Romeo, Agostino, and Pietro Galimberti. Upholstered furniture. Designers: Antonio Citterio, Paolo Nava, Cini Boeri, Joe Colombo, Sergio Asti and Gabriele Mucchi.

FLOS 118, **200**, 210, 318

FLOU Bed manufacturer; founded 1978 in Meda. Company

produces beds in a variety of sizes and finishes; c. 160 different styles. Designer: Vico Magistretti. 321

FONTANA ARTE 114,183, **202**, 294, 305, 321

FORCOLINI, Carlo b. 1947. Painter, furniture and lighting designer. 1979, cofounder of Alias; lighting for Artemide and Alias (Icaro wall lamp, *Apokalypse Now* table); owner of furniture and lighting company. Nemo (founded. 1993). 78, 101, 110

FORNASETTI, Piero 62, **204**, 296

FRANCO TOSI Machine manufacturer; founded 1881. Initially steam engines, later ship's engines and electrical units.

FRANZOLINI, Enrico b. 1952. Artist, restorer, architect and product designer. 1972, artistic contribution to *Biennale di Venezia*. Sofas and shelving units for Cappellini *(Londra, Vienna, Light-Box cabinet system)*. Furn. designs for Moroso *(Jules e Jim* sofa), Alias, Crassevig, Montina and Knoll.

FRATTINI, Gianfranco 109, 110, 128, **206**

FRONZONI, A.G.. b. 1923. Architect, graphic and furniture designer. 1945, office in Brescia, later Milan; 1965–67, publisher and art director at *Casabella;* 1978, founded Istituto di Communicazione Visiva in Milan. His work is characterized by strict reduction to graphic elements in black and white for Galli (1964 *Serie 64).*

FUTURISM 208, 268

GABBIANELLI Ceramics manufacturer; founded 1939 in Milan. In the 1950s and 60s between trad. crafts and design. Objects by Sergio Asti (*Omaggio ad Alvar Aalto* and *Turbante basso* vases, 1967), Gio Ponti, Makio Hasuike, Marcello Cuneo, Gianfranco Frattini and Enzo Mari. Part of Gruppe Ceramica Bardell since 1996.

GABETTI, Roberto Turin-based architect, partner of Aimaro Isola. 67

GABETTI, Roberto/ISOLA, Aimaro b. 1925/1928. Turn-based architects and designers. Numerous architectural projects; furniture inspired by trad. crafts, incl. famous drop-shaped hanging lamp, 1956; and wooden chairs, often with boldly curved shapes. 67

GAGGIA Manufacturer of espresso makers; founded 1948. Produced first commercial espresso makers for bars, etc.; equipped with milk steamers. From 1968 collaboration with designers (*Tell 70* model by Giuseppe de Goetzen; *Baby Gaggia* by Makio Hasuike, 1977).

GAP CASA Magazine for interior architecture and furniture design; founded 1980. Aims at dealers, designers and manufacturers.

GARDELLA, Ignazio b. 1905. Architect, product designer and writer. Rationalist. Architecture; buildings for Olivetti, Kartell and Alfa Romeo. In the 1950s experimental designs, incl. furniture for his company Azucena (founded 1947 with Luigi Caccia Dominioni in Milan). Designs with Anna Castelli Ferrieri for Kartell and Gavina (*Diagramm* chair, 1957). 60, 64, 224, 303

GARELLI Motorcycle manufacturer; founded 1919 (*Mosquito,* 1945). Since 1962 part of Agrati di Monticello.

GARIBOLDI, Giuseppe Product designer. Designs for Richard Ginori (plumbing fixtures and tableware). 1954 *Compasso d'oro.*

GATTI/PAOLINI/TEODORO Design studio; founded 1965 by architects Piero Gatti, Cesare Poilini and Franco Teodoro in Turin. Graphic and industrial design, urban planning; known for *Sacco* beanbag chair (1969 for Zanotta). 299, 348

GAVINA 118, 165, 200, **210**, 318, 320

GECCHELIN, Bruno b. 1939. Architect and Product designer. Lamps for O Luce, furniture for Busnelli and Frau, gas heaters and refrigerators for Indesit, glassware for Venini, typewriters and computers for Olivetti. 1989 and 1991 *Compasso d'oro.* 218, 274

GEDY Manufacturer of bathroom accessories; founded 1953 (*Cucciolo* toilet brush by Makio Hasuike, 1979). Designs by Matteo Thun.

GENNY Fashion company; founded 1961 by Arnaldo Girombell (run by his wife, Donatella, since 1980). *Genny* collection, *Byblos* (1973) and *Complice* lines (1975). Designers have included Versace, Claude Montana, Domenico Dolce and Stefano Gabbana. 342

GHIA Car-body maker; founded 1915 by Giacinto Ghia in Turin. Extravagant single designs. Known for VW *Karmann-Ghia* (1955); car bodies for Chrysler. Luxury car, *Ghia L. 6.4* with Osi. Bought by Ford in 1972. 213

GHIA, Giacinto Car-body designer and entrepreneur. Legendary company for car design, Carozzeria Ghia; founded 1915 in Turin. Known for luxury cars (Maserati *Ghibli,* 1968). Company was bought by Ford in 1972 (1974, *Capri Ghia,* 1975, *Mark II Escort*).

GIACOSA, Dante b. 1905. Engineer and car designer. Worked for Fiat for fifty years (1936, *500 A* aka *Topolino,* 1948, *500 B,* 1957, *Nuova 500;* and Fiat *124, 128* and *130*). 1959 *Compasso d'oro.* 66, 195

GIGLI, Romeo 80, **211**

GILI, Anna b. 1960. Explores new applications for known materials in single products and small series. Designs furniture and living accessories often characterized by symbolic, figurative vocabulary. 150

GIO' STYLE Manufacturer of plastic housewares (with in-house R&D dept.); founded c. 1950. Annual production of some 2.5 billion plates, glasses, forks, knives, etc.

GIORGETTI Furniture manufacturer; founded 1898 in Meda. Family-owned business. Designers incl. Massimo Morozzi, Anna Castelli Ferrieri and Gianfranco Frattini.

GIOVANNONI, Stefano 79, **212**

GISMONDI, Ernesto b. 1931. Lighting designer, rocket engineer and entrepreneur. Founded Artemide with Sergio Mazza and was president and sponsor of Memphis group. Under the pseudonym "Örni Halloween" and later under his own name he designed, for Artemide, the *Ator* floor lamp and the *Pilade* table lamp. 110, 256, 314

GIUGIARO, Giorgetto 81, 100, 130, 196, **213**

GIUGIARO DESIGN 214

GLOBAL TOOLS Design project and design school (1973–75). Founders incl. Ettore Sottsass, Ugo La Pietra, Alessandro Mendini, Gaetano Pesce, Archizoom, Gruppo 9999 and Superstudio. Planned as design laboratories for free experimentation, Global Tools spawned Alchimia and Memphis. 144, 258, 324

GLORIA Lighting manufacturer. 118

GRAMIGNA, Giuliana b. 1929. Architect, furniture and product designer. **250**

GREGOTTI, Vittorio b. 1927. Architect and writer, one of Italy's most important design theorists. Editor at numerous magazines (1952–60, *Casabella*); 1974–1976, director of fine arts and architecture dept. at *Biennale di Venezia.* Author (*Il Disegno del Prodotto Industriale,* 1982). 1952–67, with Ludovico Meneghetti and Giotto Stoppino Architetti Associati, with offices in Novara and Milan (in late 1950s, cofounder of Neoliberty movement), 1968–74 with Pierluigi Carri and Hiromichi Matsui Gregotti Associati. *Compasso d'oro* 1967. 328

GRUPPO 216

GRUPPO INDUSTRIALE BUSNELLI 218, 230

GRUPPO STRUM Group of architects and designers (Piero Derossi, Giorgio Ceretti, Carlo Giammarco, Riccardo Rosso, Maurizio Vogliazzo); founded 1971 in Turin. Architettura Radicale/Radical Design (pop furniture for Gufram; *Pratone* plastic turf, 1971). Contribution to 1972 exhib., *Italy: The New Domestic Landscape.* 219, 298

GRUPPO 9999 Design group; founded 1967 in Florence by the architects Giorgio Birelli, Carlo Caldini, Fabrizio Fiumi and Paolo Galli. Radical Design. Contribution to 1972 exhib., *Italy: The New Domestic Landscape.*

GRUPPO UFO Group of designers and architects; founded 1967 by Lapo Binazzi, Carlo Bachi, Riccardo Foresi, Patrizia Cammeo, Vittorio Maschietto and Sandro Gioli in Florence. Radical Design. Urban visions, in which architecture blended with art, design and literature. From 1972 Binazzi was the group's central figure. 298

GUCCI Fashion company; founded 1904 by saddlemaker Guccio Gucci as a producer of exclusive leather goods in Milan. 1960, success with Gucci *Loafers;* from 1978 women's prêt-à-porter. After a severe financial crisis, American designer Tom Ford was hired and gave the company a new image. Today, Gucci is one of Italy's most influential fashion companies along with Prada. Known for references to fashion history and for use of new materials. 81

GUERRIERO, Alessandro b. 1943. Architect and design theorist. In 1976, with his sister, Adriana, founded Alchimia studio, which was later joined by Alessandro Mendini and Giorgio Gregori. 1982, cofounder of Domus Academy; since 1983, copublisher, with Pierre Restany, of *Decoration International* magazine, Paris. Films, videos, books and numerous exhibitions. 92

GUFRAM 219, 299

HAMEL, Maria Christina b. 1958 in New Delhi. Product designer, lived in India, Thailand and Austria before settling in Milan in 1973. Was Alessandro Mendini's assistant at Alchimia in the 1980s; designs lamps, small furniture as well as suggestively colorful vases and ceramics. Works for Alessi, Swatch, Rado and other companies.

HASUIKE, Makio b. 1938 in Tokyo; based in Italy since the 1960s. Designs incl. ceramic objects for Gabbianelli, espresso makers for Gaggia and *Cucciolo* toilet brush for Gedy (1979, permanent collection of Museum of Modern Art, New York). In 1982 cofounded bags and accessories manufacturer MH Way.

HELG, Franca 1920-1989. Architect and furniture designer. From 1951 worked with Franco Albini and after his death ran his studio with Antonio Piva and Marco Albini. 90, 278

HOSOE, Isao 220, 308

HUBER, Max 1919-1992. Swiss graphic designer; art director at Studio Boggeri. Moved to Milan in 1945. 1950, corp. ID for La Rinascente; exhibition concepts (*La forma dell'utile*, Milan Triennale 1951 with Achille and Pier G. Castiglioni). Famous posters for car races with characteristic combination of abstract color planes and silhouetted photographs. 1954 *Compasso d'oro*. 134, 231, 310

ICE; (Istituto Nazionale per il Commercio Estero). Italian foreign trade office; founded 1926 for promoting exports, partcularly for small and mid-sized firms. 1989 *Compasso d'oro*.

IDEAL STANDARD Manufacturer of bathroom furniture; founded 1909 in Milan. Rapid growth in 1950s though 1970s. Designs by Achille Castiglioni (*Aquatonda* Series, 1971), Mario Bellini (*Class* faucet, 1990), Gae Aulenti, Paolo Tilche, Enzo Mari. 296

iGUZZINI Lighting manufacturer; founded 1963. Produces sophisticated lighting systems, using materials such as die-cast aluminum and plastics. Designs by Rodolfo Bonetto, Pier Giacomo Castiglioni, Pierluigi Molinari, Bruno Gecchelin and others.

INNOCENTI LAMBRETTA car and motor scooter manufacturer.; founded 1931 by Ferdinando Innocenti in Milan. Best known for its motor scooters; At 1961 Turin car show presented the *Innocenti 950* roadster designed by Ghia. In 1965 the company developed the *Mini Minor* for which took over Lambretta in 1972. Bought by Fiat in 1989.

INTERNI Magazine for interior architecture; founded 1954. Reports on designers, products and applications.

IOSA GHINI, Massimo 78, 88, 209, **221**, 265

ITALDESIGN 100, 196, 213

ITALTEL Telephone manufacturer; founded in 1921 as Siemens S.A.. in Milan. In the 1950s designs by Roberto Menghi (1966, *Grillo* compact telephone by Marco Zanuso and Richard Sapper), Giorgetto Giugiaro. Achille Castilgioni, Design Group Italia. 182

ISOLA, Aimaro Turin architect. Gabetti/Isola office with Roberto Gabetta.

JOINT Furniture and accessories manufacturer, Milan. Colorful objects incl. mirrors, bookcases and clothes trees. *Joker* by Carlo Forcolini. Außerdem shelves (incl. *Metro* system), stools and other small furniture.

KARTELL 64, 158, 172, 220, *222,* 240, 252, 314, 328, 354

KING-MIRANDA 228, 109

KING, Perry A. b. 1938 London. Product and furniture designer. *228,* 280

KING-KONG; Design Studio 1985-89; founded by Stefano Giovannoni and Guido Venturini. Arbeiten für Alessi. 212

KLIER, Hans von b. 1934, Czechoslovakia. Graphic and product designer. Graduated from Hochschule für Gestaltung, Ulm; worked for Ettore Sottsass 1960-68. Wooden toys for children. From 1969 corp. ID for Olivetti. 1970 *Compasso d'oro*.

KRIZIA 229

LA CIMBALI Manufacturer of espresso makers; founded 1912. Since 1962 collaboration with designers, incl. Achille and Pier Giacomo Castiglioni (model *Pitagora*), Rodolfo Bonetto (model *M 15,* 1970, model *M 20,* 1979). The *ET* of 1983 was the first "superautomatica" machine, which at the push of a button did everything from grinding the coffee to pouring it.

LA PAVONI Manufacturer of espresso makers; founded

1905. Invented espresso making with *Ideale* model. *La Cornuta* by Gio Ponti, 1949. *La Diamante* by Bruno Munari and Enzo Mari, 1957. Machines are still crafted partly by hand . 296

LA PIETRA, Ugo 128, 218, **230**, 299

LA RINASCENTE 106, **231**, 260, 270, 310, 327

LAGOSTINA Housewares manufacturer; founded 1901 in Omegna. One of the leading manuf. of high-quality pots, pans and silverware. Designs by, among others, Paolo Zani and Giugiaro Design (*Modia* pots and *Atmosphere* pressure cooker); also in-house design dept.

LAMBORGHINI Automobile manufacturer; founded by Ferruccio Lamborghini. Originally tractor manuf.; then competed with Ferrari. (*350 GTV*, 1964; Lamborghini *Miura,* 1966; *Countach* by Bertone with angular, futuristic look, in production since 1972.) Company was temporarily owned by Indonesian investor, bought in 1998 by VW. 130

LANCIA 52, 54, 130, 196, **232**, 286, 344

LAZZARINI, Claudio b. 1953. Architect and furniture designer. (First design project: *Dormusa* program). From 1988, collaboration with Carl V. Pickering. Interior design of offices and stores in Rome and Milan, and design of exhibition spaces, landscapes and boats.

LAZZERONI, Roberto b. 1950. Architect and product designer. Radical Design. Designs for Acerbis.

LIBERTY Italian term for Art Nouveau. In the arts and crafts, Carlo Bugatti was the most inspired representative of "Stile Liberty". The name refers to the London store of Liberty & Co., which was founded in 1875 by Arthur Lasenby Liberty and had relationships with Italy in the late 19th century. A climactic event for Stile Liberty was the 1902 *International Arts and Crafts Exhibition* in Turin. 56, 68

LINEA ITALIANA The specifically Italian formal language developing from the late 1940s onward: organic forms and flowing, elegant lines combined with functional product design. Famous examples include the *Lexicon 80* typewriter for Olivetti (1948), the *Vespa* (1946), and Marco Zanuso's *Lady* chair for Arflex (1951). 60, 83, 112, 273

LISSONI, Piero 150, **234**

LOEW, Glen Oliver Longtime collaborator of Antonio Citterio; jointly designed office furniture for Vitra and others.

LOMAZZI, Paolo b. 1936Architect and furniture designer. 88, 136, **179**, 292, 299, 348

LORENZO RUBELLI see RUBELLI

LUCEPLAN 82, **235**, 252, 306

LUMINA Lighting manufacturer; founded 1976 by Tommaso Cimini and Ermanno Prosperi. Produces primarily halogen lights. Designers: Ricardo Blumer and Yaacov Kaufman.

LUPI, Italo 238

LUXOTTICA GROUP Eyewear manufacturer; founded 1961 by Leonardo del Vecchio in Agordo. In addition to lines like *Persol*, the company produces designs by Giorgio Armani, Giugiaro, Ferragamo, Genny, Dyblos and Yves Saint-Laurent.

MAGISTRETTI, Vico 61, 110, 116, 156, 178, 224, **240**, 274, 291

MALDONADO, Tomàs b. 1922, Argentina. Industrial designer and theorist; publisher of Argentine magazine *Nueva Vision* and *Casabella* (1976-81). Director of design schools in Ulm (1954-66), Princeton, USA (1968-70), Bologna (1971-83) and Milan. 1967-1969, pres. of Intern. Council of Societies of Industrial Design. Consultant for La Rinascente. 231

MANDARINA DUCK 177, **244**, 251

MANDELLI, Mariuccia 229

MANGIAROTTI, Angelo 110, 118, 174, **246**, 333

MANZU, Pio 1939-1969. Car and product designer, author. Worked for Olivetti, since 1968 for Fiat (City Taxi, tractors and *127*). *Parentesi* light for Flos, compl. after his death by Achille Castiglioni (*Compasso d'oro* 1979).

MARCARTRÉ Office furniture manufacturer; founded 1975. Works with Mario Bellini, Achille Castiglioni (*Solone* office furniture series), Paolo Deganello and King-Miranda.

MARI, Enzo 174, 184, **248**, 346, 348

MARTINELLI, Elio b. 1922. Interior architect, lighting designer and entrepreneur. In 1942 began working in his father's lighting company (Martinelli Luce) in Lucca; in the 1950s interiors for offices and hotels.

MARZANO, Stefano b. 1950. Product designer; in 1972 joined Makio Hasuike's Milan studio; 1978 Philips Design Center in Eindhoven; 1989 Vice President for corp. ID at Whirlpool International; since 1991 Senior Director of Philips Design;

1998 *Compasso d'oro*. 83

MASERATI Automobile manufacturer. Legendary racing and sportscars. Had its peak in the 1960s and 70s. (Maserati *Ghibli,* 1966, design by Giorgetto Giugiaro, who also designed other Maserati models). In 1998, successful comeback with *3200 GT* coupe by Giorgetto Giugiaro's Italdesign.

MASSONI, Luigi b. 1930. Industrial designer and author. In 1972 appointed president of design dept. of A&D, with commissions from Boffi, Poltrona Frau and Fratelli Guzzini. Publisher of *Forme* and other design and photography magazines. Founded Mabilia studio for furniture and industrial design.

MAZZA, Sergio b. 1931. Architect, furniture and product designer. 110, **250**

MEDA, Alberto 101, 150, 235, 244, **251**, 306, 313

MEDA, Luca b. 1936. Architect and furniture designer. From 1961, architectural projects and interiors with Aldo Rossi (1985 *Biennale di Venezia*). Since the 1960s, furniture and mass-produced articles, for Molteni, Unifor and others. 333

MEGALIT 110

MELLO, Franco Furniture designer. *Cactus* clothes tree with Guido Drocco, 1972 for Gufram. 219

MELOCCHI, Mario b. 1931. Entrepreneur, packaging and lighting designer; cofounder of Cini & Nils.

MEMPHIS 77, 88, 92, 94, 102, 110, 144, 176, 184, 221, **254**, 299, 324, 331

MENDINI, Alessandro 79, 90, 92, 94, 118, 122, **258**, 266, 294, 300, 340, 348, 353

MENEGHETTI, Lodovico b. 1926. Architect and product designer. Since 1953 partner in Architetti Associati with Vittorio Gregotti and Giotto Stoppino. 328

MENGHI, Roberto b. 1920. Architect and industrial designer. In the 1950s, worked with Marco Zanuso, Anna C. Ferrieri, Ignazio Gardella and Franco Albini. One of the first designers to use plastic (gas container for Pirelli). Designed glassware and elctr. appliances. Clients incl. Arflex, Fontana, Siemens and Venini. 1956 and 1957 *Compasso d'oro*.

MERCATALI, Davide b. 1948. Product designer. *Nomade* furniture system with Maurizio Dallasta, 1974-77. 1982-87, collaboration with Paolo Pedrizetti; intelligent household objects (*Giotto* can opener). Founder of Zeus group, 1984.

MH WAY Manufacturer of bags, backpacks and office accessories; founded 1982 by Makio Hasuike (*Piuma* translucent plastic suitcase, 1983; purist, pressure-resistant *Impronta* backpack).

MICHELOTTI, Giovanni 1921-1980. Car designer. Worked for Pininfarina, Triumph in England (1959, Triumph *Herald*) und Datsun in Japan (1961, Datsun *Prince Skyline*).

MINOLETTI, Giulio b. 1910. Architect and industrial designer. Urban planning for Milan. Designs incl. *Etr 300 Settebello* train (1949 for Breda *Ferroviarie*) and *Better Living* bathroom (1949).

MIRANDA, Santiago b. 1947 Sevilla. **228**

MIRENZI, Franco b. 1942. Furniture and industrial designer; Interiors for exhibition and office spaces for Fiat, Brionvega and Zanussi. Has worked primarily for Unimark. In addition to furniture and technical objects, has also designed corp. ID programs.

MISSONI 260, **331**

MODO Design magazine; founded 1977 by Alessandro Mendini (who was its first editor-in-chief). Background reports and news from furniture, industrial and exhibition design.

MOLINARI, Pierluigi b. 1938. Furniture and product designer. Started his career in 1961 working for Guzzini, Ampaglas and Fedegari. 1988-91, president of ADI.

MOLLINO, Carlo 62, 210, **262**, 296, 348

MOLTENI Furniture manufacturer. The Molteni group owns several companies: Molteni & C. produces furniture for residential and public use; Unifor specializes in office furn.; Dada in kitchens; Citterio in closet systems. Important designer: Luca Meda.

MONGUZZI, Bruno b. 1941. Graphic designer. Studied in Geneva and London. Worked with Studio Boggeri 1961-63 ; opened his own studio in Milan in 1968. Combines influences from Swiss design with photographic elements. (1986, poster announcing the opening of Musée d'Orsay). 134, 310

MONDO 152

MONTECATINI Chemical company; founded 1888. In the 1930s worked with Gio Ponti and Marcello Nizzoli. 1964, *Algol*

Nizzoli Associati in Milan. Gas station design for Ceccato;, spark plugs for Lombardini; cover designs for *L'Architettura* magazine.

OLIVETTI 51, 52, 53, 57, 59, 64, 65, 108, 114, 122, 123, 134, 138, 177, 228, 239, 268, 272, **276**, 320, 322, 327

OTTAGONO Magazine for industrial design; founded 1966 by Osvaldo Borsani. Focuses on theoretical and historical subjects.

PAGANO, Giuseppe (Giuseppe Pagano Pogatschnig) 1896–1945. Architect, furniture designer, author. In the 1930s, furn. designer; representative of Rationalism; editor at *Casabella* and *Domus*. An antifascist, he was interned and killed in a German camp.. 303, 348

PALLUCCO Furniture manufacturer; founded 1980 by Paolo Pallucco. In addition to its founder's designs, the firm produces works by young designers and reeditions by Gio Ponti and others. Renamed Palluccoitalia, the firm has been run by Mino Bellato since 1989.

PAMIO, Roberto b. 1937. Architect, furniture and lighting designer. Worked with Renato Toso; furniture and lights for Arflex, Art Linea, Cidue, Leucos and Zanussi.

PECORA, Terri 282

PEDRIZZETTI, Paolo b. 1947. Architect, product designer and author. 1982-88, studio with Davide Mercatali (experiments with plastic, metal and other materials). Opened new studio in 1988; publisher of *Blu & rosso* and *Bagno & Bagni.*

PENATI, Marc 321

PEREGALLI, Maurizio b. 1951. Architect, entrepreneur and furniture designer. Worked with Giorgio Armani, whose stores in Italy, London and New York he designed. 1984, cofounder of Zeus. 357

PERSICO, Edoardo died 1939. Architect, graphic designer, lawyer and author. Rationalist. architect; wrote about architecture and design. 1935-36, co-publisher of *Casabella.*

PESCE, Gaetano 116, 128, 156, **283**, 299

PIACENTINI, Marcello 1881-1960. Architect and urban planner. 1927, exemplary planning of town center of Bergamo (classical and modern elements). Received important architect. commissions from Fascist government. (1928, court house in Messina; 1931-39, in Milan).

PIAGGIO Motor scooter manufacturer. Before World War II aircraft manufacturer The 1946 *Vespa* by airplane engineer Corradino d'Ascanio, was a new type of vehicle with an integral body and "aeronautic" look. In the 1950s, it became a symbol of Italian Dolce Vita. 59

PIERANTONIO BONACINA 136

PININFARINA/PININ FARINA 65, 98, 130, 138, 190, 196, 213, 232, **286**

PINTORI, Giovanni b. 1912. Graphic designer and artist. Worked primarily for Olivetti (1947, Logo). Best known for his posters for *Lettera 22* and *Elettrosumma 22*. Headed Olivetti's graphic design dept. from 1967. 278

PIRELLI 62, 104, 135, 218, 270, **290**, 294, 310, 327, 352

PIRETTI, Giancarlo b. 1940. Furniture designer. Head of research & design dept at Castelli. Ergonom. furniture for mass prod. (1969, *Plia* folding chair made of Plexiglas, which was frequently copied). Later worked for Open Ark and, from 1984, for Castilia. 1981 and 1991, *Compasso d'oro.*

PIVA, Paolo b. 1950. Architect, product designer and author (1980, Ambassador to Kuweit in Quatar). Furniture and products for B&B Italia, Poliform, Stilnovo and Giovannetti.

POGGI 90, 230, **291**

POLITECNICO DI MILANO Architecture school of Milan University. Almost all famous Italian designers studied here, many of them have also taught at the school. Since 1994 the Politecnico also has an industrial design dept.

POLLINI, Gino b. 1903; Architect and product designer. 1926, cofounder of Gruppo Sette, which advocated Rationalist architecture. 1930-1946, Italian delegate to International Congress for Modern Architecture (CIAM). Collaborated with Luigi Figini (1934-1935, Olivetti building in Ivrea; 1935, *Studio 42* typewriter with Alexander Schawinsky). 53, 276, 302

POLTRONA FRAU Furniture manufacturer; founded 1912 by Renzo Frau in Turin. Specializing in upholstered furniture, the company furnished salons and luxury liners in the 1920s. After 1945 it switched to industrial production, working with designers incl. Gio Ponti, Marco Zanuso, Pierluigi Cerri, Gae Aulenti and Mario Bellini. Today it also produces airplane seats and furniture for public/commercial use. 344

POLTRONOVA 114, 144, 179, **292**, 300, 324, 329, 344

PONTI, Gio 57, 63, 88, 136, 154, 202, 204, 251, 290, **293**, 340

PORTOGHESI, Paolo b. 1931. Architect, author, teacher, furniture and product designer. Co-publisher of trade magazines and author of numerous books on architecture. Designs for Poltrona Frau, Alessi and Ritzenhoff. 96

POZZI-GINORI Ceramics manufacturer; founded 1906 as Ceramica Pozzi spa. Specializes in bathroom fixtures. Designs by Gae Aulenti, Matteo Thun, Makio Hasuike. 1976, merger with Richard-Ginori.

PRADA, Miuccia b. 1950. Fashion designer. Studied political science and theater. In 1980 joined her uncle Mario's leathergoods company in Milan. First collection 1985 (waterproof nylon knapsack). Minimalist. Frequent use of unusual patterns, synthetic materials. 81

PUCCI, Emilio 1914–1992. Fashion designer. 1947, ski clothes. Pucci influenced fashions of the 1960s with silk jersey dresses and blouses in colorful, wild patterns influenced by Pop Art and Op-Art. Also known for his capri pants and bodysuits.

PUPPA, Daniela b. 1947. Author, furniture and fashion designer. Worked for Nizzoli Associati, 1970-74;1972-76, at *Casabella;* 1977-83 at *Modo.* Designs for Fontana Arte, Cappellini, Ligne Roset, Alchimia and Gianfranco Ferré. 202

RADICAL DESIGN 102, 144, 179, 181, **298**, 219, 230, 254, 284, 292, 322, **329**

RAGGI, Franco b. 1945. Architect, furniture and lighting designer and critic. Worked for *Casabella,* 1971-75. From 1977-1983 publisher of *Modo.* Theorist of Radical Design; active in Global Tools. With Daniela Puppa designed lamps and chairs for Fontana Arte and Cappellini. 92, 202, 292, 313

RASULO, Prospero 104, 292, **300**

RATIONALISM 55, 276, 296, 298, **302**, 322

RE-DESIGN Term used in Italy to describe reinterpretations of existing products. Raymond Loewy was an early, prominent representative of the concept with his restyling work on cars and other objects. It was picked up by Alessandro Mendini in the 1970s as part of Alchimia's design project. Claiming that invention of new forms was not possible anymore, Mendini ironically reinterpreted classic Bauhaus and Thonet chairs by covering pieces like Marcel Breuer's *Wassily* chair with patterns or adding little flags. 258, 300

REXITE Manufacturer of small furniture and accessories; founded 1968. Since 1978 Raul Barbieri has been in charge of design, often collaborating with Giorgio Marianelli (joint designs incl. *Babele* letter tray, 1995, over one million sold. Also *Cribbio* series with umbrella stand). Designs by Giotto Stoppino (c. 1990, *Biblio* cassette holder), Julian Brown, Gabriella Montaguti.

RICHARD-GINORI Ceramics manufacturer; founded 1873 in Milan. Gio Ponti artistic dir. from 1923 (vases and vessels); succeeded by Giovanni Gariboldi in the 1940s and 50s (1954, *Ulpia* tea set); and later by Gae Aulenti. 1976, merger with Ceramiche Pozzi. 56, 294

RIMA (Rinaldi Mario) Furniture manufacturer; founded 1946 by Rinaldi family of hardware dealers in Milan. After World War II, production of metal furniture; combination of iron with rubber and plastic.

RINALDI, Gastone b. 1920. Architect and furniture designer. Designed numerous delicate, elegant pieces of metal furniture, incl. *DU 10* (1951), *DU 30* and *DU 43* (1953), *DU 57* (1956) chairs, most of them for RIMA, founded by his father, Mario. In the 1970 s, *Ondalunga* sofa and *Dafne* folding chair.

RIVA, Umberto 304

RIZZATTO, Paolo 101, 235, 252, **306**

ROGERS, Ernesto Nathan 1909–1969. Architect, furniture designer and author. 1932, cofounder of BBPR. 1946-1947, publisher of *Domus;* 1953-1964, *Casabella- Continuità.* From 1962, teacher at Milan polytechnic. Was important influence on development of Italian design in the 1950s. 51, 122

ROMANELLI, Marco 82, 184, 274, **307**

ROSSELLI, Alberto 303, 352, **308**

ROSSI, Aldo 79, 96, **309**, 333

RUBELLI Renowned textile company founded 1858 in Venice. Produces high-quality decorative fabrics, incl. heavy gold and velvet materials, but also airy cloths in natural colors. Also hand-woven velvet fabrics (*Soprarizzi*) using techniques from the 16th century.

SABADIN, Gigi b. 1930. Not a designer or architect, Sabadin is a traditional artisan specializing in wood and metal. Designs furniture primarily for Crassevig. Well-known pieces include wooden cradle for Stilwood.

SILVESTRIN, Danilo b. 1942. Architect, furniture and product designer. Master of simple form. Designs for ClassiCon, Lambert, Rosenthal, Up&Up and WMF.

SKIPPER Furniture manufacturer; founded 1968. Since 1973 producer of different collections, incl. *Comput* (office furniture), *B. Ardani* (residential furn.), *Green* (outdoor furn.). Designers incl. Ettore Sottsass, Bruno Gecchlin and Angelo Mangiarotti. 246

SMC ARCHITETTURA Studio of Sergio Mazza and Giuliana Gramigna. **250**

SMEG Manufacturer of electric appliances; founded 1948 in Guastalla. Stoves, washing machines and dishwashers in classically elegant, functional designs.

SOTTSASS, Ettore 61, 65, 77, 88, 92, 96, 110, 254, 278, 292, 299, **322**, 348

SOWDEN, George James b. 1942, England. Architect, furniture and industrial designer. From 1970 collaborated with Ettore Sottsass. Computer systems and office work stations as well as research into ergonomics for Olivetti. Cofounder of Memphis (1982, *Luxor* closet). Designs for Ritzenhoff and Rasch.

STEINER, Albe 231, 290, **326**

STILEINDUSTRIA Magazine founded in 1953 by Alberto Rosselli to promote exchange between industry and design. Folded in 1962. Unsuccessful relaunch in the 1990s. 1970 *Compasso d'oro.*

STOPPINO, Giotto 127, 218, 224, **328**

STUDIO ALCHIMIA 88, **92**, 94, 102, 144, 176, 216, 254, 258, 300, 324

STUDIO BOGGERI 134, 278

SUPERSTUDIO 292, 298, **329**

SUSANI, Marco b. 1956. Studied architecture in Milan. **332**

TAKAHAMA, Kazuhide b. 1930, Japan. Architect and furniture designer. Opened studio in Bologna in 1963. Designs for B&B Italia, Simon International and lighting manuf. Sirrah.

TECNO 142, **330**

TECNO TUBO TORINO 216

TERRAGNI, Guiseppe 1904-1943. Architect and furniture designer; Rationalist. (1934-36, Fascist part headquarters in Como). Used industrial materials; designed early serial products (1936, *Lariana* tubular-steel chair; produced by Zanotta since 1982). 55, 302, 348

TESTA, Armando 1917-1992. Graphic designer. One of the most influential figures in Italian graphics and advertising. Opened in Turin in 1946. Founded successful advertising agency in 1956. Best-known for poster for 1960 Olympics in Rome and advertisements for Pirelli. 290

THUN, Matteo 77, 109, 201, 216, **331**

TOSCANI, Oliviero b. 1942. Fashion photographer and art director. Spectacular advertising campaigns for Benetton. Developed modern corp. ID for Fiorucci and Esprit; visual communication for B&B Italia. 116, 126

TOURING Car-body maker; founded 1926. 1931, legendary aerodynamic *Flying Star,* 1937, Alfa *8C 2900 B Superleggera;* 1939, Alfa *6C 2500SS Duxia;* 1957, Lancia *3500GT;* 1959, Lancia *Flaminia.* 1967 dissolved. 98, 232

TOVAGLIA, Pino 1923-1977. Graphic designer. Advertisements for Pirelli, Logos for Ottagono and Alfa Romeo. Founder of Art Director's Club Milan. Consultant for La Rinascente and Flos; directed course in corp. ID at Scuola Politecnica di Design in Milan; 1998 *Compasso d'oro* for lifetime achievement.

TRIENNALE Influential international exhibition of architecture and design. Since 1933, held in three-year intervals (with interruptions) at Palazzo dell'Arte in Milan (designed by Giovanni Muzio). Precursors were the *Biennali* in Monza (I through IV) of the 1920s, which showed primarily arts and crafts and interior architecture. The shows, each focusing on a particular subject, have had an eventful history: V. and VI. *Triennale,* 1933 and 1936, were so called "direction Triennales" (Rationalism vs. Novecento); VII. *Triennale* 1940, VIII. *Triennale* 1947 (subject, "L'abitazione", living and furniture); IX. to XI. *Triennale* 1951, 1954, 1957 devoted to new discipline of industrial design; XII. *Triennale* 1960; XIII. *Triennale* 1964 (subject "Il tempo libero," leisure time); IVX. *Triennale* 1968 (occupied by adherents of Radical Design); XV. *Triennale* 1973; XVI. *Triennale* 1982; XVII. *Triennale* 1983–1988 (exhibition cycle); XVIII. *Triennale* 1992; XIX. *Triennale* 1994 (subject, "Identità e differenze"). One of the most important institutions for the promotion of design for many years, its significance has gradually been

diminishing since the late 1960s. 1967 *Compasso d'oro.* 54, 57, 64, 90, 142, 162, 176, 204, 352

TRIMARCHI, Mario b. 1958, Messina. Studied architecture in Reggio Calabria. 44, **332**

TRUSSARDI Fashion company; founded 1910 in Bergamo, now in Milan. Initially glovemaker's workshop, later complete line of leather goods. Headed since 1970 by Nicola Trussardi. 1983, ladies' wear; 1984, menswear. Since 1991 also haute couture. Produces accessories, furniture, tableware; popular leather jackets and coats.

UFO see Gruppo UFO

ULTIMA EDIZIONE Furniture manufacturer; founded 1986. Specializes in working in old marble. Designers incl. Gae Aulenti, Ettore Sottsass, Marco Zanuso, Marco Zanini, Vico Magistretti.

UNIFOR 309, **333**

UP&UP Manufacturer of tables, flooring, bathroom fixtures, fireplaces; founded 1986; specializes in marble. Designs by Aldo Rossi, Marco Romanelli and Marta Laudani, Achille Castiglipni, Adolfo Natalini, Marco Zanini. 307

VALENTINO 334

VALLE, Gino 338, 355

VENINI 132, 201, 296, **340**

VENINI, Paolo 1895-1959. Glass designer and entrepreneur. 1921, cofounder of Venini, of of Venice's most renowned glass manufacturers. Sole owner from 1925. Venini revived old techniques and developed them further. Designers incl. Gio Ponti, Carlo Scarpa. 296, 319, 318, 340

VENTURINI, Guido b. 1957. Product designer. Representative of Bolidismo. Worked with Stefano Giovannoni for King-Kon, 1985-1989. Designs for Alessi, Ultima Edizione, Twergy and Bianchi & Bruni. 94, 212

VERSACE, Donatella 80, 342

VERSACE, Gianni 342

VIGANÓ, Vittoriano b. 1919. Architect and Product designer. Early experiments with new materials. Worked with Gio Ponti and at BBPR. Communicated Le Corbusier's ideas. Influential in the 1950s with his steel, glass and plywood furniture. Designs for Arteluce. 60, 109

VIGNELLI, Lella b. 1936. Architect, furniture and graphic designer. Studied at MIT Cambridge and in Venice. 128, 292, **344**

VIGNELLI, Massimo b. 1931. Architect, furniture and graphic designer. Studied architecture in Milan and Venice. 128, 290, 292, 340, **344**

VIGO, Nanda Architect, artist and product designer. Worked for Lucio Fontana and Gio Ponti. In addition to architectural and art projects, furniture and lighting for Driade, Gabbianelli and Glass Design.

VORTICE Manufacturer of electric appliances; founded 1954. Well-known poroducts incl. Marco Zanuso's innovative 1977 *Ariante* fan housed in a "box."

ZANI & ZANI 346

ZANINI, Marco b. 1954. Architect, furniture, glass and lighting designer. Worked for Sottsass Associati; known for designs for Memphis (1986, *Roma* chair) and glass objects for Venini. 77, 256, 325

ZANOTTA 55, 78, 114, 144, 162, 179, 181, 230, 299, 321, 329, **348**

ZANUSO, Marco 61, 62, 63, 104, 109, 122, 132, 136, 138, 145, 222, 290, 314, 348, **352**

ZANUSO, Marco jr. b. 1954. Architect, furniture and lighting designer. Lighting for his own firm, Oceano Oltreluce; furniture for Memphis; architectural projects in Europe. 303

ZANUSSI 65, 338, **355**

ZEUS 81, **357**

ZUCCHETTI RUBINETTERIA manufacturer of faucets; founded 1929 by Alfredo Zucchetti. 1975, collaboration with Studio Nizzoli (*Zetamix 6000*), later with Raul Barbieri and Giorgio Marianelli.

The author wishes to thank

Markus Schuler, Cologne,
without whose help this book would not exist. I am greatly indebted to
him for his enthusiastic, expert research and knowledgeable, inspired
editing of the sections on graphic and fashion design.

Fulvio Ferrari, Turin, for giving generous access to his photographic archive.

Jan Strathmann, Cologne, for his careful editing of the text.

Helge Aszmoneit and the German Design Council, Frankfurt, for their
valuable research assistance.

Donatella Cacciola, Rome and Bonn, for her tireless help in
compilingphotographic material.

Giulio Castelli, Milan, and ADI for assisting our photographic research
efforts; with special thanks to Alessandra Fossati.

Uta Brandes, Cologne. ICE, Istituto Nazionale per il Commercio Estero, Düsseldorf
(Dr. Andrea Ferrari, Mariana Lopper, Dr. Tommaso Maria Gliozzi). Michael Erlhoff,
Cologne. Galerie Ulrich Fiedler, Cologne (Ulrich Fiedler and Katharina Evers). Thomas
Hauffe and Elisabeth Knoll, DuMont Buchverlag, Cologne. Bruno Mocci, Cultural
Representative of the Italian Embassy, Bonn. Peter Pfeiffer, Milan. Marco
Romanelli, Milan. Heike Tekampe, Cologne.

Paolo Antonelli, Peter Boragno, Guido Boragno, Robin Davy, Klaus Thomas Edelmann,
Ruth Hanisch-Raddatz and Wolfgang Raddatz, Dr. Hans Höger, Christoph Johannsson,
Michael Junker, Olaf Kriszio, Antonia Lahmé, Ines Lusche, Manu Lange, Julia Lenz,
Kathrin Luz, Anne Marburger, Alexandra Maus, Susan Neumann, Eleonore Neumann,
Ingeborg Polster, Udo Schliemann, Klaus Schmidt-Lorenz, Ulrike Stiefelhagen,
Ute von Elsen.

Thanks to all the firms and designers who graciously supported me in my research
efforts.

And special thanks to Mandy, Bernd and Olaf.

Library of Congress Cataloging-in-Publication Data

Neumann, Claudia.
 [Design-Lexicon Italien. English]
 Design Directory: Italy / Claudia Neumann.
 p. cm.
 Includes index.
ISBN 0-7893-0335-3
1. Design--Italy--History--20th century. 2. Design, Industrial-Italy--
History--20th century. I Title.
NK1452.A1N4813 1999
745.2'0945'09045--dc21

COPYRIGHT

99-24734
CIP

DATE ᴅᴜᴇ

Fulvio Ferrari: 14, 18, 30, 35, 53 (l., c.), 55 (l.), 57 (l.), 61 (c.), 63 (c., r.), 65 (c.), 67 (c.), 71 (c., r.), 72 (l., c.), 74 (l.), 75 (l., c.), 92 (top, bottom r.), 104 (b.), 104 (t.r.), 105 (t.r.), 142, 144 (l.), 149 (l.), 164 (l.), 170 (r.), 173 (r., b.), 175 (b.r.), 210, 219 (l.), 263, 279 (t.), 285 (t.), 293, 297 (t.l., b.l.), 323 · **Studio Aldo Ballo:** 7, 19, 111 (t.l., t.r.), 125 (t.l.), 132 (l.), 139 (b.l.), 155, 156 (t.r., b.l.), 162 (r.), 171 (l., r.), 207 (t.r.), 241, 250 (l.), 295, 316 (r.), 325 (l.), 346, 347, 349 (b.r.) · **Andreas Jung / Galerie Ulrich Fiedler, Cologne:** 4, 31, 66 (c.), 91 (b.), 109, 279 (b.l.), 297 (b.r.) · **ADI Archive, Milan:** 33, 34, 62 (r.), 64 (c.), 65 (l.), 67 (l.), 68, 69 (c., r.), 71 (l.), 72 (r.), 78 (l.), 79 (r.), 103 (t.), 146, 147, 156 (b.r.), 165 (c.), 173 (t.l.), 179, 208, 246, 271 (t.l., u.r.), 273, 311 (b.r.), 315 (t.), 318, 330, 339 (t.), 352, 353, 354 · **Gio Ponti Photo Archives, Salvatore Licitra:** 39, 54 (c.), 62 (c.) · **Studio Masera:** 40, 114 (r.), 163, 329, 349 (t.l.) · **Archivio Storico of Olivetti, Ivrea, Italy:** 51 (r.), 52 (l.), 55 (c.), 67 (r.), 139, 277, 279 (b.r.), 281 · **Robin Davy:** 2 · **M. Ramazzotti:** 15 · **Ramazzotti & Stucchi:** 302, 303 (l.), 349 (b.l.), 349 (t.r.), 351 · **Nucera / Casa Vogue:** 21 · **Miro Zagnoli:** 111 (u.l., u.r.), 169 (o.l.), 316 (m.) · **Notarianni:** 316 (l.) · **Victor Mendini:** 317 (l.) · **Santi Caleca:** 317 (r.) · **Centrokappa:** 161 (b.l.) · **Bella & Ruggeri:** 25, 156 (t.l.), 250 (r.) · **Roberto Sellitto:** 243 (b.r.), 193 (r.) · **Luciano Soave:** 54 (b.r.) · **Salvador Liderno:** 38, 237 (b.l.) · **Gionata Xerra:** 237 (r.) · **Studio Azurro:** 235 · **Bruno Di Bello:** 253 (b.l.) · **Archiv Albe Steiner:** 45, 326, 327 · **Leo Torri:** 180 (r.), 306 (b.r.) · **Bruno Stefani:** 61 (b.l.) · **Serge Libiszewski:** 310, 311 (t.l.) · **Hans Hansen:** 168 · **Bernd Mayer:** 169 (b.l.) · **Axel Siebmann:** 106 · **Anghinelli:** 206 · **Paolo Roversi:** 229 (l.) · **Mici Toniolo:** 282 (b.r.) · **Franco Manfrotto:** 141 (b.) · **P. Bramati:** 306 (b.l.) · **Guy Marineau:** 335 (r.) · **Piero Biasion:** 335 (l.) · **Beppe Caggi:** 343 (t.r.) · **Abbattista:** 343 (t.l.) · **R. Tecchio:** 359 (r.)